Pictures for the Sky
芸 術 凧

Pictures for the Sky
芸 術 凧

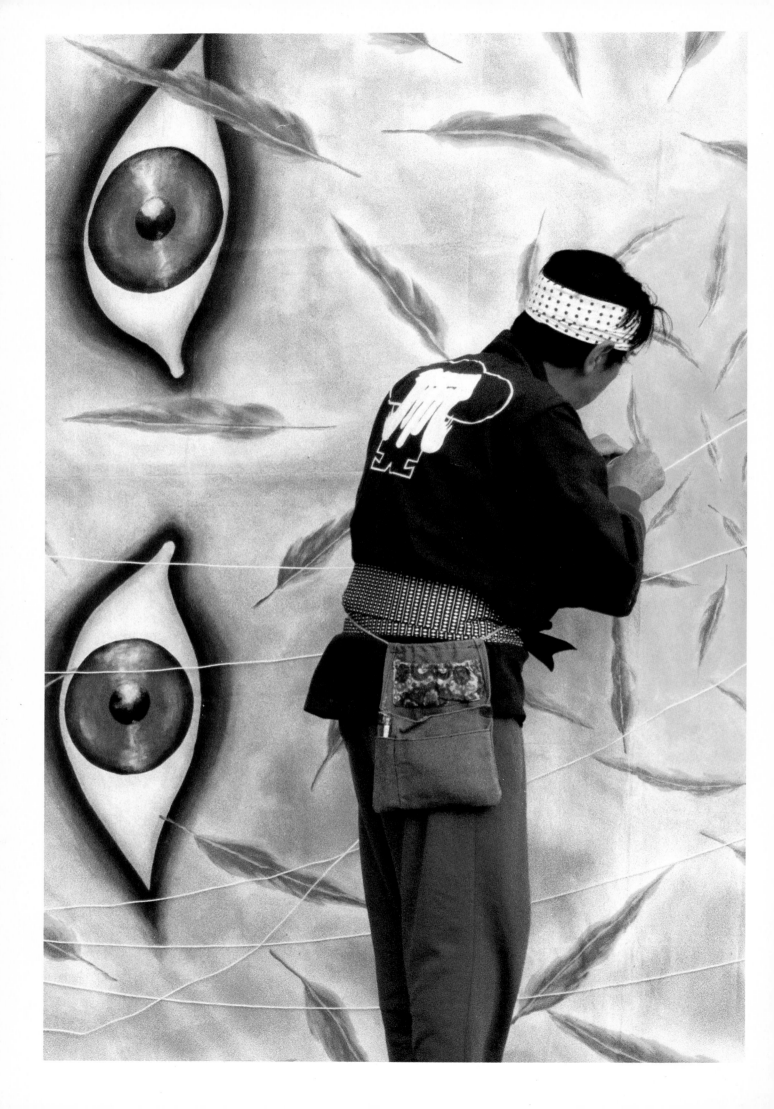

Pictures for the Sky

空舞う絵画

Art Kites

芸 術 凧

Edited by Paul Eubel

Goethe-Institut Osaka

大阪ドイツ文化センター

PRESTEL

A Project of the Goethe-Institute, Osaka

Conception, Organization, Exhibition:
Paul Eubel

Project Assistant:
Ikuko Matsumoto

大阪ドイツ文化センター企画「アート・カイト」
発案、構成、展覧会
Dr. パウル・オイベル
企画アシスタント
松本郁子

Frontispiece: Kite-maker Tatsuro Kashima attaches the strings to Chema Cobo's kite
(Photograph: P. Eubel)
口絵：凧師鹿島達郎がチェマ・コボのアート・カイトに糸目をつける（撮影P. オイベル）

Published in conjunction with the exhibition touring USA and Canada 1992-1993.

Front cover: Robert Rauschenberg: *Sky House II*, Photo by Karyn Young, Ashiya
Back cover: Kenny Scharf: *Starring . . . The Star*, photo by Helmut Steinhauser, Osaka

Prestel-Verlag, Mandlstrasse 26, D-8000 Munich 40, Germany
Tel: (089) 38170 90; Fax: (089) 3817 09 35

Distributed in continental Europe by Prestel-Verlag
Verlegerdienst München GmbH & Co Kg
Gutenbergstrasse 1, D-8031 Gilching, Germany
Tel: (8105) 21 10; Fax: (8105) 55 20

Distributed in the USA and Canada by te Neues Publishing Company,
15 East 76th Street, New York, NY 10021, USA
Tel: (212) 288 0265; Fax: (212) 570 2373

Distributed in Japan by YOHAN-Western Publications Distribution Agency, 14-9 Okubo 3-chome,
Shinjuku-ku, J-Tokyo 169
Tel: (3) 208 0181; Fax: (3) 209 0288

Distributed in the United Kingdom, Ireland and all remaining countries by Thames & Hudson Limited,
30-34 Bloomsbury Street, London WC1B 3 QP, England
Tel: (71) 636 5488; Fax: (71) 636 1695

Die Deutsche Bibliothek – CIP-Einheitsaufnahme

Piktures for the sky: art kites; [Miyagi Praefectural Art Museum, Sendai, 11.6. – 10.7.1988 . . .
Salas de Exposiciones del Arenal, Expo '92, Sevilla, 5.1. – 9.2.1992] / Goethe-Institut Osaka. Ed. by
Paul Eubel. - München: Prestel, 1992 Parallelt. in japan. Schr.- Dt. Ausg. u.d.T.: Bilder für den
Himmel ISBN 3-7913-1138-7
NE: Eubel, Paul [Hrsg.]; Goethe-Institut <Osaka>; Miyagi-ken-bijutsukan <Sendai, Miyagi-ken>

ISBN 3-7913-1138-7 (English edition)
ISBN 3-7913-1043-7 (German edition)
Printed in Germany

Foreword

The kite, its clean ascent, its dashing flight, always contains something prodigious, almost miraculous. The simple technology of the kite makes the childhood dream of flight possible. Behind the space race, behind the conquest of sky navigation, stands this paper or cloth bird, ribbed on a wooden frame.

The kite – *cometa, aguilone, papagaio, Drachen, cerf-volant, vozdushnyi smei* and *tako* – is an element common to all cultures and civilizations; it is an age-old game, a universal language. The flight of the kite has engaged imaginations on all continents since the dawn of time. But one characteristic of the kite is yet to be fully exploited: its potential as a medium for artistic expression, its versatility as a work of art.

This book documents an extraordinary event demonstrating this potential: kites as an object of contemporary artistic design. Dr. Paul Eubel, former director of the Goethe Institute in Osaka, invited over one hundred artists from twenty different countries to design the kites of their imagination. Skilled Japanese artisans ensured that these objects could fly and launched them in a unique pageantry of color.

An exhibition displaying the art kites has been touring major museums in Japan, Europe and America. The enthusiasm generated throughout the world by the exhibition led to this publication, which we believe captures the fascination and excitement of this unusual project.

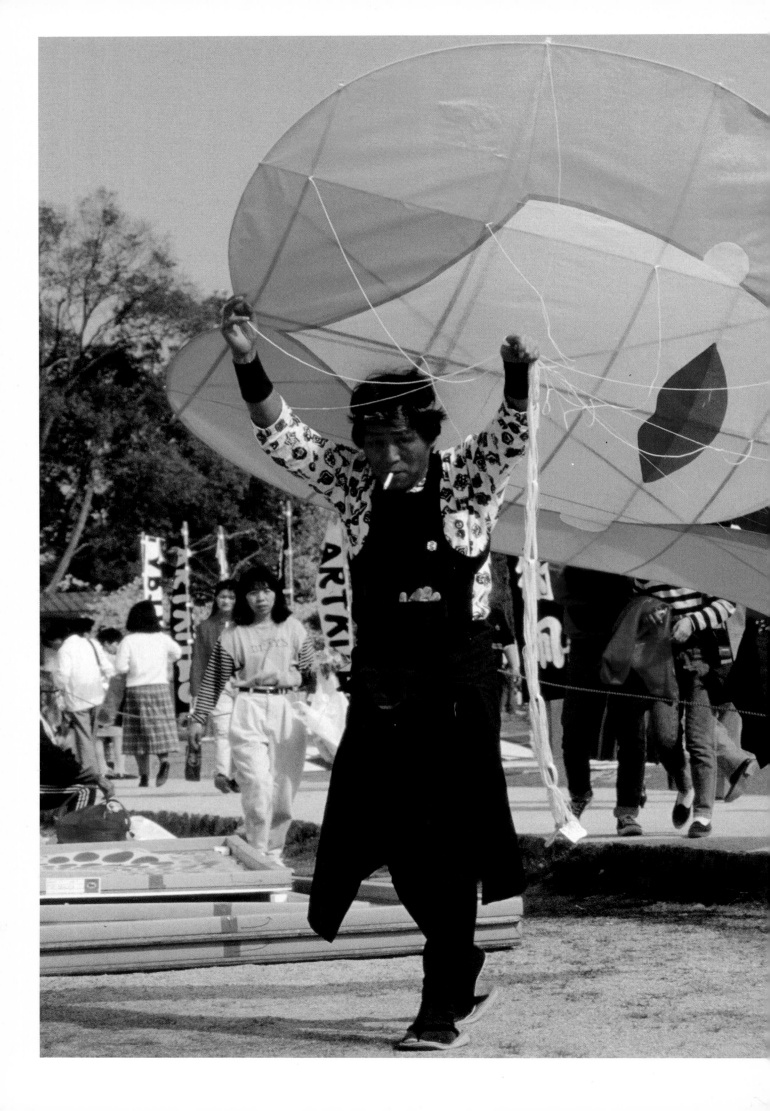

For this is all art's desire:
To lead man's mind to something higher,
And raise him from the ground
To where no compass points are found.
Without fearful hesitation
He rises, heaven his destination.
And, amid these higher spheres,
Even whispers reach his ears,
Distant world that eye can see
And the heart beats strong and free.

Goethe

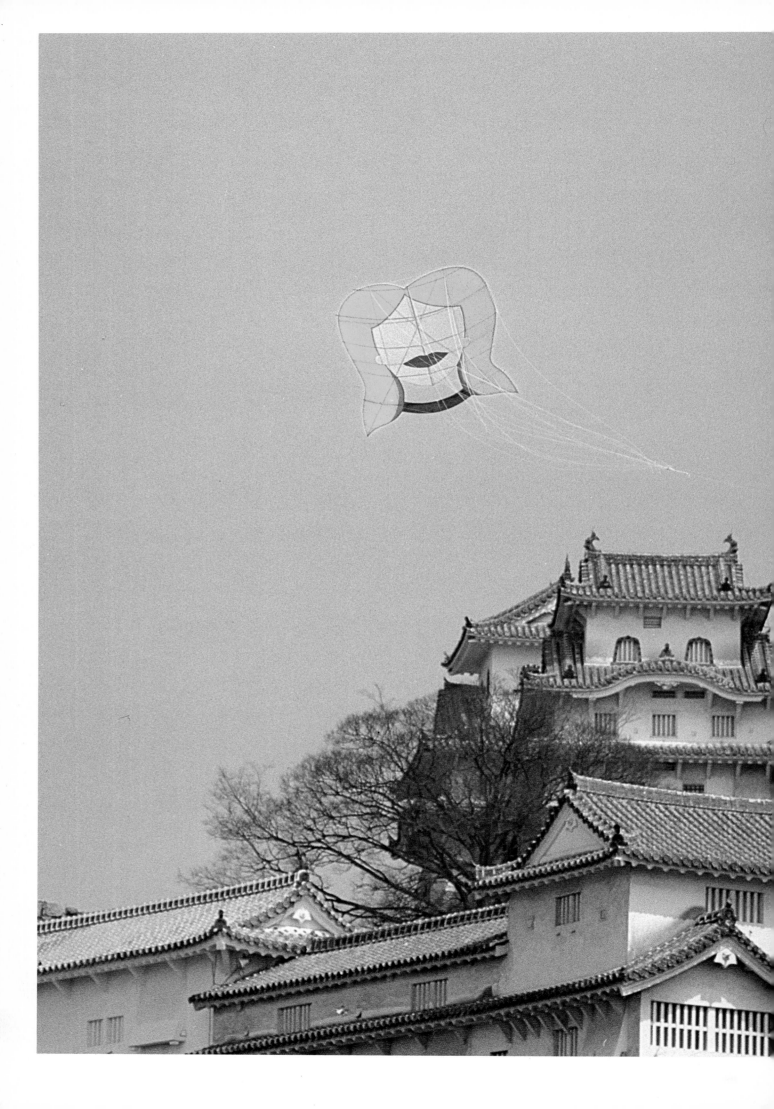

Contents:
目 次

Homo faber – Homo ludens
ホモ・ファーバー、ホモ・ルーデンス

It is a curious fact that, even as new material technology makes it ever easier for humans to frolic and soar among the clouds, our ages-old fascination with flying shows no signs of diminishing. In fact, one is hard-pressed to find many inhabitants of this planet so fond of gravity that their souls don't quiver at the merest suggestion of free, bird-like flight.

The same situation applies to fine art. Thanks to its propensity for revealing new perspectives and unimagined worlds – not to mention the intimations it offers of a far greater freedom lying just beyond the quotidien – art boasts an equal capacity to awake wonder and joy. Due to "flights" of fancy of creative artists throughout history, mankind's spirits have been continually uplifted.

Now, there suddenly appears on the horizon – or, more accurately, above the horizon – a project that seeks to wed these two transcendent phenomena. Imagine works by internationally-renowned contemporary painters and sculptors taking wing and spiralling up into the sky! Visualize art flying free, suspended against a background of infinite blue like symbol-laden phoenixes. Picture this and you will be able to share some of the excitement felt by Dr. Paul Eubel of the Osaka Goethe Institute when he first thought of the Art Kite Project.

Transforming works of art into kites and then flying the whole collection together! The idea is so natural, so elegantly simple and so rich in possibilities that one is amazed it has never been tried before. To be sure, it demands a rare level of cooperation between artists and craftsmen – in this case, over 100 artists from 20 countries entrusting their work to an equal number of Japanese kite-makers and flyers – but the rewards to both groups, both professionally and personally are equally out of the ordinary.

Even those on the periphery of the Project – the poets, composers and musicians who contributed to the Gesamtkunstwerk (collec-

人類は飛ぶ夢を実現した。しかし、空気より軽くなるという憧れは満たされていない。すばらしい理想像が実現されるための場として空にはまだ魅力が残されている。今回のアート・カイトのコレクションはこんなことをテーマにしている。コレクションの舞台になるのは空想上の美術館である。芸術が新天地を求めて高く舞い上がり、空にすみかを見つけるとすれば、どうであろうか。Dr.パウル・オイベルはこの雲をつかむような、しかし凝縮したアイデアを具現化し、ホモ・ルーデンスの遊びに対する憧れ、遊びのもつ力と、ホモ・ファーバーの発明の精神を最も適切な方法で結びつけたのである。

芸術家たちがこの文化的な催しに寄与したものは、未知の世界を創造する彼らの天分が生み出したものである。芸術家たちは私たちに合理性にとらわれない世界での体験の可能性への扉を開いてくれる。イメージや象徴、感覚などを通して、私たちが美を捉え、美が体験できるように扉を開いてくれる。一見非生産的に見える別の世界で彼らの直観は働き、広がっていく。彼らの創造の世界を直視する時、私たちは芸術に対する独自の力をふりしぼり、積極的に展開させようとする。私たちが物事を感じとる能力は芸術に親しく触れることによって鋭敏になる。日常生活における未知の世界として、私たちは芸術家の目的に縛られない自由を必要とするのである。

この自由を実現するために、風と戯れること以外により適切なものがあろうか。

芸術は越境であり、冒険であり、新しい領域への侵入である。私たちは、ギャラリーや美術館など、閉鎖された場所で芸術に出会うことに慣れすぎてしまっている。芸術は、凧とともに閉鎖された場所を飛びたち、新しい次元へ到達しようとする。芸術はそりによって肩を張り、風に向って翼を広げ、大気をはらんでふくらみ新しい姿になろうとしている。しかし、舞い出して初めてその本来の形になるのである。従来のものとは違った鑑賞がされなければならない絵画であり、普段とは違った、絵画から新しい体験を発見するための知覚を呼び覚まそうとする。この芸術が墜落するかもしれないということは、自然に依存するものの本質である。それは風という要素が予期せぬ、すばらしい戯れの共演者として加わるからである。

tive artistic creation) – seemed to sense early on that the marriage of fine art and kiting holds extremely high promise.

In the first place, mounting an original work on a kite offers a solution to a long-standing dilemma: how to liberate art from the narrow confines of museums and gallery walls without totally losing the viewing experience? Fine art, after all, has forever been linked in our imaginations with notions of freedom and escape, but few have been the individual installations able to justify frequently-heard critical metaphors like lightness, free-spiritedness and flight.

Art on a kite, however, once aloft, is remarkably free as it cavorts in the wind. It can skip and trip across the heavens with rhapsodic abandon. It can also sail among the clouds and play marvellous tricks with sunlight and shadow. In short, such art can finally live up to its image as the paragon of liberation.

On the aesthetic plane, moreover, such movement and drama causes pictorial expression to merge with dance, thus opening the way for an entirely new appreciation of the work.

This alone would be reason enough for artists to be predisposed to gravitating (or levitating) toward kites, but there are profound psychological attractions as well. One of them is the poetic-emotional connection between flying and the process of artistic creation. Perhaps because both activities produce spells of anxiety, ecstasy and transcendence, artists have often compared their labor to flight and are fairly obsessed with the concept. So kites – with their glorious 2500 year history but continuing link to childhood innocence – would be the obvious choice among sky vehicles to appeal to artists.

It has also been suggested that the emotions of kite-flying correspond to those felt by artists the moment their creations are let loose to find a new home in the world. Interestingly, it is as the symbol of such a fleeing soul that the kite has come to be understood in many parts of Asia.

どうして凧は芸術家たちをこの冒険のとりこにしてまったのだろうか。それは芸術が凧ともうひとつの点で本質的に類似しているからであろう。芸術作品が創作者の手から解き放たれた時、その人生は凧と比較できる。東洋では凧は、大地につながれた人間の肉体から離れ可視化された魂であると信じられていた。凧は呪術的に魂と結びついていて、糸の引きにより繊細な紙の面によって運ばれる大気の流れを感じ、魂の動きを感じとる。凧は巡礼者の持つ天をめぐり歩くという魂の象徴を失った。凧は、遊びとして、あるいは玩具として、しかし東洋文化の遺産となって残り、今日まで凧師たちの豊かな想像力と技を鼓舞しつづけてきた。

凧作りの名人たちは、この企画の実現のために芸術家の自由な創作を許容してくれた。手腕と技巧の知恵を遊びにもたらしたのである。素材を的確に扱う仕事の完璧さは、彼らがこの上ない専門家であることを証明している。そして、彼らが素材を扱う時の美に対する繊細な感覚は、偉大な伝統芸術を継承する者であること

Anyone who has experienced the tug of a Japanese kite, for example, can identify with the notion that it represents nothing less than one's spiritual essence trying to pull the being away from this base existence towards a purer existence in heaven.

This, in turn, leads to one final point to help explain the Project's attractiveness to many artists. Ironically, it may have been the element of risk and potential destruction inherent in participation! Wind force, of course, is a most fickle partner, prone to constant unpredictability and even violence.

Delicate paper and bamboo constructions, as they attempt their heroic spiral journeys skyward and back, become casualties of the wind at every large event. And this fact of kite life is no less operative when the paper happens to be painted by a universally-recognized artist and worth upwards of $ 1 million. Nonetheless, though this uncertainty did hinder some artists from participating in the Project, most saw it as its most intriguing feature.

Risk-taking and the threat of loss are absolutely crucial elements in the deeper levels of meaning implied by the word "play". Play also includes pleasure and celebration, of course, especially that born of communal festiveness (something the Project also incorporates) but it is mainly the sense of controlled danger that creates excitement in human play.

According to well-established sociological theory, the tendency in mankind to base civilization on playfulness (Homo ludens) is eternally at odds with an equally strong need to constantly fabricate work, order and control over the environment (Homo faber).

Societies that are heavily faber-oriented tend toward perfectionism and self-destruction, suggesting that the hope for our planet lies in finding a more balanced lifestyle. As it turns out, it would be difficult to find activities that are more illustrative of a true Homo ludens than kiting and the making of art. While requiring physical and mental effort, the two

を証明している。毎年催される凧揚げ祭や凧合戦で、凧師たちは新たな刺激を受け、自分たちが文化の伝統を担うのだと確信を得る。この企画は、一見、実現が不可能かもしれないものに対して、凧師がその技を試す挑戦の機会ともなり、彼らに芸術の創造者であると闘志をいだかせ、空に拡げていこうとする衝動をかきたてたのである。

この企画は、詩と音楽を含む総合芸術として更に大きく拡がる。

二人の企画者が行ったことは、このような総合芸術の構想を練っただけではなく、企画を進める中で、感覚的に可能であったものを実際に具現化したことである。芸術は、時には単なる商品であり、投資の対象であるが、私たちはこの冒険の中で、新しいものに挑戦しながら目的に縛られない遊びを演じる芸術を体験するのである。しかしそれは自己満足にひたった高慢な遊びではない。これらの、風を伴呂とする繊細な芸術作品は想像の中で飛ぶだけではなく、実際に天空に揚げられ、人類の使者となる。凧が舞う日本列島の上のこの天空が、かつて黒いきのこ雲に呑み込まれたあの地獄の空からそう遠くはないというしるしとして理解されるであろう。この空のコレクションは巡回展終了後オークションにかけられ、ここで得られた収益金は、空からの援助として災害救済に利用されることになっている。世界の多くの巨匠が企画のこの点にも感動し、参加を決めたのである。

文化は、生活に不可欠なものに相反して、目的に縛られないものから起り、それは遊びに起源する、とホイジンガは私たちに説いている。人間は遊びの中でこそ本来の姿になり存在の価値を満たす。テクノロジーに占領され、利益に合せて機能する新時代では、このような自然に起る遊びの尊厳が主張しがたくなっている。私たちにとってこのような遊びは、存在を再認識されてくれる非日常的な、普段の祭りの悦楽を含んでいる。20世紀の絵画が凧になって空の美術館に一堂に会した時、文字通り、世界的な芸術景観のユートピアが空に展開される。天はすべての文化の共通の屋根であるから。

我が大阪ドイツセンターが企画したこの創造物は私を魅了し、私も遊びに誘われた。楽しい想像をめぐらし、心の中で一緒に飛行することにしよう。

神学博士 クラウス・フォン・ビスマルク
ゲーテ・インスティテュート総裁

are essentially creative play and serve no "useful" function. Their union in the present collection of art kites can perhaps symbolize a kind of model of work/play harmony. This, at least, was the hope of the Project founders.

The challenge of striking a balance between work and play is an issue that seems to be well understood by the current generation of Japanese kiting masters. For one thing, they never seem to let the fact that their creations are essentially easily-destructible toys get in the way of their lavishing sublime craftsmanship on each one. They are supported in this "madness", to be sure, by a craft-loving society that continues to honor them at numerous kite festivals and competitions. But what stimulates them even more is an obvious love for the simple materials of kiting, and the thrill of making these materials into something elegantly aerodynamic.

A final note. At the conclusion of a three-year world tour of major museums, the Art Kite collection will be auctioned off with the proceeds going to the United Nations Disaster Relief Fund. It is tragic irony that the same sky that offers so much beauty and amusement also occasionally brings tragedy — as it did to Hiroshima, for example, not far from the site of the Art Kites' Japanese vernissage in the sky. It is hoped, however, that the memory of these kites in flight, surmounting and soaring over all manner of obstacles both natural and political, will bring joy and a spirit of playfulness to countless citizens of this lovely, wind-blessed planet.

Klaus von Bismarck
President of the Goethe Institute

Kites
日本の凧

The art of kite-making is probably of Chinese origin, with the earliest reliable description dating back to the 2nd century B.C. That document tells of the ingenuity of a Chinese general who flew kites in order to gauge the length of a tunnel he needed to surprise his enemy. Another ancient Chinese military story describes how the outcome of a battle was decided by one side shrewdly attaching humming strings (unari, in Japanese) to some kites. Thus modified to produce a loud, eerie noise, the kites were flown over the enemy camp in the dead of night, throwing the foe into full panic.

From China, the idea of the kite passed early into India and Arabia, eventually arriving in Europe, probably in the form of the draco, a type of streamer that was used widely in the declining days of the Roman Empire. In a manuscript called Belli Fortis by Conrad Kyeser, dated 1405, we can see such a kite-pennant, as well as its unmistakable East Asian origins.

Europeans received their first detailed description of China's many kites from Marco Polo, who served Kublai Khan for 20 years at the end of the 13th century. His "Description of the World" has a graphic account of a Chinese custom in which kites are sent aloft from ships' decks in order to divine the outcome of a planned voyage.

As for Japan, while tradition states kites were already known by the 7th century, reliable sources are available only for a somewhat later date. In a family diary from early in the Heian Period (795–1192) mention is made of a kamitobi, almost certainly a bird-shaped kite long common in China.

By the 12th century, however, kite-making was so advanced in Japan that large manned kites seem to have been almost a familiar sight. One classic tale describes how

凧のわざは、中国で発明されたと推測される。信頼できる記録の最初のものは、紀元前2世紀に溯る。敵地にひそかに攻め入るためにトンネルを掘ることになった中国の一将軍は、最初の凧を飛ばして糸の長さで敵陣までの距離を測った。別の遠征の時には、凧が攻防を決定した。真夜中に敵軍の真上にうなりをつけた凧があげられ、そのうなりの音で敵軍を脅し不安におとしいれようとしたのである。

凧は、中国からインドとアラビアを経由してヨーロッパに渡った。空飛ぶ凧の最初のものはドラコという吹き流し凧で、ローマ帝国末期に軍旗として広まっていた。1405年に出されたコンラッド・カイザーの写本「ベリフォルティス」に図入

りでのっているペノン凧は空中に浮き、地上から操られたと記述されている。構造を見ると奇抜な印象を受けるが、空を飛ぶ凧の形が東洋に由来するのは疑う余地がない。中国の凧を初めて正確に記述したのは、1275年から1293年まで中国の元帝忽必烈（フビライ）に仕えたヨーロッパ人マルコ・ポーロである。「東方見聞録」の中に図入りで説明されている凧の機能は、船が出帆する時に、甲板から凧を揚げてその飛行状態から航海運を占ったということである。

Minamoto no Tametomo, a warrior banished to an island in Tokyo Bay, saved his son by strapping him to a kite and flying it over to the mainland – an exceedingly dramatic rescue immortalized in a woodblock print by Ho-

kusai. Numerous other accounts are given of manned flights for military reconnaissance, but probably the most intriguing flying feat involves Ishikawa Goemon, the late 17th century-Japanese Robin Hood. The popular bandit had himself flown to the top of Nagoya Castle where he broke the fins off the golden dolphin ornament. Alas, for his efforts Goemon and his entire family were fried alive in oil.

It was really later in the Edo Period (1603–1867) that kite-making in Japan reached its zenith. Technical breakthroughs in papermaking resulted in kites becoming affordable for everyone and the popular Kabuki theater and woodblock prints provided a wealth of inspiration for attractive design motifs. Like so much else, the Japanese organized kite-flying into mass participation events, whole communities kiting together at prescribed times of the year. These festivals became so large and uncontrollable that the government had to constantly issue banning orders to protect the delicate rice fields from being trampled

凧が日本に渡ってきたのは、恐らく朝鮮を経由したのであろうが、7世紀頃といわれている。しかし、信頼できる最初の記述は9世紀のものである。平安時代のある一族の史書に「紙鳶」という記述があり、これは中国で知られている鳥形の凧であろうと想像される。同じ紙鳶を他の文献はいかのぼりと呼んでいる。12世紀に入ると、凧揚げのわざは著しい進歩を遂げ、人間を乗せた大凧が出現する。日本の故事に登場する源為朝は剛勇で知られた武士であるが、1156年伊豆大島に流刑に処された。源為朝は自ら大凧をつくって、それに息子を乗せて海を越えて下田に送り返すことができたという。その冒険的な脱出飛行の模様は、北斎によってその木版画に描かれている。当時、多くの場合、人間を乗せた凧については、偵察と戦闘を目的として用いられたと伝えられている。飛行術の傑作ともいえる話を、大盗人石川五右衛門が残している。17世紀末、石川五右衛門は名古屋城の金のしゃちほこのうろこを三枚盗むために、凧に乗って屋根まで上ったのである。しかし、この盗人の勇ましい行為は、悲惨な結末をむかえた。捕えられ、家族もろとも油の釜煎に処されたのである。

日本の凧は、江戸時代（18、19世紀）に最盛期をむかえる。これはちょうど紙の生産が進み、安く庶民の手にはいるようになってきた時代である。絵柄には、流行芝居や浮世絵の多色摺り木版画の影響がはっきり見てとれる。現在知られている凧の形のほとんどすべてが、幕末の頃に出そろっている。それは浮絵絵の大家国政の「凧登り上る花形（凧を揚げる歌舞伎役者）」に描かれている（東京の凧の博物館所蔵の三部作、左の絵）。各地での凧あげ祭の熱は高くなる一方で、田畑が荒らされるのを避けるために藩は幾度も禁止令を出した。とこ

under. This was clearly the golden age of Japanese kites and nearly every style known in Japan today was already fully developed by the end of Edo, a fact attested to by the woodblock print "Kabuki Players Flying Kites" (Tako noboriagaru hanagata) by the ukiyo-e master Utagawa Kunimasa. (Shown here is only the left side of a triptych on view at the Tokyo Kite Museum).

By the time Japan was well into its Meiji Restoration Period (1868−1912) official bans were unnecessary and rice fields were eminently safe. Kite-making as an art and kite-flying as a sport were both in severe decline. Of course, the rapid industrialization of the island nation – with the attendant loss of free time and open space – had something to do with it. But probably more important was the shift to the Western calendar. Traditionally, the Japanese had favored the New Year holiday for their kiting activities, and this had always fallen at the height of the windy season. With the new calendar, however, suddenly New Year came months earlier, a meteorological disaster for an activity that lives by the wind.

The decline in the sport has continued – the number of professional kitemakers in Tokyo, for instance, having dwindled from 100 to only one in a few generations – but the knowledge of the craft is far from lost. In all parts of the country enthusiastic hobbyists are preserving traditional techniques of bamboo work, cord-tying, painting and, of course, flying. In fact, some of Japan's annual kite festivals are held, not so much out of custom or for tourism's sake, but as social gatherings where technical exchange can take place among these scores of men and women – safeguarders of a precious Japanese heritage.

The Art Kite Project is dedicated to furthering this splendid artistic tradition.

ろが明治維新後、凧あげ熱は衰えはじめる。その衰退の一因は、日本が西洋の時代の進歩に順応しようとしたからであろうか。また日本の伝統の中では、凧を揚げることが一番好まれた正月の遊びであった。それが1874年に旧暦から新暦へと移行し、正月が季節風の吹かない時期になってしまったことは、「風が命」の凧にとって衰退の大きな一因になった。時代の流れは都市化、地方分権化を招き、ますます凧はあげられなくなっていった。

昔は百人を数えた東京在住の凧職人のうち、現在なお存命の人は一人だけである。しかし、日本の凧が誇る知識と技巧は今でも生き続けている。日本各地には竹細工や彩色の伝統的技術を駆使している凧師がいるし、糸目付けや凧揚げに優れた技巧をもつ凧師もいる。そして観光を目的としない凧揚げ大会は現在も開かれており、仲間との共同体験の場として社会的なつながりをつくる役割を担っている。「芸術凧」の企画はこの伝統を受け継ぐと共に、現代美術にも、そして日本の凧のもつみごとな伝統工芸にも目を向けようとするものである。

Styles of kites
凧のかたち

From the over 300 types of Japanese kites known, seven were selected for their extreme suitability for the Art Kite Project: rokkaku (hexagonal), Tosa, kerori, Edo, hakkaku (octagonal), wanwan and Hamamatsu. Participating artists were also free to experiment with any shape that entered their imagination, and a few did so. Thus, the collection features several works – for example, Wesselmann's "Blonde Kite" as well as all three Motonaga pieces – which one can be certain never before appeared in the sky!

The job of making such free-form submissions airworthy fell to the Project's regular team of kitemasters. Drawing on their experience and technical expertise, as well as a large dollop of intuition – they succeeded in reaching the stage of a completed test flight in nearly every case. Outside of this standard kitemaking process stood four free-forms which, seemingly by pure coincidence, had counterparts within the larger Japanese kite lexicon. In these instances – Geiger's "Kimono Kite" (almost a true sode), de Saint Phalle's "L'oiseau amoureux" (yakko), Verhoef's "Troublesome Kite" (Hachijojima) and Watanabe's "Skyleap Hop Hop" (Baramon) – the art pieces were entrusted to specialists in each of these styles.

Tsugaru

The Tsugaru kite originated in Aomori Province in northern Honshu where, owing to the cold climate, straight-grained Japanese cypress must be used instead of bamboo. One of the most splendid of all Japanese kites, the Tsugaru's bright paintings mainly portray scenes from epic tales of heroism. The paintings are often framed in black, and more Japanese paper (washi) is attached to the back for re-inforcement. Sometimes the paper includes old documents, invoices, pages from old books and so on, giving the Tsugaru a uniquely picturesque reverse side.

300種以上もある伝統的な和凧の中から、私達は、アート・カイトプロジェクトにふさわしいと思われる7種の形を選び出した。六角凧、土佐凧、ケロリ凧、江戸凧、八角凧、ワンワン凧、そして浜松凧がそれである。更に芸術家が好みの形を自由に創造できるようにもした。実際に何人かの芸術家はそれを実行して、いまだかつて空に飛んだことのない独自の凧を考案した。トム・ウェッセルマンの「ブロンド・カイト」や元永定正の三部一組の凧がそれである。これらの凧を揚げるためには、凧師の優れた技術が必要になる。自由に形を作ったつもりが、偶然、既存の和凧に似ていて、その形の専門家に製作を依頼したという凧もあった。ルプレヒト・ガイガーの「赤の凧」(袖凧)、ニキ・ド・サン-ファルの「恋する鳥」(奴凧)、トーン・フェアホーフの細長い凧(八丈島凧)、渡辺豊重の「天翔けるモクモク」(バラモン凧)など。

次に代表的な日本の凧を紹介する。

津軽凧

本州北端青森県が発生の地である。寒冷気候のため竹が育たず、ヒバの柾目板で骨を作る。津軽凧の絵柄は、和凧の中で最も華やかなもののひとつで、強烈で鮮やかな赤、青、紫、黄、茶、橙、緑などの色が使われて歴史上の英雄伝の一場面が描かれる。津軽凧は縁が黒い紙で縁取りされるのも特徴のひとつである。凧は無地の和紙や時には古文書で裏打ちされ、裏側も独特の美しさをもっている。それは強風に耐えられるよう凧の補強にもなり、またうなりが太鼓のように響くよう、共鳴体の役割りもする。

Rokkaku

Named for its hexagonal shape, the rokkaku comes from Niigata Prefecture in central Honshu, facing the Sea of Japan. Its bamboo frame features only two bones running cross-wise and one the length – the latter detach-able for easy rolling and transporting – and the paintings are generally portraits of warriors or battle scenes (musha-e).

In Shirone, Niigata Prefecture, a famous festi-val takes place every June in which rokkaku compete in aerial skirmishes. Teams are arrayed along both sides of a canal, the losers of each combat suffering the ignominy of having their fallen kite disintegrate in the water.

According to tradition, this festival dates back almost 300 years. A canal had been built for irrigation and transportation, but soon after completion one bank burst and Shirone was flooded. A costly re-construction only led to the bank giving way again. This time, as soon as the damage was repaired the local feudal lord ordered a kite festival, cleverly reasoning that the feet of thousands of spectators would solidly pack the earth. The bank held firm and the festival has continued to this day.

Edo

Originating in the Edo District (now Tokyo) this kite has a bamboo framework which usually consists of four horizontal, one verti-cal and two diagonal bones, though addi-tional verticals can be found in larger models. Strips of paper are often wrapped around the bamboo so that the kite paper can be pasted on more securely, and the paintings are usu-ally nishiki-e; i.e. modelled after polychrome ukiyo-e prints. Depictions are of samurai in beautiful battle regalia or sometimes Kabuki actors, plus signs from the Oriental zodiac, especially the dragon.

Long bridle lines attached to the kite serve to stabilize the flight as well as lend a certain

六角凧

六角形のこの凧は、中部日本、日本海側の新潟で生まれた。竹枠は、二本の横骨と真中の一本の真骨から成り、持ち運びに便利なよう、この真骨を取りはずして、巻ける作りになっていて巻凧ともいう。絵柄は武者絵が主流である。新潟県で毎年六月に催される大凧合戦では、六角凧も揚げられる。中ノ口川の両岸に二手に分かれ凧を揚げ、揚綱をからませ、ひっぱりあって綱を切り落す。その様子は綱引きのようで、切り取った綱の長さで勝敗を決める。言い伝えによれば、この大凧合戦の起源は、こうである。250年ほど前、白根は何度も洪水にみまわれた。時の領主は中ノ口川提防改修工事の完成を祝って土手の上で凧揚げ大会を催した。この時、凧揚げのために土手の上を走りまわった何千本かの足が土を固く踏みしめ、その後、土手はくずれることがなかったという。

江戸凧

江戸は、東京の古い呼び名である。江戸凧は17世紀頃からこの地で広まった。骨組みは横骨と縦骨に二本のすじかいが入り、大凧になると、縦骨が増える。多くの増合、絵紙をのり付けしやすくするため、竹に和紙を巻いて巻き骨にする。絵柄は主として浮世絵の影響を受けた錦絵と、次いで華やかな武具を身につけた武者絵が多い。他には歌舞伎役者と十二支の動物や文字をデザイン化した江戸文字の凧がある。長い糸目のため、安定感があり、飛ぶ凧は王者の風格を持っている。江戸凧の上部には、時には、弓形

dignity. Moreover, the Edo is frequently equipped with a bow-shaped humming string, or unari. In the air, the string resonates against the kite, creating a wind-harp sound.

のうなりが取付けられる。一本の長い丸竹に籐のテープが張られる。このうなりの振動は、凧本体に伝わり、凧はまたこの音色を凶暴なうなりにまで共鳴させる。

Kerori

Unique in appearance, the kerori from Aichi Prefecture is thought to be derived from the Japanese folding fan, not only because of its shape but also from the way in which the paper is attached. Formerly, such kites were given to families on the birth of their first son, a fan being a symbol of good fortune. The kerori is not noted for any particular painted designs, but it has relatively few thin bamboo bones in its framework and thus can be easily flown, even in a weak wind. Bridle lines are attached at only two points on the central axis.

The size of traditional Japanese kites is determined by the size of the hand-made washi paper sheets. When this valuable paper has to be cut to suit a particular kite form the remaining pieces are then used in a tangram – like manner to avoid wastage.

ケロリ凧

この独特の形の凧は、中部日本の愛知県地方でよく見られる。名前の由来ははっきりしない。紙の張られた状態が末広によく似ているところから、扇の形からきたと考えられているのであろうか。長男が生まれた家への贈り物として使われた、というのも扇は、末広がりという意味で幸福を約束するとみなされていたからである。ケロリ凧には、伝統的な絵柄はない。比較的細い竹が数小なく使われるので、この凧は弱い風でもよく揚る。糸目は、真骨の二ヶ所に取付けられる。

Hamamatsu

Lying in the central Japan Prefecture of Shizuoka on the Pacific Coast, Hamamatsu City hosts a huge, unforgettable kite festival every year from May 3–5. On the first day, "congratulatory kites" are flown, bearing the names of each local district's new-born first sons, and conveying best wishes for their prosperity. On the following two days, kites boasting the districts' heraldic emblems engage in fierce aerial combat. At times as many as 100 large, square kites crowd the sky, a drama rivalled only by the excitement on the ground, where 30-man teams equipped with cable winches attempt to manoeuver their kites amid a din of trumpets and whistles.

浜松凧

浜松市は中部日本の太平洋側、静岡県の大きな町である。ここでは毎年５月３日から５日までの「端午の節句」に、大規模な凧揚げ合戦が催される。凧揚げ祭の初日には「初凧」と称して、生まれたばかりの長男の成長を願ってその子どもの名前を記した凧を空に揚げる習わしがある。

後の２日間には、町印が描かれた凧どうしの凧合戦が繰り広げられる。時には百近い数の大きな正方形の浜松凧が空に舞う。

空での混戦模様は、そのまま地上の大騒ぎにもつながる。地上では一つ一つの凧を30人がかりで揚げるため、ケーブルウィンチを手にし、ラッパや太鼓や呼び子をうるさいほどに鳴らして音頭をとる。

色鮮かな法被とお祭り気分は、中世騎士の馬上試合を思い起こさせる。

The framework of the Hamamatsu kite consists of a tight grid of five-millimeter thick bamboo bones bound together with hemp, the whole lattice-like structure braced with two diagonals. Only after the paper has been pasted over the bamboo is the design painted on with bright dyes. In this process, the contours are often treated with liquefied wax (in order to prevent a blurring of colors), making for a striking, stained-glass window effect.

Before competing in combat, the kites are equipped with a bamboo and straw rope tail.

The manufacture of the linen kite lines is limited to one shop to guarantee an equal chance for all, and also to avoid the insertion of blades, knives or other unpleasant devices frequently used to cut the opponent's kite lines.

Wanwan

First flown on the occasion of the reconstruction of Renge-ji Temple in Okazaki, northern Shikoku, the wanwan probably got its name from a round lacquered tray called a wan. Indeed, the kite is actually oval in shape, but becomes round when cords on its back are tightened just before take-off.

Though enormous kites were common throughout Japan in the 19th century, the original wanwan – 20 meters in diameter and weighing up to 2500 kilograms – certainly ranked among the largest. Its 150-meter rope tail alone weighed 750 kilograms, and as many as 200 men with a 15 centimeter-wide, kilometer-long hawser flying line were needed to get it up in a good sea wind. Lift-off occurred with the help of a special scaffolding but, once in the air, a kite that colossal was impossible to bring down. Teams simply waited for the wind to die down.

浜松凧の竹の骨組みは、5mmほどに割った細い竹を縦と横に重ねて、交差した所が麻糸で結ばれ、狭い格子状に作られていく。補強のために丸竹（女竹）も使われる。飛ばす時には長い縄と竹棒をしっぽとして凧にとりつける。凧合戦が公平に行なわれるために、麻の凧糸の製造は一ヶ所に限られている。

浜松凧は、先ず竹の骨組みに紙が貼られ光を通す染料で彩色される。にじみを防ぐため輪郭は液体の蠟で引かれることが多い。ステンドグラスのように光の透過性が特に美しく映える凧である。

わんわん凧

わんわん凧の故郷は四国の鳴門である。呼び名はその円形に由来するとも、丹塗の盆「わん」からきているとも言われている。正確には、少し横長の楕円形をしたこの凧の形はそりを入れることによって円形になる。わんわん凧は1692年、岡崎の蓮花寺再建の時に作って飛ばしたのが始まりであるとされている。19世紀に入って、各村々が大凧を作って飛ばすようになった。直径20メートル、重さ2000キロという大きさは、日本最大の凧の一つに数えられている。しっぽでさえ長さは150メートル、750キロになる。このような大凧を強い海風まぜに乗せるために、男の人200人を必要とする。引き綱には、直径15センチ、長さ千メートルの綱が用いられる。凧を揚げる段になると、まず、砂浜に深く埋めた電柱

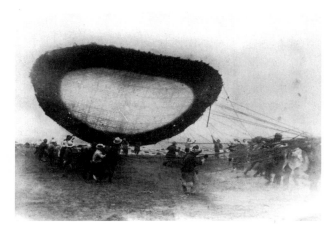

Today's wanwan are somewhat smaller, but otherwise retain their traditional form, with typical painted designs being family crests and geometric patterns.

Tosa

Tosa is the old name for the region of Kochi, located at the southern tip of Shikoku Island. The Tosa kite is a perfect square, balanced on one point and usually patterned with simple, geometric figures. It has a framework of five bones, two of which are attached to the upper edges and two others simply tied to the central vertical for easy folding and carrying. The Tosa is remarkable for its extremely stable flight and ability to reach great heights. At certain kite festivals there are competitions to cut off and bring to earth a long paper tail attached to the kite.

Hakkaku

This eight-sided kite (so its name) can be found in many corners of Japan from Okinawa to Shikoku to Aichi. (In Kanagawa Prefecture it is called Yatsubana, which means "eight flowers".) The bamboo framework is formed by overlaying two rectangles and then rotating one slightly, while the painted designs are generally geometric paterns. Very often a humming string is attached to the upper part. In Okinawa the tips of the stars are characteristically painted red with a small white circle.

を杭にし、凧綱の端をそれに結びつける。このような大凧を揚げる場合、引き降ろすのはまず不可能といってよい。風がだんだん弱くなって、凧が落ちてくるのを待つしかないのである。現在徳島で揚げられているわんわん凧は伝統的な形を維持しつつ、大きさは小型になっている。わんわん凧に描かれる絵柄は家紋が多く、単純な幾可学模様も好まれる。

土佐凧

土佐とは四国の南、現在の高知周辺を指す昔の名称である。四角形のとがった方を上に向けた土佐凧には、単純な幾可学模様が描かれることが多い。骨組みは、五本の竹の棒から成る。上部の斜骨二本とおお骨には、和紙を巻きつける。斜骨は固定され水平の骨（ぶんぶ骨）がしばりつけられる。この二本の横骨をはずすと折りたため、持ち運びに便利である。土佐凧はすぐれた安定性と強い上昇力をもっている。凧合戦の際、親凧につけた長い紙のしっぽを子凧で切り落とすという競技もある。

八角凧

この八角凧は、静岡、愛知、神奈川県南東の横須賀（これらの地方では「八つ花」と呼ばれている）、沖縄など、各地に伝わっている。枠は、二つの正方形をずらして置いた形で、うなりが取付けられる。幾可学的な絵柄が多い。沖縄では、星型の各尖端が丸く色抜きされる。

Washi

Handmade Japanese paper (washi) is an essential part of the Japanese kite. Not only is it beautiful but washi exhibits great strength, and thanks to its absorbency, also acts as an ideal medium for the famous bright colors of the kites. The Art Kite Project acquired a particularly outstanding paper made by the Shibas, an elderly couple from Toamura in southern Shikoku.

Their Tosa washi is made entirely from mulberry bark (kozo), without any additives whatsoever. Owing to its thickness and long fibres, it is especially strong and, when many small sheets are pasted together to form a large surface, a seamed checkerboard pattern is created, highly valued for its beauty.

和　紙

手漉きの和紙の美しさは、和凧の表現の美しさを決める本質的な要素である。和紙は凧の材料として、堅牢なだけではなく、吸湿性が良いことから、多くの凧に使用されるあざやかな染料の効果を出すためにも理想的な支持体である。芸術凧のために用いられた和紙は、東京の和紙の研究家である坂本直昭（紙舗直）のお世話により、四国の南部、十和村の芝夫妻が漉いて下さったものである。この地方は昔「土佐」と呼ばれていて、その呼び名で有名になったこの和紙は、純粋に楮だけが使われ漉かれている。その長い繊維と密度の高い組織のおかげでどんな風にも耐えられる。小さく切られた紙を張り合わせて、より大きな長尺物にすることもある。張り合わせて生じる継ぎ目模様も、多くの凧の美しさに欠かせない大切な要素になる。

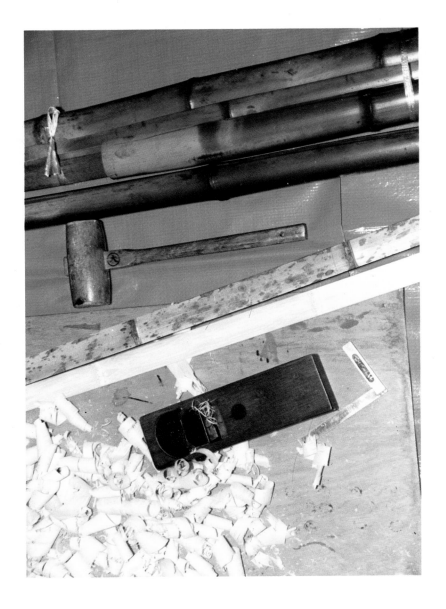

Bamboo

With the exception of kites from the northern-most prefectures, all Japanese kites have frameworks made of bamboo, an ideal material for supporting airborne works of art. Though easily split in the direction of its grain, it is known for its hardness, flexibility and, with an application of heat, bendable nature. Depending on the type of kite, either male (odake) or female (medake) bamboo is used, still leaving the choice of using the whole cane or only thin strips.

Close attention is always paid to the overall aesthetic appeal of the bamboo in a Japanese kite, kitemakers often going out of their way to acquire specially treated pieces with a mottled finish (fuiri no take) or bamboo taken from smoke-darkened farmhouse beams (susudake).

竹

日本の北部を除いて、和凧の骨には一般的に竹が用いられる。竹はまさに空飛ぶ芸術作品には理想的な素材である。竹は硬いがその繊維に添って容易に割ることができる。竹はしなやかで、熱でどんな形もつくることができる。凧の形により、雄竹や雌竹が用いられ、また丸棒の竹が用いられたり、あるいはうすい表皮だけが用いられたりする。竹による凧の構成の美しさは注目すべきものである。特別の凧には、化学的な処理により表面に斑点をつけた斑入りの竹や、古い農家の梁に使われ煤で黒くなった煤竹を用いることもある。

The Project
アート・カイト

In spring 1987, artists were invited to partici-
pate in the Project. Here are the letters sent
to the German artist, Emil Schumacher and
the Japanese artist, Kazuo Shiraga, as well
as their replies.

1987年春、世界の芸術家にアート・カイトの企画の内容とそれに
参加を依頼する招待状が出された。
ここには一例として、ドイツの画家エミール・シューマッハーと
日本の画家白髪一雄に出した手紙および彼らの参加承諾の返事
が掲載されている。

Osaka, 10th July 1987

Dear Emil Schumacher,

it is with some hesitation that I invite you to participate in our Art Kite Project! For me, your pictures are of a seriousness and depth which lead me to think that their creator might consider a request from the sphere of "homo ludens" very much out of place. However, let me explain our intentions:

Our Institute is organizing an international cultural event with the title "homo faber — homo ludens" (Man as Worker, Man as Player) with theatre, music, film, lectures and — in the center of this — an international ART KITE event.

In this project we want to use the technology of the traditional Japanese kite as a canvas for modern art. We are inviting the most prominent artists from throughout the world to paint an art kite using paper, cloth or canvas of any size and form. From these paintings we will have the kites made in Japan by the best kite-makers in the traditional Japanese style. As you probably know, these traditional Japanese kites are amazing works of technical perfection which, through the use of "washi" (Japanese paper) and bamboo, are works of art in themselves. To add to that, these kites have excellent flight properties. From the many styles of Japanese kites, we have chosen 7 which seem most suitable, although any other design is also possible. Information on these styles is enclosed on a separate sheet. We suggest the kite to be no larger than 580 × 230 cm in size. In the case of a folding type kite any size is possible.

We will gladly supply to you on request Japanese washi paper of any size desired. Enclosed is a sample of the paper which becomes white with the time from contact with light, and after many years takes a solid, almost parchment-like consistency.

May I point out one special quality of kites as art: unlike paintings they get light from behind as well as the front, much like stained glass windows. Therefore colours (like water colours or dyes) and somtimes wax are used which make the paper transparent. We have enclosed one sheet of Japanese washi paper which shows this effect.
We are planning to collect the paintings for the art kites by the end of February 1988 and shall have the kites built here in spring 1988. In April these kites will be flown once in Japan. It will be a once-in-a-lifetime sight to see the works of the most significant artists of our time flying together in the sky. Following this "event" the kites will go on a three-year tour of some of the most famous museums in the world. At the end of the tour, the collection will be sold by auction, the proceeds going to the Disaster Relief Project of the United Nations.

This, then is our plan. So far the response has been very encouraging. As a prominent representative of twenthieth century art in Germany we hope that you will participate in the Project.

There is just one last thing I would like to mention: although we are using the finest construction for the kites and the best professional fliers, the wind naturally remains a factor beyond our control. Thus, there is a possibility that any one kite might not survive its maiden flight. We hope this will not discourage you. After all, a certain amount of risk is inherent in the deeper meaning of "homo ludens", of game-playing which kites so clearly embody.

We are very excited about having you partici-
pate in this exhibition and as mentioned ear-
lier, we will gladly send you, upon request,
Japanese paper of any size.

Please accept my sincere thanks for your
attention and I look forward to hearing from
you soon.

Yours sincerely

Dr. Paul Eubel
Director Osaka Goethe Insitute
(German Culture Center, Osaka, Japan)

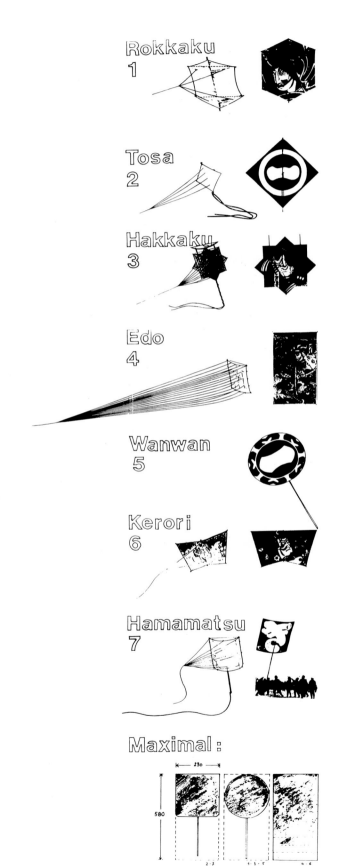

Rokkaku
1

Tosa
2

Hakkaku
3

Edo
4

Wanwan
5

Kerori
6

Hamamatsu
7

Maximal:

Dear Paul Eubel,

many thanks for your letter and the invitation to take part in your interesting and unusual Art Kite Project.

As you say in your letter, my painting tends towards the depths and, to quote myself, "is nearer the earth than the stars", yet I find your idea so fascinating that I should be very happy to participate.

I find that the kerori kite form is most suitable for my painting and the format will be approximately half the maximum size. I am happy to paint on the traditional Japanese paper and would be grateful to receive it as soon as possible. Please send me one or two extra sheets if possible – one never knows if the first brush stroke is the final one.

I am looking forward to working on the project in the sky,

with best wishes,

Hagen, 20th July 1987

白髪　一雄　様

大阪ドイツ文化センターは、今年から来年にかけて「ホモ・ファーバーとホモ・ルーデンス」というテーマのもとに、さまざまの関連プログラムを企画しています。私たちが一般に「文化」と称するものについて、その根源や内容、あるいはその目的とするものに焦点をあて、いろいろな分野から考察していこうとするものです。
「ホモ・ファーバー」は「働く人間」を意味します。そして「ホモ・ルーデンス」は「遊ぶ人間」、即ち、人間にとって日常生活において不可欠なものは別にして、個々人の根源的な自由から起こる、人間に満足感を与える行動を意味します。
オランダの文化史家でもあるヨハン・ホイジンガはすべての文化は「遊び」に起源し、遊び」が人間文化を作ってきたと述べています。

このテーマのもとに、有形の企画の一つとして「ホモ・テクノロギクスとホモ・ルーデンス」があります。東西の各国から世界的に有名な芸術家を招待して、凧を作るというもので、現代という時代に作られる新しい芸術と日本の伝統的な凧の技工を組み合わせようという企画です。
芸術家の方々には、紙、布、キャンバスなど材料はもちろん、大きさも形も自由に絵を描いていただき、日本で一番という凧作りの名人たちに、その絵から日本の伝統的な技法に従って凧を作ってもらいます。
皆様はすでに御存知のことと思いますが、日本の伝統凧は、技工の完璧さにおいて驚嘆に値するものであり、和紙や竹を使って作られる凧は繊細な芸術作品であると云えます。そのうえ優れた飛揚能力を備えています。

私たちは、数多くある日本の凧の形の中から、この企画に合うと思われるものを七つ選びました。しかし、これ以外のどんな形でもかまいません。
おおよそのサイズとともに同封の資料をご覧下さい。サイズは輸送の都合上制限されますが折畳みや巻き物状（長さ5.8mまで）の凧も不可能ではありません。
ご希望に応じて、非常に適切と思われる和紙をお送りすることができます。これは光に反応して時間が経つとともに白くなり、黄ばむことはなく、また年数が経つほど丈夫になり羊皮紙のような堅牢さをもつ良質の和紙です。しかし、お望みであればキャンバス、布、プラスチックなど他の材料の使用も可能です。
日本の凧の特徴についてもう少し付け加えます。凧は絵画の場合

とちがって、空に揚がった時、彩色した部分が光の透過により、その色のあざやかさはステンドグラスに似ています。そのため日本の伝統凧には透明度の高い染料が使用され、また色の滲みを防ぐためには、液状のワックスが使われることがあります。このようなことがお分かりいただけるよう、一角が染料とワックスで色付けしてある先ほどの和紙も同封しますので参考にして下さい。

ここで、私たちの今回の企画についてもう少し詳しく説明いたします。
「芸術凧」の絵は1987年の年末を期限として集められ、凧が製作されます。1988年はちょうど龍年でもありますが、春に一度だけ日本の空に揚げ、「芸術凧フェスティバル」を行います。「凧揚げ」を担当するのは、それぞれの凧の形を本拠とするそれぞれの地方の名人たちです。
なお、日本の芸術家の皆様の中には凧を自分でつくられる方も少なくありません。凧まで完成されるのも私たちには大歓迎です。現代の著名な芸術家の皆様の作品による空の展覧会は、二度と体験できないすばらしい光景となることと思います。
このヴェルニサージュのあと、芸術凧の展覧会は巡回展として二年間、世界の有名な美術館を廻り、最後に、芸術凧コレクションはオークションにかけられ、その収益金は災害救済金として国際連合に送られることになっています。
これが私たちの企画のあらましです。これまで多くの芸術家たちから賛同を得ています。二十世紀の日本を代表する著名な芸術家の皆様が、私たちの企画に是非御参加下さいますようお願いいたします。

最後にもう一つ、申し上げておかねばならないことがあります。私たちは、凧造り、凧揚げについては、専門家に依頼するなど、「ホモ・テクノロギクス」として、この企画が遂行されるためにいかなる努力も惜しみません。しかし、凧揚げに欠かせない風は自然のたわむれであり、計算どおりに行かないこともあります。芸術凧が空中に揚がった次の瞬間、墜落してしまうことが起こらないとも限りません。このような事態が起こった時には、（最小限にくい止めたいと思いますが）どうぞ皆様も「ホモ・ルーデンス」として御甘受下さいますようお願いいたします。

このような私たちの無類の企画にも御参加くださるという良いお返事とともに、御希望の紙の大きさをお知らせ下さい。心からお待ちしています。

<div align="right">
大阪ドイツ文化センター

館長　Dr．P．オイベル
</div>

大阪ドイツ文化センター
松本郁子様

早速で恐れ入りますが、貴センターからご案内いただきました
「芸術凧」、とても素晴らしいご企画と存じます。
喜んで参加させていただきたく考えて居ります。和紙に油絵具を
使って足で描くと一番良いのですが、重量の点が心配です。
いろいろ考えますので、どうかよろしくお願い致します。

1987年5月14日　尼崎にて

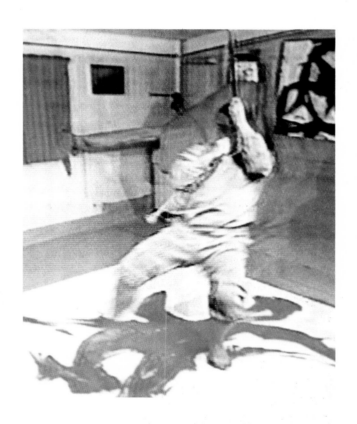

Kazuo Shiraga painting his kite (see p. 191). The artist
paints with his feet while suspended from a cable.

Une peinture pour le ciel

En rêve : faire une peinture de ciel. Ou plutôt: peindre pour le ciel. Et puis un beau jour, sans crier gare, s'y mettre, réaliser une peinture effectivement destinée au ciel. Une peinture qui, à peine terminée, m'échappera des mains, échappera à toutes les mains, s'affranchira de la pesanteur et montera dans l'air aussi haut que les plus hautes fumées.

Cela a commencé par l'arrivée dans l'atelier d'une boîte en carton, oblongue et étonnamment légère. A l'intérieur, mollement roulée, une large rame de papier de riz marouflé sur une fine toile. "C'est comme un carré de ciel prélevé dans la matière même du ciel", ai-je pensé en la délivrant, "il s'agira de ne pas trop l'alourdir". Mais déjà l'ocre pâle du papier m'attirait assez pour savoir qu'il me serait difficile de m'en tenir à cette bonne intention.

Maintenant agrafée au fond de l'atelier, la pointe dirigée vers le haut—J'ai choisi pour mon odako la forme dite tosa—cette ample et belle surface crème a presque l'air d'être retenue de force; elle a même quelque chose d'un peu terrible, ses angles immobilisés de part de d'autre de l'axe central du mur—rappelant vaguement ces grands oiseaux nocturnes que des mains anonymes clouaient jadis sur certaines portes ...

Et toujours présente à l'esprit, durant le travail, l'impression accablante et merveilleuse, que cette peinture n'aura pas de vie sur cette terre, que son destin est de s'éloigner de nos regards et que tout juste sèche elle regagnera bien vite sa place au-dessus de la tête des hommes. En conséquence, if faut travailler sinon dans la hâte, du moins dans une qualité d'urgence—je dirais même de grâce—dans la crainte quà tout moment elle ne s'arrache du mur et s'envole. Bien sûr, là-haut elle sera encore reliée par un fil aux mains expertes qui la gouverneront depuis le sol—mais rien ne m'empêchera de penser qu'elle n'aura de cesse que de retrouver, naturellement, sa part de ciel, qu'elle se dérobera à la science des manoeuvres. Qu'elle se perdra. Elle volera alors au gré des courants d'air et des vents d'altitude, loin de nos yeux, emportant dans l'infini les grands signes noirs qui la recouvrent, eux aussi voués à la dissipation. A l'oubli.

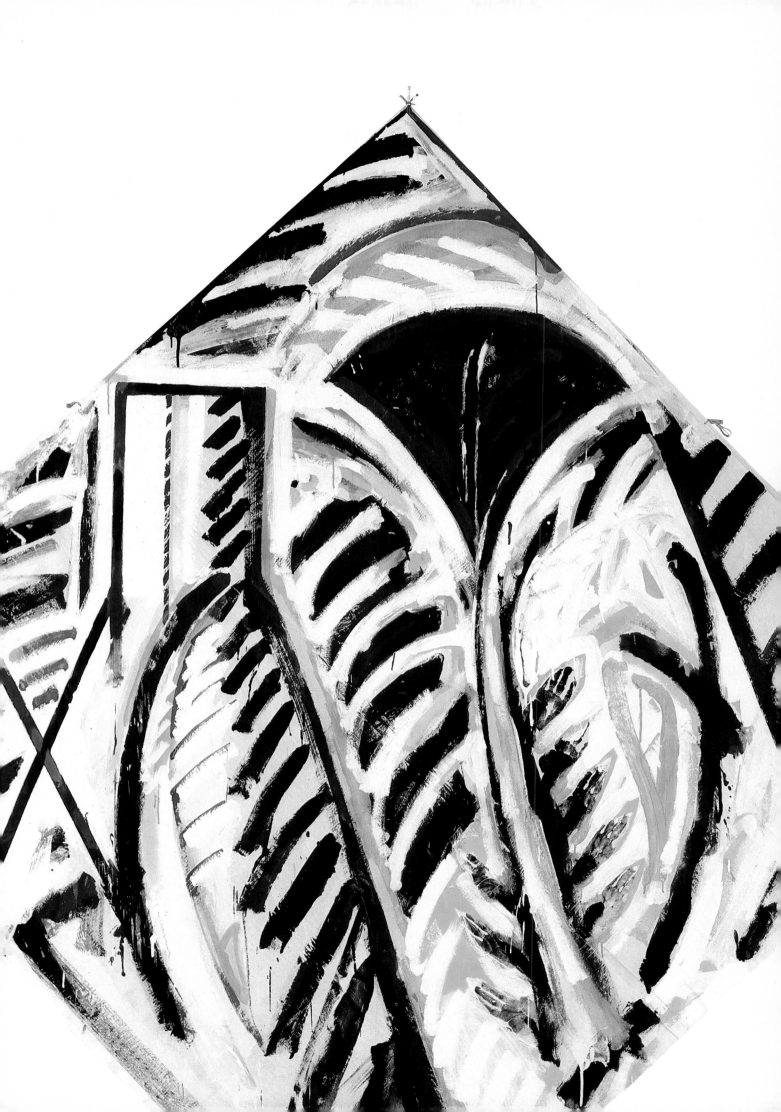

Un mot ici, en passant, sur la situation particu-
lière de cette peinture dans l'ensemble de la
serie en cours : appartenant, formellement, aux
derniers avatars des intérieurs (elle en présente
ostensiblement la figure centrale, la "lampe", flan-
quée de la palme, nouvellement venue ...), elle
s'en désolidarise pourtant—et précisément par
son statut d'"oeuvre volante". Elle ne fait que tra-
verser l'ensemble des autres peintures, comme
un nuage parmi les nuées; elle gagne ainsi, sur
tous les fronts, une mémoire, une famille, mais
surtout sa liberté. Mais elle demande pour cela
(elle l'exige, même), d'être d'emblée et substan-
tiellement pensée dans ce même sentiment de
fébrilité, de precarité. Pas d'atermoiements,
donc—et pas de remords : au risque des airs et
de la disparition, elle oppose la certitude de sa
parfaite opportunité. Etrangère aux autres peintu-
res, à leur destin, elle sortira de l'atelier essentiel-
lement différente. Fugitive, éphémère.

De tout son poids de papier, voilà ce qu'elle dit.

Alors enfin terminée, puis descendue et enroulée
à nouveau dans son coffre de carton, elle est
repartie rejoindre ses soeurs dans le ciel
d'Himeji.

Cette peinture de ciel a emporté avec elle non
seulement le souvenir de son court passage sur
terre, mais aussi un fragment du mien, un peu de
ma propre fugacité. Et ces deux instants, liés
dans la complicité et finalement condamnés au
même oubli, dérivent en ce moment dans un
espace lointain, un repli de la mémoire où déjà le
doute s'installe : le souvenir, peut-être ?

En tous les cas, loin, bien loin—à perte de vue.

Gérard Titus-Carmel
Avril 1988

A painting for the sky

A dream: to paint a picture of sky. Or rather: to paint for the sky. Then, suddenly, to paint a picture actually intended for the sky. A picture which would not belong to me, or to anybody, but which would escape gravity and fly away in the air, rising higher than the highest coils of smoke.

It all started when a light and surprisingly long box arrived in my studio – it contained a softly rolled sheet of Japanese paper in fine material. "Its really like a piece of sky itself" was my first thought on unwrapping the paper, "I mustn't make it too heavy." But already the pale ochre was attracting me and I knew I would have difficulty in resisting.

Pinned up on the wall in my studio, with its point uppermost (I had chosen the Tosa form for my Kite) the beautiful creamy surface seemed held back by force, reminding me vaguely of the great night birds which anonymous hands used to nail to certain doors . . .

While working I was both oppressed and stimulated by the thought that this painting was destined to leave the studio when hardly dry and regain its place above our heads. I did not work hastily, but felt just the same a certain urgency to finish – perhaps I feared that the paper might tear itself from the wall and fly off. Of course, once in the sky, the kite would be held down by a line in expert hands, but I suspected that it would escape from our control and fly back to its proper place in the sky – that it would disappear, blown here and there by the wind's caprices, carrying its black markings into infinity. To be forgotten.

A word about this painting in the context of my series "Intérieurs" (Interiors) it is clearly the central element – the "lamp", flanked by the recently arrived palm. But it does not really belong, being a "flying work", it passes over the others like a cloud amongst clouds: it

wins all sides – a memory, a family, but above all freedom. The price to pay (the price it demands to pay) is to be thought of with the same feeling of feverishness, of precariousness. So no laments and no regrets: its perfect timeliness opposing the winds and disappearance. Foreign to the other paintings, and their destiny, this work leaves the studio essentially different. Fugitive, ephemeral.

With all its weight of paper this is what the painting says.

This sky painting carries not only the memory of its short passage on earth, but also something of myself and my own passing. These two moments, linked in complicity and condemned to be forgotten, are now flying together somewhere in the sky – a spark of memory, or, and here doubt begins, memory?

In any case far, very far, away.

Gérard Titus-Carmel
Paris, April 1988

凧の思想　　大岡信

地上におれを縛りつける手があるから
おれは空の階段をあがっていける

肩をゆすって風に抵抗するたびに
おれは空の懐ろへ一段一段深く吸われる

地上におれを縛りつける手があるから
おれは地球を吊りあげてやる

The kite's view

As hands bind me down to the earth,
I can climb the heavenly steps.

Each time I shake my shoulders
against the wind,
I am drawn deeper and deeper
into heaven's womb.

As hands bind me down to the earth,
the earth clings to my cord.

Makoto Ooka

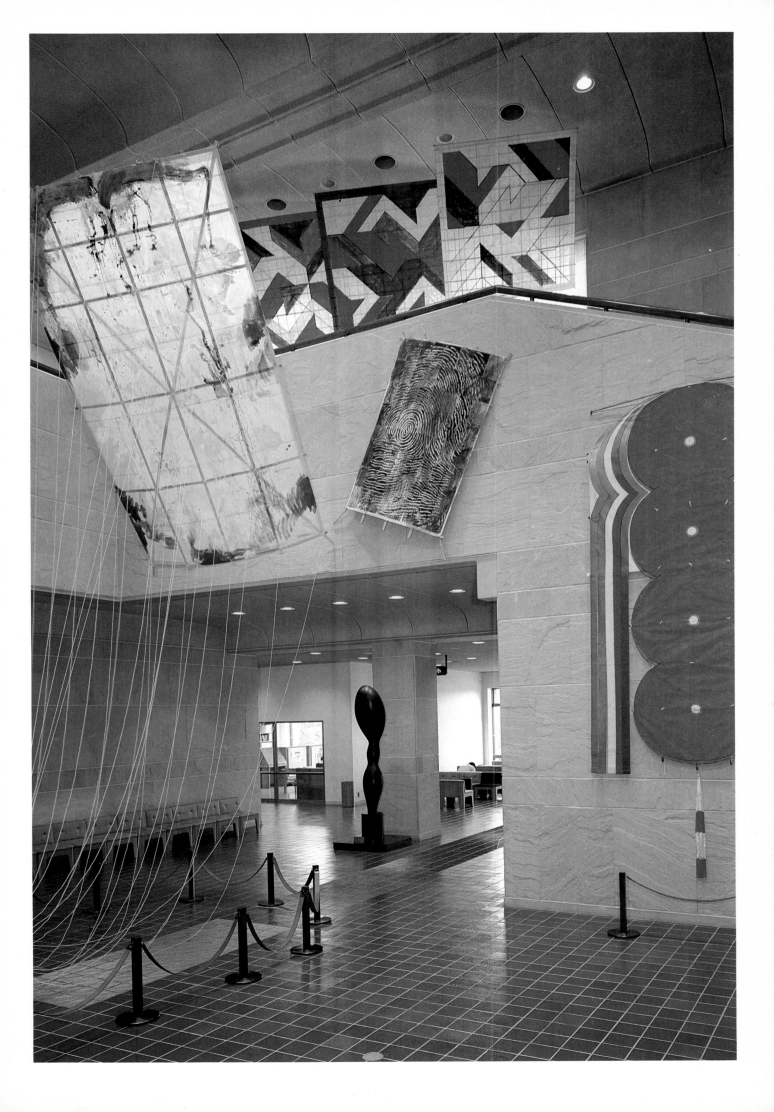

The poems "The Kite's View" and "The Song of the Kite" were written for this Project by the poet Makoto Ooka of Tokyo

Miyagi Prefectural Art Museum (Sendai), June 1988

「凧の思想」（29頁）と「凧のうた」（118頁）は詩人大岡信によりこの企画のために書かれたものである。

宮城県美術館（仙台）1988年 6 月

Pictures for the Sky

空舞う絵画

Paul Wunderlich

Born 1927 in Eberswalde, Brandenburg,
lives in Hamburg

With a nod to traditional European portraiture and a page from Jugendstil's elegant treatment of lines, Wunderlich's kite is a Queen of Hearts playing card turned piercingly malevolent. Full of ominous sevens, (both the stylized figure "7" and things arranged in sevens), plus other hidden elements (like the strange hat that resembles a rapidly beating heart) the picture is charged with black and white, positive-negative and other opposing energies. Especially powerful is the Queen's oval face, with its animal eyes and Mona Lisa erotic lips – all effects that Wunderlich creates with a spray gun and stencils.

His goal is to de-personalize his work – to bring the figure to perfection – but Wunderlich couldn't resist adding a sketchy self-portrait, as well as a dog and two Japanese women's faces. The various possible inter-relationships between all the elements add to the enigma of this kite.

The Queen of Hearts was amongst the first paintings to return to Japan where, being in the shape of an Edo kite, it was taken directly to Tokyo (formerly named Edo) to be mounted. Kite-maker T. Kishida, a retired flight engineer who is now a bonsai gardener, skillfully transformed the Queen into a heavenly body, even matching the kite loops to her colourful dress! When the kite flies up into the sky the light from behind enhances this beautiful picture.

パウル・ヴンダーリッヒは彼が引いたトランプのカード「ハートのクィーン」を凧にして見せた。

この絵の画面構成を支配する特徴は、シンメトリーに配置され、陰と陽に相互に関連するフォルムの遊びである。基調となる色は黒である。台座、これは彼女に彫像の如き感じを与えているのだが、その上にはユリの花のような姿が立っている。「悪の華」が。

神秘的なエネルギーは、卵形の顔の周囲に集中している。帽子は血のような深紅から素晴らしい葉の緑色へ変化する色のスペクトルである。そしてそれは電気を帯びた髪の上で、あたかも炎の舌の如くめらめら燃えて、人の心を落ち着かせない人体の器官のようなものを連想させる。生き生きと鼓動する心臓であろうか。それは歪像画法の不均整の形のまま、アラベスクにと、異化されている。獰猛な猫のような黄色い体には、暗い野獣の眼と鼻の白塗りがよく似合っている。スフィンクスの謎めいた顔から放たれる鋭いまなざしは観る者の目に迫り、半開きの唇には官能的なモナリザの微笑が息づいている。

この「ハートのクィーン」は、マネキン人形のような非のうちどころのない人工美、官能的な庇護マントを身につけた近寄り難いほど様式化された聖母マリア、狩猟服に身を包んだ雄々しいダイアナ、そして冷やかで暗示的なヴィーナスなどのさまざまのものを身につけている芸術性を究めた創造物であるのだ。

優雅なコスチュームに目を転じると、技巧を凝らしてフォルムに変化がつけられている。そこにはハートのクィーンの象徴がスペードやクローバーと同じように描かれている。計算されてはいるが隠された意味が、装飾的な遊びになっている。神託を告げる謎の神木は7回現われ、その茎にはそれぞれ7枚の葉がついているというのである。

パウル・ヴンダーリッヒはこの美しい創造物を完璧な姿にするため、自分の手を脱個性化して、エアブラシと型を使用し、もうひとつの画面では、鉛筆によるスケッチで、語るようなディテールを描写している。その自画像と犬、2人の日本の女性の顔の習作は個性的な手描きで、芸術家の感情を反映している。ここでも相互のつながりはやはり、謎めいたままである。

Queen of Hearts
Acrylic, pencil, crayon
Edo kite 164 × 100 cm
Kite-maker: T. Kishida

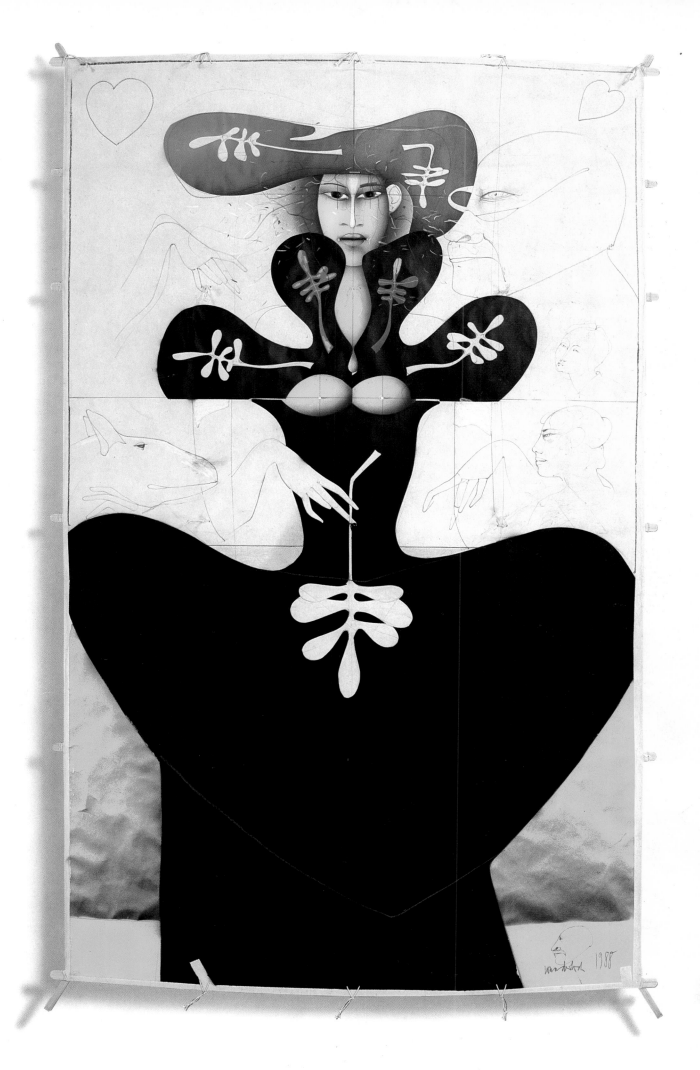

The Queen's triumverate: kite-maker Tetsuya Kishida
brings the completed Queen of Hearts. The artist is
present in a self-portrait.

凧師岸田哲弥により、完成したばかりの「ハートのクイーン」が届けられ
た。この二人の間にはやはり作家がポートレートになって顔を見せている。

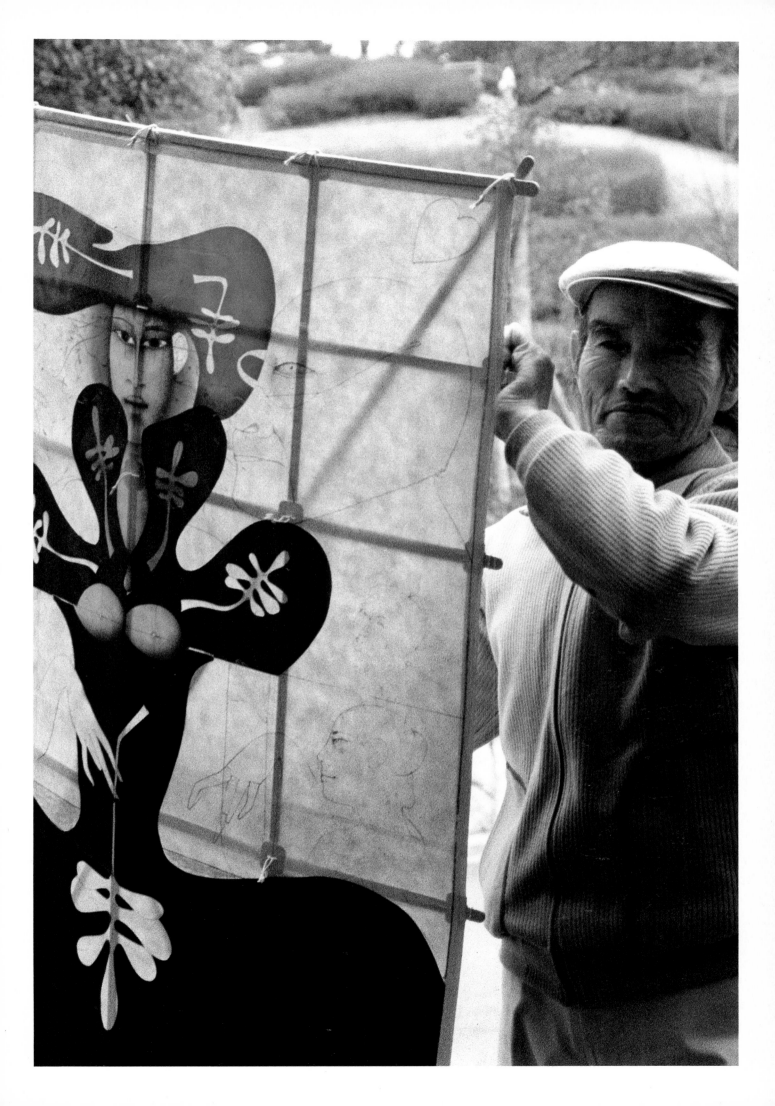

Bernard Schultze

Born 1915 in Scheidemühl, West Prussia,
lives in Cologne

Following studies in Berlin and Düsseldorf, Schultze travelled to Paris, a trip which inspired him in 1951 to join the German Informel abstraction movement. Specifically, he helped found the Quadriga Group, which boasted as a member K.O. Götz.

It was in 1956 that Schultze's paintings first started to feature cloth and debris. This was followed the next decade by similar ideas in 3-dimensions, constructions which the artist called "Migofs". These amorphous objects combined characteristics of animals, plants and people in dramatic and sometimes chilling ways, their red and green tones reminiscent of German mysticism.

Schultze feels a special affinity for the late Gothic sensibility, a world which influenced him deeply as a child. In his fairy tale landscapes are echoes of German Romanticism; in his collages are those of Surrealism. Only recently do we find brighter colours and freer brush strokes, revealing Schultze to be a consummate draughtsman. The key to understanding his mystico-poetic kite is offered by the artist himself:

"When the washi lay spread out before me I imagined it was a dragon's skin because dragons, too, take to the air and their skin gets colorfully marked, scarred and patterned in mysterious ways. The whole piece developed like a letter, composed line by line as the summer winds swirled about me. Only admirers of the poet Jean Paul can decipher the writing. Maybe I was thinking of his hero, the airman Giannozzo, and his fantastic adventures. In short, it all came out with great speed, and you may look upon it as a dragon skin, a letter from me and a scribbling à la Jean Paul."

ベルナルト・シュルツェは、芸術家としての教育をベルリンとデュッセルドルフで受けた。パリ滞在中に刺激を受け、1951年彼の作品は抽象的なアンフォルメルへとその方向を転換することになる。シュルツェは他の多くの芸術家やK．O．ゲッツの属していたグループ・クワドリガの提唱者の一人でもあった。

1956年を境に、布の端切れや廃物を立体的に貼りつけた絵が現われ始めた。60年代の初めにこのようなレリーフ状のものから三次元的立体造形作品へと展開させ、それを「ミーゴフ」と名付けた。ミーゴフはいわば動物、植物、人間の中間的なかたちにつくられた物で、この形の定まらない瘤のような盛り上りを組み合わせて、彼はたびたび不気味で恐しいばかりの舞台状のインスタレーションをつくりあげたのである。

色はあらゆるバリエーションの中で緑と赤が勝っているが、大部分は混ぜあわされた弱々しい色調で、死滅や枯死を連想させる。ドイツ神秘主義の空の空の思想、メメント・モーリ（汝、死を忘れるなかれ。）を感じさせているが、シュルツェは子供の頃すでに深い感銘を受けていたグリュネワルトの後期ゴシックの絵画の世界にも親しみを感じているのである。しかしそれだけではなく、彼の計り知れない童話的風景の中にはドイツロマン主義が、そして増殖的なコラージュの作品にはシュールレアリスムの流れが息吹いている。

作品の色調は後に明るくなり、その筆のタッチもより自由で奔放なものになった。優れた素描家としての才能もその作品の中にはっきりと現われている。

ベルナルト・シュルツェは、また言葉の達人でもある。彼の秘密に満ちた、しかし詩的な凧の絵を解読する手がかりとなる鍵を、彼は比類のない名文で私たちに与えてくれている。

「私の"龍の表皮"があなた方の気に入ったそうで嬉しく思っています。というのも、大きな和紙が手元に届いて、私の目の前に広げられたその時、あなた方を喜ばそうともくろんでいたことでしたから。凧は空中を楽しく飛びまわる一匹の動物です。それで、その表皮は色彩豊かな刻み目やシンボル、神秘的なかかわりなどで満たされていますが、青い空に浮んだ時にやっと生き、性格がわかり、虐待されるかもしれないし、認められるかもしれないのです。そもそもこの絵全体は、夏の風に纏われながら、私が一行一行書き綴っていった一枚の手紙のようにできていきました。この文字を解読できるのはジャン・パウルの崇拝者だけかもしれません。恐らく私の脳裡には彼の「ほうき星」のことがあったのでしょう。とにかく風に煽られてあっという間にできてしまったのです。そこであなた方のところには、半分は動物の表皮、半分は手紙、半分はジャン・パウルのメモというものが届くというわけです。」

Dragon Skin
Watercolor
Edo kite 180 × 120 cm
Kite-maker: T. Kashima

David Nash

Born 1945 in Surrey, England,
lives in Blaenau Ffestiniog, N. Wales

Trees, either as the raw material or the subject, are the main focus of Nash's work. As a wood carver he employs ax and saw to sculpt trunks, roots and branches into pieces that seem half organic and half artificial, all the while treating wood not as a fixed object to be manipulated, but as an ever-evolving, living thing.

Nash has written: "The word 'tree' is near to being a verb with a sense of increase, growing, spreading, doing and being; working with plant instinct, transforming raw material, engaging light, moisture and warmth. There is a presence of evolved wisdom in the success of a tree's life."

In Japan (where Nash has frequently worked), trees are revered and are viewed as symbols of a human's own growth and ageing process. Held in especially high esteem is the pine tree, its image being an integral part of the Noh theater stage. Nash's "Flying Tree" is almost certainly a reference to this 600 year-old performing tradition. Interestingly, Nash was the sole artist to choose the octagonal hakkaku kite. Perhaps others found it too limiting, but Nash has neatly filled its rigid geometry with the irregular roots, trunk and canopy of his pine. Also, in accordance with the tradition of this kite style, it is outfitted with a humming unari bow, a device that imitates cicada when the kite is in the air.

彫刻家ディヴィッド・ナッシュの場合には、木が作品の中心的なモチーフである。根も枝もついた樹幹を素材にしてノコギリとおのを使って制作される作品は、自然的な部分と人工的な部分が混ざり合っている。木材はただ作品の素材となるだけでなく、成長する自然の姿をとどめている。

「『木』という言葉は動詞に近く、言ってみれば増加、成長、拡張、行動、存在を意味する。植物の直感と取り組んで、生の素材を変化させ、光、湿気、暖気を引き入れてゆく。成功している木の一生の中には進化した知恵がある。」

ディヴィッド・ナッシュが幾度も仕事をしたことのある日本でも、木は人生の象徴としてしばしば引用される。とりわけ松の木は尊重されている。日本の古典能舞台の後座の鏡板には松の絵が描かれる。ディヴィッド・ナッシュの「飛ぶ樹」は、この日本の伝統を紹介しようとするものなのか。彼はまた、八角凧を選んだ唯一の芸術家でもある。おそらくこの形は、他の芸術家たちにはあまりにも完璧で決まりすぎていたのだろう。ナッシュは絵の枠になっている厳格な幾何学の形を、根や幹や樹冠といった有機的で不規則な形態のもので埋めている。

伝統的な八角凧と同じように、この凧も上部にうなりを付けている。ここに張られた弦により、空飛ぶ凧は遠くまでうなりの音を響き渡らせるのだ。

Flying Tree
Acrylic 200 × 200 cm
Hakkaku kite
Kite-makers: N. Yoshizumi, T. Okajima, F. Fujieda,
O. Okawauchi

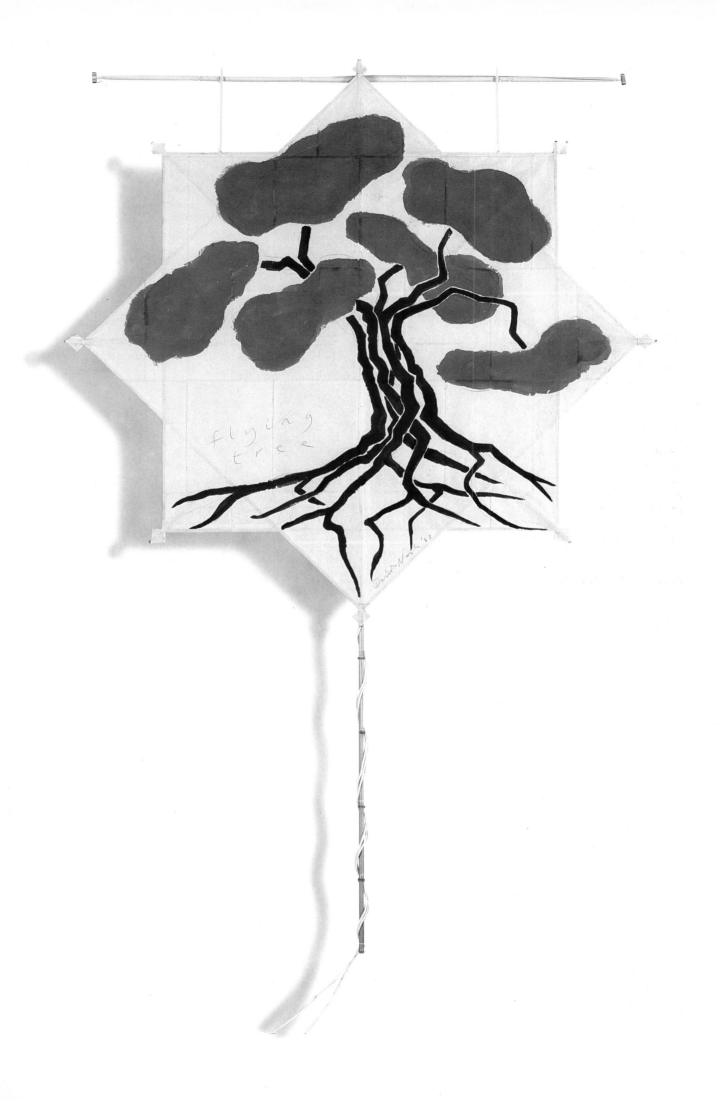

Mitsuo Kano

Born 1933 in Tokyo,
lives in Kamakura

The most experimentally-minded of all the Japanese participants, Kano is credited with tremendous innovations in the field of color research. His works exhibit a truly scientific meticulousness and he even presses his own oils to achieve the desired effect. The result is a unique, personal style that has extended from collage to frottage to etching, the last of which he has tinkered with by using a gas burner directly on the zinc plates.

Famous for his work with decalcomanie and beeswax, Kano has an atelier that is a cluster of unconventional "artistic" devices like thermometers, hygrometers and barometers. All these scientific instruments are necessary for measuring and controlling the variable drying rate of his media. He often works over still wet undercoats and pigment layers, and his works emerge complete within a very short time span. More importantly, because of the radical difference in application process between adjoining areas of his pieces, the spill-over tolerance – the line separating a clear success from a complete failure – is thin, indeed.

Therein lies Kano's unique appeal: the tension created between the cool geometrics and the chaotic swirls is that between reason and emotion, calculated engineering and pure chance.

加納光於は日本の芸術家の中でも熱心な実験家である。彼の好奇心は色彩のみならず技法にも及んでいる。学問的な綿密さで顔料の研究をして、絵の具に必要な油を自ら絞る。試行錯誤を繰り返し彼の芸術のための本物の技法を生み出したのである。加納はまず銅版画を始めた。更に、熱処理した亜鉛版により金属版画をつくり、コラージュやフロタージュに取り組んだ。デカルコマニーによる版画に似た効果が彼の創作の本質的な要素のひとつになった。ここでエンコスティックの使用が大きな役割を果たすことになる。大判のプレートの上に塗られた絵の具を、まだ下塗りが完全に乾いていないカンヴァスに写し取る。絵の具の乾燥の度合いが作品の出来具合いに決定的な役割を演じるのである。温度計、湿度計、気圧計といった普通には使われないものがこの画家には不可欠な道具となる。どの作品の場合も、それが成功か失敗かはほんのわずかな限られた時間内で紙一重の差により決まる。

加納光於の絵画は、多くの場合左右対称であり、幾何学的に構成された抽象画である。 絵の組み立てが合理性をもとに成っているのに反して、色彩が生み出す構成は、 冷静な即物性から有機的にふくらむフォルム、無秩序な渦やじっとりぬれた感じのするものまで幅広い弧の中に描いている。理性と感情、計算と偶然の間に起こるこのような緊張感から、彼の絵画は魅力に包まれている。

Untitled
Encaustic, oil
Kaku kite 255 × 193 cm
Kite-makers: N. Yoshizumi, T. Okajima, O. Okawauchi

Emilio Vedova

Born 1919 in Venice,
lives in Venice

The leading figure in Italian Lyrical-abstraction, self-taught Vedova continues to experiment with the expressive linear patterns that already defined his work as early as 1937. With Goya's interplay of black and white and Tintoretto's ecstatic calligraphy as early points of departure, his œuvre has been characterized by the tension between aggressive brushstrokes and meditative lines, dynamic forms and tranquil surfaces, black and white, and light and darkness.

After World War II Vedova's expansive energy burst beyond the picture frame and, in huge ateliers, he arranged multi-media presentations. Later, in the mid-1960s, novelly employing numerous powerful projectors and 20-kilowatt xenon lights, he projected dazzling glass plate images called "Light-Space Interventions". The plates for these images had been cut, perforated, engraved, printed on, corroded and treated with molten metal, thus producing huge variations in transparency, coloration and relief. Vedova also used "Light Interventions" for the operas "Intolleranza" and "Prometheus" by Luigi Nono.

The '60s found Vedova creating "Plurimi", and in the '70s the creations "Plurimi binari" appeared: movable, asymmetrical wood panels painted on both sides. Altering the intersections and overlapping the panels made possible a wide variety of effects. Most recently, he has been grouping together large painted discs – some on the floor, some hanging and still others free-standing – that produce a sense of weightless uplift.

Vedova's Venetian Kite integrates all the elements of his art in a masterful manner. Though strongly expressive it still retains the intimacy of a sketch. And through the interplay of black and white, he achieves an effect of transparency recalling his glass projections. The contrast between light and dark, and movement and rest, results in a tension that gives the kite the visceral tautness of a drum. His kite resounds.

情熱のこもった大胆な動作で絵を描くエミリオ・ヴェドーヴァは叙情的抽象表現主義を代表するイタリアの重要な芸術家である。1936年、37年に独学により始めた表現豊かな筆の運びのその作風は、今日も変ることなく、作品の特徴となって筆跡に表われている。ゴヤの白と黒や、ティントレットの興奮のカリグラフィーの中に見られる暗い緊張感が彼の絵画の出発点になっている。攻撃的な筆の迫力と瞑想的な線の跡、ダイナミックに動くフォルムと静かな面、白と黒、そして明と暗との間に起こる弁証法的緊張感が彼の全作品の中で決定的な役割を果すのである。彼のタブローは、彼が情熱的な意志表明をする行為の現場であるといわれている。絵画制作の経過はバレエの振り付けであり、黙想的な動きでもある。そしてそれは画面にしっかりと痕跡を残し、精神的な衝動をたどる手掛りとなる。

戦後、彼の精力的なエネルギーは画面の粋を飛び越えてしまう。彼の大きなアトリエでは、多次元に延びるインスタレーションが実現され、マルチメディアによる演出の構想が展開していく。60年代半ば、エミリオ・ヴェドーヴァは、光・空間干渉装置を作り出す。何台かのプロジェクターと20,000ワットのキセノンガスライトを用いてガラスプレートのダイナミックな投影を繰り広げていくものである。ガラスのプレートを切断したり、彫ったり、刻印やプリントを施したり、腐食させたり、更に金属を溶かし込んだりして、これに様々な光度値、色彩、レリーフ効果を与えて多くの現象を展開させていったのである。彼はルイージ・ノーノのオペラ「プロメテウス」に光干渉装置を使い新しい演出を試みている。

70年代には「Plurimi」が生れる。アシンメトリックな可動の木版に、両面に描かれた絵画である。これをずらすことによって交差したり、重なったり、変化に富んだ表現が可能になる。最も新しい作品のシリーズ「Dischi」は絵の描かれた大円盤であるが、それを横に置いたり、掛けたり、立てたりすることにより、いくつかの異なる空間インスタレーションができ、その中では観る者が宙に浮いているような感覚になる。

ヴェニスからの凧は、エミリオ・ヴェドーヴァの絵画の要素をそのまま備えているのが印象的である。抽象表現主義的であるのにスケッチの凝縮された密度がある。白と黒の構成により、あのガラスの投影装置を思い起こさせる絵の透明感を得ている。絵の中では明と暗、静と動のコントラストにより太鼓の表面に張った凧の表皮のような緊張感が生まれている。この凧は鳴り響きそうである。

From Venice to Osaka., Venetian Kite.
Oil on canvas
Kaku kite 250 × 124 cm
Kite-maker: T. Kashima

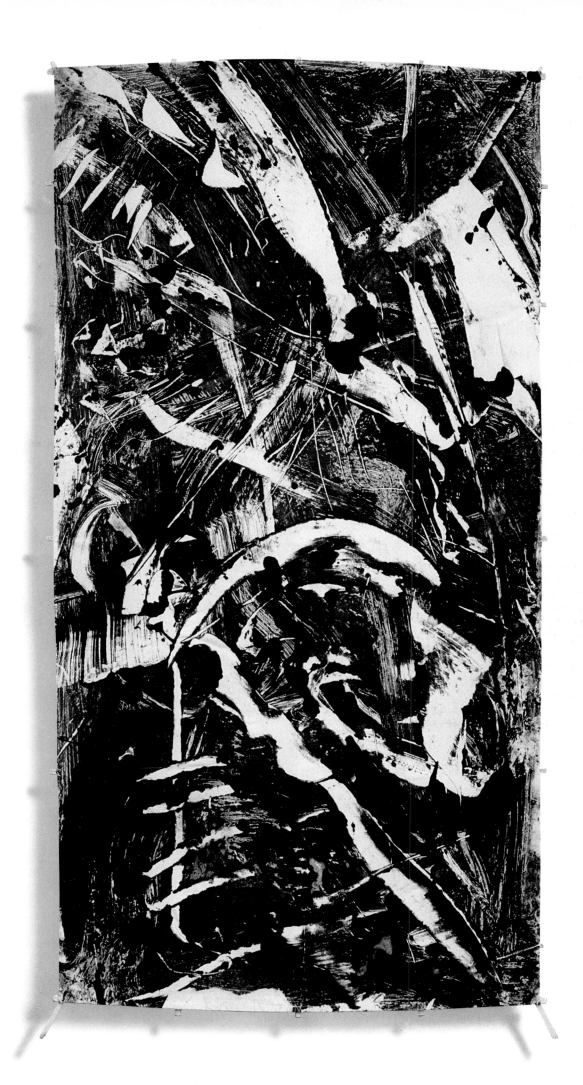

Venice, April 1988

1988年4月、ヴェニスにて

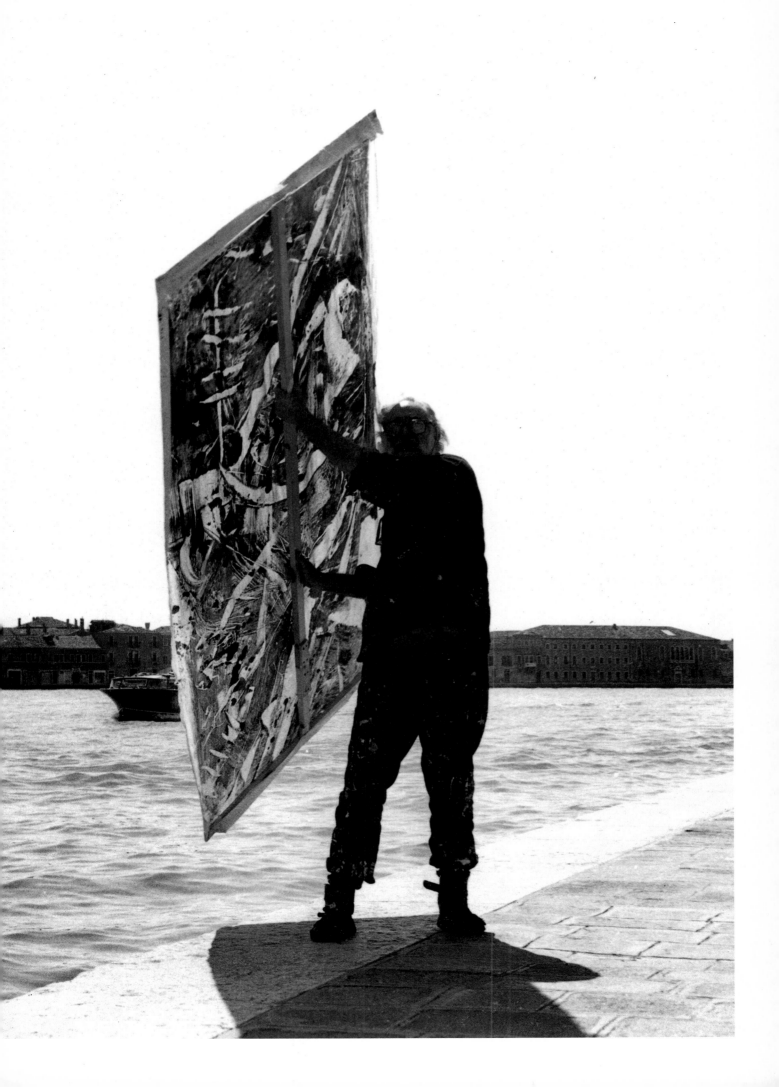

Yae Asano

Born 1914 in Suzuka, Mie,
lives in Suzuka

The most senior member of the Japanese art kite painters, Asano still lives in the house of his birth in a small town. Despite the disapproval of his tobacco-trading father, he devoted himself to painting and developed independently his own abstract style noted for its sensitivity, intellectuality and total lack of connection to contemporary trends. More amazingly, in a nation in love with group orientation, he has never been able to feel at home in any art group.

Asano is a painter of lines. On large sheets of paper he pencils freehand endless parallel lines, producing drawings that resemble woven cloth or cut and polished stones. His oil paintings emerge out of a similar process, starting with still wet white undercoating which he etches in with a pencil or nail.

For his kite, however, he saturated a good half of the surface in black ink and left the other half white, except for a small splotch which he calls "playing around". This simple, ascetic design evokes the austere beauty of classical Japanese forms which, in turn, led naturally to the idea that the kite should be made by a master from Kyoto, the ancient cultural center of Japan.

For the frame Takashi Uno used susudake (smoked bamboo), taken from the eaves of old farmhouses. Such bamboo is dark from years of smoke but, when polished, glows with the warm luster of amber. As for the criss-crosses, Uno took great pains to tie the strings exquisitely, thus creating a brilliant piece of craft to back a work of fine art and highlight the essential unity of the two.

浅野弥衛は、「アート・カイト」の企画に参加した日本人の中でも芸術生活を最も長く続けてきた作家の一人である。浅野は、煙草の産地でもあった町で生れ、現在もその生家に住んでいる。父親は煙草仲買人であったが、稀有なことに、その息子は芸術に人生を捧げることができたのである。彼はこれを与えられた使命とし、確固たる意志と無言の粘り強さでやり通している。浅野は、環境にも、芸術の傾向や流行にも全く左右されることのない、繊細で知的な抽象の芸術を独学で築き上げた。一時は美術文化協会に属していたが、その後すぐにフリーになる。

浅野弥衛は線の画家である。線を、鉛筆を使ってフリーハンドで、大判の紙の上に無数に平行に引いていく。彼のドローイングは織った布か、磨かれ、刻み込まれた石塊のようである。作品は、浅野の仕事が限りない秩序と忍耐を必要とすることを示しており、それらは作品の中にも蓄積されている。しかし、作品からは、画家がこれ程までに禁欲的な仕事をするにもかかわらず、緊張を緩め悦楽する様子さえ伝わってくる。油絵の作品もよく似た方法で制作される。白で厚く地塗りをしたカンヴァスに、色が完全に乾いてしまう前に釘や鉄筆で刻んでいく。全画面がリズムのある無数の細い線で埋まるまで引っかき描かれていく。その絵画のあるものは手紙が綴られていくようであり、またあるものは古い塗りものに入っているひびのような搔き絵である。絵には初めも終りもなく中心点もない。絵は画面を越えて更に限りなく続き脳裡から離れない。

浅野弥衛は、凧の絵に珍しく墨を使い何度も繰り返して塗り和紙になじませた。白と黒の境堺線の乱れたところと、無彩色の面の黒い点はホモ・ファーバーの浅野弥衛が（自らそう述べているが）少し遊んだ痕跡である。

瞑想的な静寂、禁欲的な清楚さ、時間の超越を象徴する浅野弥衛の凧の絵は日本画と日本建築の厳格な美しさを表わし尽している。そこで私たちはこの凧の製作を、日本の古都、京都出身の凧作りの名人に依頼した。宇野隆は浅野のアート・カイトに煤竹を使い組み立てた。煤竹は古い農家の天井の木組みによく使われた竹で、長い年月と煤煙により竹の表面が飴色の艶を得る。磨くと光沢が出て琥珀のようになる。凧師は竹の交差する箇所を麻糸でしばり巧みに、美しく仕上げた。このように、一作品の中で芸術と工芸が一体になり二つの面を持つ総合芸術になったのである。

Untitled
Japanese black ink 160 × 110 cm
Edo kite
Kite-maker: T. Uno

The reverse side is also a work of art. Kite-maker
Takashi Uno used 200 year-old bamboo and linen
strings for this kite.

裏面もまた芸術作品である。凧の製作者宇野隆はこのアート・カイトに200年
前の煤竹と麻糸を使った。

Ulrike Rosenbach

Born 1943 in Salzdetfurth,
lives in Cologne

A member of Joseph Beuys' master class in Düsseldorf from 1964–70, Ulrike Rosenbach already dealt with the role of women in a male-dominated society in her very first sculpture, "Bonnet for a Married Woman". It was in video, however, that she found an effective medium for her message, seeking to communicate the reality of women and women's power.

Rosenbach's material is clearly autobiographic, but she has broadened and enriched it by adding historical and mythic dimensions, giving her performances the air of a ritual. Employing slow-motion video photography (which puts her near Minimalism and Conceptual Art), she strives to demonstrate the "processes of change that transform oneself". These videos are then edited into still photos which are famous for their dramatic shock value.

Rosenbach's "Black Angel" is derived from a performance entitled "The Woman Trickster". In her notes on this kite she explains:

"The angel-kite is a further realization of a basic figure which has appeared in my work for years. The angel figure is my favorite ready-made and is taken from the Mystery Frieze of the Villa dei Misteri in Pompei. This angel can be seen as both a male and female erotic figure, its transformation rising out of the ecstasy of a woman intimate with Bacchus. As for the angel's exuberant pose, that comes from my own experience.

ウルリケ・ローゼンバッハは1964年から1970年までデュッセルドルフ芸術大学で彫刻を学び、ヨーゼフ・ボイスの一番弟子でもあった。

彼女の最初の彫刻作品「ある既婚女性のためのずきん」は、男性優位の社会における女性の役割をテーマに制作したものである。やがて女性解放を目ざした芸術活動の新しいメディアとして、ビデオ・アートを見つけることになる。「女性のあり方と女性のもつ力」の現実を伝えたいという試みにおいては、自伝的主題から出発してはいるものの、これを歴史的かつ神話的次元にまで拡げていっている。これにより彼女の創作は儀式的な性格を帯びてくる。ビデオにゆっくりと収録していく技法は、ミニマル・アートやコンセプト・アートに近づくものであるが、この技法により意識化、すなわち「人を変えてしまう変化の過程」を創造しようとしている。彼女はいままでの伝統的な階級的見方に修正を加える新しいメディアの美を得ようとたたかっているのである。

ビデオ・アート及びパーフォーマンスから彼女の考えをしばしば露骨に表しているフォト・コンポジションが生れた。彼女のアート・カイトの「黒い天使」は「オイレンシュピーゲライン」という題のパフォーマンスにさかのぼる。このことに関して彼女は次のように述べている。

「『天使の凧』は、何年も前からしばしば私の作品の中に姿を現わしている基本になる人物像をテーマにしたもう一つの作品である。この天使像はイタリアの古い町、ポンペイにあるヴィラ・デイ・ミュステリ（謎の家）の謎のフリーズからとった私の好きな「レディーメイド」である。正面のフレスコの要素、そして『神話的な結婚』の構成要素として、この天使はエロート（愛の神）、より正確にはエローティン（愛の女神）と理解されるものである。なぜなら、この天使の意味はエクスタシーによって酒神バッカスと結ばれた女性の変身にあるからだ。私の天使の喜ばしい認識と彼女の変容の意味は、私自身の経験の象徴なのである。」

Angel Kite
Japanese black ink
Kinshoji kite 160 × 110 cm
Kite-maker: Japanese Kite Association Kyoto

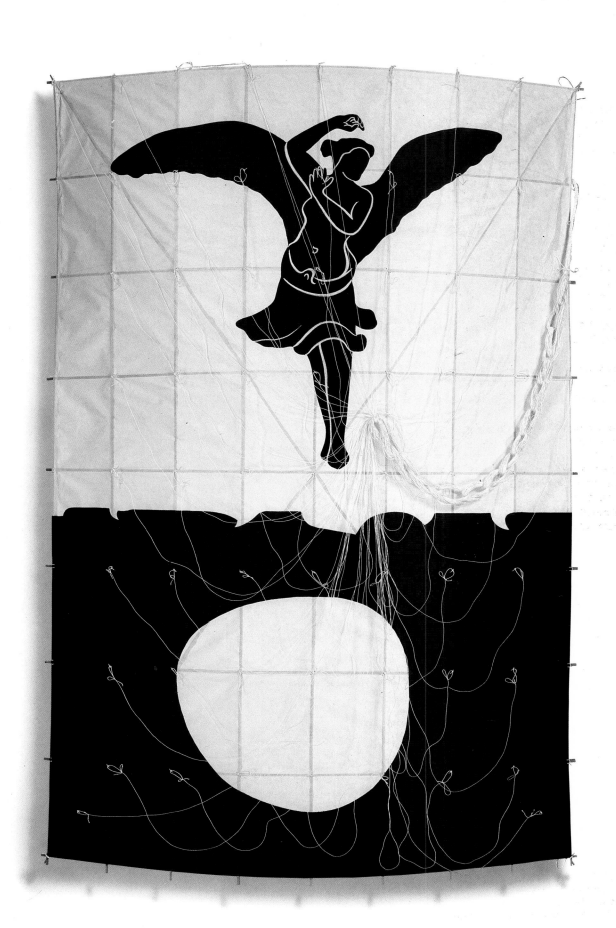

Yayoi Kusama

Born 1929 in Matsumoto, Nagano,
lives in Tokyo

Following art studies in Kyoto, Kusama lived in New York from 1957 to 1972 where she caused a sensation with her anti-war orgies and nude happenings at the Stock Exchange and in front of the United Nations.

At the same time, sometimes working with Warhol, she was actively involved in painting and sculpture.

Many of her paintings surrealistically combine an object, like a boat or sofa, with a rich overlay of organic undersea-type growth. One enters a world of softly pullulating plants, sea anemones and coral, all covered over with a network of dots. The seeming endlessness of the pattern, instead of being bizarre, suddenly strikes the viewer as a proper depiction of things – a confusing but necessary realization of our perceptual limits, much like the strange distance and depth sensations of a deep-sea diver.

Out of Kusama's works comes the cry of the horror vacui, the fear of being lost in endlessness. One searches anxiously for a centerpoint, but there is none – no relief from what some see as microscopic organisms and others imagine to be a world of flickering flames.

Are the thousand tiny flames of her kite the beginning of an unquenchable fire which will spread over the entire sky to become an enormous world conflagration?

草間彌生は、京都の美術学校で学んだあと、1957年ニューヨークに移り住み、1974年まで制作活動を続ける。彼女の仕事は絵画や彫刻だけでなく、ミュージカル、映画、パフォーマンス、反戦ストリーキング、ボディー・ペインティング、ファッション・デザインの分野にまで広がった。

シュールレアリスムを思わせるアンサンブルの形式で、モノクロームの絵に色鮮やかな布製の繁茂するようにつくられたオブジェを組み合せて、ボート、はしご、ソファーなどを作っている。このようなインスタレーションは、観る者がまるで水中の世界に誘われるようである。そこには豊かにおい茂った水にゆらぐ植物、いそぎんちゃく、珊瑚礁などが生息する。どのオブジェも網の目や水玉模様の布でつくられている。同じパターンの無限につづく繰り返しは、突然、自然界やありふれた物の姿に変わる。同時にその有機的で植物的なフォルムは限界を越えてさらに成長を続ける。それは単に見る者の眼の中で成長し続けるように見えるだけではなく、空間に対する我々の知覚をも揺がすのである。珊瑚礁の海にもぐった時、自分のさし出した手がはじめて感じる生きた相互関係を意識に伝達するような体験の効果がこれである。

我々は彼女の絵の中に「限界の超越」の現象を体験する。同じ模様の、しかも型にはまった反復は不安さえ感じさせる。無への恐怖に対して強迫観念で抵抗する断末魔の苦しみ、無限の中に迷い込んでしまう時の底知れぬ不安を感じさせるのである。

絵筆は、このような恐怖感を呪縛し同時に追い払う手段となる。視線は中心を求めてさまようが無駄である。このような絵には支点はない。

もはや理性では押さえられなくなった時、人は説明によって納得しその現象を追い払おうとするものである。顕微鏡の中では、細胞核が絶えず新たな微生物に分裂していくのならばひっきりなしに表面に湧き出てきて、ひいては何千億の数で全宇宙を満たすであろう鞭毛虫は有機体の原子分裂と言えるのか、あるいは彼女の芸術凧の千にものぼる踊る小さな炎は天に広がって世界を焼き尽すとどめる術のない劫火の一部なのであろうか。

Fire
Acrylic
Edo kite 270 × 154 cm
Kite-maker: T. Kashima

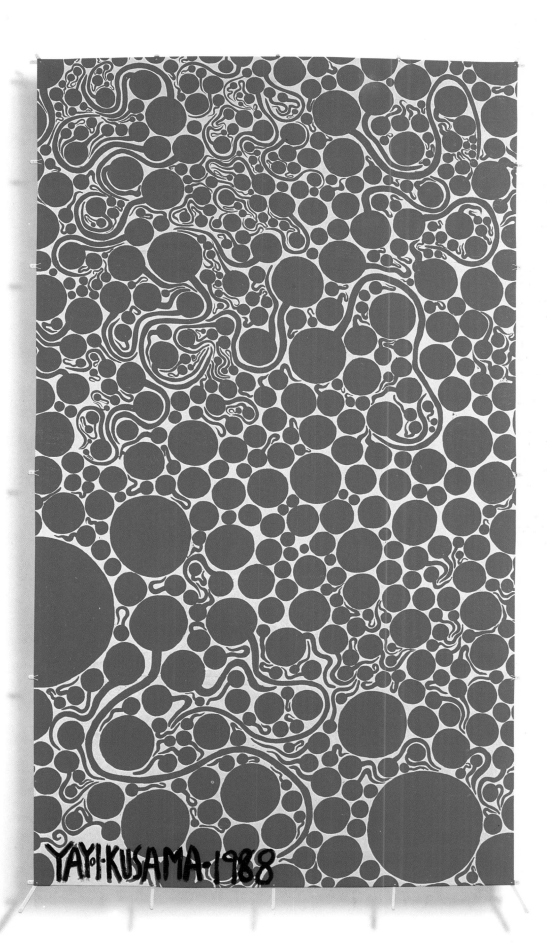

Panamarenko

Born 1940 in Antwerp,
lives in Antwerp

In both his drawings and constructions Panamarenko creates fantastic flying machines reminiscent of Zeppelins and other contraptions from the early history of aviation. His creations appear air-worthy and give the impression of the kind of precision machines one might expect to find at a science museum, an effect strengthened by the patina of antiquity he imparts to his works. But they are, in fact, just playful products of the imagination, pointing beyond the technical to the mythical, to mankind's age-old dream of flying. By evoking the dream of Icarus, Panamarenko creates his own mythology.

Although a Panamarenko construction might be lifted by the imaginative powers of an observer, only as a kite can his ideas really take flight. Illusion and reality are engagingly combined in this art kite; the sturdy balloon seems to raise the kite upwards, while the printed rope securing the gondola appears intermeshed with the kite's real cord.

We peer through this kite's glass-like transparency, as if through a window, the glass dome in the photo capturing the light of the sky.

パナマレンコはドローイングや造形作品に、現実離れした飛行機や飛行船の試作を発表している。そのうちのいくつかはツェッペリンや、飛行が可能になった初期の頃の飛行機の構造を思い出させる。彼の制作する装置は、一見飛行可能のようであるが、実際には楽しい空想の作品である。これらの作品のほとんどは、科学博物館の展示物のような印象を与えるインスタレーションに設置される。この印象は、それぞれのオブジェに与えられる特有の古めかしさによっても強調される。科学技術の時代を越えて神話の世界、飛行がまだ人類の夢であった時にまで溯ろうとするのか。古代のイカロスの夢をもう一度呼び覚まそうとする中で、パナマレンコは彼個人の神話を実現しようとしているのである。

観る者にとっては、彼の飛行オブジェが空中に浮き上がるという空想だけでもう充分なのに、今度はそれが凧となって実際に空に揚がろうとしているのである。おもしろい幻想と現実が混り合うのだ。窓ガラス越しに見るように、ガラスのように透明な絵を通して見る。ガラス張りの丸天井を通して太陽の光が射し込んでくる。はち切れんばかりの気球が凧をつり上げ、ゴンドラを持ち上げているザイルは本当の凧の糸目と複雑に重なりあっている。一人乗りの人力飛行機は、今度ばかりは心地よい一回きりの飛行に成功し、上へ上へと飛んでいくことであろう。

The Aeromodeller Kite
Digital image processing electro-static
reproduction 'Color D.I.P.S'
Senka-Ika 164 × 117 cm
Kite-makers: N. Yoshizumi, T. Okajima, S. Okawauchi

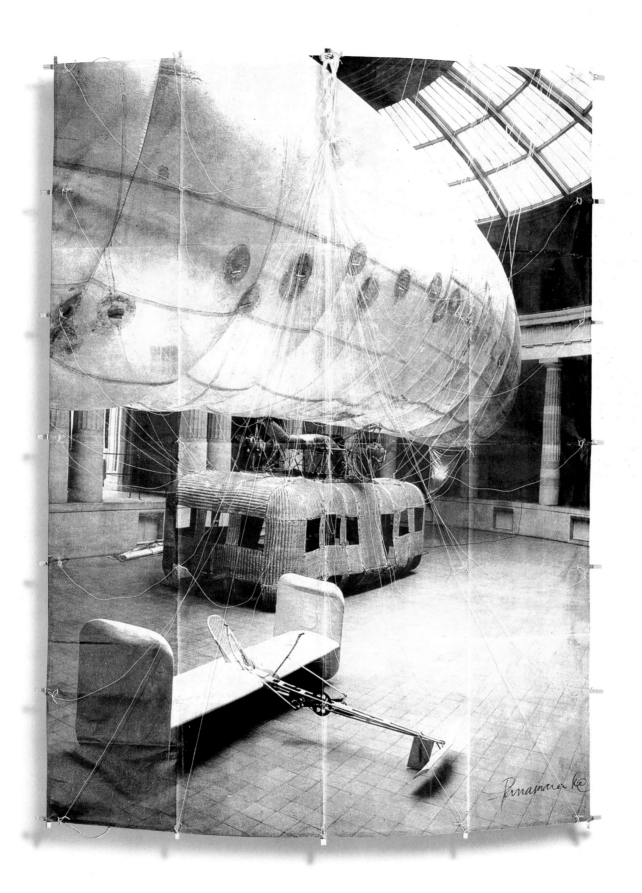

Kite-maker Nobuhiko Yoshizumi fastens
strings to Panamarenko's Aeromodeller Kite.
凧の製作者吉積信彦がパナマレンコの「飛行船凧」に糸目をつける。

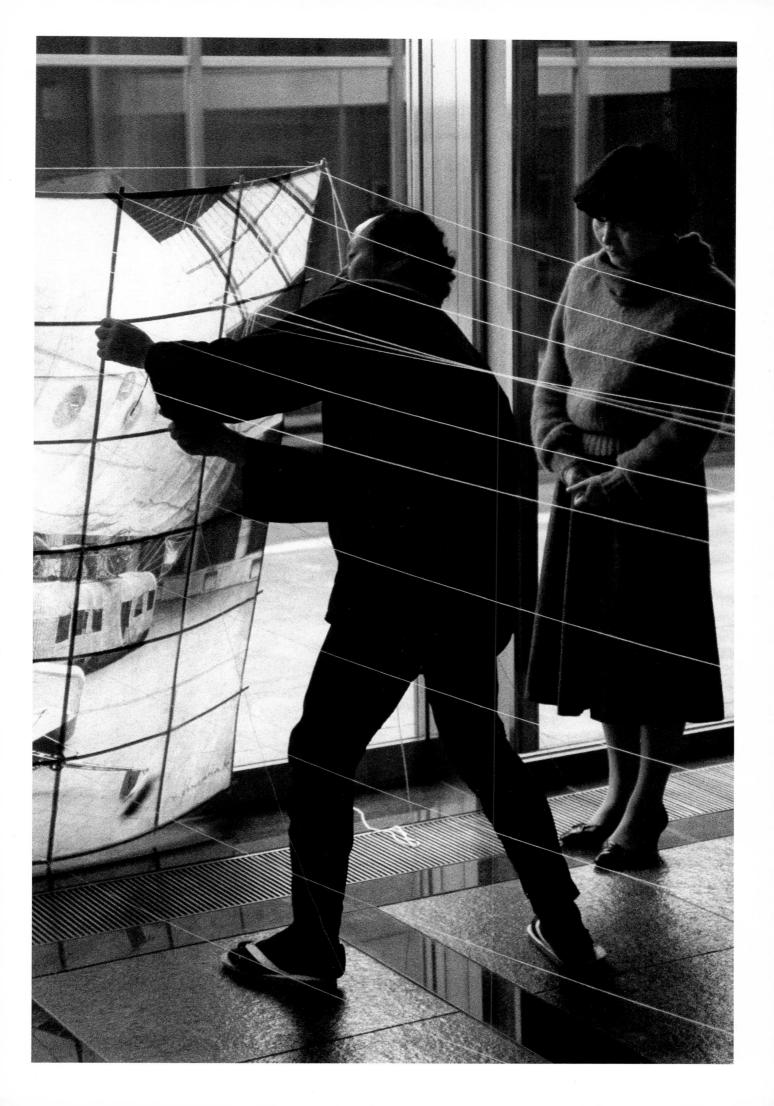

Zvi Goldstein

Born 1947 in Cluj, Rumania,
lives in Jerusalem

FUNCTION, PROGRESS AND UNIVERSALISM IN THE THIRD WORLD!

Goldstein was born in Rumania, lived in Israel until 1958, and spent the 1960s in Italy, where he came into contact with Conceptual Art. Since then, his work has centered around written axiomatic expressions. In his placard and signboard-like works, which have the air of utopian visions, he incorporates objects such as pipes, funnels, rails, and desks painted in the basic colors of De Stijl. In their impersonal, technical form they suggest space travel, rockets or electronics, and their style seems rooted in Russian Constructivism. The overall impression in his installations is of industrial fairs or research laboratories; the objects seem to be usable but exactly how is not clear. Everything has a model-like quality.

The observer scans his texts in vain for an explanation, only to discover more emphatic proclamations in bold-faced type that read like slogans from political manifestos. The texts agitate, the Third World being the central theme.

In his endeavour to develop a new language of art for the Third World, free of Euro-centrism, Goldstein's ideological work draws on Austrian-born British philosopher Karl Popper and his model of the three worlds: the world of objects, the world of consciousness and a third world as a realm of theories, hypotheses and models.

In this sense, art is for Goldstein the method to develop ideas in a principled manner. His utopian models represent an attempt at a political language of art for the future.

機能と進歩と普遍主義を第三世界に

ルーマニア生まれのツヴィ・ゴルトシュタインは1958年以来イスラエルに住んでいる。70年代をイタリアで過ごし、そこでコンセプト・アートに出会う。この時から彼の作品は文字による命題とかかわりをもつようになる。これらは短い文章としてインスタレーションの構成の一部になっている。告示効果のある図や掲示された文章と、管状のもの、じょうご、レール、台架、机などのオブジェが、ユートピア的な感じを与えるデ・スティルの地色の中に描かれ組み合わされている。非人格化された工学的なそれらのかたちは、宇宙飛行、ロケットあるいはエレクトロニクスを暗示し、その様式はロシア構成主義を下地にしている。このようなインスタレーションは産業博覧会や試験場を思わせる。オブジェには、その用途ははっきりしないものの、いかにも機能性と使用法があるかのように思える。しかし、すべて見本のような性格のものでしかない。

テキストの中に何か説明はないかと探してみても無駄である。太字の大見出しで書かれた力のこもった宣言文にぶつかるだけで、政治的内容のスローガンや概念が作品の中に組み込まれている。文章は扇動的で、中心になるテーマは第三世界である。

ツヴィ・ゴルトシュタインは、ヨーロッパ中心主義から脱却した第三世界のための新しい美術言語を求め、政治思想を表わす彼の作品の中で理論家カール・ポッパーの思想とその三つの世界のモデルを引き合いに出している。彼の三つの世界とは、物理的な物の世界、意識の世界、そして第三の世界としての理論と仮説とモデルの世界である。

このような意味で、ツヴィ・ゴルトシュタインにとって芸術は理念を原則に従って展開させる手段なのである。彼のユートピア的モデルは本来の政治的な一芸術言語の連結管なのである。

Function, Progress and Universalism in the Third World.
Dye
Edo kite 160 × 110 cm
Kite-maker: M. Yamaguchi

Test flight in Itami
伊丹での試験飛行

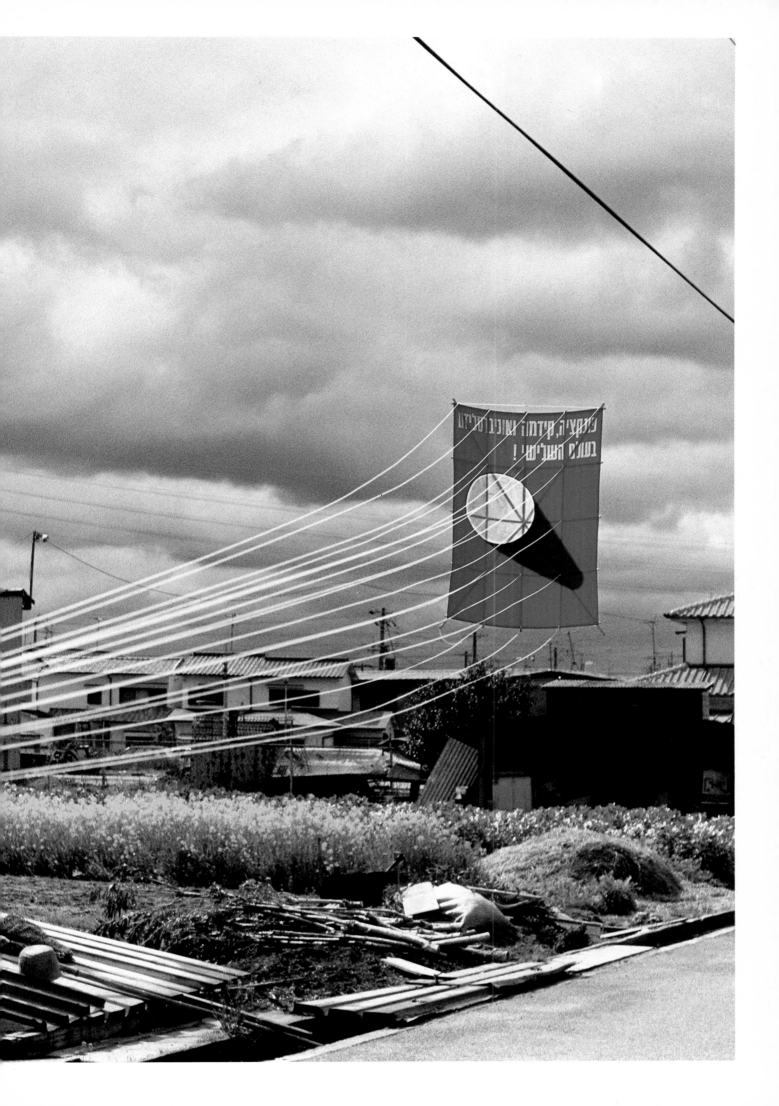

Emil Schumacher

Born 1912 in Hagen,
lives in Hagen

A man who Theodor Adorno contends is the most important living German artist, Schumacher is a master of Abstract Expressionism, "a true German who follows his own path with boldness." "Philosophy and literature", asserts the painter, "have shaped, mobilized and formed me. From out of conscious experience comes my work".

Schumacher's paintings are often described as landscapes, or as views of the earth's interior. The painter applies colors in a manner analogous to peeling off the earth's crust, ever driven by an urge to find out what hidden vistas can be revealed through the use of his materials. He doesn't work parallel to Nature as did Cézanne, but like Nature, mirroring the processes of growth, selection and destruction. Although his paintings are abstract, they always retain a link with the concrete. "The sensibility inherent in my work is always consistent with natural phenomena." Nature serves as a starting point, a source of inspiration and a whole to which his art returns and becomes a part of.

Characteristic of his paintings, which give the impression of having been baked in a melting furnace, is the combination of graphic movement and artistic texture. Earth-colored landscapes or fiery red streams of lava are interpenetrated by calligraphic symbols. Variations of forms such as hills, triangles and vaulting arches course through the painting surface like veins. Linear and multi-dimensional artistic forms come together in a tense balance, the author's signature itself becoming an important element of the work.

Although "The earth is nearer that the stars", Emil Schumacher was fascinated by the idea of creating art for the sky. He chose the kerori as his kite form and invested it with a mystery in which one is meant to perceive the shape of a dragon. (In German "dragon" and "kite" are homonyms, "Drachen".) The mountain silhouette is something of a tribute to the tradition of East Asian water-color painting, and the contrast of painted and unpainted areas vividly highlights the structure and color of the handmade Japanese paper (washi).

ドイツ抽象表現主義の大家エミール・シューマッハーは「真摯に自分の道を歩む典型的なドイツ人」である。テオドール・W・アドルノは、彼を現存の最も重要なドイツの芸術家であると評価している。また画家自身はこう語っている。「哲学と文学に私は陶冶され磨かれる。そしてその間に蓄積されたものと意識的な体験から作品が生まれ出るのだ。」

シューマッハーの絵は、しばしば「風景画」、大地の「世界の内側の絵」とみなされている。画家は素材に傷をつけることによって何が見えてくるかを知るため、あたかも大地の年輪を折りとるように塗った絵の具を堀りかえす。彼はセザンヌのように「自然の流れに添って」仕事をするのではなく「自然界のように」仕事をする。自然の成長を絵画にとり入れ、選び出し、自然が破壊をもたらすように絵画の中で破壊を表現する。彼の絵画は抽象的ではあるが、常に具体的なものと関連をもっている。「私の感性の世界は自然の事象に適合する。」自然は彼に絵を描くきっかけを与え、インスピレーションの源となる。彼の芸術そのものがついには自然の一部となるのである。

あたかも溶解炉から流れ出たかのような印象を与える彼の絵画の特徴は、グラフィック的な動きと絵画的な構成がうまく嚙み合っている点にある。土色の風景や真赤な溶岩流の間をほとんど書道のような図形が貫通している。丘や三角、アーチのような単純なフォルムを血管のように色の面が貫いているのだ。線のかたちと絵画的なものが緊張に満ちた均整を保ち、画家のサインも絵画の構成要素となっている。「線の描く道を絵の力が支配し、絵画の度量はそれで決まるのだ。」

「大地が星より近い存在」であるのは明らかだが、空に絵を描くというアイディアが彼を魅了した。そしてシューマッハーは神秘的な形のケロリ凧を選んだ。竜の姿かあるいは伝説の動物のようでもある秘密めいた記号を描いてシューマッハーのアート・カイトとしている。シルエットになって描写されている風景は東洋の水墨画に対する敬意のあらわれであろうか。囲まれたり、締め出されたりしている無彩色の面によって手漉き和紙本来の生きた構造と色合いが絵の内容を息づかせている。

Heaven and Earth
Acrylic 115 × 210 cm
Kerori kite
Kite-maker: T. Kashima

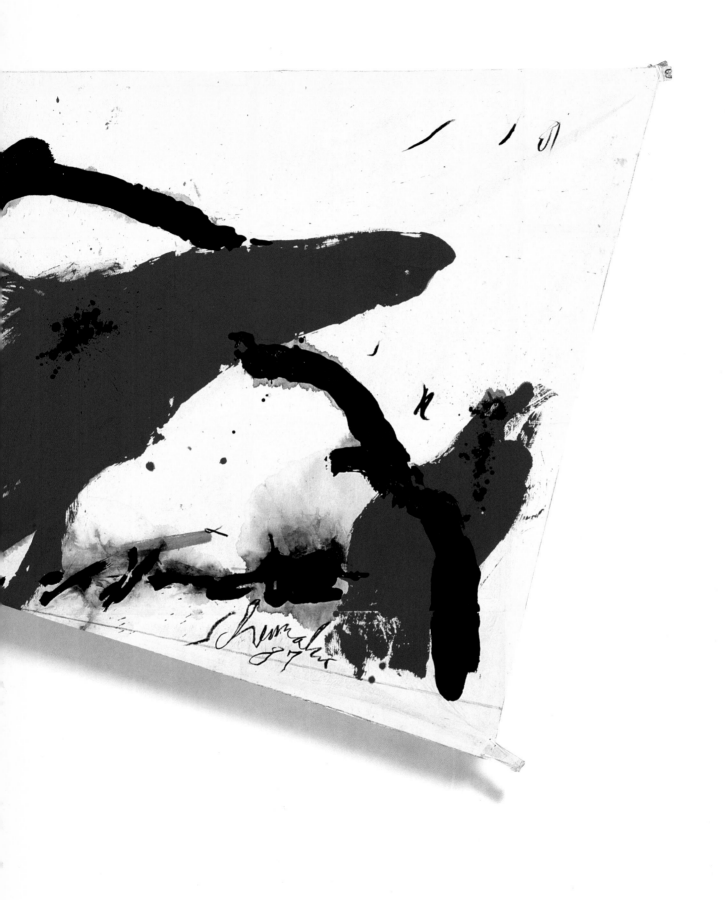

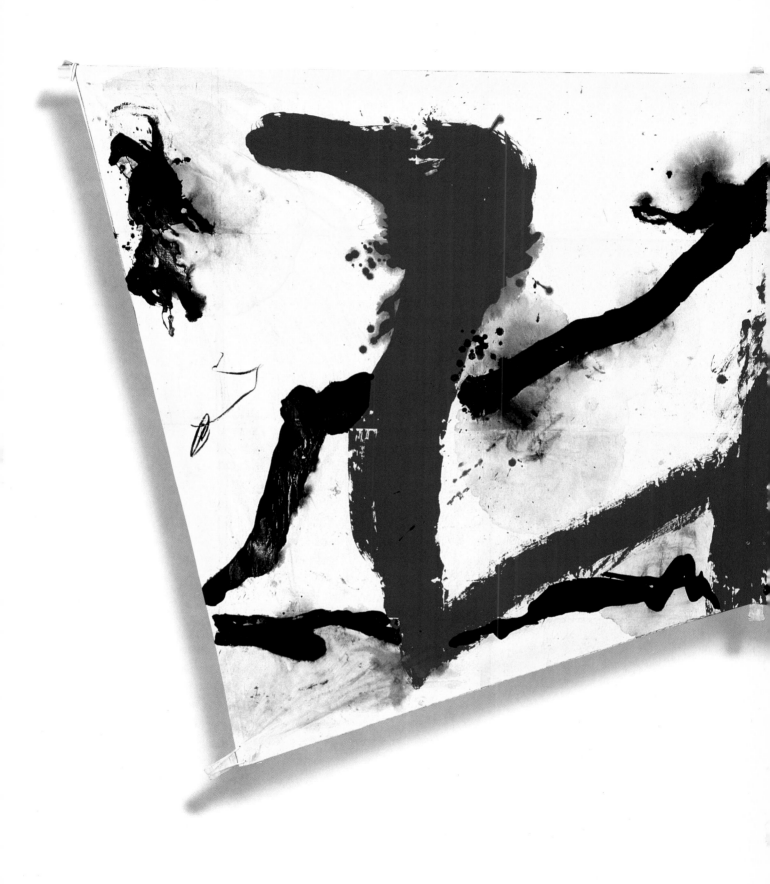

Bruno Ceccobelli

Born 1952 in Montecastello, Perugia,
lives in Rome

As part of the young generation of Italian painters, Ceccobelli has assimilated the influence of Abstract Expressionism, Conceptual Art and arte povera. He feels particularly close to the work of Marcel Duchamps, his own paintings swinging between abstraction and Realism.

Highly evident in Ceccobelli's pieces is a preference for dark colors. "Black is the color of the internal, the inward and, as such, is complete. Black is my raw material. With it I can make the symbols which embody my ideas and my feelings. From out of black one can pull real illusions as though from out of a magician's hat. Light can only become visible out of darkness. My love of black has something to do with my love of meditative paintings."

The round shape of the wanwan kite, representing Ceccobelli's conception of the anima, has been transformed into a mandala. In Buddhist iconography the black footprints represent the passage of Buddha "I hope to go to Heaven soon and, while I am dreaming, I send you a greeting from above".

ブルーノ・チェコベリは最も若いイタリアの画家世代に属し、抽象的表現主義、コンセプト・アート及びアルテ・ポーヴェラの影響を受け、消化して独自のものをつくり上げている。彼はデュシャンの作品と深い繋がりをもっていると感じていて、その絵画は抽象と現実との間を漂っている。暗い色を好んで用いるのが目立つ。「黒は内側の色、内部の色であり、色として完成している。黒は私の生のマテリアルであり、そこには私のアイディアや感情を具現化する独特の記号を置くことができる。黒からは、魔術師の帽子のように現実の幻影を引き出すことが出来る。光は闇によってのみ目に見えるものとなる。私が黒を好むのは、私が瞑想的な絵が好きだということとも何か関連があるのかも知れない。」

彼は丸い形のわんわん凧をアート・カイトに選び、マンダラの絵に変形させている。この形は彼にとって「アニマ」のコンセプトを表わしている。仏像学はこの黒色の足跡を「仏足跡」として用いている。

やがて空に舞い上がり、「あなたにごあいさつすることを夢みながら……」空に立って上から見下ろそうとするのか。

Standing upon the Sky
Mixed media
Wanwan kite 220 × 230 cm
Kite-maker: U. Fujinaka

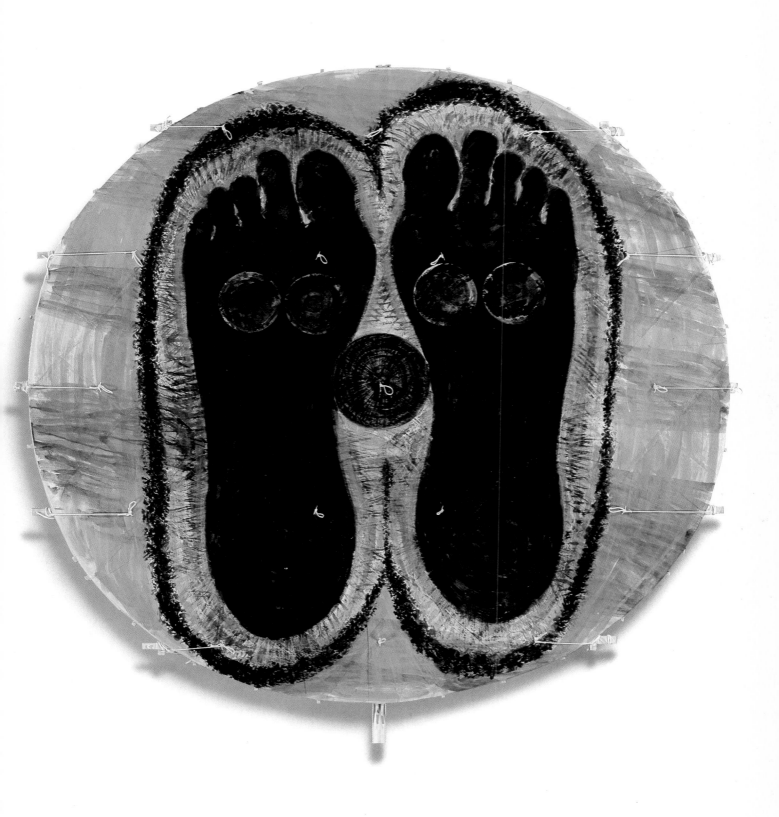

Kite-maker Umeo Fujinaka fastens the strings on
Ceccobelli's wanwan kite

ブルーノ・チェコベリのわんわん凧に糸目をつける凧師 藤中梅雄

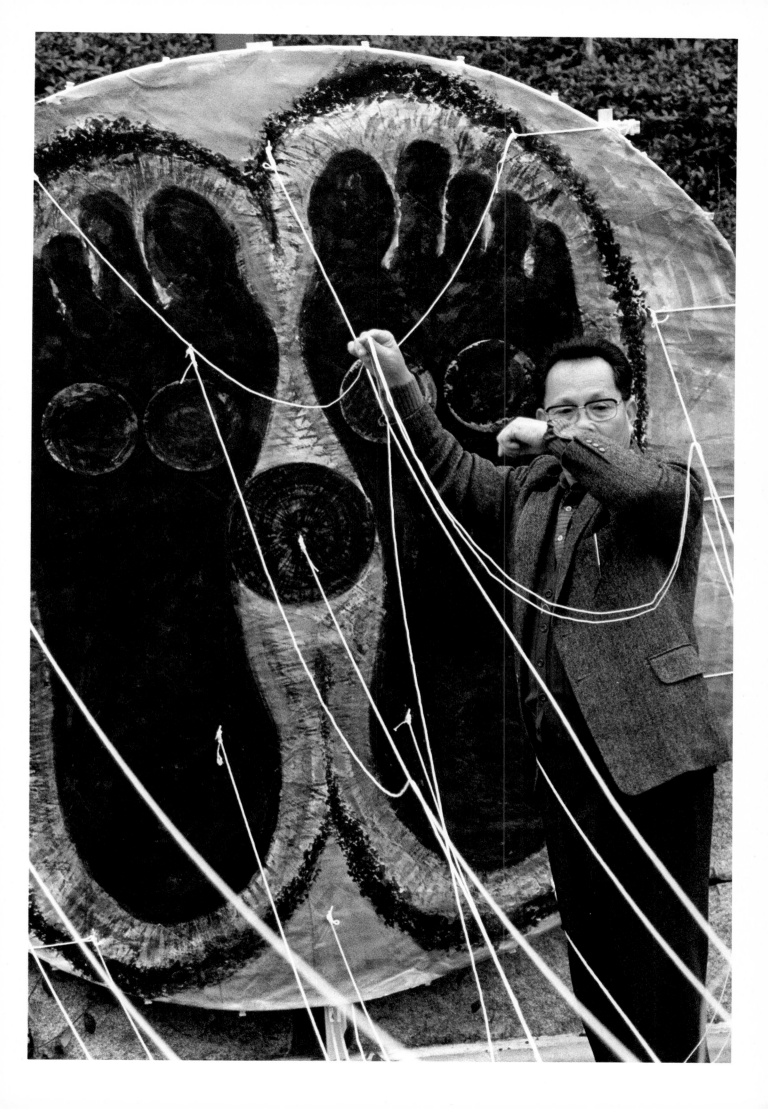

James Brown

Born 1951 in Los Angeles,
lives in New York

With an art training background that includes the Immaculate Heart College in Hollywood, the Ecole Supérieure des Beaux Arts in Paris, and the Istituto Michelangelo in Florence, Brown somewhat surprisingly creates works suggestive of prehistoric cave paintings replete with primitive markings, thin lines, crude, ritualistic objects and totem poles etched into dark backgrounds.

In Brown's kite, two symbols enter the kerori shape from the outside, projecting onto the dull, dry, earth-color paint like random objects with uncertain origins, unknown meaning and no relation even to each other. This leads the observer to think they are seeing only a small part of a larger whole.

One can imagine Brown's kite being flown only at dusk, to cavort with bats and other strange, nocturnal creatures.

ジェームズ・ブラウンは、ハリウッドのイマキュレート・ハート・カレッジ、パリの私立芸術大学、フローレンスのインスティトゥート・ミケランジェロで学んだ。

彼の絵画は、先史時代の洞窟壁画を思わせる。そこには原始記号、細い線、粗野な祭器やトーテムポールなどが、全体を暗く塗った画面に、ひっかいたように描かれている。

ケロリ凧のそのたぐいまれな形が、彼を特に魅了した。全体を鈍く、乾いた土色でおおい、その平面に外側から二つの記号が突き出ている。この記号は、ずっと前からそこにあったように見えるが、由来も意味も説明し難く、相互関係もないようだ。この絵は数多くある絵の一部であり、その中の二つの記号が、もともと絵画の中心として意図されたものではないということを示している。眼ははっきりしない平面をさまよい、更に示唆を求めてゆく。そして好奇心は、この絵の横にある作品に向けられるのである。

この重たい土色の凧が、空に揚がるのを想像するのは難しい。敢えてするとすれば、コウモリと夜鳥が気がねなく姿を見せる夜明け前であろうか。

James Brown Art Kite
Acrylic 112 × 209 cm
Kerori kite
Kite-maker: T. Kashima

Akira Kurosaki

Born 1937 in Talien, Manchuria,
lives in Kyoto

As a young art student Kurosaki one day fortuitously came into contact with the rich tradition of the polychrome ukiyo-e woodblock print:

"As I stood surrounded by splendid art pieces, my gaze fell upon one singularly fascinating ukiyoe-e print. Somehow overlooked or unrecognized, it was evidently a precious original, bright and beautiful, done on washi, with a Japanese nature scene depicted in exquisite detail. Captivated by its charm I left the old bookshop with print in hand . . . and more mystery than I could then imagine."

This fascination with woodblock prints has not abated since that formative experience. Working in close collaboration with an engraver and printer, Kurosaki has continued in the illustrious tradition of Utamaro, Hokusai, Kunisada and Kuniyoshi. Following some monochrome woodcuts came prints which required eight blocks, fifteen colors and seventy printing processes – contrasts between bright red and black being a dominating feature. In stage-like assemblages he has combined allegorical stairways, parts of the body and geometric figures along with impressions from visits to the United States and China!

In contrast to earlier prints, a new phase of greater subtlety and subdued coloration began in 1980 with his "Tracks" series. The brushstroke motif, which covers his paintings like flowing waves, has been varied in an enigmatic way in the art kite: the vortex of lines represents his enlarged fingerprint, which he plans to officially register in the sky.

若い美術学生であった黒崎彰と日本の純粋な伝統芸術、多色彩りの浮世絵との出会いは、彼にとって決定的な一瞬となったことであろう。

「ある古本屋の店先で、たくさんの豪華な美術書に混ってあった一枚の浮世絵が私の目に焼きついた。無造作に放り出されていたその一枚が実は浮世絵のオリジナルであった。輝かしく美しく、何と和紙を使い、しかも日本の自然をこの小さい画面に密に取り入れているのだ。たった一枚のこの紙のとりこになって、私はその古本屋から出たが、手の中はこの紙の不思議さで満たされていた。」

この時以来、この作家は木版画に魅了されてしまっている。彫師、摺師との密な共同作業により、歌麿、北斎、国政、国芳等の輝かしい伝統を継承しているのである。初期の頃のモノクローム版画に続いて、その後は8版15色70度摺りという複雑な技巧を駆使するまでに至っている。鮮烈な赤と黒を対比させそれを基調になる色としていた。舞台上のような場面にアレゴリー風の階段、人体の部分や幾何学的な物体を組み合わせ、形象描写がなされているが、その版画はしばしば、一つのアンサンブルにまとめられている。北アメリカや中国旅行の印象が制作上の契機になり、次期の作品につながっている。

色彩豊かな版画と並行して、1980年以後、黒崎彰は緻密で色調を抑えた「軌跡」のシリーズを制作している。今回のアート・カイトの作品は、それ以後の面全体に浮ぶように広がっている波型の筆跡のモチーフが応用してつくられた。渦巻形の指紋の線を思い切り拡大して摺り、黒崎彰は大空に署名しようとしているのである。「凧が舞い上がる大空に、様々の望みを込めて私のしるしを押し署名すること。それは凧と共に版が作る始源的な造形の発想ともいえよう。」

Signature in the Sky
Woodblock printing, Japanese black ink,
persimmon dye, chine-collé
Edo kite 208 × 140 cm
Kite-maker: T. Uno

Günther Uecker

Born 1930 in Wendorf, Mecklenburg,
lives in Düsseldorf

Uecker first gained international recognition with his "nail sculptures": white-painted boards with innumerable nails hammered in circles, spirals, whirls and rows. Columns, chairs, tables and even TV sets have also received his nail treatment, not to mention violins, chests of drawers, a concert grand piano and other "fetishes of our culture". Akin to Lucio Fontana's perforations and cuttings, or Arman's assemblages, these nail sculptures awake our perceptions with their use of unconventional and provocative materials.

Whatever holds true for Uecker's nail reliefs in terms of structure, rhythm and shading can also be said about his paintings. What he achieves in the first case by varying the angles of the protruding nails he realizes in the other through the use of points and lines. This produces an effect of lively movement, so much so that these paintings are called "Optical scores".

Uecker's art kite arises from this same body of work. A whirl-like black and white pattern – suggestive of iron filings in a magnetic field – unwinds over the rigid geometrical frame of the bamboo rods visible from behind the washi. To further extend the whirl effect, black ribbons have been attached to points all over the kite.

When in flight, these flutter in the wind as if a burst of energy were emanating from deep inside the kite, or as if a comet where trailing a tail of meteorites.

In the 1960s Uecker was a member of the ZERO group which regarded light phenomena as the source of, and most significant element in, all painting. In its play between light and shadow, movement and rest, his kite conveys an ever-varying series of visual impressions. It is an optical pyrotechnic show, a kinetic flying sculpture created from a bare minimum of materials.

ギュンター・ユッカーは、釘の彫刻で世界に名を広めた。白く塗った木の板に無数の釘を、円形に、螺旋状に、渦巻き状に、あるいは列に並べて打ち込むのである。柱や椅子やテーブルやテレビにも打った。それだけでなく、ヴァイオリンや戸棚やコンサート用グランドピアノ、その他諸々の「文明の呪物」にも、縦横無尽に釘を打ち続けた。彼の釘の彫刻は、ルチオ・フォンタナの画面に孔を穿けたり画面を切り裂く行為や、あるいは、アルマンのアサンブラージュと同じように、素材に思いきった攻撃を加え、そこに起こる現象を通して視覚を鋭敏に呼び覚まそうとしたのである。

釘のレリーフの場合と同じように彫刻においても、ユッカーにとって大切なのは、構成とリズムと光の微妙な動きである。彫刻作品で釘を打ち込む角度を様々に変えることで得るものは、光による集中性、陰影、ダイナミックさの様々な変化の仕方であり、絵画においては、生き生きとした動きを作り出す点と線の構造で獲得している。彼はこれらの絵画を「光の総譜」と名付けた。

凧の絵も、これと同じような関連のもとに作られている。ユッカーは、厳格に幾何学的に組まれた背後の竹の格子が透けて見えるスクリーンの上に、光の渦巻きを引き起こす黒と白の色彩を走らせた。点の流れる様は、磁力に引っぱられる鉄粉を思い起こさせる。この渦巻きの動きの延長として、凧の周囲に黒いリボンが翻える。この黒いリボンは、まるで噴き上るように、絵の内側から湧き出るエネルギーを大気圏へ放出する役割を果たす。凧は空中では、後に長く尾をひき黒い彗星のように飛ぶであろう。

ユッカーが60年代に属していたグループ・ゼロが重視していたことは、光がすべての絵画の根源であり、最も大切なエレメントであり、光が絵画をいかに芸術的に形成させるかということであった。明と暗、光と影、静と動の戯れの中で、彼の凧は、まるで光の花火のような変化に富んだ視覚的印象を私たちに与えてくれることであろう。ユッカーのアート・カイトは、ごく少ない素材で作られたキネティックの飛ぶ彫刻である。

Crash
Slate, silk ribbons
Hamamatsu kite 160 × 160 cm
Kite-maker: Sumitaya

Rissa

Born 1938 in Rabenstein, Chemnitz,
lives in Wolfenacker (Westerwald)

A teacher since 1969 at the Düsseldorf Art College, Rissa creates art that is both representational and innovative. Unusual scenes are played out between objects – scenes which could conceivably occur in real life, but seem far better suited to the imaginary world of the painting surface. As Informel has used the accidental as a means of creating abstract forms, Rissa has tried to employ the accidental in her exploration of relations between objects, coordinating chance images in uncommon ways so as to produce associations which surprise and provoke. These conjured-up constellations of people and objects result in an alienation from the real world and a tension between clarity and mystery.

But while the intellectual basis of Rissa's painting is related to Informel, its appearance bears the markings of Cubism, the distinct contours of her brushstrokes splintering the painting surface into a quasi-prismatic segmentation. She is concerned, above all, with effective matchings of contrastive fields of color and the maintenance of a unified color ensemble. The result is often a peculiar coldness, as though "the brush had been dipped in prussic acid".

Barring the highly-differentiated coloration of the scorpion's body parts, Rissa's art kite shows an essentially uncomplex surface structuring. Micro and macroforms interpenetrate one another, while the discontinuance of color reinforces the enigmatic quality of the subject. The bamboo frame showing through from the reverse side has been integrated into the work's composition (in the unpainted diagonal between the blue circle segment and the human profile), thereby generating a sense of three-dimensionality, in which shifting light throws the otherwise rigid painting structure into fluid movement.

女流画家リサは1969年以来、デュッセルドルフ芸術大学の教授でもある。その絵画は具象的で作意的である。彼女は、絵の中で稀有な対象物を取り合わせ、型破りなストーリーを展開させ、描写している。その物たちの出会いは、現実に起りうる普通のものであったり、あるいは絵画の世界でのみ実現しうるものであったりする。アンフォルメルが偶然を抽象的なフォルムの形成の材料として制作の一環に組み入れているとすれば、リサは、絵画イメージの中で、具象的な物どうしが相対関係に達する時、偶然を取り入れている。ここで彼女は非凡な方法で、偶然の可視的思いつきを加え、組み合わせている。このようにして思いがけない内容のかかわりが生じることになる。このような人と物という作意的な組み合せは、現実の世界では違和感を生じさせて、同時に明解さと不可解さの間に緊張感を生じさせる。

リサは絵画理念においてアンフォルメルの影響を受けている一方、キュービスムにも烈しく取り組んでいる。本来、輪郭をつけるために行う筆使いから、まるでプリズムのような表面の分割が展開している。ここで彼女が興味をもつのは、特に、絵の中の色のアンサンブルに見られる色と色の組み合わせと、明確な色調の保持である。リサの絵はしばしば、ある種の冷たさを持っている。「あたかも彼女が絵筆を青酸カリに浸して使うように。」

リサは、アート・カイトの場合も、色構成による面の分割を行い、さそりの体の部分部分をみごとに細分化し描写している。ミクロとマクロが互いに交錯しているようである。真ん中の無彩色の部分は神秘的な作品内容を意味している。また、彼女が、青い円形の部分と人の顔の間を広い斜めの巾で色を塗らずに残しているのは、竹骨の格子を作品の構成に取り入れているからで、こうして巧みに作品に立体感を与えている。しかもいろいろな方向からの光の当り方によって、不動のはずの絵の構成が動き出すようにさえ見えるのである。

The Kiss
Poster color 160 × 160 cm
Hamamatsu kite
Kite-maker: Sumitaya

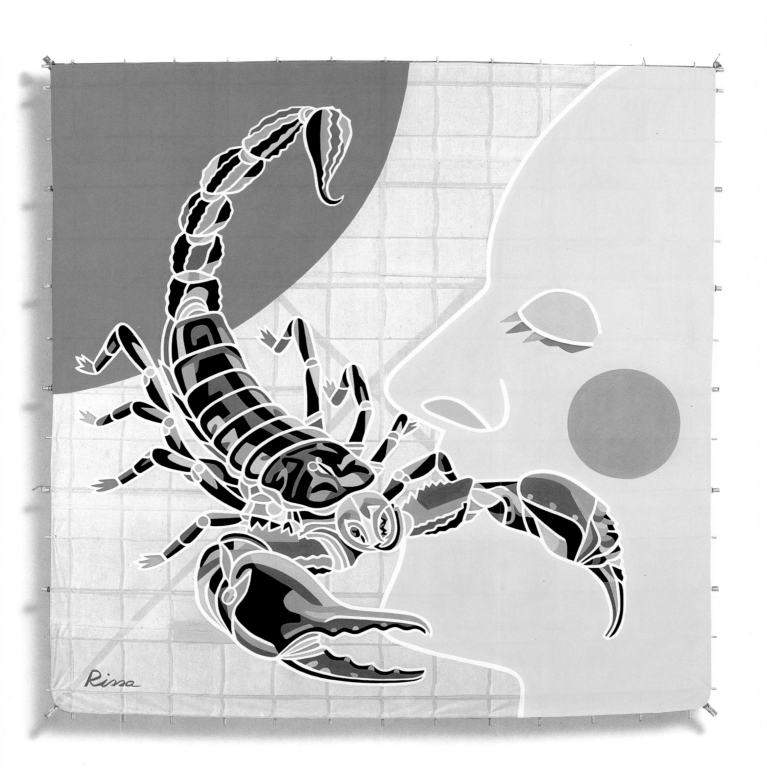

Several artists painted directly on a kite form. Shown here is Rissa in her studio in Wolfenacker, Westerwald.

ドイツでも何人かの芸術家が白張りの完成した浜松凧に直接絵を描いた。
リサもその一人。ケルン近郊のアトリエにて。

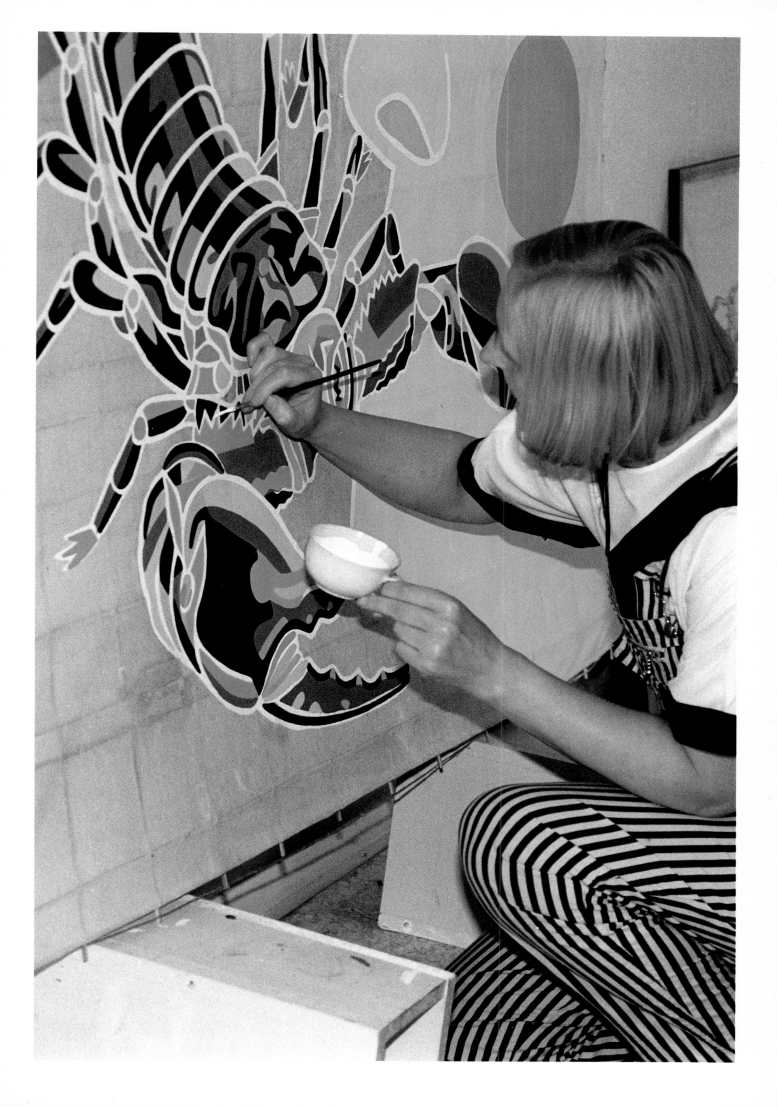

Per Kirkeby

Born 1938 in Copenhagen,
lives in Copenhagen, Laeso and Karlsruhe

Kirkeby's beginning was in collage – a selection of microcosmic excerpts of the world or little pieces of perception – all evolvable into a new reality. Later, he combined these fragments with ornamentation and line, frequently using compositional structures (which he terms "architechtones"), such as landscape figures, trees and caves.

Kirkeby works with a variety of motifs, some of which are hazily veiled over while others become simplified beyond recognition. These images function as a "synthetic memory", or a guide to the painting process – closer to subconscious structures than extracts of reality. They have been called "forms of forgetfulness" or "memory matrices".

Like a landscape momentarily illuminated by a flash of lightning, the fragments appear disjointed. Only through the recognition of their inter-relatedness and mutual associations can a coherent picture be perceived.

However, neither figurative nor abstract, narrative nor conceptual, Kirkeby's paintings are not involved with reconstructing reality. Instead, the observer is transported into a hypersensitive, contemplative and somewhat vague mental state – a condition that has come to be called the "Kirkeby Effect".

Kirkeby did not give a title to his kite but he wrote that "Breeze" might be appropriate. The painting's restrained use of pigment leads one to think of drypoint copper plates, across which the artist has engraved layers of memories, as if in a diary.

ペル・キルケビイはその仕事をコラージュで始めた。縮小された現実世界の引用、知覚の断片から彼は一つの新しい真相をつくり出した。後に彼は現実世界の断片に装飾や線などを組み合わせている。彼がしばしば用いた組み合わせの要素（キルケビイはこれを構成体、あるいはモチーフと呼んでいる）は、風景の中の像、木、洞穴などである。しかし、このモチーフを個々にとらえると、ベールにつつまれたようにとりとめなく、モチーフの根拠だけに凝縮されていたり、モチーフそのものは脱落してしまってネガの印象だけが残るよう表わされている。モチーフは「統合の記憶」、すなわち絵画の制作過程の導き手として機能する。それは現実世界の引用というより、むしろ意識にのぼらない記憶の組み合わせか印象の複製であり、「忘却の形態」と呼ばれる。「謄写原紙に書き残された記憶」のようであろうか。観る者は、最初、これらの断片を突然稲妻によって照らし出された風景を見る時のように相互の関連なくとらえてしまう。そして個々のものの網目のような繋がりが認められ、連想による構成の推論が成立してようやくあるべき画像がまとまってくる。しかし、ここでは現実世界の再構成が重要なのではない。キルケビイの絵画は具象的でもなければ抽象的でもなく、叙述的でも観念的でもない。彼の絵画は、観る者の連想をある空間・時間の連続体へと結びつける官能的感覚を呼び覚ます。これは、過度に敏感で物思いに沈んだ、そして少しもうろうとした現象であるが、かつて「キルケビイ作用」という概念で表現されたこのような精神状態に、観る者は陥ってしまうのである。

「この凧の絵にタイトルはない。」とキルケビイは書いているが、例えば「そよ風」というタイトルも悪くないかもしれない。色彩を抑制したこの絵はドライポイント銅版を思い起こさせる。芸術家はここに心の内を記す日記のように様々の記憶の層を刻んでいったのであろうか。

Breeze
Charcoal, pencil, Japanese black ink
Hamamatsu kite 208 × 208 cm
Kite-maker: Sumitaya

Karl Otto Götz

Born 1914 in Aachen,
lives in Wolfenacker, Westerwald

A member of the COBRA Group since 1948 and a teacher at the Düsseldorf Art Academy from 1959 to 1975, self-taught Götz began with simply painting on photographs. Then, experimenting with stencils, he produced sprayed-on pictures. This was followed by his unique "air-pump paintings", which involved spraying liquid colors onto the surface of the canvas, then painting over by hand.

Over time Götz's paintings have acquired an array of symbols, owing to things called "black rhythms" – construction principles he has written down in his own private "structural primer".

Close contact with composers led him to divide painting into motifs, themes and variations. One day in 1952, while mixing colors for his young son, he accidentally discovered a way of achieving his ideal of superimposition, penetration and metamorphosis. Quickly working gouache into wet paste (positive), stripping off the color with a knife or trowel (negative) and finally drawing over the still wet surface with a dry brush, he was able to make a huge breakthrough, both artistically and technically. A period of intense concentration precedes the actual paintings, then the artist completes all three stages rapidly.

"In my case, spontaneity is a means to an end, a means to develop new forms or, as it were, dissolution. And in my case this means speed . . . speed as a means, not as a final goal. I follow the old axiom of the Surrealists: grasp the wonder of creation through psychological spontaneity and paroxysms".

The mastery with which Götz commands his artistic forms is evident in his three kites: an Edo, a kerori and a Hamamatsu fighting kite. On paper – especially on absorbent washi – no corrections are possible. The spontaneous act leads at once to an unalterable result.

カール・オットー・ゲッツは初期の作品を独学によって展開させていった。彼の仕事は、シネマトグラフィックな絵画や、ステンシルを使う「吹き付け画」で始まっている。「空気ポンプ」画法は、液状の絵の具を空気ポンプでカンヴァスの上に流して広げ、描いていくというものであった。ゲッツは1948年以来、コブラ・グループに加わり、1959年から1975年まで、デュッセルドルフ芸術大学の教授でもあった。

「黒いリズム」については、彼が「構成の入門書」の中にも書いているが、50年代になると絵画の表現が多義的な重心を伴うリズム化された色彩記号となった。

同時代の作曲家との親交や音楽家たちの組織や催し物に対する関心により彼の絵画は「モチーフ」、「テーマ」、そして「ヴァリエーション」の要素によって構成されるようになっていった。1952年の終りには重なり、浸透、変成というイメージを具現化すべき絵画上、技術上の鍵となる体験をすることになる。幼い息子のために糊状の絵の具を混ぜていて出会った発見がそれである。まず糊でキャンバスに地塗りをしそれがまだ湿っているうちに素早くグワッシュを重ねる（ポジ）。 次に絵の具をナイフかヘラ状のもので剝しとり、最後に乾いた筆で湿った部分に描き込んでいくというやり方である。このような絵は高度な集中力が先行して、何秒かのうちに迅速にできるものであるが、コントロールも含めて例の三段階のプロセスを経て制作される。ゲッツはこのような方法を見つけ出し、それをもとに常に新しい表現の仕方を展開させていった。一瞬にしてでき上るという描画過程が、同時に絵画構成を支配することにもなった。

「私の場合、自発性が、新しいフォルムをつくり出し、さらに次の新しいフォルムのためにそれを解体していくための手段になった。そして、私の場合は自発性が迅速性であった。迅速性は手段であるが、最終的な目的ではない。私はシュールレアリストたちのかの綱領を守ったのだ。すなわち、精神的な自発性と衝動によって創作中に奇跡をつかむのだ。」

ゲッツは浜松凧、大江戸凧、そしてケロリ凧の三枚の絵を描いたが、そのどれにも、なんとすばらしい技でフォルムの絵画言語が駆使されていることか。吸湿性に富んだ和紙は、どんなことがあろうともやり直しがきかない。直感的な動作がそのまま絵の出来ばえになるのだ。

「芸術を天に描く」という着想の魅力はゲッツの芸術思想からそうかけ離れたものではない。そのカリグラフィック的な絵画は、記号の性格をもち、距離をおいて見ても、簡潔にして含蓄に富んでいる。このような絵画的記号は日本の多くの伝統凧の図柄にもなっている。特に町どうし、村どうしのけん凧に使われるものは文字と文字が空中で合戦するのだ。

Untitled
Casein 160 × 160 cm
Hamamatsu kite
Kite-maker: Sumitaya

Untitled
Casein
Kerori kite 193 × 366 cm
Kite-maker: T. Kashima

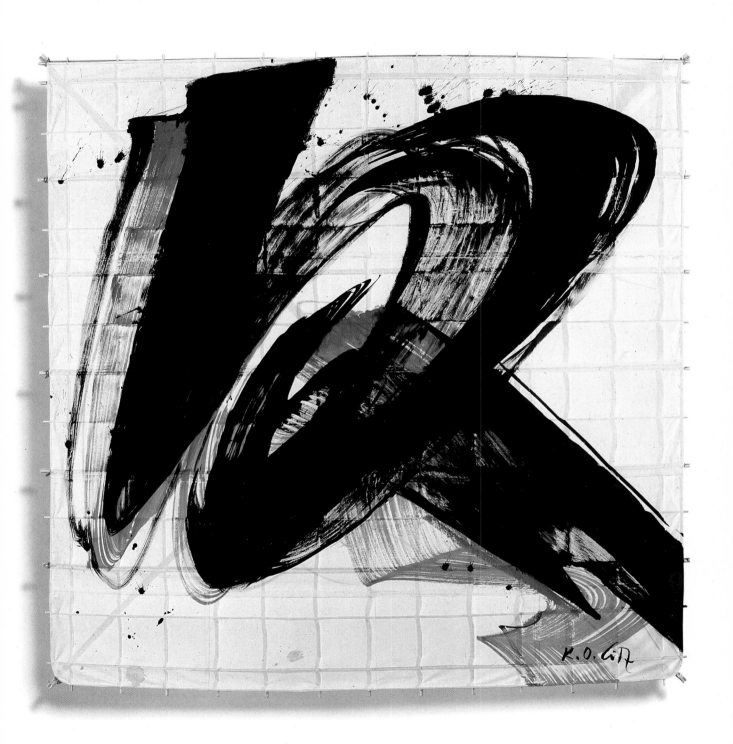

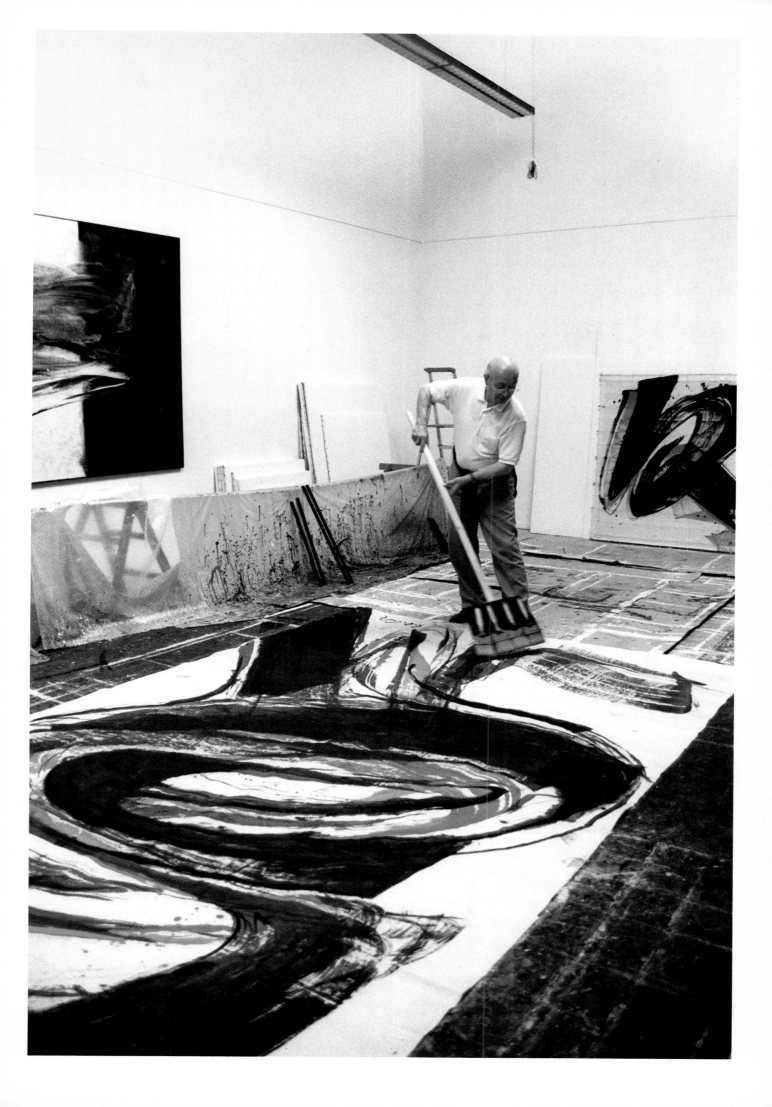

Michael Buthe

Born 1914 in Sonthofen, Allgäu,
lives in Cologne and Marrakech, Morocco

Decisive in Buthe's artistic development was a 1970 trip to Morocco. Out of his confrontation with North Africa's culture arose a style that, since Documenta 5 (Europe's most important avant-garde showcase), has been termed "self-mythologizing".

From a wide assortment of materials – peculiar objets trouvés, exotica, fetishes, daily use items, etc. – he has assembled installations which conjure up the magical and enchanting world of Oriental myths and fables. Even his very act of creation has become part of the ritual, his atelier having been transformed into a pagan hall of worship, or a Shrine to Echnaton.

In Buthe's creative process traditional artistic genres coalesce. A subject for a drawing, for example, may become an actual part of the finished work. Objects are painted, bedecked with flowers, wrapped in colorful cloth and clamped together into sculptures. These sculptures all represent magical shrines with evocative names like "Homage to the Sun", "The God of Baby-lon", "Zarathustra" and "Homage to a Prince of Samar-kand".

Red, blue and gold are the basic colors of Buthe's œuvre, a body of work that, set against the predomi-nantly rational ethos of our times, offers an oasis of sensuousness full of mystery and magic.

ミヒャエル・ブーテにとって、1970年のモロッコへの旅が後の芸術展開に決定的な体験となる。北アフリカでの異文化との対決を通して、彼独自のスタイルをつくることになり、それは「ドクメンタ5」以来、「個人の神話」という概念で表現されるようになる。彼は、収得物やエキゾチックな小道具類、呪物、日用品などあらゆる素材を用いて、魔術的にしかも魅力的に、東洋の神話とメルヒェンの世界を呼び起こすような空間インスタレーションを創作している。彼の芸術の創造は聖なる儀式となり、アトリエは礼拝堂、エジプトのエシュナトン博物館のようになっている。

この創造の過程には、芸術のさまざまの伝統的なジャンルのものが一つの作品の中に区別なく融け合っている。素描画にオブジェを取り込んで作品にする。オブジェが彩色され、羽根をつけ、カラー布でくるまれ、かすがいで固定され、「太陽の賛歌」、「バビロンの神」、「ツァラトゥストラ」、「サマルカンドの王子への賛歌」のような詩情に満ちた題がつけられ、空間彫刻、神秘的な礼拝堂、神殿、聖域などに創りあげられていくのである。

赤と青と金色が彼の芸術の基本となる色で、それは合理性に根ざした今日の時代に魔力に満ちた感性のオアシスをよみがえらせているのである。

Fuji Love
Mixed media
Hamamatsu kite 160 × 160 cm
Kite-maker: Sumitaya

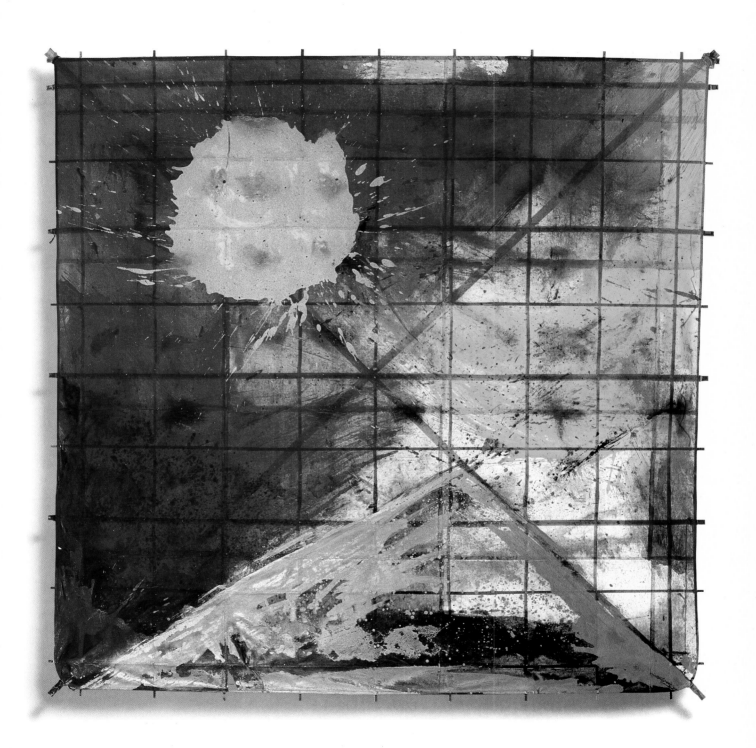

Lee U-fan

Born 1936 in Korea,
lives in Kamakura

韓国生まれの李禹煥は、1956年来、日本で画家、彫刻家、エッセイストとして活躍している。このように多くの分野で仕事をしながら、ヌーボー・レアリズムやアルテ・ポーヴェラに相当する60年代日本の「もの派」運動の精神的な支柱となって、ハイデッカー的存在論を参考にした理論家となった。この運動で特に好まれた素材は、土、石、木、鉄などである。

Living and working in Japan since 1956, Lee is a sculptor and essayist as well as painter, having been a spiritual founder and theoretician of the mono-ha movement of the 1960s. This Japanese equivalent of Nouveau Realisme and arte povera stressed the use of crude materials like earth, stone, wood and iron.

As a sculptor dealing in the ponderous, Lee creates installations that evoke an almost prehistoric era. Boulders are combined with massive iron sheets, or stones embedded in lumps of cotton – the contrasts creating a tension which somehow lends the whole a quasi-spiritual aura.

彫刻家としての李禹煥は、知性あふれた巨人である。例えば、太古を思わせるインスタレーションでは、どっしりした天然の岩石と、大きな人工の鉄板を組み合わせて設置し、作品にしている。あるいは綿の塊の中に石をねかせる。ものとものとの間に生まれる緊張感は作品を霊的アウラでとりまく、そんな関連性の中に表現を探っているのか。

As a painter, on the other hand, Lee is a sensitive lyricist, continuing the Oriental calligraphic tradition of reducing compositions to one color and one figure. For him color gradation is an important stylistic device, the texture changing with the progress of the stroke as the brush dries up.

画家としての李禹煥は、繊細な詩人でもある。彼の作品は、東洋の書道の伝統を湛え、創作手段を一つの色、一つのかたちだけに制限している。「様式上の重要な手段は、カンヴァスに一気に筆の跡をつけていく時、筆のかすれにより自然に生じる色のグラデーションである。彼の作品には「点より」、「線より」、「風より」という三つのタイトルがある。彼の凧の絵は、揺れ動いているタッチから「風より」に属する。

Lee's entire painted œuvre can be divided into three neat headings – "From Lines", "From Points" and "From the Wind" – with the art kite, naturally enough, belonging to the last.

The artist has written: "In calligraphy, points and lines attain completeness in themselves as points and lines; after creating the main form they still remain as isolated marks. In painting, on the other hand, points and lines exist in relation to space, and strive within that space to exercise influence".

「書道の点や線は、ほとんど点や線自体として自己完結化されたり、幾つかの単位にまとめられることによって、自己を閉ざすことを好む。絵画の点や線は、空間との関係のなかで成立され、どこまでも空間全体の強さとして自らを開示することを望む。」

Heaven
Japanese black ink 160 × 160 cm
Hamamatsu kite
Kite-maker: Sumitaya

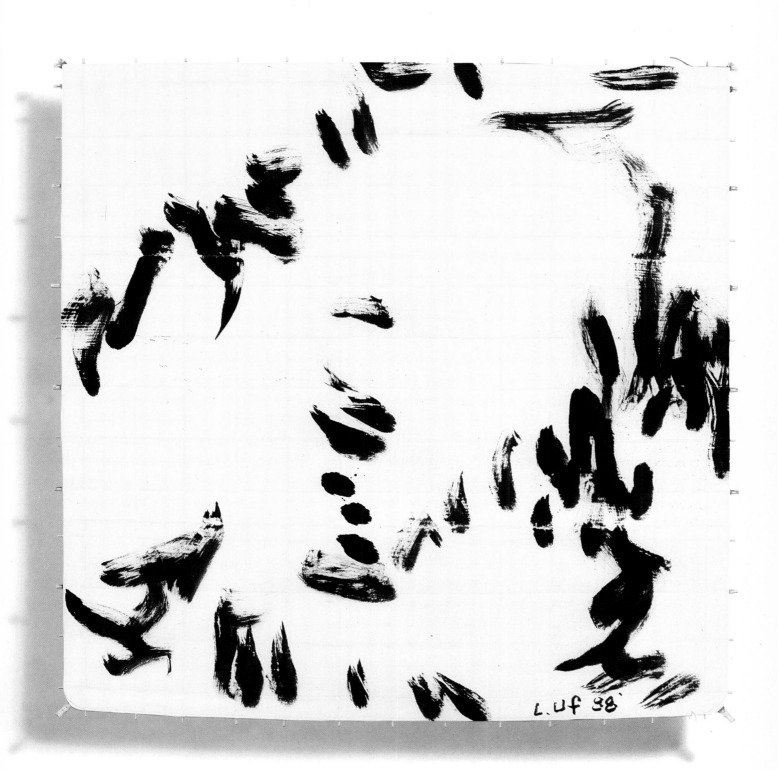

K.R.H. Sonderborg

Born 1923 in Sonderborg, Denmark,
lives in Paris and Stuttgart

Though he took on the name of his birthplace, Kurt Rudolf Hoffman actually grew up in Hamburg, a port that daily presented the spectacle of loading cranes. Fascinated by the cranes' black and white grating, and influenced by French Tachism and Oriental calligraphy, Sonderborg has painted works of lattice-like design with Indian ink and tempera since 1952. Later, calligraphic monograms and kinetic symbols appeared, applied rapidly to the painting surface with fierce brush strokes.

As his speed of application increased, so did the size of his works. A steep diagonal shooting across the painting like a comet became a predominant motif, while the swift sweeps and wipes of the brush – the time it took to make them being recorded in the title – all seemed to intensify the sense of speed, his central theme.

An extended visit to New York in 1960 led to a marked change in Sonderborg's style. Suddenly, well-defined lines offered a relieving contrast to the chaotic whirl pattern.

His source materials consisted of visually arresting objects discovered by chance and recorded with his camera: housing facades, construction sites, rusting steel, telephone poles, water tanks and trolley car wires. He also used scenes gathered from newspaper photos, fascinated as much by the silhouette of a combine harvester as he was by tire tracks in the snow or the mechanism of a machine gun.

Translating these constructions into art, Sonderborg dramatized them and accentuated their lines of force. "Figurative painting is interesting only when it surprises", he has said.

In his latest work Sonderborg steers away from an art style based on miscellaneous discoveries, and returns to earlier motifs and basic forms which he varies freely.

His art kite consists of several such structures – a black block sitting heavily and unstably atop a tilted spiral – which he has invested with a top-heavy and black/white tension.

生まれ故郷の地名ゾンダーボルクを本名の後につけその雅号としているクルト・ルドルフ・ホフマンはハンブルクで成長した。そこで彼は毎日のように、港の積み込み用クレーンを目にして、数々のクレーンのつくる白黒の格子柄に魅了されてしまった。フランスのタシスムや東洋の書道にも触発されて、1952年からゾンダーボルクは、墨とテンペラで格子状の線画を描きはじめた。その後、彼の作品は速い調子と激しい筆運びで画面に叩きつけていくカリグラフィック的な記号の絵画、キネティックの動きの残像のような絵画になっていった。

記号法に加速がつくに従って、彼の絵の画面もしだいに大きくなっていく。ゾンダーボルクが好んで使うモチーフは、急勾配の線で、それは画面を横切って落ちる彗星のように見える。速い動作で描かれる彼の絵画には、勢いのよい筆運びや筆を払いのける動きが見られ、高速度なスピード感の印象さえ受ける。

1960年冬、ゾンダーボルクはニューヨークに赴き、そこでの滞在が彼の記号の様相を変えていく。出来るだけ現実の姿に近づけようと絶えず試みる。こうして混沌とした渦巻状の記号からはっきりとした線の絵画へと変わっていく。彼はまず、よく観察した物の構造や、偶然目にとまった物をカメラに収め、時には報道写真と組み合わせて、さらに手を加え絵画のモチーフにしている。建物の正面、建築現場、鋼鉄のさび、電柱、水漕、市電の架空線などがそれである。刈り入れ機やクレーンの空にむかってそびえたつシルエット、雪の上に描かれたタイヤの跡、ピストルの氷のように冷たいメカニズムさえ、彼を魅了し続ける。彼は物の構造を紙の上に移しとり、脚色し、主になる線がなにからかを明らかにする。「形象描写は、それが予期せぬものであれば、おもしろい。」

最近の作品は、彼の偶然の発見物などの構造から離れ、初期のモチーフと原型に戻り、それらを即興的に自由に変化させている。よく見られるモチーフのひとつは、画面のほぼ中心にどっかと座り、傾いた渦巻や斜めにのびる直線により白と黒のコントラストが緊張感を生みだす黒い塊である。

Untitled
Acrylic
Hamamatsu kite 208 × 208 cm
Kite-maker: Sumitaya

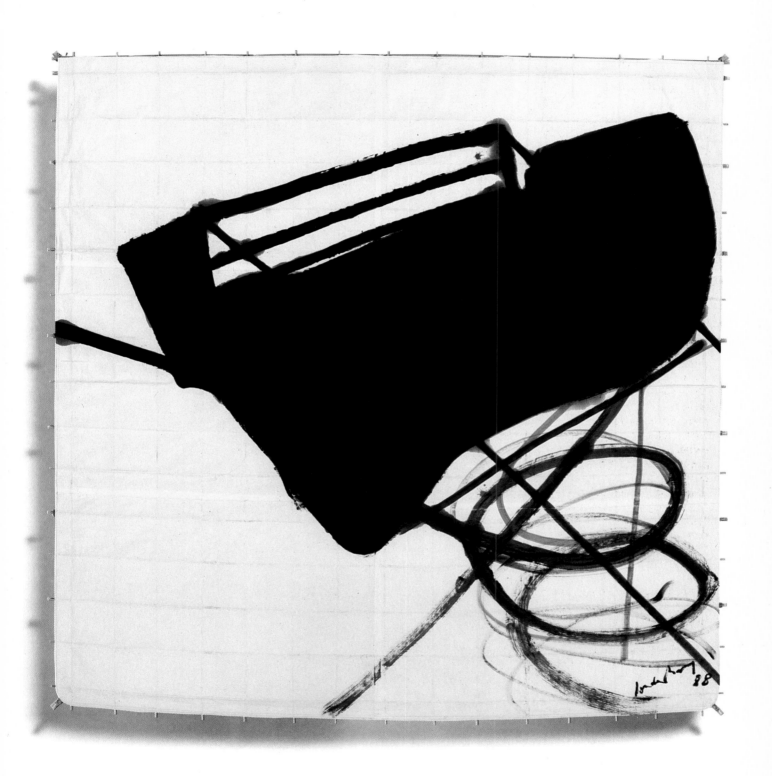

Gotthard Graubner

Born 1930 in Erlbach, Vogtland,
lives in Düsseldorf

For his uncanny ability to make pigments come alive and float about the room like melodies, Graubner has been dubbed "The Color Magician".

His earliest works were simple nude drawings, but even then an interest in volumes over lines was evident, a tendency greatly strengthened when he moved into watercolors. Graubner's first sponge gouaches, appearing in 1962, were flat works in which one could clearly see the physical structure of the sponge. Later, sponge balls soaked in oil paint became the application method of choice, only to evolve into – when Graubner noticed how beautiful they were – the actual work of art, itself.

Rather than unravel and mount his cloth covering, however, he simply duplicated the effect by soaking more and more paint into a canvas on the floor, letting it become saturated until a "color body" was created. The results are his famous "cushion paintings". Eschewing representation, perspective and even meaning, Graubner is most concerned with the sensation on the eyes caused by the subtlety of the hues, the spreading of the thick pigments, and the atmospheric effect of corporealized light. He sometimes refers to his works as "trampolines for light".

"My paintings grow with light, fade with light; beginnings and ends are interchangeable. They do not denote a state but are, themselves, transition."

ゴットハルト・グラウブナーは「色彩の妙手、色彩の魔術師」と呼ばれている。実際に、彼は色を息づかせ、彼の絵画は、楽の音のように部屋に流れる色彩の音楽であると定評がある。

グラウブナーは、素描、特に体の輪郭をぼかす裸体画の習作から始めた。彼の関心はカリグラフィック的に描く線より、むしろその線に包み込まれた湾曲のある肉体に向けられていた。その傾向は水彩画にも見られる。

1962年に、平面状に色を押しつけた、海綿の組織までが認められる最初の海綿グアッシュが生まれた。後に、油絵の具をたっぷりしみ込ませた海綿の球状のものが色を塗るために使用されるようになった。最終的には、このふくらみをもったものが制作の対象、色の本体となる。このようにしてグラウブナーのクッション絵画が生まれ、後に、スポンジを詰めて厚く丸みをおびた彩色の土台になる色彩有機体が創造されることになる。これらの作品は特殊な手法で描かれる。グラウブナーはキャンバスを垂直に立てて色を塗るのではなく、この厚みのあるキャンバスを床に置きハケで塗っていく。素材がいわば「色の肉塊」と化すまで絵の具をしみ込ませる。

制作が始まると、対象となっている材料のことも、作品の見通しや「意味」すらも彼の念頭から離れる。大切なものは視覚的センセーションであり、色調のニュアンスの魔力、濃縮と拡張、そして「併合した光」としての色の大気中での作用である。グラウブナー自身、その色彩有機体を「光のトランポリン」と呼んでいる。

「私の絵画は、光が多くなるに従ってふくらみ、光とともに消えていく。始めと終りは入れ替えることができる。私の絵画は状態を表わすのではない。過渡的なものである。」

Veda and Altair
Mixed media
Kaku kite 210 × 210 cm
Kite-makers: N. Yoshizumi, T. Okajima, I. Fujieda,
S. Okawauchi

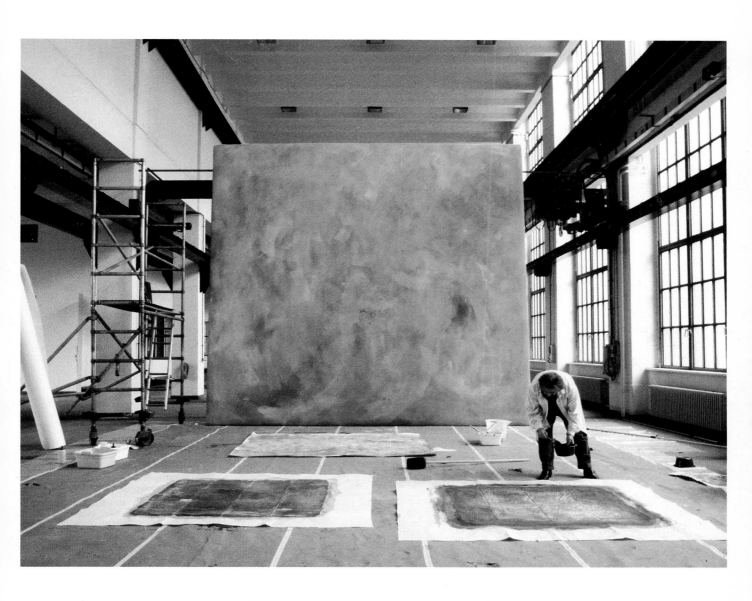

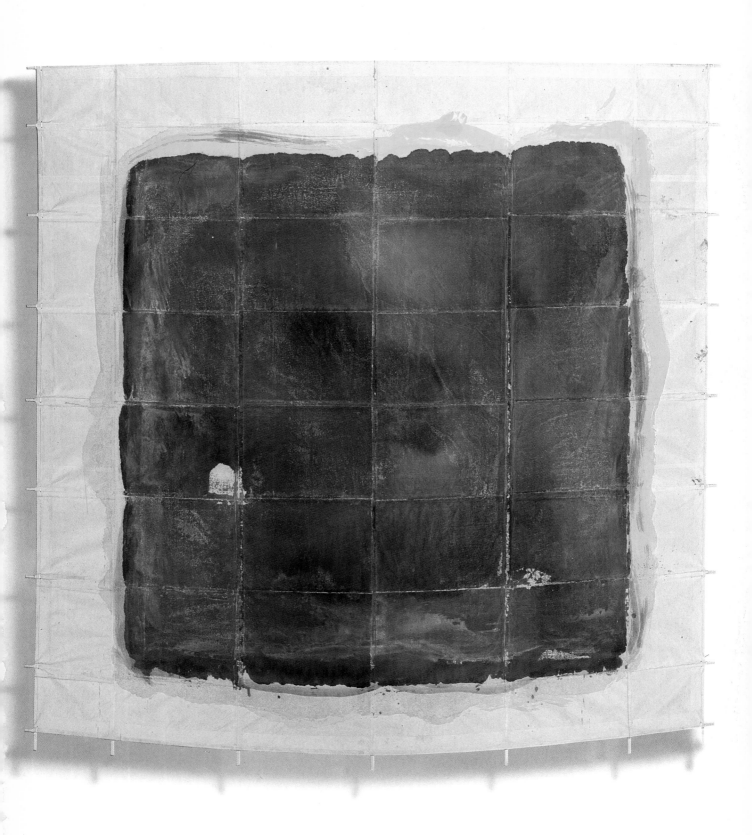

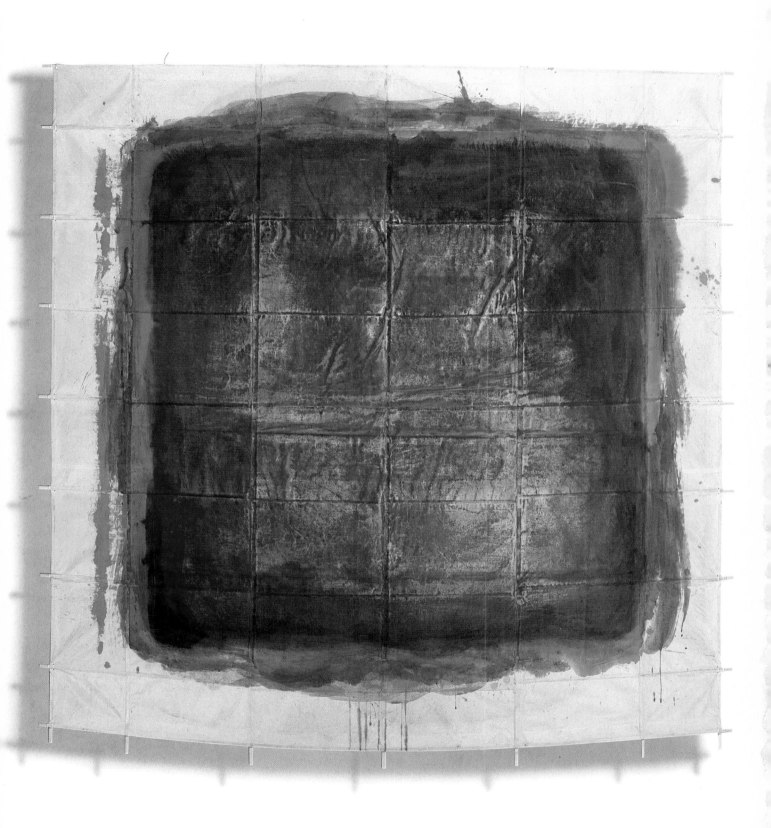

Friedensreich Hundertwasser

Born 1928 in Vienna,
lives in Vienna, New Zealand and
at sea on his boat 'Rainy Day'

Rooted in a Viennese tradition that encompasses both Baroque and Jugendstil, variously influenced by Klimt, Egon Schiele, Klee, Persian miniatures and Hokusai, Hundertwasser has succeeded in pulling together myriads of sources and yet still arrive at his own unique, unmistakable style.

His paintings blend the everyday with the poetic, the real with the imaginary, and the banal with the fantastic. Moreover, they constantly weave between concrete representation and decorative abstraction without ever straying far from the living energy of Nature.

A dedicated internationalist, Hundertwasser is also obsessed with the preservation and re-introduction into our lives of natural things. His architectural models of wooded roofs, for example, argue for a more human, ecological lifestyle as opposed to pure rationalism and "the chaos of the straight line". This latter point helps explain why, since 1953, Hundertwasser's motif has been the labyrinthian spiral.

The imagery on his insect kite is possibly a bird's eye view ("In the future, the manner of viewing things will be from the top down and from the bottom up.") of winding canals and shining islands. Two of the islands make up a face, and suddenly we have a terrestrial landscape looking down on us from the sky!

The eyes also call to mind the protective mimicry of insects, a connotation that leads beyond camouflage and into mythology.

フンデルトヴァッサーの色彩豊かな作品は、オーストリアの伝統、バロック様式の豊潤さ、そしてユーゲントシュティールの装飾の豊かさに根づいたものである。クリムト的な構成を基本にして、彼はエゴン・シーレやパウル・クレーの影響を受け、ペルシャの細密画や北斎の木版画をも消化し、まるで東洋的な華麗さをもつ彼独自の様式をつくり出している。

彼の絵画の中には、日常的なものと詩的なもの、現実的なものと虚構的なもの、平凡なものと奇抜なものが融合していて、その両者は前ぶれもなしに具象的な描写から装飾的な描象へと変っていく。そしてそれらは常に小生物や自然と関連づけられている。

自然保護の信条は、彼の一世界市民としての社会参加を意味している。屋上に植林をしたり、あるいは他の環境保全のための建築モデルを使って人間性に富んだ環境を主張し、建築に於ける合理性や「直線のつくる無秩序」に反論している。

1953年以来、彼の絵の中によく表われるモチーフは渦巻である。俯瞰的な透視画法により表意文字的な特徴が一層強調されている。彼は一番弟子たちに「上から見、下から見ること、すなわち縦の視線は将来の見方である。」と教えている。

フンデルトヴァッサーのあぶ凧の背となっている絵も、従って鳥瞰図の見方によるものである。渦巻状の道のある美しい水辺の町の風景で、この迷宮の中には二つの小さな光る島がある。水辺の町が顔のようにも見え、私たちを見上げている。そしてまた昆虫の背にある見せかけの目が敵を追いやろうとしている。カムフラージューであり神話でもあるのか。

Cicada Flight: Floating Water
28-color woodblock print
Cicada kite 31 × 34 cm
Kite-maker: M. Sato

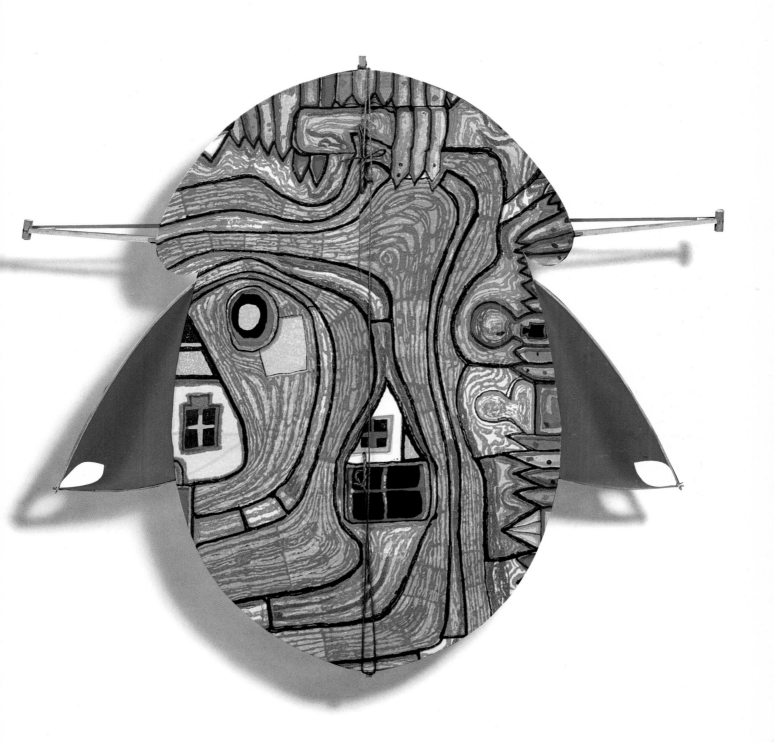

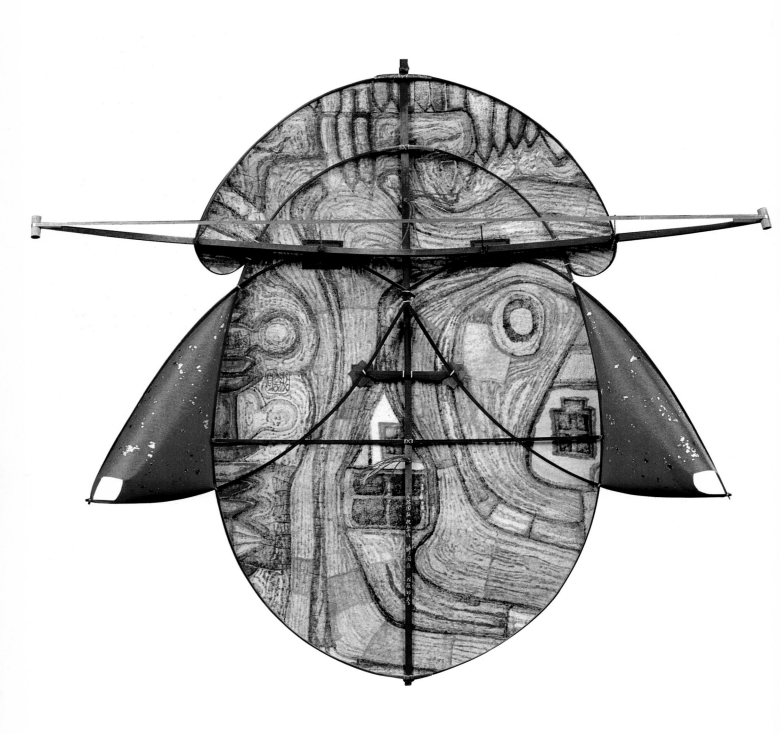

This small art kite represents a triumph of East meeting West. Designed by a European, it was made into a woodcut by traditional Kyoto masters and then transformed into a fragile cicada kite by Nagoya's Masaaki Sato. Sato continues a 200 year-old Edo Period tradition by skillfully assembling cicada, bee, horsefly and other insect kites. For the frames he uses equally old susudake, bamboo culled from the roofing of old farmhouses. Over generations of exposure to hearth smoke, the bamboo acquires a magnificent dark-brown tone highly valued for its beauty and associations.

Sato has scratched his signature on the back of the tiny bamboo and written: "Built by Kofu (Sato's artistic name) from Biwajima in Owari Province (ancient name for Nagoya area) in the spring of the Year of the Dragon (1988)."

Like most cicada kites, Hundertwasser's has an unari, a taut cord which vibrates in the wind like the chirping of cicadas.

この小さな「アート・カイト」は東洋と西洋の出会いによる総合芸術になっている。絵は東洋的要素に深いかかわりをもつ西洋の画家のもので、この木版画こそ京都の彫師と摺師によってつくられたものである。そしてこの作品をあぶ凧にしたのは名古屋の佐藤昌明、彼の手に掛かれば、絵は蟬、蜂、あぶ、そしてその他さまざまの昆虫凧になってしまう。この凧は江戸時代に起った200年もの伝統をもつ和凧であるが、ここに使われている煤竹もやはり200年経った古いものだ。煤竹は古いほど珍重され、煤がついて黒く光り、凧のアクセントにもなっている。

この凧にうなりがついているのもその伝統的な特徴であり、これは凧が空に揚った時、蟬が羽をすり合わせて鳴くように唸るのだ。

ここにある小さい日本の虫は、美しい着物に身をつつみ、人類の平和共存を主張する羽をつけた使者のようである。いかにも人間と自然の平和共存を訴えているかのように。

この小さな芸術作品の裏面に美しく組み合わされた煤竹に、凧師は次のように刻り込んだ。「尾張国枇杷島住鯱風作戊辰初春」 辰の年1988年初春、尾張の枇杷島に住む鯱風によって製作されたと。鯱風は佐藤昌明の雅号。

Hisashi Momose

Born 1944 in Sapporo,
lives in Morioka

Momose's special charm lies in his blending of Japanese tradition and innovativeness. Though color is important to him, he is interested more in the subtle gradual shading (bokashi) of woodblock prints than in strong contrasts, which he feels makes each pigment lose its effect.

To achieve the desired bokashi, Momose avails himself of many traditional techniques, including urazuri, or painting on the reverse side. When the paint soaks through to the front surface, Momose can heighten the already striking effect by sanding the image and drawing out still more color. This is what he did for one of his kites.

For the other kite he attained a similar effect by a completely different process. Starting with painted paper sprinkled with gold and silver dust, he overlaid strips of super-thin Nepalese paper in increasing layers toward the center of the work, thus arriving at a bokashi-like treatment, a mysterious veil of mist covering the colors. His picture has the subdued dignity of old Japanese gold background paintings.

百瀬寿の作品は、日本の伝統と実験的意欲が結びついて独特の魅力を醸し出している。彼にとって色は大切であるが、そのコントラストには興味がない。日本の伝統的な色摺り木版画において高く評価されていたような繊細な色のニュアンス、色の階調の変化、いわゆるぼかし、色彩のグラデーションを求めているのである。彼の説明によると、強烈なコントラストの色調を並べることで配色の効果は出し尽されてしまう。洗練されたグラデーションの中でこそ、ハーモニーの情感の滲み出る繊細さが見い出されるのである。こうして生れた作品が、日本の伝統的な屏風、ふすま、錦織りを思わせる、光沢の穏やかな方形を碁盤の目のように連ねた絵画である。

百瀬は望み通りのグラデーションをつくり出すために古い技法を多様に駆使している。その一つが多色摺り木版画で知られている裏摺りの技巧で、彼の場合は裏面に彩色している。その効果のすばらしさは、不均等に表面に表われる色の滲み具合である。百瀬は更に手を加えて、彩色した面を下にして支持体の裏面に貼り、乾いてからサンドペーパーで部分的にこすり取り、再び純粋な色合いが表面に見られるという方法をとっている。彼は二つのアート・カイトの一枚をこの方法で制作している。

二つ目のアート・カイトには百瀬は、全く異ったやり方で同様の効果の得られる手法を応用している。先ず、彩色と金粉、銀粉を施した帯状の紙をつくる。(彼は他の色彩を輝かしく見せるためしばしば金属粉を触媒として使用している。)そして絵の画面に透きとおるほどの薄いネパール紙を貼り重ねていくのであるが、グラデーションがぼかしの効果を表わすよう、そして同時に神秘に満ちた薄霧のベールで覆われた色調が出るよう、列によって二重、三重、あるいは何層かに重ねて貼っている。このようにしてできる彼の絵面は、金地に描いた日本画の渋さを彷彿とさせる落着いた品位を保っている。

Square-Twelve Stripes Orange to Pink and Gold to Silver
Acrylic, Nepalese paper, Japanese paper, mixed media
Hamamatsu kite 160 × 160 cm
Kite-maker: Sumitaya

Twelve Stripes, Yellow to White
Acrylic, Nepalese paper, Japanese paper, mixed media
Hamamatsu kite 160 × 160 cm
Kite-maker: Sumitaya

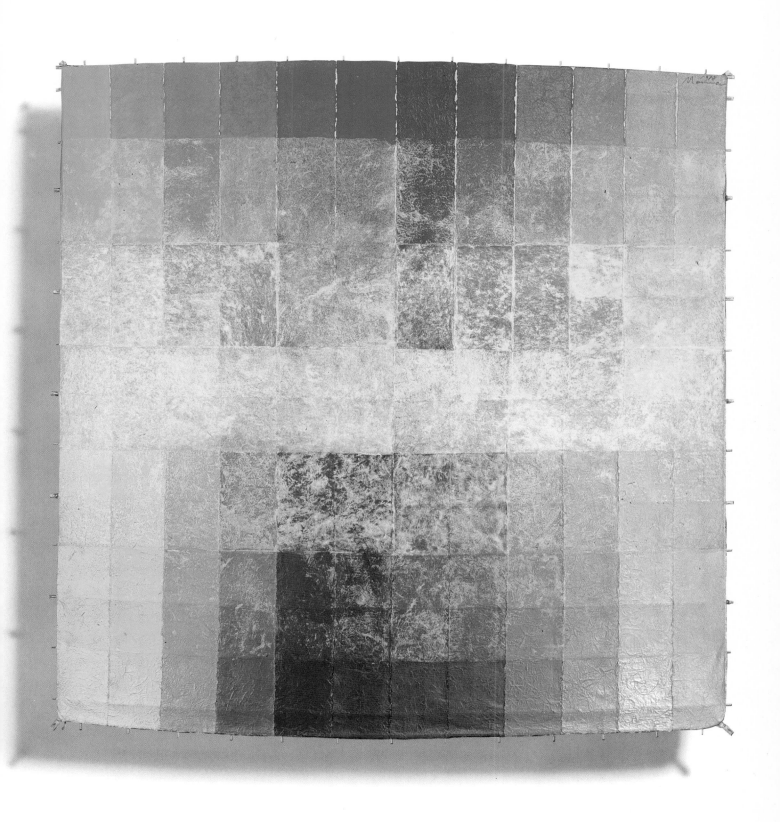

Olle Kåks

Born 1941 in Hedemora, Sweden,
lives in Stockholm

The two principal subjects for Kåks are landscapes and the female body. Originally treating them as distinct genres, he has combined the two since the Orphelia I-XX Exhibition in 1986. Though the starting point would seem to be de Kooning's nude studies (Woman I, Woman II), Kåks uses the female body itself as landscape. Figures more than faces exhibit personality and thus he continues in the tradition of Munch, Matisse and Kirchner.

With the development of a checkerboard structure – small, square-shaped works on the same theme combined into large tableaux – Kåks' Expressionism altered radically. From De Stijl to Schwitters, Warhol, and Sol LeWitt, the checkerboard has stood for impersonality and machine age reproducibility, the idea being that each fragment is but a tiny part of an immense whole. Kåks' kite, therefore, but a snippet of Swedish imagery, is at the same time a universal symbol of the eternal Feminine. Says the artist about his art kite: "It is something very earthly high up in the sky."

オレ・コクスの作品にみられる二つの顕著なテーマは、風景と女性の体である。最初、彼はこの二つの主題を別々に様々なカンヴァスの上に展開させていたが、1986年になってひとつの作品の中にこれらのテーマを統合し始めた。(オフェリアⅠ－XX) このような彼の絵画にきっかけを与えたのが、デ・クーニングの裸婦画(ウーマンⅠ、ウーマンⅡ)である。オレ・コクスの場合、裸婦がそのまま風景画になる。顔は全く問題にされないが、それでも人物たちには人格が感じられる。彼の裸婦像は、ムンク、マチスあるいはキルヒナーの表現力の豊かな伝統により近いといえる。大胆な筆のタッチも、先駆者たちの中にすでにみられるものなのである。

オレ・コクスの絵画における表現主義は、今や彼の特徴となっている。構成、すなわち格子図形によって、ある種の屈折を経験する。彼は同じ主題を種々に変化させた正方形の絵を組み合わせて、大きなタブローに制作している。この格子の構成というものは、デ・ステイルから、シュヴィッタースやウォーホルを経て、ソル・ルウィットに至る現代美術史においては、非人格化された表現として扱われてきた。格子というテーマの中心概念となる反復は、はてしなく広がりゆく全体の中の一部分にしかすぎない個々の絵の、断片的な特徴を表現している。この意味において浜松凧に仕上げられたオレ・コクスの絵は故国、北欧のスウェーデンに対するイメージの世界の断面であり、同時に、永遠に女性的なるものの普遍的な象徴でもある。

作家は凧の絵の制作にあたり、「なにか地球上からのものを天空に高く高く…。」とコメントを書いている。

Cress and Woman
Acrylic
Hamamatsu kite 205 × 205 cm
Kite-maker: Sumitaya

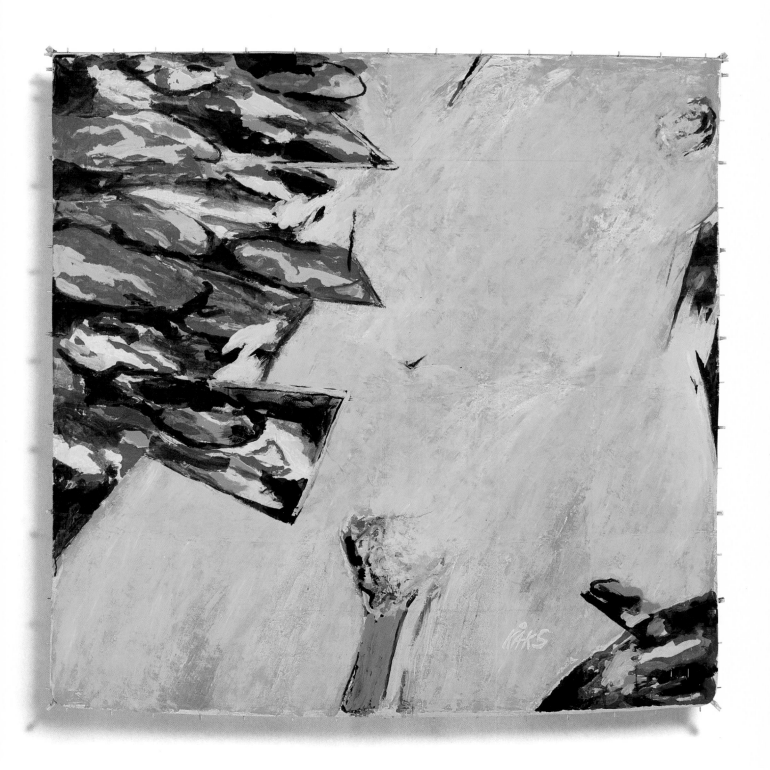

The workshop of the kite-maker Sumitaya in Hamamatsu. The paintings of Olle Kåks and G. K. Pfahler are being transformed into kites. A visiting team of kite-flyers from Sodecho watches.

浜松の凧師すみたやのアトリエでは多くの作品が空舞う絵画に姿を変えた。ここに見られるのはオレ・コックスとG. K. プファーラーの作品。アートカイトが製作された時には早出町のラッパ隊も応援に加わった。

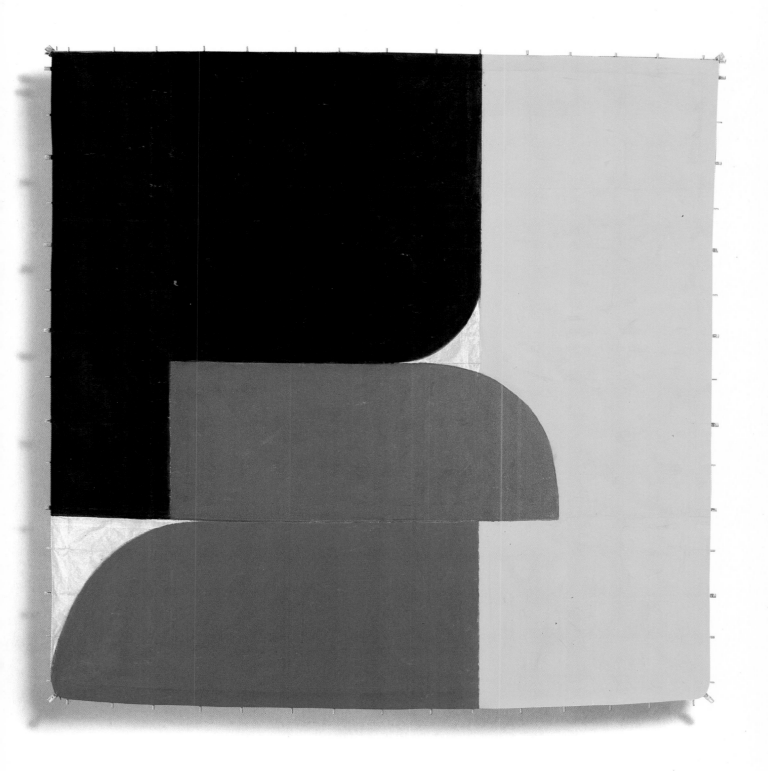

凧のうた　　大岡信

高く昇って
青空をさすってゐると
「おおい　なんていい　ここちだよ」
からだの四隅に響くやうな
大声がする

お前のからだの清潔な
骨と皮の　額のうへを
眩しげに、うっとりと
陽のこが　ただひとり
滑べりっこして　遊んでゐた

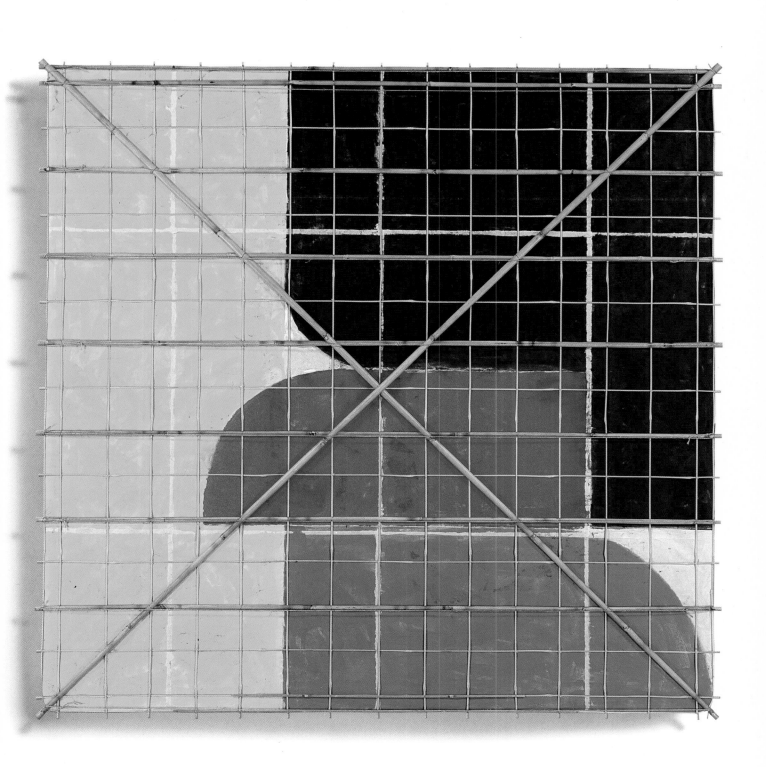

The Song of the Kite

Climbing high
to caress the blue sky
"Oh, how pleasant".
Raising my voice
to resound in all four corners of my body.

On my face and over the skin and ribs
of my taught body
glides sunlight, enchanted,
over and over again, lost in play,
almost too harsh.

Makoto Ooka

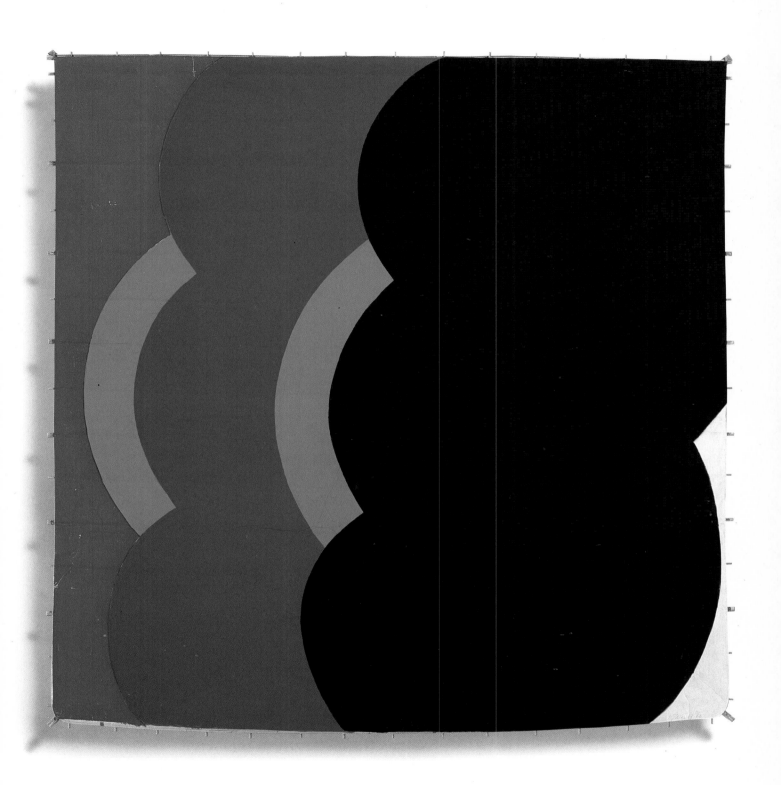

Richard Paul Lohse

Born 1902 in Zurich,
†1988

Having spent his early career designing flags, advertisements and cubist works, Lohse in 1937 co-founded Alliance, an association of Swiss artists dedicated to the Bauhaus and Mondrianesque idea of applying rigorous mathematical laws to art, and thus educating humanity.

"Constructivism is an encyclopedic art, the art of reason – a moralizing, ideological, political art as well as analysis and order, all in one."

After intense research into standardization of materials and the laws of color, Lohse produced in the 1940s his famous "serial order" pieces. Their basis was the square but, unlike Mondrians's works – where neutral lines divide the color areas – he allowed his colors to confront each other directly. His purpose was to create an order that would suggest a much higher ideal, thereby achieving for the eyes what twelve-tone music was meant to do for the ears.

Lohse's kite demonstrates this principle of order. What appears close up as a shimmering field of color transforms itself, as it glides skyward, into a tranquil, harmonious structure.

リヒャルト・パウル・ローゼは芸術家として活動を始めた頃、旗の下図、広告、後期キュビスムの試作などの仕事をしていた。1937年、アリアンツというスイスにおける現代美術協会を組織して、構成的なものの中に、調和のとれた全体を追求した。モンドリアンとドイツ・バウハウスの影響を受けた彼らは、人間を更生するために、芸術を厳格な数学的法則と組み合せた。「構成主義の芸術は百科全書的な芸術、理性の芸術であり、観念的、政治的であり、分析と秩序の芸術でもある。」

絵の構成、普遍化や規格化、素材の客体化、絵の中の動き、漸増的か、漸減的か、色の飛躍や干渉の問題などを深く研究するうちに、ローゼは40年代の始め、あの有名な連鎖的秩序に到達する。ここで彼が色を連鎖的に組み合わせ使っている基本的なフォルムは正方形である。色はグラデーションの効果と、隣接しあう色がお互いに調和のとれたコントラストをつくり出すように配列されている。モンドリアンの場合と違って、中立的な色調の線によって分断される必要がなく、色と色が直接対峙している。

「連鎖的な秩序の基本となっているのは、色の量の均一性と、色の連続と組み合せの拡張ということである。どの色も各列に同じ量の色が使われており、それぞれの色の系列が全体の中で占める割合も同量である。描かれた連鎖は、また、想像できうる限りの大きな連鎖の中のひとつでもあるのだ。」

リヒャルト・パウル・ローゼは連鎖的な秩序という形で、音楽の世界でいう十二音階の技法に匹敵する構成主義の基本理念を絵画の世界で実現したのである。音楽は音階によって「聴覚の概念的不変性」が成り立っているとすれば、ローゼの絵画では、「視覚の概念的不変性」が色の配列によって成り立っているといえようか。

この秩序の基本は今回の彼のアート・カイトにもはっきり見られる。これは近くで見ると目にチラチラして混乱を起こしそうな色の面の集まりのようであるが、凧を高く見上げた時、静かな調和のとれた構成の作品になっているのである。

30 Systematic Vertical Color Series
Acrylic 208 × 208 cm
Hamamatsu kite
Kite-maker: Sumitaya

Eberhard Fiebig

Born 1930 in Bad Homburg,
lives in Kassel

As a sculptor Fiebig developed in the 1960s a "pleat-ing" technique joining segments of plastic, sheet metal and aluminum to sculpted objects. The joining process remains clearly visible in the final work, since he believes "Art must reveal its vocabulary (materials) and syntax (process)".

Recently, Fiebig has created metal sculptures of monumental dimensions, in the style of triumphal arches or city gates, arousing considerable attention. He has transferred similarly weighty features to his graphic works, as well.

His square Hamamatsu kite, for example, reflects an architectural sturdiness even when viewed from far below. The transparency of the Japanese paper high-lights the decisive color rhytms, and the unpainted sections show the bamboo frame.

Says Fiebig about this piece, punningly: "A kite is not a dragon is not a dragon".

彫刻家エーバーハルト・フィービッヒは、60年代、プラスチック、ブリキ、アルミニュームなどの素材から板状のものを繋ぎ合わせるという「褶曲形」の基本を生み出した。選び出した素材をさまざまな形に繋ぎ合せていく配列のプロセスが作品の中に読みとれる。「芸術作品は、そのヴォキャブラリー（素材）とシンタックス（過程）が認識されなければならない。」

フィービッヒは近年、記念碑ほどの大きさの凱旋門や城門の形をした重量感のある金属の作品を制作しているが、これらは町の景観に欠かせないものになっている。

がっしりとした組立て方の基本は、彼のグラフィックの作品にもよく表れている。グラフィックは平面のものであり、白と黒を主体にしているため活字を思わせるものであるにもかかわらず、立体感があり、明らかに金属を扱う彫刻家の手によるものだと、その作風をしのばせている。

エーバーハルト・フィービッヒは正方形の浜松凧に、やはりずっしりと重々しい構造の絵を描いている。特に離れて見るとその印象は強い。和紙そのものが光を透過することから、いかに力強いリズムで絵の具を塗りフォルムをつくったかが読みとれる。無彩色の部分には竹骨の格子の美しさが見られ、それが作品全体の構成に組み入れられているのがよくわかる。

この作品についての作家のコメントは、「凧は龍ならぬ、凧ならぬ。」

Ionization
Water-based industrial paint
Hamamatsu kite 235 × 235 cm
Kite-maker: Sumitaya

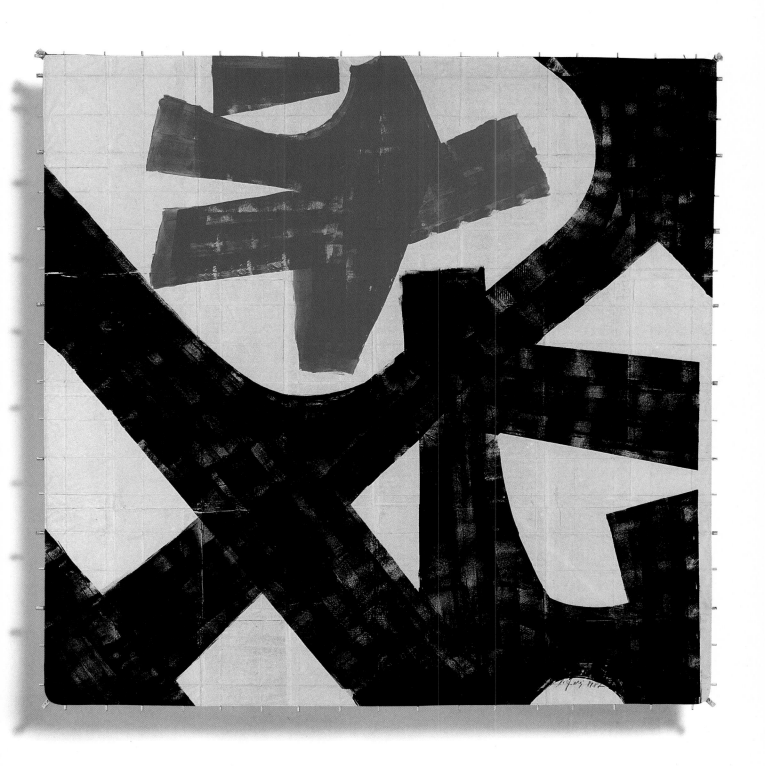

Klaus Staeck

Born 1938 in Pulsnitz near Dresden,
lives in Heidelberg

A lawyer, politician, publisher, writer and TV personality, Staeck is above all a committed political artist. He has been making placards since 1971 and, akin to John Heartfield, has furthered photo-montage as an art form, taking his posters, broadsheets and actions into the street and blurring the line between art and politics.

Staeck's text and picture montages are the perfect medium for addressing important social problems, since they arouse curiosity and expose contradictions in society. He uses his art particularly in the service of pacifism, the environment, and freedom of speech.

With his art kite "Caution! Art!" Staeck has applied an ironic twist to the oft-feared explosiveness of artistic freedom.

クラウス・シュテックは法律家、政治家、オーガナイザー、出版者、作家、報道関係者などの肩書きを持っているが、とりわけ政治色の強い芸術家である。1971年以降、ポスターを描いている。ジョン・ハートフィールドの伝統を受け継ぎ、彼はフォトモンタージュを芸術様式として更に発展させた。自分の芸術をもって街に出てゆく。ポスターのみならず、絵葉書やシール、チラシを描き、芸術と政治の境界線上での活動を通して世間に語りかけている。この絶えざる尾根歩きは、彼の芸術と生活とを結びつけようとする試みである。

彼にとって芸術とは、重要な社会問題が表現できる機会を彼に与えてくれる、自由で卒直な場である。彼はこれを、弁証法的な矛盾によって成立させ、なおかつ緊張感を生み出すテキストと写真のモンタージュ技法を用いて、関心を呼び起こしている。絵画を通して、彼は我々を取り巻いている虚偽を、絵の闘いの中で暴露しようとしている。絵画は人々の思考を促し、啓蒙に寄与すべきものなのであるとし、人々を批判的な見方に導いて、支配者たちの独占的な意見に対して反世論の態度が確立されるよう役立つべきものであると唱えている。

彼が作品で取り上げているテーマは、言論の自由、平和の保障、環境問題、社会問題、偽善と反動に対する闘い、などである。

シュテックは、政治の領域までも干渉するこの権利を幾度もの訴訟の中で、憤慨した相手から守り抜かねばならなかった。たいていの場合、法廷は彼の芸術的かつ政治的な発言に対してその自由を追認した。

シュテックはそのアート・カイト「危険美術」で、多くの人が怖れを抱いている芸術の自由の爆発力を、皮肉をこめて暗示している。

Caution! Art!
Dye 208 × 208 cm
Hamamatsu kite
Kite-maker: Sumitaya

Gerhard Richter

Born 1931 in Dresden,
lives in Cologne

At the heart of Richter's work is the question of verisimilitude. He has posed this problem in so many ways – and given answers so varied, radical and contradictory – that his œuvre, marked by "incongruity as a stylistic principle", is almost a zen primer on the subject.

In the early 1960s Richter emerged as a leading exponent of Photo-Realism in West Germany, his particular method involving painting over images projected onto a canvas. His subjects included family snapshots, landscapes and urban scenes, all reproduced in grey tones as if they were out of focus.

Only in 1976 did multi-colored abstract paintings appear, full of floating, overlapping color strata and visible brushstrokes that allowed the observer to share in the creative process. At the same time, he also started to produce color squares methodically arranged in rows (like paint manufacturers' charts) that sometimes had as many as 1024 different hues!

Richter's Hamamatsu kite is subdivided into 64 squares with white lines between the colors. The random conjunctions produce both stark dissonances and unexpected harmonies, though the whole comes across as remarkably unified.

ゲルハルト・リヒターの絵画作品の中心には、像の真実性に対する問いかけがある。多様な問いかけと、それに対する答え方がまた多面的、ラディカルでしかも矛盾していたため、ある時には画期的な大家と呼ばれ、ある時には彼の「様式の基本が不統一」であると言われた。

60年代初頭、ゲルハルト・リヒターは西ドイツにおけるフォト・リアリズムの代表的な芸術家として頭角を現わした。彼の技法は、カンヴァスに投影した拡大写真の上に絵を描いていくというもので、家族、風景、都市、人物、自画像や物体の写真を題材に用いた。ほとんどの場合、彼はこれらをピントのぼけた写真のような絵画にし、灰色を基調にしている。

1976年以降、彼は色彩豊かな「抽象絵画」、大型の絵画も制作している。これらの作品では、色が何層かに重ねて塗られ、浮き上った絵画空間の印象を与える。画面の条痕と目に見える躍動的な筆の動きが、卓越した制作過程を追体験させてくれる。

更にこれとは全く異質な作品群として、様々の方法を駆使していくつかのヴァリエーションに完成させた色面のシリーズがある。このカラーボードからは、塗料製造業者が使う色見本のカードを見ている印象を受ける。ここでは、正方形の色が色調の順に並べられているか、あるいはバラバラに並べられているのである。後にこの色のスケールは系統的に色を混ぜていくことで拡大され、遂に1024種類の色を使ったカラーボードを描いた。「未だかつて、私は1024色を一度に見たことがなかった。だから試してみたかったのだ。」

偶然にばらまかれた色のポリフォニーによって、嗜好、構成、意味などにとらわれない色表現が生まれた。芸術家自身は、これを「人工の自然主義」と名付けた。

リヒターは浜松凧の面を、64個の正方形に区分けした。白い線によって仕切られたこの色面は、ありとあらゆる色によって埋められているが、その色は全く偶然に選ばれたものばかりである。個々に眺めると、調和のとれた色の配置になったりする。それでも全体の印象は、色の配列がやはりまとまっていること、明るい色と暗い色、暖かい色と冷たい色、原色と混合色などが、偶然並べられているにもかかわらず、計算されたようなアンサンブルにまとまっていることである。

Untitled
Acrylic 160 × 160 cm
Hamamatsu kite
Kite-maker: Sumitaya

Takeshi Hara

Born 1942 in Nagoya,
lives in Tokyo

A giant blow-up of gracefully light, uniformly wide brushstrokes zig-zagging across sketches, lithos, silkscreens and air-brushed originals have been Hara's unmistakable trademark since 1972.

Though such brushstrokes are traditionally an indication of a spontaneous creative gesture, Hara's – in their perfectly controlled color gradations and immaculate execution – suggest just the opposite. It is this contradictory message between impulse and calculation, flourish and artificiality, that intrigues the eye and allows for personal interpretations.

At festivals, Hamamatsu kites usually bear the crest of the district of origin; Hara has continued this tradition by flying his personal signet in the sky.

「ストローク」一筆跡。これを1972年以来、原健は作品の主要テーマにしてきた。このモチーフは、素描、リトグラフ、シルクスクリーンなどの作品になり、あるいはエアブラシを用いて表現されている。このストロークはどれを見ても手首の力を抜いてエレガントにそして規則的にリズムをつけてジグザグに動かし描かれたように見える。均一の筆幅が少し人為的な印象を与えるが、ひといきに制作されるのであろうか。

筆跡にしては、彩色の仕方が普通ではない。色調は筆の動きによって変化していき、それゆえに様々な色が層をなして、微妙なグラデーションとコントラストを作っていく。その過程で、個人的な要素はすべて流麗な完璧さの前にかき消されてしまう。芸術的な発言の中にも私情にとらわれることなく、観る者の持つ客観性が保持されていなければならない、という主張なのか。

作品はいかにも即興的に、自然な速い動作で仕上げられるかのように思えるが、実際の制作過程はそれとは程遠いものである。とはいえそれはやはりパフォーマンスを速記したかのように、ある空間と時間の連続性から成り立っている。矛盾、衝動、人為性、それにインパルスや計算が混ざり合って作品の魅力となっている。

浜松の祭用の凧の図柄にはそれぞれの市街区の町印が描かれる。多くの場合、用いられるのは最初の一文字で、これが巧みに正方形の凧の平面内にデザインされている。遠くから見てもはっきり確認できなければならない。原健はこの浜松凧の特性を生かして彼個人の署名を空に揚げているのだ。

Strokes
Acrylic, silver powder
Hamamatsu kite 240 × 240 cm
Kite-maker: Sumitaya

Raimund Girke

Born 1930 in Heinzendorf, Silesia,
lives in Berlin

A strong proponent of art for art's sake, Girke initially practiced a fierce reductionism in the pursuit of new visual experiences. At first, his palette was limited to grey, black and white, which was then followed by a period of only white.

Gradually his palette expanded. Yet still, in every piece, one senses a recapitulation of the artist's search for the true values inherent in colors. The viewer experiences each layer of pigment as if he were parting a succession of veils retracing the artist's journey in reverse.

Frequently, over a dark, rhythmic background, bright, broad stripes are laid. Also visible in the composition are natural body movements of the artist, a reminder of the physicality of his creative process.

In one respect, Girke's art kite represents a departure from his standard oil paintings, where the turbulent brush strokes are always firmly balanced; motion and stillness hold each other in check and the works exhibit a profound quietude. (The Stillness of Constant Movement could be a fitting title for many of them.)

But the art kite is radically different. From out of a bright, peaceful zone bands of color shoot diagonally upwards, leaving a slipstream of emptiness in their wake. The whole seems poised for imminent take-off. It was presumably the wing shape of the kerori kite, (as well as the whole thrust of the Project, of course), that inspired Girke to add to Morning Coolness this aerial dynamism.

"My kite should affect one as light and bright, and even within a closed-in area should dissolve into the surrounding light. Once constructed into a kite the painting will float free and relaxed, up into the light of heaven. Light and fluid colors will seem at times in motion, at other times at rest. They will imbibe the rays of heaven, intensify and concentrate them."

ライムント・ギルケの絵画は何物をも描写しない。絵は絵そのもので、絵以外の何ものでもなく、「基本の絵画」である。

新しい画像の実際と視覚の原体験を追求して、ライムント・ギルケは50年代に、まず極限に至るまでの単純化を試みる。色は白、グレー、黒といくつかのアース・カラーだけに限定し、1959年以降は、「白」の絵を描く。

この極端なまでもの鋭敏な知覚の時期が過ぎると彼のパレットには色が戻ってくる。しかし、どの作品にも色を発見するプロセスを改めてたどることができる。次々と塗り重ねられた層は、次第に密になる色のベールの間を徘徊でもするかのような感じを体験させる。濃い青のリズミカルになされた地塗りに広巾の筆で明るい色の帯が描かれていく。まるでそこに画家の自然な動作、体の動きの残像が見られるようである。

ところが、ライムント・ギルケの凧の絵には油絵に見られるいつものあの主張と異る点が表われる。動きのある筆運びにも全体から見てバランスが保たれているし、静と動とは均衡を保っていて、どの絵も大いなる静寂の中に吸い込まれていくものである。「連続した動きの静けさ」は彼の作品にぴったりのタイトルであるが、凧の絵は全く違っている。明るく静かな部分から色の帯が斜め上に突き進んでいる。一方向にひっぱる力が流れを起こして動きを呼び、静止していた絵が浮力を得て、「飛翔」する。

恐らく、凧が空高く揚るイメージとケロリ凧の独特の形がこの芸術家に、凧の表皮の中にこの躍動感を表現してみようと思い立たせたのであろう。絵のもつ全エネルギーは、凧の右上の先端に集り、この軽い紙を高く引き上げようとしているかに見える。この凧は飛びたがっているのだ。

ライムント・ギルケはこの作品についてこう語っている。「私の凧は軽く、明るく飛んでほしい。こぢんまりした面であっても光の中に溶け込んでいけばいいが。組み立てられて凧となった絵は、自由にのんびりと空の光の中に漂うだろう。流れるような軽やかな色は止ったり動いたりしながら空中に留まるだろう。空の色を迎え入れて更に色を高め、凝縮していくのだ。」

Morning Coolness
Acrylic
Kerori kite 180 × 340 cm
Kite-maker: T. Kashima

Ryusho Matsuo

Born 1951 in Kainan, Wakayama,
lives in Berlin

After completing his studies at the Seika Art School in Kyoto, Matsuo worked as a freelance graphic designer before embarking on further studies in Hamburg and Berlin. Girke's student since 1982, he describes his artistic views as follows:

"With my brush I try to overlap numerous semi-transparent layers and join them together into a brushed color field. In this way an internally-dynamic surface of pigment arises and the physical elements in the picture obtain, by means of impulsive brushstrokes and application of color, a sublimated meaning, analogous to calligraphy.

According to my understanding, there is a special relationship between color and brushstrokes in which a particular hue is painted with a particular rhythm, and the overlaying of several levels of color results in a sense of lapsed time.

Each of these levels is an improvisation combining thoughts, feelings and the direct physical activity of painting itself. Thus, each layer represents for me a specific sensory state associated with a period of time.

I paint on the floor and often use square-shaped canvases, for I work inwards from the four sides and four corners. After the first application of pigment I step back and intensely examine the condition of the canvas before deciding on the next color and kind of brushstroke. In this way there arise intense, complex painting structures.

I painted with the idea in mind that the kite would rotate in the sky. Thus, with the square Hamamatsu kite, I again worked inwards, always moving to the opposite direction, alternating my position from side to side."

松尾隆晶は京都精華大学で学んだあと、フリーのグラフィックデザイナーとして活躍し、その後、ハンブルグとベルリンで更に研鑽を積み、1982年にライムント・ギルケの一番弟子になった。
松尾隆晶は「制作について」次のように書いている。

私は、筆を用いて描く事により生じる形状要素を、半透明で多くの層に描き重ね、これを一つの密度のある筆跡層・色層面（Painting-Color-Field）に仕上げる制作を試行しています。その制作から、一つの内面的な動きのある色面ができあがります。キャンバス（平面）の上に衝撃的に色を置くことにより、筆跡は、身体的要素を得、絵画面に『書』に類似する昇華した意味を得ます。
（1978年から79年の終わりまでの、連続して透明色を重ねる作品は、モノクローム派の色面に近くなって行きました。それ以来、再び私は私自身の自動的・直感的な表現方法に、重きを置いています。）
私は、色と筆跡には一つの重要な関係があると理解しています。一つのある定まった色は一つのある定まった筆跡・律動によって描かれる事です。多くの色層を重ねる事は、描かれた各層の間の時間的な隔たりのために、一つの時の経過が作品に構成されます。
これらの各層は、思考、感性、そして描く時の直接の身体的要素とにより生じる、一つの即興的な絵画形態（絵画する事自身の姿）です。この様にこれらの各層は、私にとって、ある一つの時間帯での特別な一つの感性的・精神的フォルムを現わします。

制作の初めに、私は制作プロセスを計画します。けれども、制作中は、感性的経験からくる自動的・直感的な意思に制作を委ねます。
私は床で制作し、よく正方形のキャンバス（平面）を用います。というのは、全四方、全四隅より制作を進行してゆくからです。基本的には八つ、可能な方向が在ります。これで、各コンセプトによって、異なった可能性が生じてきます。

ローキャンバス（多くの場合、綿布）に、最初の色を置き、その後、集中的な熟視・考察に従い、次の色と筆跡を決定します。この制作行程と同様に、次の行程、又、次の行程へと制作を進めて行きます。この様なプロセスにより、複雑で凝縮された絵画構成が成立するのです。

私の描いた『浜松凧』はほぼ正方形の形です。私は、凧が飛行中に回転しても良いように、各四方より交互して、そのつど（各行程ごとに）、反対方向から制作を進めて行きました。

GPQ-D.H. N.r.g.-Sept.-Dec '87
Mixed media
Hamamatsu kite 208 × 208 cm
Kite-maker: Sumitaya

Mein Drachen soll
in der Witterung leicht und
hell sein, soll trotz eines
kompakten Bereiches sich in's
Lichte hinein auflösen.
Die Malerei wird eingebunden
in die Konstruktion des
Drachens, frei und gelöst im
Lichte des Himmels schweben.
Fließende, brillante Farben
werden ruhig oder bewegt
in der Luft stehen; sie werden
die Farben des Himmels
aufnehmen, sie steigern und
konzentrieren.

Isolde Wawrin

Born 1949 in Altdorf (Black Forest),
lives in Düsseldorf

Following studies in lithography and activities as a graphic artist, Wawrin attended the art academies of Karlsruhe and Düsseldorf before a scholarship led her to Paris. There she decided to "opt out of a society intent on following a suicidal path . . . and become an Indian in the middle of the stink of the traffic".

She has used her art to extol the beauty of the unity of mankind, animals and plants, and to bemoan the lost communion between this life and the next world. Her symbolic language is purposefully simple: plants, snakes, insects, birds, fish; plus the sun and stars, lightning, houses and totem figures – all serving to mirror the primal longing for harmony between Man and Nature.

Wawrin's art kite surprises with its rapturous blue ground and golden sun. The symbols seem to represent a picture of happy times, perhaps related to the recent event of motherhood for the artist, or the artist's dream of a harmonious, innocent world.

イゾルデ・ヴァヴリンはリトグラフの見習いをしたあと、グラフィックデザイナーとして仕事をし、その後、カールスルーエとデュッセルドルフの芸術大学で学び、奨学金を得てパリに赴いた。彼女はパリで、「コンクリートビルの谷間で自殺に追いやられそうな、文明病に冒されそうな細道から逃げ出し、排気ガスの充満するまっただ中で……インディアンのように生きよう」と心に決めた。

それ以来、彼女の作品は、人間と動物と植物の調和の美しさ、善き精霊と悪しき精霊の融和の妙、さらには無残に破壊された此岸と彼岸の間の生の調和を物語っている。彼女の絵の中の記号言語は極端に単純化されていて、植物、へび、昆虫、鳥、魚などの周辺に忽然と星や、太陽、雷、鉤、つの形、家やトーテムポールなどが現われる。それらは自然と人間が和合することにあこがれた古代からのひそかなメッセージなのである。

彼女はまず、この古代の知恵の記号を白く地塗りしたカンヴァスに、直接指で描き広げていった。それは、昔、洞窟の壁や動物の皮に描かれたような単純な符号であった。線を主体とするその構成は神秘的なその記号文字を彷彿とさせる。「現実と空想の間には記号が存在する。」

彼女の凧の絵には、あふれるようなブルーの地に、真黄色の太陽が描かれている。その色合いには目がくらみそうだが、ここで記号は喜ばしい、幸福のシンボルのように映る。妊娠という喜びの体験が込められている至福のひと時の作品であろう。そして、これから生れてくる子のためにも、この上なく平和な世界を思い描いたのかもしれない。

.Soon . . .
Acrylic 237 × 230 cm
Hamamatsu kite
Kite-maker: Sumitaya

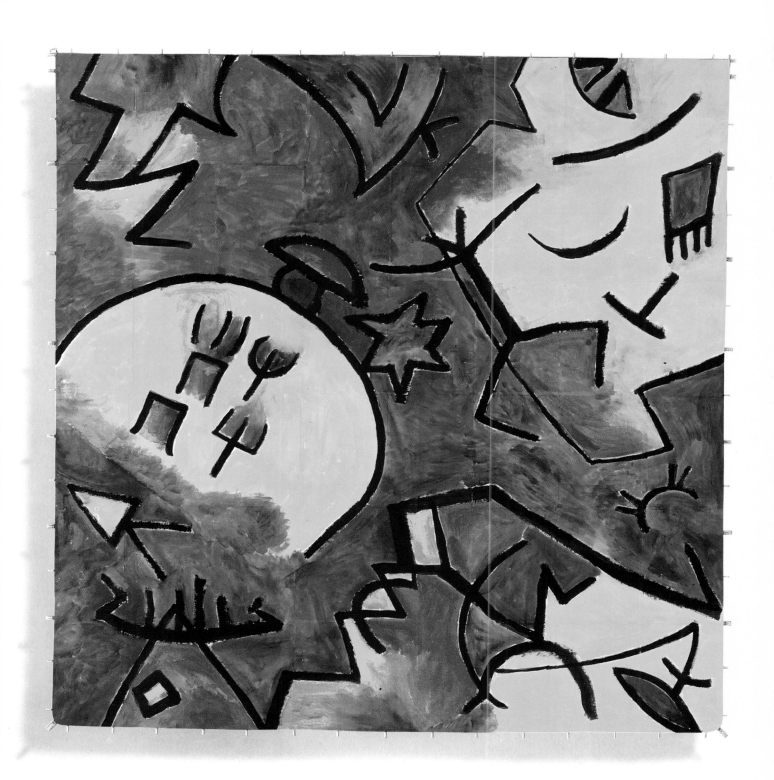

C. O. Paeffgen

Born 1933 in Cologne,
lives in Cologne

The most striking features of the work of Paeffgen, once a member of the bar, are the triviality of his subjects and his method of artistic production. He begins with a photograph, possibly from a news magazine, that he partly or wholly traces over with a black felt pen. He then enlarges the photo with the aid of a projector before starting to paint.

The bordering process achieves powerful effects, occasionally clownish, but often laced with an agitated sharpness. They cause one to reflect on the ubiquitousness of media in our times.

Paeffgen's sculptures are mainly based on objects with a distinct semiotic function; for example, a heart, star, letter or question mark. With these he forms toy-like works out of styrofoam, paper, carpet or wire netting.

For his kite Paeffgen has again decided to use a commonplace motif – a heart pierced by an arrow symbolizing the pangs of love – chosen as universally recognizable. (The idea that this image would be seen over Japan seemed to Paeffgen both appealing and incongruous, and the unusual color scheme of the heart suggests that he might have intended some hidden meanings.)

As for a title the artist has chosen the more elegant French. "'Liebe' is too heavy to take off; 'L'amour' – now that will surely fly!"

法律を学んだ芸術家、C. O. ペフゲンの作品では、まずそのテーマの通俗さに驚かされる。このことはまた、彼が説明する制作方法にも通じる。「作品のもとになるのは一枚の写真、それも新聞や週刊誌などの記事や情報の写真である。これを全体あるいは部分的に黒のサインペンでなぞって彩色する。こうしてできた写真をスクリーンの上に拡大するのだ。」

この "縁取り" のプロセスによってペフゲンは驚くべき効果を上げている。彼の作品は、時には道化師のこっけいさや、しばしばアジテーターの激しさの如き記号的効果を得ているのである。そして身辺にあふれているメディアの実体について考えてみるべきだと喚起してもいる。

ペフゲンの造形作品は記号やあるいはシンボルの機能をもつ具象的な物を扱ったものが多い。ハート、星、月、文字、疑問符などがその例であるが、発泡スチロールや紙、カーペットや金網を使っておもちゃのようなオブジェをつくっている。

今回のアート・カイトにも彼はやはりありふれたモチーフを引用している。矢の射止めたハート、これは恋のしるしとしてあまりにもよく使われている。このモチーフは普遍的な解りやすさのために選ばれたものなのだろうか。この芸術記号が日本列島の上空、極東の空で読みとられるということが彼にとっては魅力なのであろうし、またばかげてもいる。この絵の色使いが普通でないことが、モチーフの引用にもひとひねりしてあることを窺わせている。

ケルン出身の芸術家はあえてエレガントに、フランス語のタイトルをつけている。そしてそのコメントは「Liebe（愛）は重すぎて飛ばない。そこで恋、浮きあがる恋。」

Love
Acrylic 208 × 208 cm
Hamamatsu kite
Kite-maker: Sumitaya

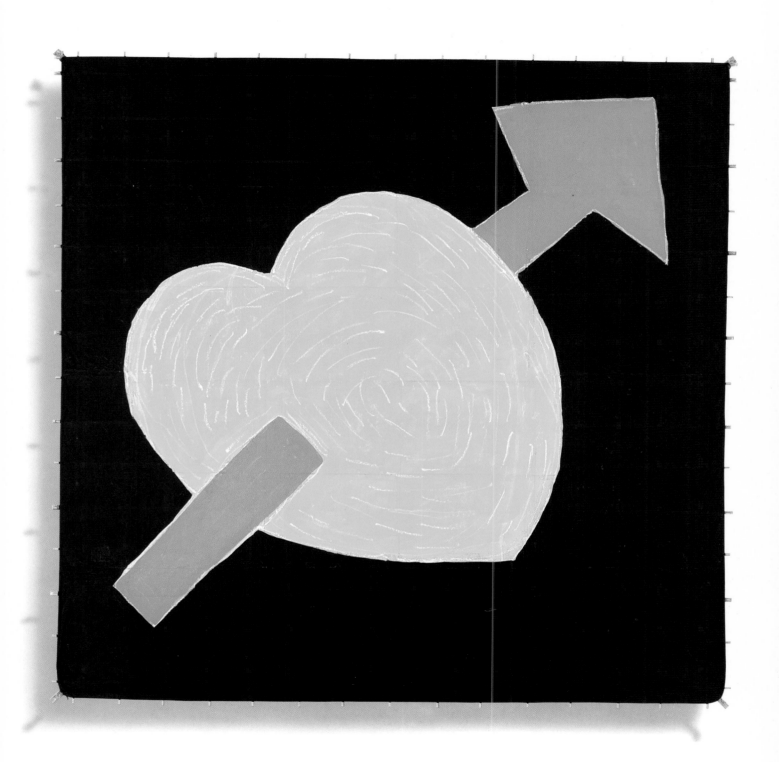

Graham Dean

Born 1951 in Birkenhead, Merseyside,
lives in London

Dean's early work combined absurd, comical elements with a hyper-realistic manner of representation. Famous examples were his portrait of Mona Lisa and Leonardo da Vinci together in bed, or his painting of the English Queen in Australian exile. Later on, his work included vivid portraits of technical brilliance tinged with a peculiar coldness.

In 1981 Dean began experimenting with watercolors and soon attained a compelling mastery of this medium, while his work with film further broadened his repertory of formal materials. Employing fade-over effects and "cuts" he has managed to realize on one canvas a sense of simultaneity in a sequence of scenes as well as a layering of different levels of reality.

For his Project piece, Dean characteristically chose the type of kite best suited to realize the stained-glass window effect of his transparent colors – the Hamamatsu, the most colorful of Japanese kites.

Done primarily with dyes which are fully absorbed into the Japanese paper, the painting has a transparent effect. This is because the Hamamatsu frame consists of a light lattice of many thin bamboo strips so the paper need never be thick, even for large kites. Thus, both the front and the reverse sides of such a kite are of equal brilliance.

初期のグレアム・ディーンのスタイルは、超写実主義表現を、内容的に見て意味のない組み合わせやこっけいさをねらった組み合わせで結びつけるものであった。例えば、モナ・リザとレオナルド・ダ・ヴィンチの夫婦の寝床でのポートレートや、あるいは、オーストラリア亡命で有名になった英国女王のあの絵など。その後すばらしいテクニックと異様な冷たさをたたえた、強烈な印象の肖像画の時期が続くことになる。

1981年、グレアム・ディーンは水彩絵具を試験的に使い始め、たちまちこの素材を駆使する画家として名人の域に達した。テレビ映画の仕事をすることにより、彼の表現手段のレパートリーはさらに広がった。二重写しとカットの手法で、連続場面を同時に、あるいは様々の現実の局面をオーバーラップさせて、一枚の絵の中に実現していったのである。彼のエロティックな描写は世間を騒がせることになった。水彩絵具を使って表現する裸体の肌の微妙な色合いがいかに力量に富んでいるかはよく知られているところである。グレアム・ディーンがアート・カイトの企画参加の招待状を手にした時、彼の水彩絵具でステンドグラスの効果が最大に発揮できる凧、浜松凧を選んだのは当然のことであった。

浜松凧は和凧の中でも色彩が最も鮮やかなもののひとつである。透明度の高い染料が主に使われるということと、その骨組みに、多数の細い竹骨が格子柄に組み合わされているということが浜松凧の特徴である。このため大きな凧でも紙はかなり薄いものが使われ、凧の表も裏も変りなく色鮮かな仕上りになる。

The Kiss
Dye 185 × 160 cm
Hamamatsu kite
Kite-maker: Sumitaya

The framework of a Hamamatsu kite consists of a narrow lattice-work of bamboo strips, reinforced by diagonals. Painting is done with dyes which penetrate through to the back of the paper.

浜松凧の裏は密に組まれた格子状の竹骨でできている。二本の丸竹のすじか
いが入りしっかりした骨組は強風にも耐える。絵の具は主に染料が使用され
和紙によく浸透して裏面も美しく映える。グレアム・ディーンはこのような
染料の効果をそのアート・カイトに生かしている。

Rupprecht Geiger

Born 1908 in Munich,
lives in Munich

Geiger holds the view that "Painting is primarily a matter of color" and, indeed, it is the motivating force behind his works, forms serving only to further demonstrate the power of color.

Originally trained as a landscape painter and architect, Geiger grew fascinated with light after some quasi-mystical experiences with it, first in Russia and then in Greece. In 1949 he became a founding member of Zen 49, a group that sought to carry on the abstract tradition first delineated by Kandinsky and Klee.

To arrive at the true basis of color, Geiger stripped away all hand-drawn elements and stopped using a brush. Instead, he applied color with a cloth-covered stipling brush and, later, with a spray gun. Not surprisingly, he was also one of the first painters to experiment with new, synthetic Day-glo colors.

In this large pink and red kite, Geiger has boldly set against each other analogous colors with a warm and cool opposition, the tension thus created broken only by the transparent borders of washi.

The T-shape of the kite is a Geiger classic but also resembles the traditional Japanese kimono kite called sode-dako. In flight, the frame becomes exceedingly bowed, creating a whole new set of proportions, the ones Geiger really intended us to see.

ルプレヒト・ガイガーの絵画におけるテーマは色である。色で始まり、色で終わる。「絵画では、まず第一に色彩が問われると私は考えている。」彼にとってかたちは色彩がうつす手段にすぎないのである。

もともと風景画家であり、建築家であったルプレヒト・ガイガーは、ロシアでの戦争の時、モスクワ近郊の空と限りなく広がる高原の空に反射する光のパレットを体験した。のちにギリシャで、"満ち満ちた光の中に色彩を放射する物体"に感動している。1949年に、ガイガーは、カンディンスキーとクレーの後継者であるという自負から、抽象美を追求するグループ・ゼン49を組織した。

自律的な色彩表現を実現するため、彼はあらゆる手跡の要素や、筆跡を抹消し、筆の代わりに突き描きの技法を使い、後にエアブラシを用いて色を塗っている。合成の画材が開発された時、ガイガーはそれを積極的に仕事に取り入れていった最初の一人でもある。

ピンクと赤から成る彼の大凧には、熱気が湧いてくるような二つの色の大画面が対峙させられている。この二色を区切っているのは和紙に蝋を塗った透明な帯である。

この凧のかたちは、ガイガーがもともと作品の形態語彙としているものである。偶然にも、日本の伝統的な凧のかたちに彼の構想と酷似しているものがあったのだ。袖凧というこの凧は名前もかたちも日本の"きもの"に由来している。ガイガーのアート・カイトは、この凧が糸のそりと風圧とによって縮小する面積の割合を計算に入れた上で、飛んだ時に初めて作家の意図したかたちになるように仕立てられたのである。

The Red Kite
Day-glo paint
Sode kite 400 × 400 cm
Kite-makers: H. Kawasaki, T. Okamoto, S. Inaba

The paper on big kites has to be re-inforced on its back to stand up to the wind. This in done by application of thin cloth or, as here, by linen threads held down by pasted paper squares. This pattern enhances the beauty of the flying kite as rhythmic silhouettes within the color fields.

大凧の場合は、補強のため薄い綿布や和紙で裏打ちされる。習志野の袖凧の裏打ちには古文書と生の麻糸が使われ、この二つの素材が織りなす格子の模様は光の透過により表にも美しくうつる。

Tami Fujie

Born 1950 in Toyama,
lives in Toyama

Dubbed "frameless pictures", Fujie's paintings are executed on large rolls of washi joined together in various ways – sometimes hanging one above the other in a cross or kimono form, sometimes arranged in grand spirals or serpentine lines. Her exhibitions actually resemble installations, for the venue – a temple, a gallery or outdoors – dictates how the works are mounted.

Fujie paints mainly with ink and oils on washi, using a broad brush. The strong bands of pigment often pass beyond the limits of one roll of paper and onto its neighbor, the palette dominated by greens and blues (suggestive of nature) dramatically set off by reds.

Fujie painted two works for the sky. They are meant to be arranged in a cruciform manner, one suspended above the other 70 centimeters apart, in such a way that the brushstrokes of the front surface seem to flow continuously into those on the kite behind.

The construction of this difficult kite was undertaken by kite-makers from Kyoto, who tested the design with models before going ahead with full-scale assembly. Their workshop being too small to accomodate such a massive kite, the whole process took place in a Buddhist temple.

藤江民の作品は「縁取りのない絵」と呼ばれている。彼女は大きく繋ぎ合わせた和紙に絵を描き、その作品を十字形や着物の形に重ねてぶら下げたり、大きな渦巻や蛇行する形に組み立てている。その展覧会はむしろインスタレーションと言ってもいい。彼女は寺院やギャラリーや大自然など展示の場所に合せて作品をアレンジし、設置する。

藤江はたいてい和紙に版画インクと油絵の具で描き、色を塗る時には幅の広い筆を使う。力あふれる色の帯は、しばしば一巻の紙だけにはおさまらず次の紙面にまで続く。グリーン系、ブルー系の自然を思い起こさせる色がよく用いられ、そこに濃い赤でアクセントがつけられる。生き生きしたリズムが絵の内面を決めているが、全体を見ると構成的に均整のとれた穏やかさが漂っている。

藤江民は天のために二枚の作品を描いた。この二枚の絵は十字架の形に前後の間隔をとって空に飛ばそうとするものである。力のこもった筆運びによる太い色の帯は、その間隔が70㎝と決められている前の絵から後の絵へと続いて流れている。
この複雑な凧の製作は日本の凧の会京都のメンバーが引き受けてくれた。彼らはこのアート・カイトの製作に取り組む前に、いくつかのモデルを作り、このオブジェの飛行の特徴を確認している。この凧は彼らの凧の製作場所には大きすぎたため、最後の組み立ては京都のお寺の大広間で行われた。

Untitled
Oil, acrylic
Free form 260 × 400 cm
Kite-maker: Japanese Kite Association, Kyoto

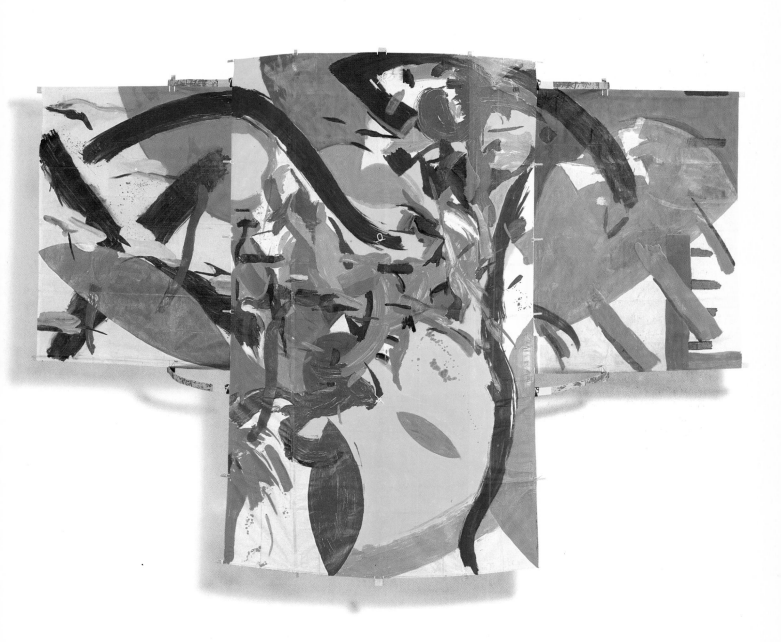

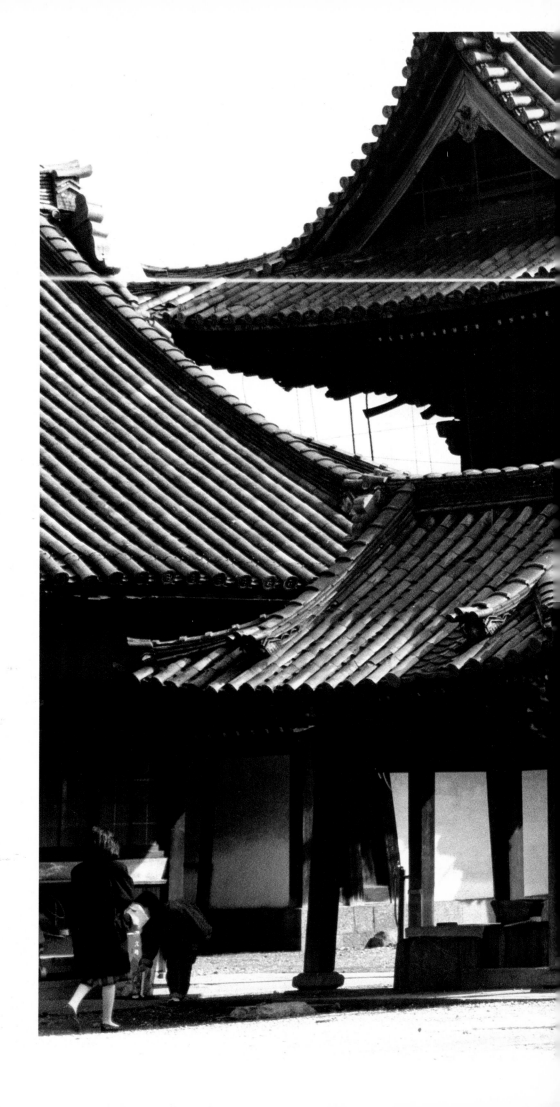

Test flight in Kyoto
モデルの試験飛行、京都にて

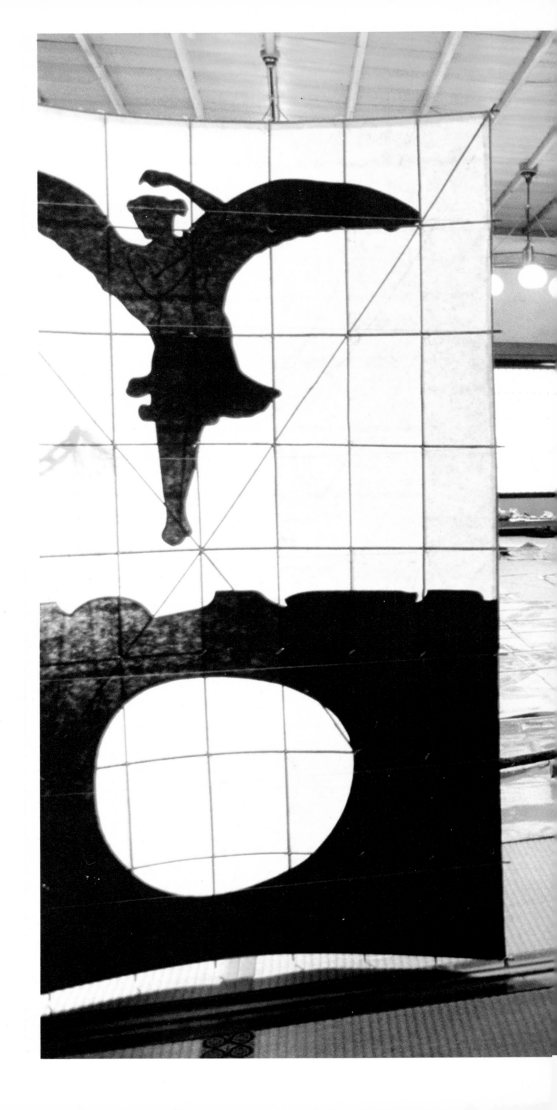

Kyoto, February 1988
京都、興正寺にて、1988年2月

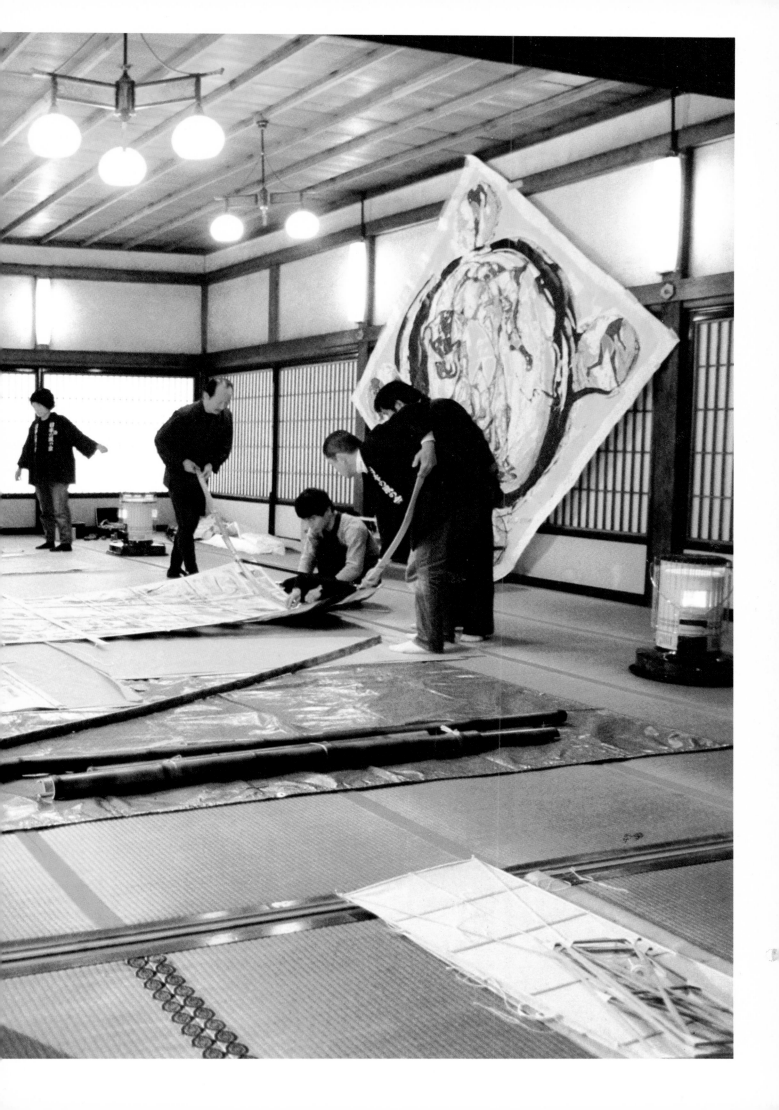

Keiji Uematsu

Born 1947 in Kobe,
lives in Düsseldorf

Upon moving to Düsseldorf in 1975, Uematsu began work on a series of photographs in which he shows himself pointing out objects in various surroundings. In one such picture he holds a distant church steeple between his thumb and forefinger, an early indication of the interest in spatial relationships that has continually guided his work in sculpture as well as painting.

In his sculptures he contrasts space and matter, weight and volume, tension and mass, and thickness and transparency – all by manipulating a few very basic materials. These include rocks, beams, metal plates, glass panes, cloth and branches, the altering of whose arrangement reveals texture and gravity, push and pull, weight and balance. Moreover, he creates with these installations an awareness of how space is defined by the presence of such limiting objects.

In his latest work Uematsu has hung red, yellow and white funnel-shaped cloth objects from the ceiling, along with steel wire and trimmed branches. Caught between gravity and the suspension force, the cones hang tenuously in space. This same idea was applied to a "sculptured" kite, and then to a second one which he painted. He has made the invisible visible and shown on his kite the forces at work when a kite is in flight.

植松奎二は、1975年にデュッセルドルフに居を構えた時、風景の中でオブジェの上に彼自身を写した写真のシリーズでスタートした。彼は親指と人差指を伸ばして遠く離れた教会の尖塔をとらえる。このような空間と様々な力学的関係をとらえようとする動きは、彼の立体並びに絵画制作における基本の一つである。

所定の状況に合わせて、彼の立体作品における空間と物質、重量と広がり、張力と質量、密度と透明度を対照させる。これに加えて、石、角材、金属、ガラス板や布、枝を刈り込んだ木の幹などの素材も使用する。これらの素材の配置を変えることで、物質の安定度、重力、圧力と引く力、支えと重量、重さとバランスを可視化するのである。更に、これらのインスタレーションを通じて、空間は物質的現象に囲まれて存在するものであると意識させられる。

最も最近の作品のシリーズでは、赤、黄、白のじょうご状の布を天井からメタルワイヤーで吊り、その袋状の内側の頂点と天井との間に、木の幹を突っ張らせている。重力とこれに逆らう布の張力の微妙な緊張の中で、これらのじょうごはかろうじて空間に浮いている。彼はこの原理を立体凧の方に実現した。またこれを平面作品とし凧の絵を描いている。凧の空中における浮遊の原理を、相対する二つの力の均等性を具体化すること、そして、不可視のものを可視次元へ移行させることに成功している。

Inversion Cone, Yellow/Red
Acrylic 208 × 208 cm
Kite-maker: Sumitaya

Cone White/Yellow/Red 1988
Cloth, bamboo, cord
Free form 166, 140, 125, 38 cm
(picture not in the catalogue)

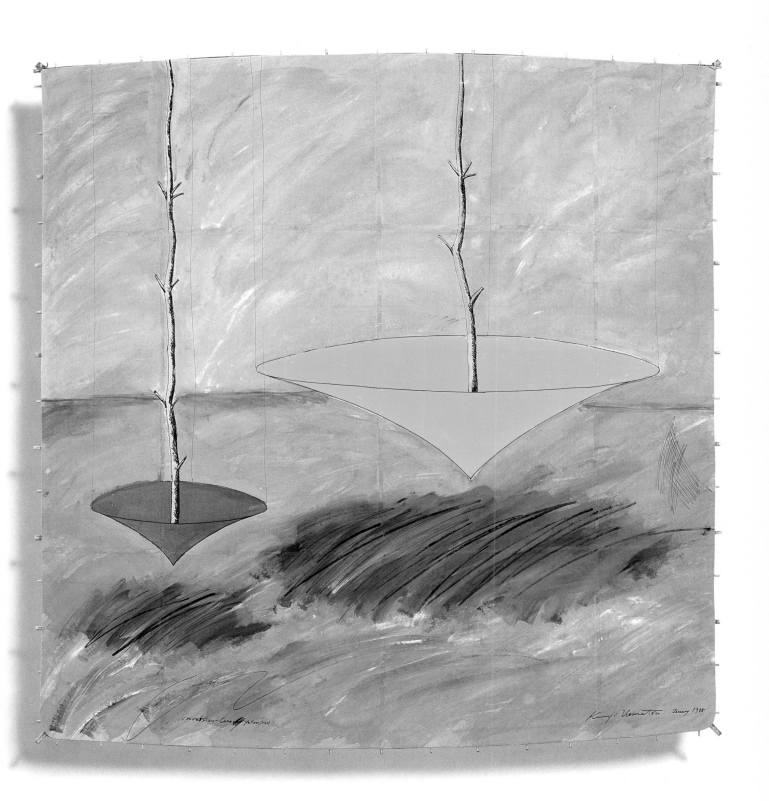

Inversion–Cone *yellow/red* Kenji Uematsu January 1988

Hisao Domoto

Born 1928 in Kyoto,
lives in Kyoto

Domoto began his career in the style of nihonga, traditional Japanese painting. However, a sojourn in Paris in the 1950s brought about a shift to the Informel, in which style he created large, powerful oil paintings dominated by raging streaks of color and whirling structures.

In the '60s his kinetic tableaux cooled down into rigid geometric forms, especially the circle, a kind of Domoto trademark since 1967. Joining together segments of intersecting circles into pastel bands of color, his interest in positive-negative forms – already dramatic in his Informel pieces – gave rise to multi-dimensional combinations of color and form.

Domoto has since moved form oils on canvas to acrylic on paper and, in series like "Eclipse" and "The Sun", he has created color fields of harmonious structure and spiritual depth. Unlike his earlier works, which all had horizon lines, his new paintings suggest both the limitless space above us, the cosmos, as well as a bird's-eye perspective of the turbulent surface below, the ocean.

In his recent paintings the vibrant movement of his earlier works has re-surfaced, an element of organic restlessness pushing through the rigid geometry of circles to ripple over the paper in rhythmic waves. Such a convergence probably signals new creative developments in Domoto's art.

The Hamamatsu kite was the obvious choice for an artist who most recently has focused on square pictures. His kite was painted in the style of his "Water Series"; when in flight it acts as a mirror reflecting back to us its view from on high.

堂本尚郎は、伝統的な日本画の画家として出発したが、1950年代末、パリ滞在中にアンフォルメル絵画へ移行した。そのエネルギッシュな油絵の大画面の中では、野生的に引いた色線、大きく渦巻く筆の跡がなまなましく見られる。

60年代になって、堂本のタブローはむしろ鎮まり、幾何学的な厳格なフォルムに変わった。1967年からは、円形が描かれるようになるが、これが主要な構成要素になっていく。重なりあった円形が生みだしたセグメントは、パステル風に塗られて、帯状に結びつけられている。すでに彼のアンフォルメルの絵画にはっきりと表れているポジとネガの構成は、彼を多元的なフォルムと色彩の組み合わせへと導くこととなる。堂本は、油彩に代えてアクリルを、カンヴァスの代りに紙を使うようになる。「蝕」や「太陽」のシリーズの中では、調和のとれた色彩構成と宇宙的な深さを実現している。彼の初期の作品では、いわば風景画の場合のように水平線が重要であったのに対して、この頃の絵は、我々の上にある際限なき空間（「宇宙」）か、あるいは我々の下で動く面（「水」）を鳥瞰図的に捉えようとでもするかにみえる。画面を捉える唯一の方向は、観る者の目の向け方にあるのみだ。

近年は再び作品の表面に動きがみられるようになり、律動的な波状の動きが巧みに見え隠れしている。以前のように幾何学的な円形が主要な構成要素になってはいるものの、異形のものがある種の混乱をもたらしていて、新たな創造的発展を予告している。

最近では正方形が彼の作品の基本的なフォルムであるところから、堂本尚郎のアート・カイトにはそれに近い浜松凧が選ばれている。天空への凧に彼は、「水」のシリーズからその一つを描いた。上空から見たものを地上に映し返す鏡の凧になるといえようか。

Critical Threshold: Water
Acrylic 240 × 240 cm
Hamamatsu kite
Kite-maker: Sumitaya

Otto Piene

Born 1928 in Laasphe, Westfalia,
lives in Düsseldorf and Groton, Mass.

"Light is the first condition of seeing. Light is the sphere of color. Light is the life element of both man and painting."

Together with Heinz Mack and Günther Uecker, Piene founded Group ZERO in the late '50s to oppose what they perceived as a superannuated Abstract Expressionism. Seeking a return to the source of painting, they pursued a new thematic treatment of light, turning the canvas into an instrument for capturing, structuring and expressing all the nuances of intangible light energy.

Like an magician, Piene manipulates the elements of light, air and fire. First he developed a kind of raster screen out of punch cards, through which he applied paint onto the canvas.

Piene has also projected the interplay of light and smoke onto paper and canvas with the help of punch cards. He has created circular "smoke paintings", as well, realized by the random flickering of flames.

Under the general heading of Sky Art, Piene has recently produced "light sculptures", luminous, kinetic objects and transparent balloons filled with colored gas – all designed for open-air events like his launching of a vinyl rainbow for the Munich Olympics.

All typically Piene elements are present in his art kite. True to his dictum that it is not the artist, but light, itself, that does the painting, he has left the surface of the washi largely uncolored so as to make best use of its transparency. Also, he has allowed the silhouette of the bamboo framework to be incorporated into the composition.

Working within this fixed rhythm, Piene has lit little flickering flames in each identical square. As in his smoke paintings, he has again employed the circle as a sign of concentration, but this time the interplay of randomness and calculation creates a different effect: the paint was sprayed on in such a way that the running of the gold pigment becomes an integral part of the design.

The title of this poetic kite evokes sky, stars and gold. Piene seeks "A peaceful conquest of the soul, rendering it sensitive".

「光は、見えるということすべての第一条件である。光は天空における色彩の層である。光は人間の生命要素であり、絵画の生命要素である。」

1950年代の終り頃、オットー・ピーネはハインツ・マックやギュンター・ユッカーらと共にグループ・ゼロを設立した。彼らは生き残りのタシズムに反対し、絵画の根源に立ち戻って芸術における光という新しいテーマ展開を見い出そうとしたのである。彼らはタブローを、非物質的な視覚エネルギーである光をとらえ、構築し、ニュアンスを表現するための道具へと変容させていった。ピーネはこの時、まるで魔術師のように光や空気、炎などを扱った。

彼はまず、自分で穴をあけたカードをつくり、その穴を通して絵の具をカンヴァスに塗り込むという網目スクリーン画を編み出した。光はここで動きの担い手となって震動を起こすのである。彼は同じ網目スクリーンを光のバレーにも使っている。可動式のハンドランプがそのパーフォレーションを通して空間いっぱいに光の乱舞を生み出すのである。そしてさらに、穴あきカードを使って、光と煙を紙カンヴァスの上で作用させた。意図された偶然によって炎の描く丸い形の煤煙の絵画が生れたのである。

デュッセルドルフで行われた壮大な光のキネティック・パフォーマンスでは、光彫刻や動く発光体、着色ガラスを詰めた透明の光風船などを使って、「スカイ・アート」プロジェクトを実現し、その後今日に至るまで、ピーネは「スカイ・アート」の仕事をすることになる。

今回のアート・カイトには、彼の芸術の今日までのすべての要素が集結されている。彼自身ではなく光が描くのだ、というそのモットーに従い、和紙のもつ光の透過性も活かして彩色はあまり行っていない。それによって竹骨のシルエットも絵の構成要素になっている。そのリズムに従って、規則正しい碁盤目の中にゆらめく炎が描かれている。煤煙の絵画と同じように、精神集中の可視的なフォルムとしてここでも円形を使っているが、それはまた操作された偶然によってそのモチーフを生き生きと変化させている。金色の絵の具はある分量まで垂れ流れるよう吹き付けられたのである。

空、星、そして金色の輝きのニュアンスを持つ詩的なアート・カイトによって、オットー・ピーネは「感受性による精神の平和的な征服」に成功しているのであろうか。

Star Coins
Spray color, gold
Hamamatsu kite 160 × 160 cm
Kite-maker: Sumitaya

Tadaaki Kuwayama

Born 1932 in Nagoya,
lives in New York

"Neither ideas, thoughts, philosophy, feelings, meaning – nor even the artist's personality – are inherent in my paintings. They are pure art, that is all."

With this remark in 1964, Kuwayama described the nature of his art, a conception wholly in accord with Minimal Art trends in America at that period and reminiscent of similar observations from Frank Stella. More than with most artists, a glance at Kuwayama's personal history is useful for explaining his work.

Following studies in traditional Japanese art in Tokyo, Kuwayama moved to New York in 1958. Using washi and Japanese brushes, he started out by painting monochrome surfaces in dry color tones, subdivided into sections by silver strips. Later, he switched to canvas and acrylics, with his colors taking on the cool, reflective smoothness of lacquer. Adding metal powder helped accentuate the synthetic character of this "cool" art.

Since the mid-1960s Kuwayama has been using chrome strips and thin black borders to subdivide and surround his color squares, thus establishing a type of personal style termed "systematic painting". Recently, besides panel paintings, he has been creating "picture screens", hinged pieces that draw upon the ancient tradition of Japanese folding screens.

The ascetic concentration found in both the proportions and stillness of his paintings is reminiscent of the geometrical structure of classical Japanese architecture. In the way it confines itself to only bare essentials, Kuwayama's art does, indeed, deserve to be called "pure".

「観念も思想も哲学も感覚も意味も、また画家の人間性さえも、私の作品の中には入っていない。アートそのものがあるだけである。ただそれだけなのだ。」

1964年、桑山忠明はこのように自らの芸術を説明している。彼の見解はこの時期のアメリカン・アートの傾向（ミニマル・アート）と一致していて、フランク・ステラの同じような発言を思い起こさせる。とはいえ、客観的に観賞する限りでは、彼の芸術が、その個人的な生い立ちの中に見られる納得のいく説明になっている。日本の伝統芸術の背景がなければ、あるいは60年代のアメリカの芸術がなければ彼の今日の芸術は想像し難い。

東京芸術大学で日本画を学び、その後1958年に桑山はニューヨークに渡る。彼は最初、和紙に描いていた。和紙のモノクロームの表面に乾いたつや消しの仕上りになる絵の具を日本画の筆で塗り、その画面は銀箔の帯によって分割した作品にしていた。その後、アクリルとカンヴァスの作品に移行する。彼の色彩は、エナメルの、反射する冷たい滑らかさが強くなっていく。メタリックパウダーを加えることにより、このクール・アートの人工的な特徴がより強くなっていく。60年代半ばより、彼の作品は、四角の色面を黒の細い縁どりで囲み、画面がクローム・ストリップで分割される色面パネルになる。このシリーズで彼は独自のスタイルを確立し、「システミック・ペインティング」に位置づけられる。近年は、レリーフ絵画だけではなく、立体絵画も制作している。それは何重にも折りたためる、両面に彩色された空間造形であり、日本の屏風の伝統に結びついたものである。

桑山の絵画はまた、日本の伝統的家屋における幾何学的構造を思い起こさせる。その厳しい節度と凝縮は絵画のプロポーションの中にも、瞑想的な静寂の中にも再現されている。彼の芸術は真髄だけに制限された「ピュア・アート」であるのだ。

Four Black Squares
Acrylic 237 × 237 cm
Hamamatsu kite
Kite-maker: Sumitaya

Frank Stella

Born 1936 in Malden, Massachusetts,
lives in New York

Entering the New York art scene in 1959, Stella immediately became its enfant terrible because of his "Black Paintings". These works consisted of various geometric forms with black stripes, between which thin, unpainted white spaces on the canvas served to illuminate and structure the surface.

The patterns on these works first included triangles, labyrinths, diamonds and concentric squares; and then, later, "V", "L" and "T" forms, trapezoids and parallelograms, as well as series based on combinations of semi-circles. Stella colored in the shapes with deep, smooth pigments from Hard Edge painting, allowing the outer edge of the canvas to follow the outline and thus produce "shaped canvases". The unusual forms notwithstanding, Stella's prime concern as an artist is color.

"My painting is based on the fact that only what can be seen there is there. It really is an object. Any painting is an object and any one who gets involved enough in this finally has to face up to the objectness of whatever it is that he's doing. He is making a thing . . . What you see is what you see."

In 1970 Stella once again caused a stir in the art world. In contrast to his preceding minimalist phase, the new works – boasting exotic colors highlighted by thickly-intertwining metal relief that produced a sense of three-dimensionality – came to be called "maximalistic".

Stella's art kite, however, points back to his earlier concentric squares series, a motif that he has varied and continues to explore to this day. The kite is an adaptation of a piece called Gran Cairo, a title referring to the name the Spanish conquistadors gave to the Yucatan, an area whose stepped pyramids inspired the geometry of the painting.

フランク・ステラの輝かしい経歴は、1959年、ニューヨークの美術界に異端児として登場することから始まる。彼はブラック・ペインティングで衝撃的なセンセーションを巻き起こしたのである。それは、黒い帯から幾何学的なかたちが組み合わされ、構成され、黒い帯と帯の間が細く色抜きされた白い空間のある絵画であった。これらの線はデルタ、ラビリンス、ダイヤモンド型、正方形の中の正方形などを形成していく。後には、V字型、L字型、T字型、台形や平行四辺形など、不整多角形シリーズや分度器シリーズがそれに加えられる。カンヴァスの外形が幾何学的な図象に基づく「シェープド・カンヴァス」になるのである。ストライプや分割した部分を彼はハード・エッジの様式で濃く、均一に彩色する。カンヴァスのかたちが普通でないにもかかわらず、彼の絵画にとって重要なのはやはり色彩である。

「私の絵画は、そこに存在するものが視覚的であるという事実に基づいている。事実、絵画はひとつのものなのだ。どんな絵画ももものであり、ものにぶつかってかかる人間は誰でも、行為が何であろうとその物質性を認めるにちがいない。画家がひとつのものをつくっている。そのもの……。君が見ているものが君に見えるものなのだ。」

1970年、フランク・ステラは再び美術界に衝撃を与える。思いもよらぬ様式の転換により、画家としても彫刻家としても第二の輝かしいキャリアを築いていく。それは、これまでのミニマル・アートの表現に相反して、マキシマル的であると表現されるものである。色彩の支持体に荒々しく交錯したメタルレリーフであり、エキゾチックに様々の色を使って彩色し、立体絵画の印象を与えるものである。

フランク・ステラは、今回あの有名な「Concentric Squares」に溯ってアート・カイトの作品にしている。正方形の中に次々に正方形を描いていくという基本を、彼は60年代に展開させ、最近まで繰り返し様々のヴァリエーションを作ってきた。そして凧の絵は「Gran Cairo」から変形させたものである。そのタイトルは、ユカタン半島のスペインの南米征服者の呼び方と、この絵に引用されている幾何学模様の暗示を得たその地の階段状のピラミッドに由来している。

Frank Stella Art Kite
Acrylic 208 × 208 cm
Hamamatsu kite
Kite-maker: Sumitaya

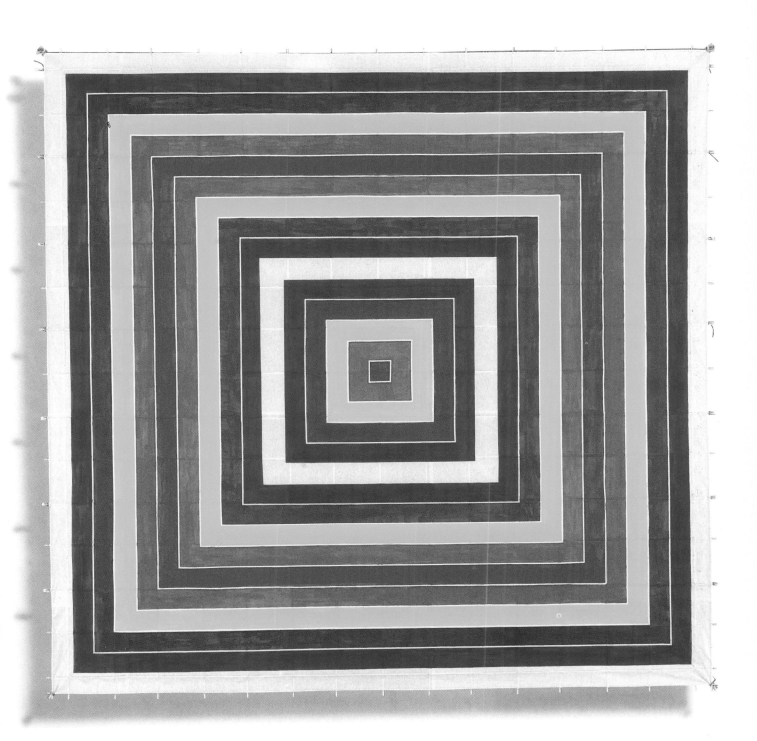

Jan Dibbets

Born 1941 in Weert,
lives in Amsterdam

It was a 1967 experiment with a lawn that led to the development of Dibbets' personal style. Having cut out and removed sod in the shape of a trapezoid, he photographed the site from such an angle that it appeared to be a rectangle, and thus began his use of "perspective correction" as a stylistic device.

In photography, Dibbets found a most suitable medium for realizing his conception of optical illusion. What we see in a photo is not the same as what is photographed, of course, but only an image on the surface of the film. The artist has gone to great pains to arrange subjects so as to produce the desired photograph, even repeating the lawn experiment on a gigantic scale with a bulldozer on a beach on the North Sea coast!

By making montages out of spatially sequential photos, Dibbets has also created panorama graphics, landscapes and building scenes that reveal changing aspects of light, shade and perspective. In similar works done in chronological sequences he managed to capture the invisible flow of time and make it visually apprehensible to the observer.

With his art kite Dibbets again demonstrates the phenomenon of perspective correction. Against a black background we recognize an object which appears to be suspended by black strings. The eye perceives a foreshortening of perspective, but this remains puzzling until one turns the work upside down and sees how it is produced. But no matter how it is regarded, the foreshortening effect remains an illusion, for the wooden object is mounted directly onto the paper surface.

As for the black lines, they are actually a complicated arrangement of susudake – old, smoke-stained bamboo retrieved from the eaves of old farmhouses – the whole ingenious solution being perfected by Kyoto kitemaster Nobuhiko Yoshizumi. There is no better illustration of the Homo faber vs. Homo ludens aspect of Japanese kite-makers than that they often painstakingly create exquisite work for the unseen back side of a kite, work that will never be known by anybody but themselves.

ヤン・ディベッツは、1967年に、彼の芸術様式の基点ともなるべき、大地を利用した実験を試みた。姉の家の前にある芝生を刈り込んで台形をつくり、これが矩形に見える角度から写真を撮った。これが彼の表現手段となる「遠近法の矯正」の現象の最初の試みなのである。

彼は写真の中に、視覚的イリュージョンという彼の考えを実現するための適切なメディアを見い出した。写真に写し取られたものは撮影されたものそのものではなく、写真の表面に表われたものの像にすぎない。そこでディベッツは、物体が写真の上で自分の望むかたちになるように物体をしつらえたのである。芝生の実験を彼は北海の浜辺でブルドーザーを使って大きい面を描いて繰り返していった。

後になって、景色、建物などの連続写真を様々の位置から光や陰影、遠近法で裏づけ、パノラマ・グラフィックにしている。彼はまた、時間の経過を連続的にすることにより、見えない時間を視覚的にとらえ、流れる時間の現象を可視的に記録することに成功している。

ディベッツはそのアート・カイトにも「遠近法の矯正」の現象を持ち出している。黒く塗られた背景の上には、白い面の前に浮ぶような、黒い糸で止められている物体が認められる。白い和紙の上に作られているこの四角い幾何学的な構造はいかにも日本的空間を思わせる。これが我々の目には謎めいた遠近法による短縮に写る。(この絵を逆にしてみると、遠近感覚がよりよく理解できる。)いずれにしても、遠近法による短縮現象はイリュージョンである。ここで木製の物体は和紙の上に平らにとりつけられている。

ヤン・ディベッツ・アートカイトの製作は、きわめて高度な技術を要することになるが、日本の凧づくりの人々の中でも特に完全主義者たちを刺激することになった。京都の吉積信彦は芸術家の期待に応えて製作にとりくんだだけではなく、同時にホモ・ファーバー，ホモ・ルーデンスの精神をも満たす凧を作った。白い和紙の面に見られる黒い線は、近くでやっとわかるほどの細く削った煤竹でつくられている。複雑に編まれたその様子は紙に透けて見えるが、遠くからはとうてい認められない。凧の裏側にこそ凧の隠された美が潜んでいるのだ。

Minneapolis-Kyoto
Japanese black ink, balsa wood, bamboo
Kaku kite 182 × 182 cm
Kite Association Kyoto

Shu Takahashi

Born 1930 in Hiroshima,
lives in Rome

Living and working in Rome since 1963, Takahashi reveals the influence of Italian design in his paintings, works in which monochrome surfaces of white, black and red predominate. Within his four-part paintings – mainly oblong in shape – these surfaces are contoured with elegantly curving lines, and are nearly always symmetrical, like the smooth lines of the human body.

After painting variously shaped segments of the canvas in contrasting hues, the artist stretches them over correspondingly shaped wooden frames and then fits them together. (When hanging separately in his atelier, these positive and negative forms – reproducing the curves of violins, cellos and grand pianos – make the room look like an instrument maker's workshop.)

It is essential that each contoured form is joined together with its exact complementary piece, making Takahashi's works "symbolic" in the original sense of the word: rejoining together two halves of a severed whole.

The meeting line – often deepened with a furrow and vividly painted in a contrasting shade of color – represents the visual crux of his pieces and almost always runs vertically up the center. Moreover, as the two halves approach each other, subtle gradations of pigment heighten the excitement.

Many of Takahashi's works are designed to be shown two different ways. Not surprisingly, therefore, the artist informed the Project that his kerori kite should be occasionally turned upside down in the exhibition!

1963年、高橋秀は奨学生として研鑽を積むためローマに移り、それ以来イタリアの首都にて芸術活動を続けている。

彼の絵画にはイタリアのデザインを窺わせるものがある。白、黒、赤といったモノクロームの平面が全体を支配している。ほとんどが横長の形であるが、正方形のものも含めて四角形のカンヴァスの中で、モノクロームの平面が互いに対をなして落着いたバランスを保っている。しかも常にエレガントなうねりをもった輪郭線でかたちがつくられ、その多くはシンメトリーである。このようなかたちからは、自然に人間のなめらかな体の線を連想してしまう。彼の絵画は素材に彩色されているだけではなく、面レリーフのように様々なかたちのものが前後に重ねられている。この画家は変形のカンヴァスの一片一片に彩色し、適当に輪郭をとった木の支持体の上に広げ、それをレリーフ状に構成している。彼のアトリエにはこれらのポジとネガの素材が所狭しと掛かっており、楽器を製作するアトリエを思わせる。ヴァイオリンやチェロやグランドピアノのもつやわらかな曲線がそこにある。重要なことはそれぞれの輪郭によるかたちが的確なベターハーフと接合されるということである。このように見ると高橋秀の絵画は、二つに裂かれた一対のものを再び接合させるという意味において「象徴的」であるといえる。

接合の場が彼の絵画の中心的なテーマであるが、そのため切断点は常に絵の中心を通って垂直に延びる線上にある。多くの場合、それはくびれのような深みをもっており、例えば赤などの刺激的な生々しい色に塗られている。二つのかたちが出会う尖鋭の部分には、傷口の痛みに触れるかのような官能的な繊細さを表現する色のグラデーションがなされている。

高橋秀の絵画は、二つの表現様式によってその構成が実現されている。かたちの要素が上下、左右の二重の鏡像に写るよう、作品の上下を逆にすることである。従って今回のケロリ凧が、彼の希望により時には上下逆に掛けられたとしても驚くことではないのである。

Untitled
Acrylic 170 × 300 cm
Kerori kite
Kite-maker: T. Kashima

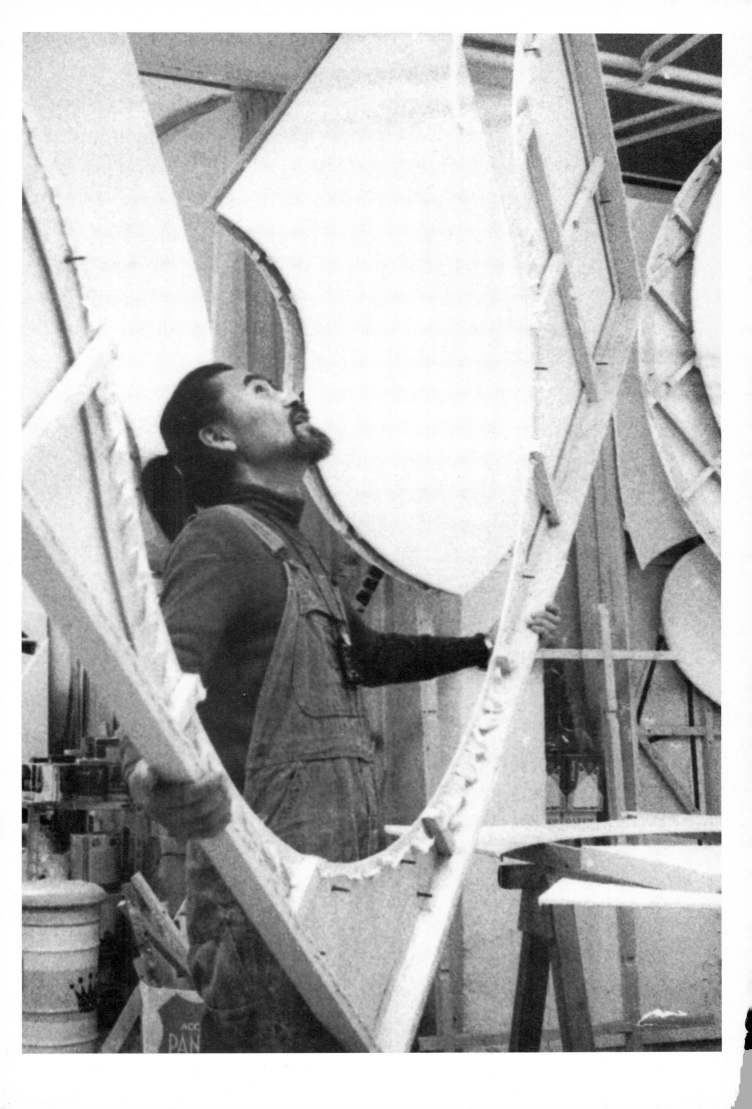

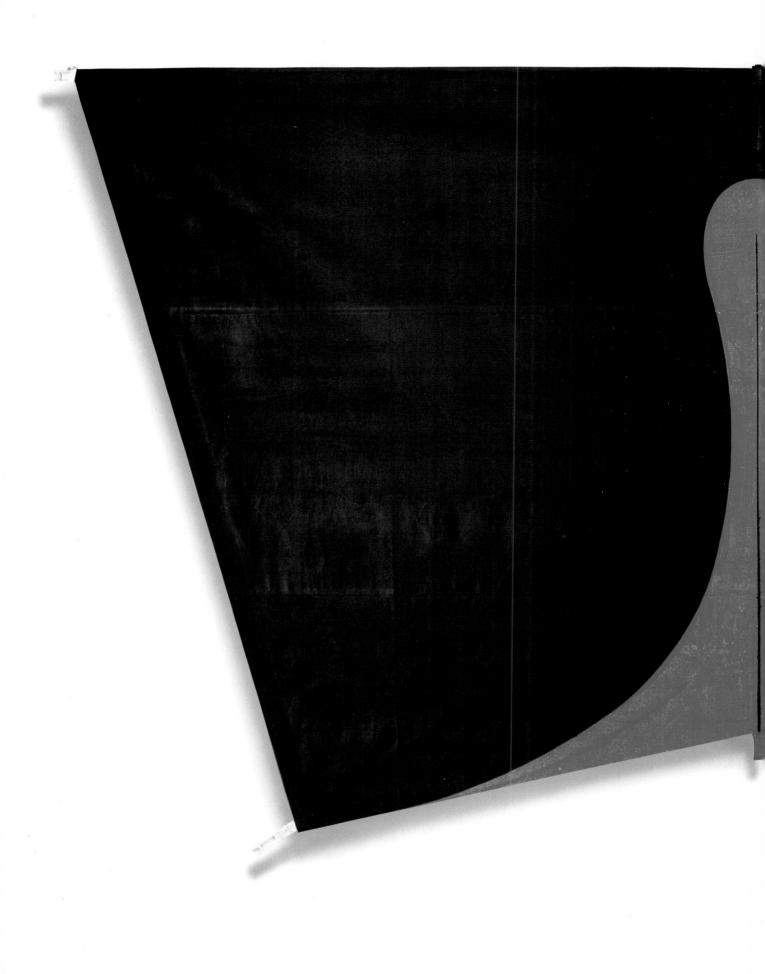

Yoshio Kitayama

Born 1948 in Shiga,
lives in Kyoto

Since washi, bamboo, wire, string, dye and glue have been his materials of choice for over a decade now, Kitayama – perhaps alone among all the artists in the Project – must have felt at home with the art kite challenge. His regular bamboo wickerworks – the main focus of his creative efforts – are covered with bits of colored paper and they are made to shift position ever so slightly, like a suspended mobile, to maintain their fragile balance. The rhythm of their convoluted structure generates a sense of movement, while waves, loops, whirls and little nests are all discernible inside the form. Finally, the sculpture casts delicate silhouettes on the wall, a calculated projection of its frailty.

The titles of Kitayama's works – generally odd phrases picked up from the radio – have no recongnizable connection to the pieces. And yet, there exists a relationship between his work and the syntax of the Japanese language. As a Japanese sentence can be extended indefinitely by means of conjunctions, so could the branches of Kitayama's sculptures extend forever into space.

このプロジェクトに参加した芸術家のうち、普段の自分の作品の素材にしているものから凧を制作したのは唯一北山善夫だけである。1979年以降、彼はその仕事に竹と和紙を用いている。針金、紐、染料、糊などは彼の作品に欠かせない材料である。竹の枝を編んで立体的な形を作り、それに細かい和紙の色紙を張りつけて完成させていく。作品は宙に浮かんでいるようであり、ちょうどモビールのようにくずれやすいバランスを重心の移行によってかろうじて保っている。構成のリズムから動きが生じて、作品を含む空間の中に波、輪、渦巻や巣が形成されていく。彼は空間彫刻を支える物として壁を用いることが多く、作品が投げかけるやわらかな影も、軽さと繊細さを表現する要素となる。

北山が作品につけるタイトルには作品との関係が見られない。その多くは、偶然ラジオから流れてきた文句の一部を取ってつけられる。それでも彼にとっては、作品の構造と日本語のシンタックスとが内なるつながりを持っているのである。それは接続詞で日本語の文章を無限に長く延ばすことができるのと同じように、彼の作品も枝分かれして拡がり、成長してゆくのである。

Fresh Water, Please!
Bamboo, Japanese paper, acrylic, copper wire
Free form 166 × 128 × 81 cm

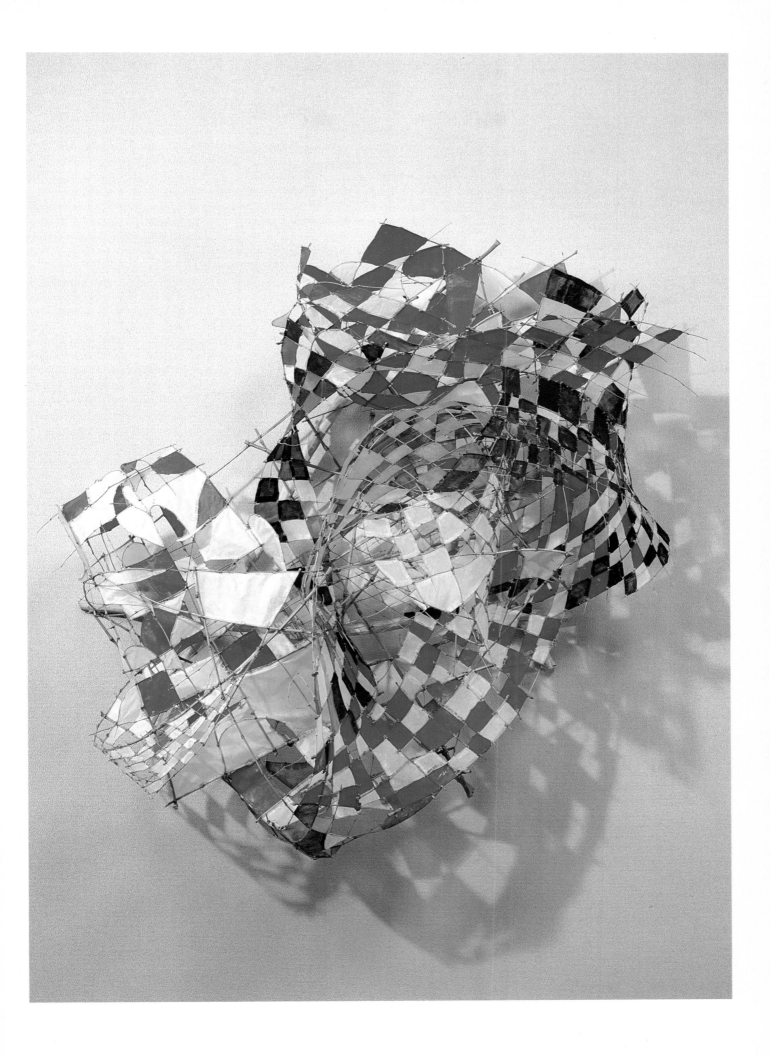

Ben Vautier

Born 1935 in Naples,
lives in Nice

"There's nothing to be said of Ben Vautier. He has said it all. No matter how and no matter where. And, at times, no matter what." (Claude Fournet)

「ベン・ヴォーティエについて語ることは何もない。彼が自らすべて語ってしまっている。どんな風にでも、どこででも、時には何でも」（クロード・フュルネ）

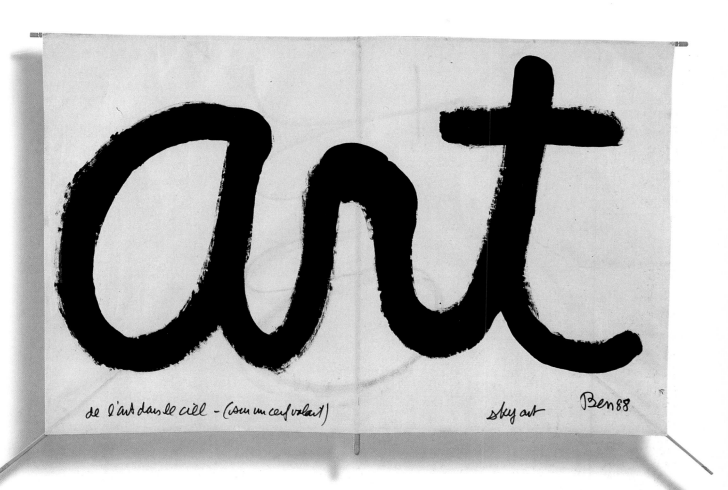

Art of the Art in the Sky
Acrylic 64 × 98 cm
Tahara kite
Kyoto Kite Association

Ay-O

Born 1931 in Ibaragi,
lives in Tokyo and New York

Of all the painters who place light at the center of their work, Ay-O is probably the most analytical, having methodically broken light down to its components in his color spectrum pieces. Since 1962 his paintings have resembled rainbows, consisting of all the natural hues between ultra-violet and infra-red. He also colors figures in brilliant spectral patterns – frequently borrowing motifs from the polychrome ukiyo-e wood-block prints – and treats solid objects that "need covering" in a similar way.

At the 1966 Venice Biennale, Ay-O represented Japan with his "Rainbow Environment", and in numerous rainbow happenings around the world his pieces have caused a sensation – most recently at the Eiffel Tower, where his full-length banner helped celebrate its centennial.

Ay-O is producing fewer and fewer figurative works of late, his most recent series being limited to a strict color spectrum arranged in 96 horizontal strata. But this reductionism is leading to greater intensity, precision and seriousness.

光を創作の中心にする多くの画家の中でも、靉嘔の光の扱い方は最も分析的である。彼は光を分解して彼のスペクトルの色を作品に描いている。1962年以来、彼の作品は虹のように、スペクトルの紫からスペクトルの赤までのすべての色を包括している。靉嘔は最初、フィギュラティフな像を対象に色あざやかなスペクトルに彩色していたがそのモチーフになるのは、しばしば浮世絵の多色摺り木版画を引用したものであった。時には立体作品も色とりどりのスペクトルで覆っている。1966年のベニス・ビエンナーレでは日本を代表して「虹の環境　№.3」を出品した。数多くのレインボー・ハプニングにおいても、彼の人工虹はセンセーションを引き起こしている。エッフェル塔の100周年記念の際には、塔の尖端から地面まで虹の帯を張り下したのである。

近年になって、フィギュラティフな作品が少なくなってきており、最近の作品のシリーズでは、96色のグラデーションに凝縮した色彩スペクトルを水平に扱った絵画内容に変ってきている。この単純化によって彼の絵画は、内的緊張度を高めることになった。表面的な機知にとってかわって厳格な真剣さが、効果にとってかわって精神性が生まれた。断念することが獲得することになったのであろうか。

Rainbow Kite
Silk-screen 92 × 183 cm
Buka kite
Kite-maker: T. Uno

Ernesto Tatafiore

Born 1943 near Naples
lives in Naples

Though a practicing psychoanalyst, Tatafiore is more widely known as a member of a group of young Italian artists called Transavanguardia. Already as a child he painted landscapes and, to this day, his art has remained figurative, encompassing drawings, painting and collage.

Often his drawings are executed on extremely thin paper, which he then tears up and pastes on other paper or cardboard, giving his work a fragmentary aspect. Written messages are also a common element – titles, commentaries, etc. – and these must be seen as an integral part of the whole piece.

The writing and quotations often refer to the relationship between art and myths or history – he has done a series on the French Revolution, for instance – and one can always find a correlation between image, language and thought. It is not always readily apparent, however, as his inventiveness is addressed to the emotions as well as the intellect. Tatafiore's art kite depicts a few creatures of the sea, like the cuttlefish and octopus, that have long been a part of kite symbology. But encountering a whale in the sky is far less common, and an observer could easily be thrown into a state of perplexity and wonder!

エルネスト・タタフィオーレは「トランスアヴァンギャルディア」として知られるようになったグループ「若いイタリア人」の一人である。精神分析の医師でもあるこの芸術家は、生粋のナポリ人で、幼少の頃からすでに、父親のそばで写生をしていた。彼の絵はそれ以来具象画である。その様式は伝統的なもので、ドローイング、平面絵画、コラージュなどを制作している。好んで透けるほどの薄葉紙に描いているが、時にはこれを引きやぶったり、他の紙や厚紙に張りつけたりもする。そのため未完成のような印象を与えることがしばしばある。また彼の作品には、よく文字が描き込まれ、絵のタイトル、コメント、画家のサイン等がそのまま絵の構成要素となっている。

書き込まれた文字や引用句は、彼の絵と歴史（フランス革命に関する一連の作品を描いている）や、神話、思想との関連性を示している。絵と言語と観念の相関関係はたとえその意味関係が時には不明瞭であっても、つねに存在する。彼の絵画の着想は、感性はもちろん理性にも訴えるものであり、官能的であり、また知的でもある。

タタフィオーレはアート・カイトに、自然科学の講義に使う図表のように黒い石盤の上に海洋の小動物を描写している。絵を見て描かれたものを観念的に分類しようという意識は自然に働いてしまうものである。タコとイカは、日本語では昔から凧を表現する言葉であるが、空をとぶ魚として鯨に出会うことを、観る者はどう理解すればいいのか、困惑してしまう。しかし、それはまた感覚に訴えてさらに楽しみを得、注意深く観察するよう刺激しているのであろうか。

In Naples there is a point
where affluence and poverty,
light and darkness,
sky and sea
touch each other.
At this point
images grow lighter
and fly.

ナポリには
どこにでもひとつの点がある
それは富と貧困、
光と闇、
空と海とが触れる点
この接点で
おまえの心象は軽やかになり
そして飛んでいく

Tatafiore in Naples
Acrylic, paper collage
Buka kite 120 × 200 cm
Kite-maker: H. Shimizu

le cose
dell'aquilone
al vento
diventano
MARE

aquilone per il Goethe
di OSAKA
titolo:
"Tatafiore a Napoli"

colori acrilici

A NAPOLI

"Tatafiore a Napoli"

c'è sempre un punto
 a Napoli,
dove ricchezza e povertà,
le luce e il buio,
il cielo e il mare
 si toccano.
In quel punto
le tue immagini
si fanno più leggere.
 Volano.

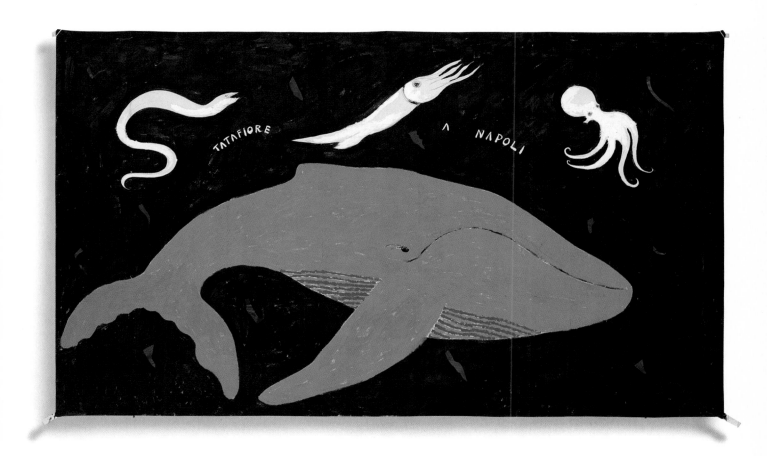

Bukichi Inoue

Born 1930 in Nara,
lives in Kamakura

While at the Künstlerhaus Bethanien in Berlin from 1974–79, Inoue developed a "raw space" principle for his "Box Sculptures" in an attempt to give form to the invisible. For him the box represents the human condition and the storehouse for universal culture; plus, at times, a shrine, a coffin, the Ark of the Covenant or a time machine.

In Inoue's metal sculptures, space is surrounded by blocks or else enclosed in a hexahedronal shape. Yet, it seems to project itself outward and even break its encasement. Inoue has put such cuboid structures to use architecturally, as well; for example, in his designs for Japanese art museums.

Inoue's most recent works are entitled "My Sky Hole", signifying the hole through which the artist regards the cosmos. Starting with catacomb-like pieces covered with cubes of plexiglass and iron, he has progressed in this series to huge installations composed of block-like elements.

Using the sun, moon and earth as the models for his sculptures, he has endeavored to approach the essences of these bodies in his work. Naturally, he has long sought a kind of aerial suspension – a celestial installation – of these pieces, something which he can now approximate. With his black sun made into a kite he can elevate his "Sky Hole" concept to a much-desired higher plane.

井上武吉は武蔵野美術大学彫刻科を卒業して、その後フリーのアーティストとして活躍する。1963年、64年には世界一周旅行に出て、パリ、バルセロナに滞在する。1967年、帰国して母校の教師となる。1974年から1979年まではベルリンの「ベタニアン芸術家会館」に住み、この間、Boxをテーマにした彫刻の基本となる「なま空間」を展開する。彼の思想は見えざるものを形作ることである。ここでBox（箱）は、「人間の条件」にとって、宇宙的な宝の大箱という意味で、文化的に価値のあるもの全体であり、それらは社、契約の聖櫃、棺、そして同時にタイム・マシーンでもあるのだ。

彼は数多くの金属彫刻を通してこの原理を現実のものにしている。この彫刻はブロックの間にある空間が取り囲まれていたり、あるいはその空間が正六面体であったりする。この箱のかたちを打ち破るように空間が外へ突出しているものもある。彼は建築家として、この立方体を博物館の建物として実現させている（箱根の彫刻の森美術館、池田20世紀美術館）。

さらに、その後パリに行って、そこでの滞在中に、このコンセプトを変化させたが、それが井上が今日も取り組んでいる「My Sky Hole」である。「Sky Hole」とは、ここでは天をのぞく穴のことで、この穴を通して宇宙を考えようとするのである。この観点から彼の関心はまず地下に向けられ、墓室のようなカタコンベをつくり、その入口と出口の上にはプレキシガラスと鉄の立方体を設置している。

後に、ブロック風の空間素材からなる大規模なインスタレーションにおいて、彼は宇宙的次元を作品に表わそうとしている。例えば平面の弓形にした鉄素材を地面に配列し、あたかも地面から突き出た巨大な規模の物の一部が目の前にあるような印象をよび起こそうとしている。制作の対象として太陽、月、地球などへの接近を彫刻を通して試みていることも理解できる。この芸術家にとっては宇宙に浮いているのが理想的な状態なのだそうであるが、それを実現するには多大なエネルギーが必要となる。しかしそれは無い。井上武吉は少なくともそんな彼の夢を「My Sky Hole」シリーズの「黒い太陽」の凧に託して宇宙に飛ばそうとしているのであろう。

My Sky Hole 37-4 Black
Dye
Free form 210 × 396 cm
M. Okatake, K. Sagawa (Osaka)

Ivan Rabuzin

Born 1921 in Kljuc,
lives in Novi Marof, Yugoslavia

At the turn of the century, Paris discovered Henri Rousseau, his simple, mysterious charm inspiring Picasso, Braque and Apollinaire. Ever since, naiveté – with its pre-naturalistic flatness, precise contours and lack of perspective or shadowing – has been assured a secure place in the lexicon of respected art styles. And, as one of the exhibitions at the 1958 Brussels World Fair showed, it can be found globally, stretching from Haiti to Yugoslavia, from Cuba to the Soviet Union and from Germany to Argentina. As for subject matter, it is mostly based on rural and low-class urban environments.

For our 20th century museum in the sky, Rabuzin has painted one of his typical landscapes: gently rolling hills, round-topped trees arranged in systematic order and a glorious sunrise. Optimism and harmony pervade his work. "I create an order in my paintings that pleases me, I create a world as I would like it to be."

Made into a pair of kites, Rabuzin's earth and sun will circle around one another and, with the help of the wind, stage a sunrise over a charming landscape. Accordingly, the artist has incorporated the Japanese sky into his piece, and he dedicates it all to the children of the world.

19世紀末頃、パリの画家や文筆家たちは税関吏であったアンリー・ルソーの絵画を発見した。その素朴で神秘に満ちた表現の魔術はパブロ・ピカソ、ジョルジュ・ブラック、ギョーム・アポリネールといった近代絵画の先駆者たちに感動を与えることになった。この「フランスの幕開け」より、ナイーヴ・アートは芸術史上に確固とした地位を築いたのである。1958年、ブリュッセル万国博では、この絵画様式がタヒチ島からユーゴスラビア、キューバからソ連、ドイツからアルゼンチンにまで至る国際的な動向として展示作品の中に発表された。この「前自然主義的絵画」の特徴は、平面描写、輪郭の正確さ、遠近画法や立体性を得るためにつける陰影の放棄などである。

今回の「20世紀の空の美術館」のためにイヴァン・ラブジンは、その典型的な風景画を制作した。ゆるやかに連なる丘陵、整然と並べられた丸刈りの木々、その上に昇っていく華やかな太陽が描かれている。楽天主義とハーモニーとが彼の絵画の基調となっている。「私は絵画の中で自分に合ったある秩序をつくっている。それは私がそうあって欲しいと望む一つの世界を創造するということである。」

一対の凧となって大地と太陽は空中でもお互いのまわりを施回しあい、風の力にも助けられて愛らしい景色の上に日の出を演出することであろう。こうして、二枚の絵の背後に見える日本の空も彼は芸術の中に組み込んでいる。この作品が世界の子供たちへの挨拶として理解されることを願っているのである。

Open Sky
Gouache
Buka kite 122 × 185 cm
Kite-maker: H. Shimizu

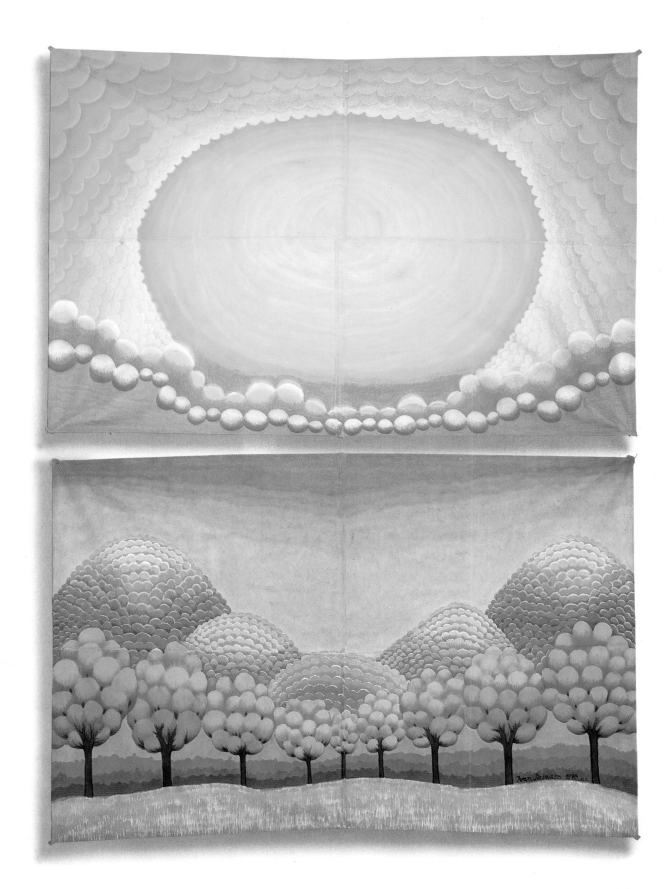

Minoru Onoda

Born 1937 in Manchuria,
lives in Himeji

With seemingly inexhaustible patience Onoda ("The Dot-maker") has strung together millions upon millions of dots in the creation of his artistic universe. Starting from a tiny point, his paintings – through imagination, discipline and industry – develop cosmic dimensions, their inherent principle of perpetual proliferation giving the impression of organic growth.

The dots spread in all directions, have no top or bottom but well out of themselves and stream endlessly beyond the picture frame. The artist, himself, sees them as an expression of life as well as automated mass production.

In the 1960s, as a Gutai Group member, Onoda created a point world on the slightly raised relief surface of boards. His art kite is completely flat, yet it mimics this earlier raised surface, an effect achieved by curved lines and subtle gradations of color in the undercoat.

The points are ordered according to a mysterious schema; one moment they seem to follow a geometric pattern, the next a flower motif. The magic of these macro-structures lies in the energy radiating outwards from their centers. Seen in their entirety, the large figures are suggestive of microscopic cross-sections of flowers or coral, balanced in composition and reflecting an inner harmony.

There is, however, an air of tragedy about these paintings. The accumulation of countless elements and their endless proliferation are a reminder of the emptiness and meaninglessness of human activity, and in such a work we are surely confronted with the ghost of Sisyphus.

小野田實は「マルの行為者」と呼ばれ、自らもそのマルを「私のマル」と呼んでいる。尽きることを知らない忍耐力と根気で、彼は何千万、何億という数のマルを描き続け、そこから独自の絵画世界を創り出してきた。彼の絵は極微の単位から出発して、空想やたゆまぬ努力、規律によって、宇宙的次元へと発展させている。彼の絵が有機物の生命に似ているのは、絶えることのない繁殖の原理が支配しているからである。彼の絵はマル自身から生れ、上下左右の区別なく、あらゆる方向に増殖し続ける。絵の縁を越えてもまだ勢いよく成長を続け、永久に増え続ける。画家自身はそのマルを生命のパラフレーズ、そして同時にオートメーション工場における大量生産のパラフレーズと理解している。

60年代、具体グループに参加していた頃、小野田はこのマルの世界を、レリーフ状の盛り上がった板の上に表現していた。今回の凧の表面も一見、波うっているように見えるが、それは下地に描かれた曲線や、精妙にグラデーションのつけられた地塗りによってその効果がでているのである。

神秘的な規則に従って並べられたこれらのマルは、ときには幾何学的なモチーフになり、ときには花のモチーフになる。このマクロ構造の魔力は、鮮烈な、自らの内から輝き出る力にある。絵の全体像はミクロ的な断面図や花、サンゴなどを彷彿とさせる。構成的にバランスのとれているこれらのマルは、静寂と調和を求めている。

それでもこの絵には、一抹の悲劇性が漂っている。測りしれない分子の集積と果てしない繁殖は、人の行為の無力さとむなしさを思い起こさせる。この作品において我々人間に対峙しているのは、画家の姿をしたシジフォスである。

Work 88-2.24
Acrylic
Tosa kite 282 × 282 cm
Kite-maker: Kite Association, Tosa

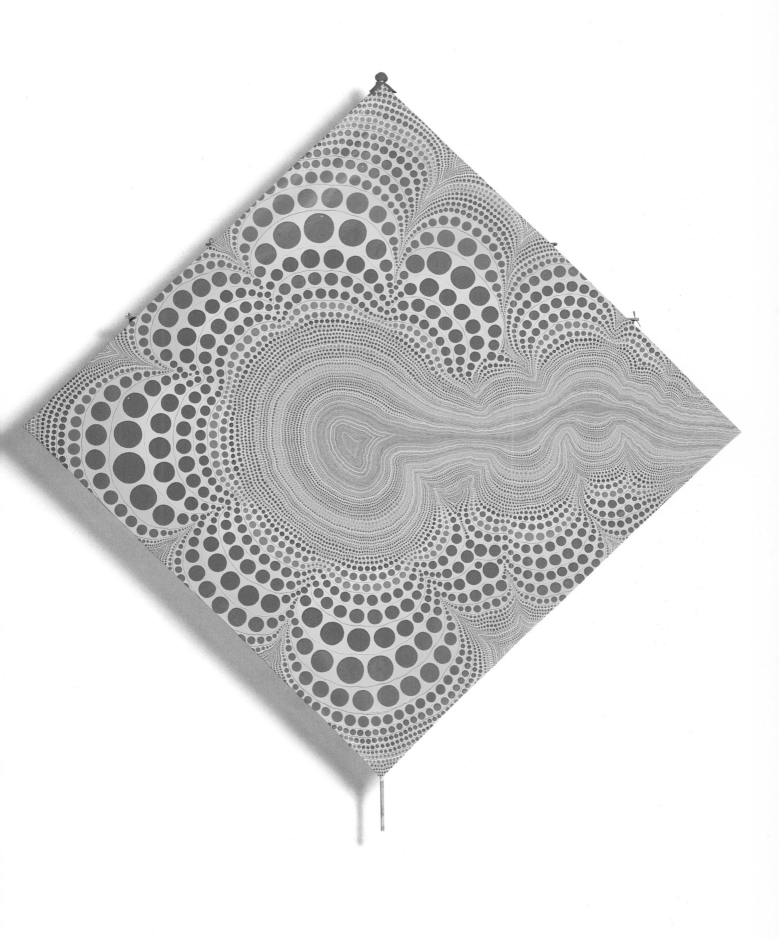

The birth of a heavenly coral reef.
Minoru Onoda, Himeji, February 24, 1988
小野田賣の「空の珊瑚礁」はこのようにして繁殖していった。 姫路にて

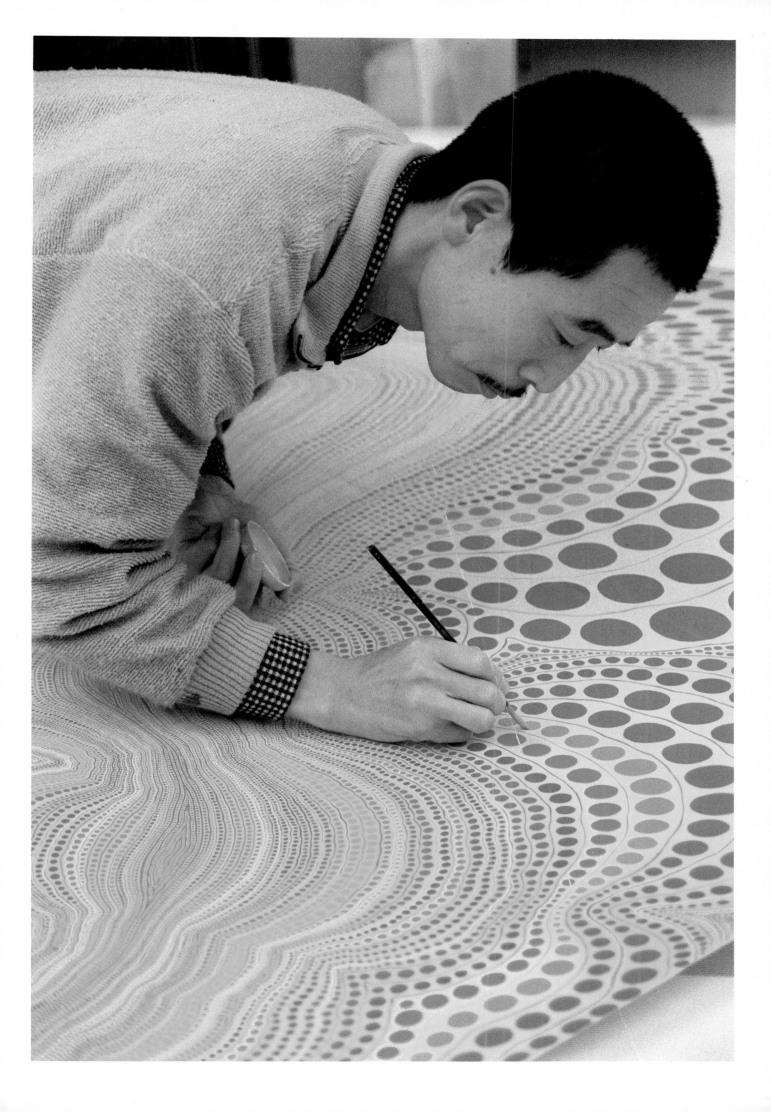

Kazuo Shiraga

Born 1924 in Amagasaki,
lives in Amagasaki

Strongly influenced after the war by elements in German Expressionism, Shiraga devoted himself thereafter to abstract painting, remaining active in the avant-garde Gutai Group from 1955 until its dissolution in 1972.

Founded by painter, industrialist and art patron Jiro Yoshihara, the Gutai Group (Society for Concrete Art) had as its goal the emancipation of painting and sculpture from all prior conventions. Venturing with the Group into Dadaistic performance art, both on stage and in the streets, Shiraga once threw himself into a heap of mud and wallowed there theatrically.

It was at the Group's second exhibition, in 1956, that Shiraga first covered a floor with paper, placed mounds of oil paint on it, and then proceeded to paint with his feet – a technique that to this day remains his trademark. To free his feet for painting, he hangs from a rope suspended from the ceiling. Such works, according to Gutai ideas, accurately record an artist's physical encounter with his materials, and his struggle with the creative process.

In 1960 the Gutai Group staged a Sky Festival in Osaka in which paintings were sent heavenward on balloons. With such a tradition behind them, it came as no surprise that Gutai members Shiraga, Motonaga and Tanaka were among the first to volunteer for the Art Kite Project, suggesting their Homo ludens spirit still burns brightly.

戦後間もないころ、白髪一男はドイツ表現主義に出会い、自分の絵画に必要な要素がそこにあるのを発見した。それ以来、抽象絵画の道に情熱を捧げてきている。1955年前衛派のグループ「具体美術協会」に入会、1972年の解散まで主要なメンバーの一人であった。

具体美術協会は実業家であり、画家であり、また芸術の保護者でもあった吉原治良を中心に、若い芸術家たちによって結成された。その目的は、絵画と彫刻における因襲からの解放であった。その芸術家たちは様式においてはアンフォルメルの傾向をもっており、野外や舞台でのダダイズム的なパフォーマンスで次第に知られるようになった。例えば、白髪は大量の泥の中に飛びこんで全身で格闘するなどのアクションを見せた。

1956年の第二回具体美術展では、紙を床に敷き、その上の絵の具の塊を足で拡げながら作品をつくっていった。それが彼のフット・ペインティングの最初の試みで、その基本線はそれ以来現在まで、彼の創造の中心となっている。彼の制作に必要な道具として、アトリエの天井につるされたロープがある。そのロープにぶら下がりながら白髪は、足で絵を描くのである。それは物質に接触するときの画家の身体的行為の痕跡として、具体運動の、理念にもとづく意図を端的に示している。

1960年、具体は大阪でスカイ・フェスティバルを企画した。会員やヨーロッパおよび国内の芸術家仲間の作品を気球に乗せて空に揚げた。それから30年たって、大阪は再び国際的アート・フェスティバルの出発点となる。現在最も注目を浴びている世界の芸術家たちの作品を空に結集させようというのである。この企画に参加の意思を表明した最初の芸術家は白髪一男、元永定正、田中敦子であった。たとえ「具体」が過去のものになっているとしても、当時の仲間たちの間にはいまもホモ・ルーデンスの精神が脈々と生きているのである。

Purple
Oil 250 × 190 cm
Tsugaru kite
Kite-makers: G. Fukushi, T. Kashima, N. Yoshizumi

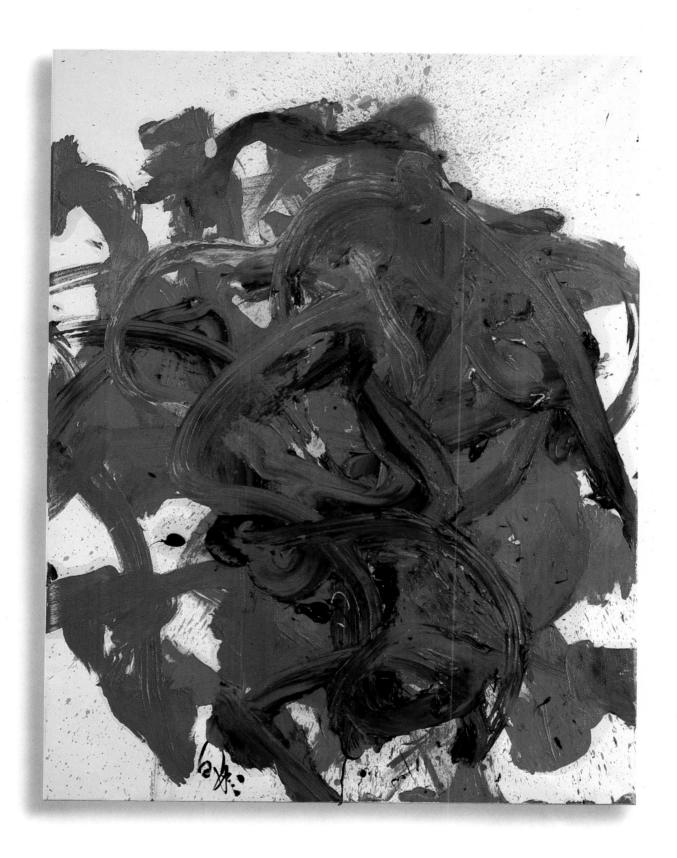

いかのぼり

きのふの空の

ありどころ

　　　蕪　村

A kite

in the same place

in yesterday's sky.

Buson
(1716–1783)

Altitude Flight
Japanese ink, acrylic
Tosa kite 282 × 282 cm

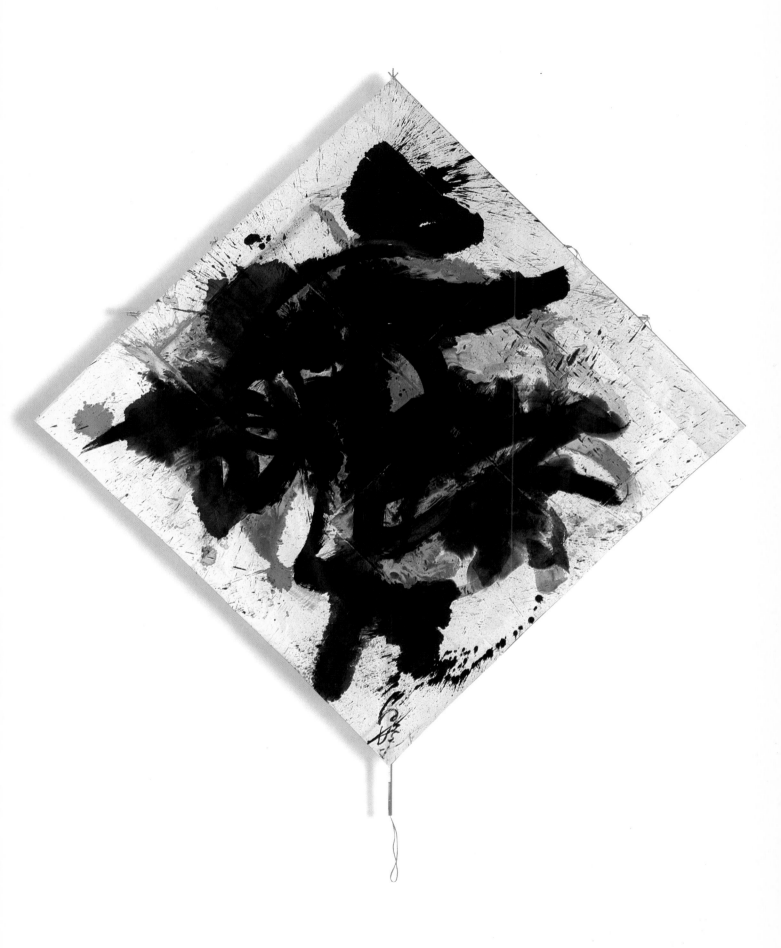

Keiji Usami

Born 1940 in Osaka,
lives in Tokyo

Seldom is the genesis of an artist's inspiration as easy to reconstruct as Usami's. Visiting New York in 1966, he saw an old Watts riot newsphoto showing four men: one bending over, one throwing a rock, another running and the last standing. He cut out these figures, pasted them over his high-rise apartment window, and watched them interact with the outside environment for days on end.

These four figures are the pillars of Usami's œuvre. Over the years he has varied their colors, painted them with laser beams and, more recently, worked them into cosmic mandalas, all the time his focus being issues of identity, objectivity and phenomenological inter-dependence.

For his art kite, Usami worked for the first time with paper, resulting in a work far livelier than his usual pastel-rich canvases.

宇佐美圭司の場合ほど、一芸術家のフォルムの語彙がその芸術の創世記をこれほどまでに明確に再現可能にしている芸術家はそうあるまい。1966年4月、彼はニューヨークに行き、1965年10月号の「ライフ」誌の中の一枚の写真に眼を奪われた。ロサンジェルスで起ったワッツ暴動のデモの一場面のものであった。宇佐美はその中から、かがむ男、投石する男、駆け出そうとする男、そして立ち止っている男の人型を切りとり、39階のアパートの窓に貼りつけた。そこで彼は四つの人型と外部の世界がいかに関連しあうかを体験していったのである。

この時の四つの人型とその背景にある世界との相互の関連性が、後々宇佐美が駆使していく絵画のモチーフになっていく。多様に色彩を変えながら、部分像を重ね合せ、四つの人型の錯綜の仕方を変化させている。その背後にある哲学は、現象学的な相互依存である。ここで彼にとって重要なことは、可視的なものを認識していく時のなりゆきである。四つの人型をもとに、共通の部分像と交換可能な部分を扱うことにより、見る経過を具象化していくのである。彼は、このような基本概念をレーザー光線を使っても様々に実現している。

80年代には、彼の絵画はますます複雑になり、リズムのあるその構成は、まるで絵の中に宇宙が模写されてでもいるかのような曼陀羅を連想させる。

宇佐美圭司は「アート・カイト」の制作の機会に初めて和紙にアクリルを使った。和紙は、地塗りをしたキャンバスに描くよりも、筆のタッチに抵抗があるというのが制作後の感想だ。「凧の絵はいつものパステル調の絵よりもずっと力強く、生き生きとしたものになった。」と彼はその反応をはっきりと述べている。絵が凧になった時、遠くから見ても絵の構成が明確になることを考えに入れたのであろう。

Keiji Usami Art Kite
Acrylic 325 × 325 cm
Tosa kite
Kite Association Tosa

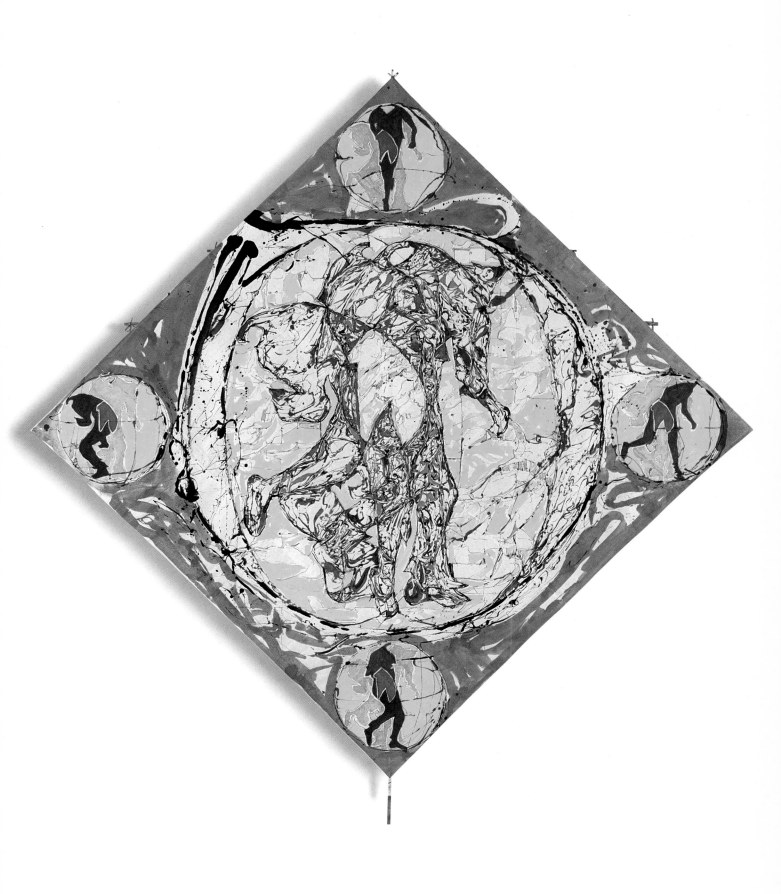

A motif from New York for the sky over Japan. Keiji
Usami in his Toyko studio painting his art kite.

ニューヨークで生れたモチーフが日本に渡って空を翔けまわる。アトリエで
アート・カイトの制作をする宇佐美圭司

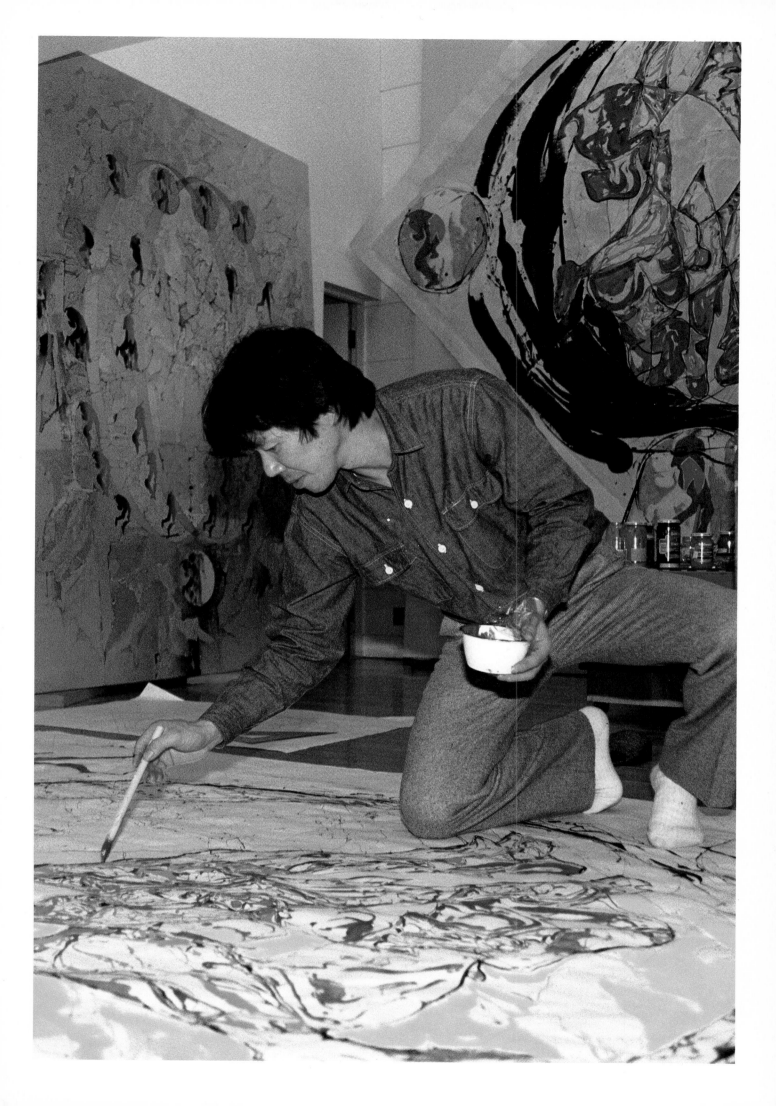

Gérard Titus-Carmel

Born 1942 in Paris,
lives in Paris

Though he has worked extensively in drawing, etching, lithography, silk-screening and Conceptual sculpture, Titus-Carmel has recently turned his attention to large-scale painting. Impressive and obscure in their meaning, these tableaux – generally done in series and variations on a theme – have the physical presence of stage sets.

Objects for Titus-Carmel, though they may be surrounded by geometric patterns or flower-like arabesques, always stand out in statuesque isolation. Some of them seem to represent fans or axes, others flasks or plectrums, but they all appear to be rising upward majestically – an effect heightened by his use of dark backgrounds accented in shimmering white.

Often deriving inspiration from old curios, the artist's links to Japan are numerous. A samurai helmet led to one long series of paintings, while other works have included bamboo-ware, kimono stands and even Shinto paper offerings.

"A word about the kite in the context of my present work. It belongs to the latest variations of my 'Intérieur' series, featuring as it does a lamp as its central figure flanked by newly-included palms.

A dream: to paint a picture of the sky. Or rather, to paint for the sky. And then, one fine day, out of the blue, to begin and realize a painting destined for the sky. A painting which, hardly finished, escapes from my hands, escapes from all hands, frees itself of weight and rises in the sky as high as the highest clouds of smoke."

大きな素描画による作品、銅版画、リトグラフ、シルクスクリーン、更にはコンセプトアートに近い彫刻作品などと並んで、最近、ジェラール・ティテュス・カルメルの芸術の創造の中心になっているのが大きなタブローの作品である。作品をシリーズにすること、ひとつのテーマからヴァリエーションをつくることも彼の創作に重要なことである。これらの絵画は、印象深く、怪しげな意味をもつテーマのもとにつくられる舞台装置の演出のようでもある。彼は多くの場合、そこに幾何学的な図形と植物的で有機的なフォルムを、銅像のように他から遊離させて描き、組み合わせている。そこに描かれるものは、斧、弦楽器のばち、扇子、フラスコといったものを想起させ、それらに何か儀式的な意味でも与える記念碑のように、堂々と浮き上って表現されている。彼はよく、一度は魅せられて求め、時には何年か自分のアトリエに放置している物からインスピレーションを得る。兜もそのひとつであり、これは彼が日本に旅行した際、骨董品屋で買い求めたもので、絵のシリーズのモチーフにしている。引用する他の日本のものといえば、竹細工品、着物掛け、かご、神祭の御幣やぬさ、あるいはともえの紋などである。

黒っぽい絵の背景の色と、輝くような白により際立って美しく明るく映える支配的な土の色が彼の絵画の中で古代の儀式的な厳かさを表現している。

画家自身によって書かれた凧の絵の制作についてのテキストは別に掲載されている。（日本語訳27、28頁）

Picture of the Sky (1988)
Acrylic 284 × 284 cm
Tosa kite
Kite-maker: Kite Association, Tosa

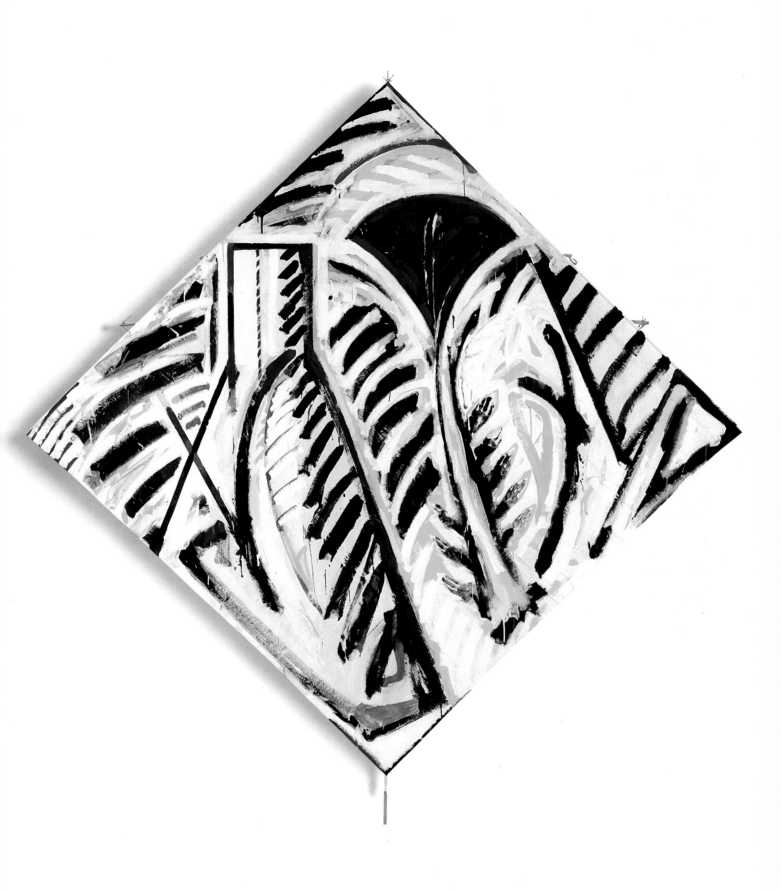

Franz Erhard Walther

Born 1939 in Fulda,
lives in Hamburg

Sculptor Walther, a professor at the Hamburg University of Fine Arts, has been working chiefly with textiles since 1963. Out of such materials he creates hoses, crosses and boxes that he subsequently "wears" – the work of art being incomplete until it incorporates the body and actions of the user!

The fully-enveloped wearer of a Walther piece experiences new conceptions of inner and outer space, as well as a consciousness about material and communication.

"When I stand in one of my works, I can think better and clearer. Other people have had the same experience."

Walther's kite is also a body covering, based on his own head and neck proportions. Of course, there is room for a body only in the spiritual sense, the blood-red collar marking the way into a world beyond the visible.

彫刻家フランツ・エアハルト・ヴァルターはハンブルク造形芸術大学の教授であるが、1963年末以来、とりわけテキスタイルに取り組んでいる。堅い木綿の布を素材にして、ホース状のもの、十字形のもの、箱形のものなど、器具様の精巧な作品を制作している。これらの作品はほとんどが彼自身の体格に合わせて作られていて、すべてが使用可能であり、また、使用されるべきものである。使用するという行為が伴って初めてその作品は完成する。作品を観る者は、同時に使用者となって機能を果し、そのようなかかわりによって本来の作品になるのである。空間、時間、身体が作品の本質的な形成要素である。このように彼の作品は芸術家独自の精神的プロセスであり、観る者との対話のプロセスでもあるのだ。

ヴァルターの作品を被覆することによって受容者が体験することは、ある特別な内界と外界の知覚であり、素材や身体や空間、さらに場面や関連性のもたらす内の状況や外の状況を認識することにある。作家自身、「私は自分の作品の中では、よりよく、より明確に思考できる。私と同じ体験をもった人もいるはずだろう。」と述べている。

ヴァルターの「龍の表皮」の大きさもまた、その身長、頭や首の大きさに合わせてつくられている。"身体を覆う"べき彼の布製の凧は、ただ、その精神を覆うだけだ。そして真赤な抜け穴は、向こう側の世界への道を意味しているのか。

Measurements for Flight
Cotton cloth
Tosa kite 250 × 250 cm
Kite-makers: N. Yoshizumi, T. Okajima, I. Fujieda,
O. Okawauchi

Sadamasa Motonaga

Born 1922 in Mie
lives in Takarazuka and Iga-Ueno

Born in a small city in Western Japan famous for its ninja heritage, Motonaga has called his work "ninja art" – for its changeability, the crafty humor, and the curious performances of its colorful creator.

When he joined the Gutai Group in 1955, Motonaga's paintings already consisted of simple forms on bright backgrounds, variations of which have appeared again and again to this day. A small, black flying triangle of 1957, for example, re-appeared in his 1970s silkscreens. Now, two decades later, that form has finally taken flight as a kite, accompanied by two of his distinctive round forms spray gun-colored in Motonaga red.

Prior to his stay in the US in 1966, where he developed this distinctive style called "funny painting", Motonaga had acquired a name for himself as an Informel artist, and his paintings were marked by subdued colors and a deep seriousness. Paints were poured onto the surface and their flow was regulated by a constant turning of the canvas. Though his current work seems a distant departure from that, the two creative periods actually share similar rudimentary forms and color combinations.

元永定正は、忍者の里として知られている三重県の小都市、伊賀上野で生まれた。忍者は覆面装束で敵の陣中などに入り込み敵情を探る任務を負い、そのためにあらゆる兵術、術策、変相、速歩などの術を修得していた。そして、隠形の術もその中に含まれていた。元永はかつて、自らの芸術を忍者芸術と称したことがある。作品の中での変身、型破りなパフォーマンス、そして又、狡猾なユーモアを使い、世界を色とりどりのかたちで覆っていく画家であり、グラフィック・デザイナーである。そんな点が忍者芸術と呼ぶゆえんであろうか。

1955年、元永は、当時最も注目を浴びた前衛派のグループ「具体美術協会」に参加し、明るい下塗りのカンヴァスに、単純な図形を描いていた。この頃のフォルムは、その後繰り返し彼の作品の中に現れる。例えば、1957年の小さくて黒い飛ぶ三角形（当時は14本の脚があった）。これは70年代になって、シルクスクリーンのFlying Triangleとして再び現われるのである。そして今、また凧となって空高く舞い上がろうとしている。この凧には、あの元永の赤に染められた、特徴ある丸いかたちの二枚の凧もお伴をしている。それは、20年来、彼がカラー・スプレーを駆使して、色様々に変化させてきたかたちの変容である。

1966年のアメリカ合衆国滞在のあと、元永は、この絵画技法とファニー・ペインティングと呼ばれている様式に取り組む以前に、すでにアンフォルメルの画家として、名声を得ていた。当時の絵画（1958－66年）は、どっしりとした色使いと重量感のある激しさを特徴としていた。画面には赤く燃える溶岩のように絵の具が流れ、制作過程を追体験することができる。元永は、カンヴァスに絵の具を注ぎ、カンヴァスを動かしてその流れを調整したのである。今日の作品の様式とは全く異なった特徴を持っているとしても、よく観察すれば、その構図になるかたちや独特の色の組み合わせには、やはり連続性がある。

Form in Red
Red Form with 7 lines
Black Triangle with 17 lines
Dye
Free form 280 × 210 cm 150 × 200 cm 100 × 210 cm
Kite-maker: K. Shimizu

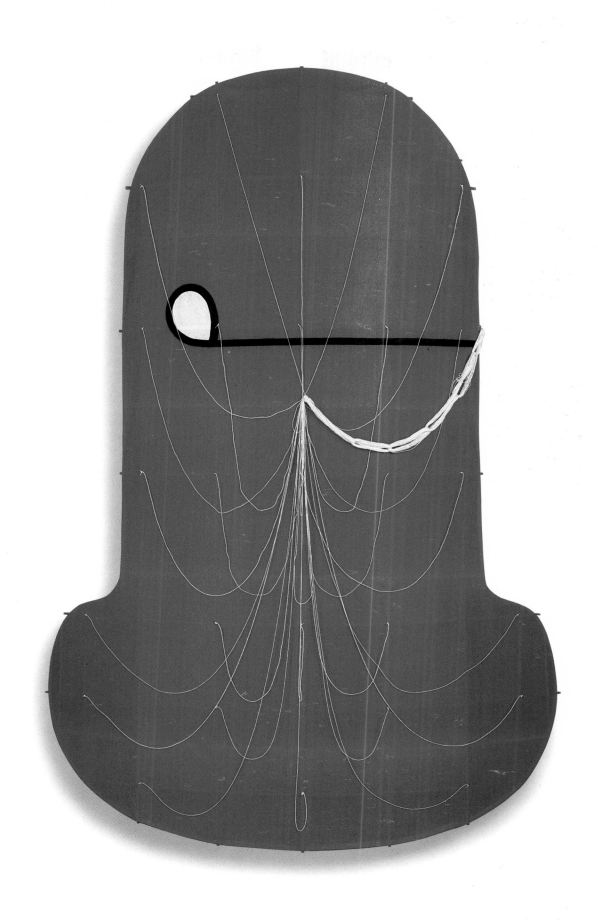

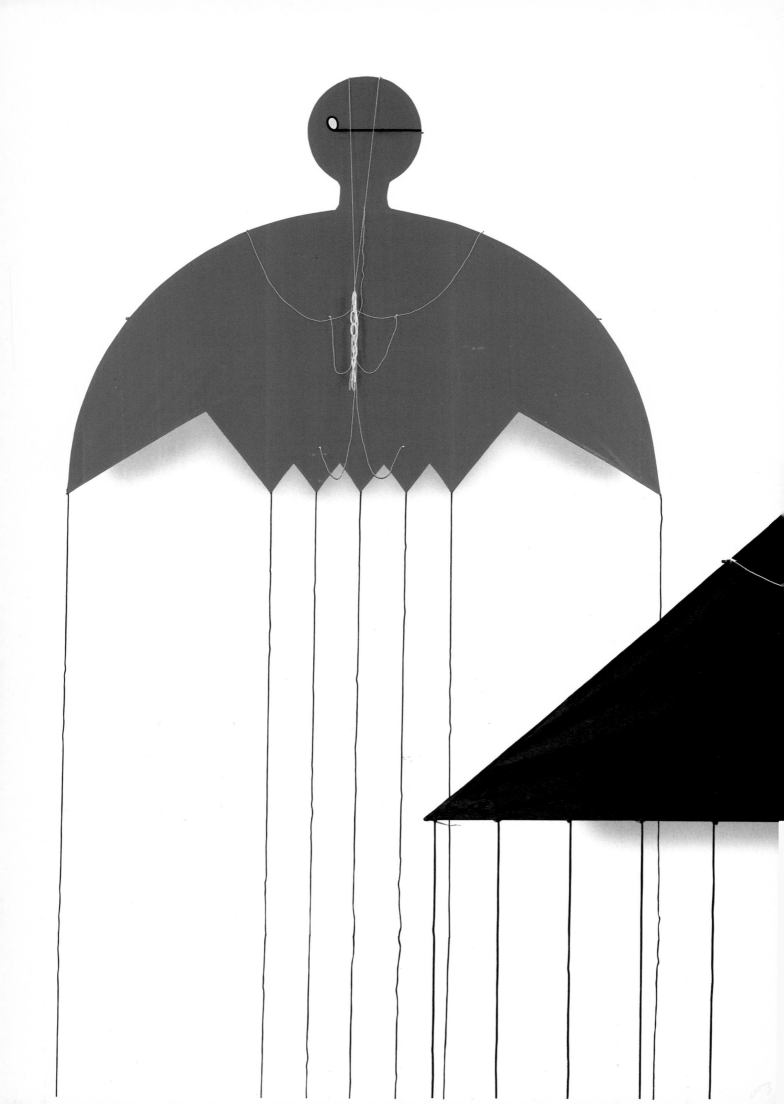

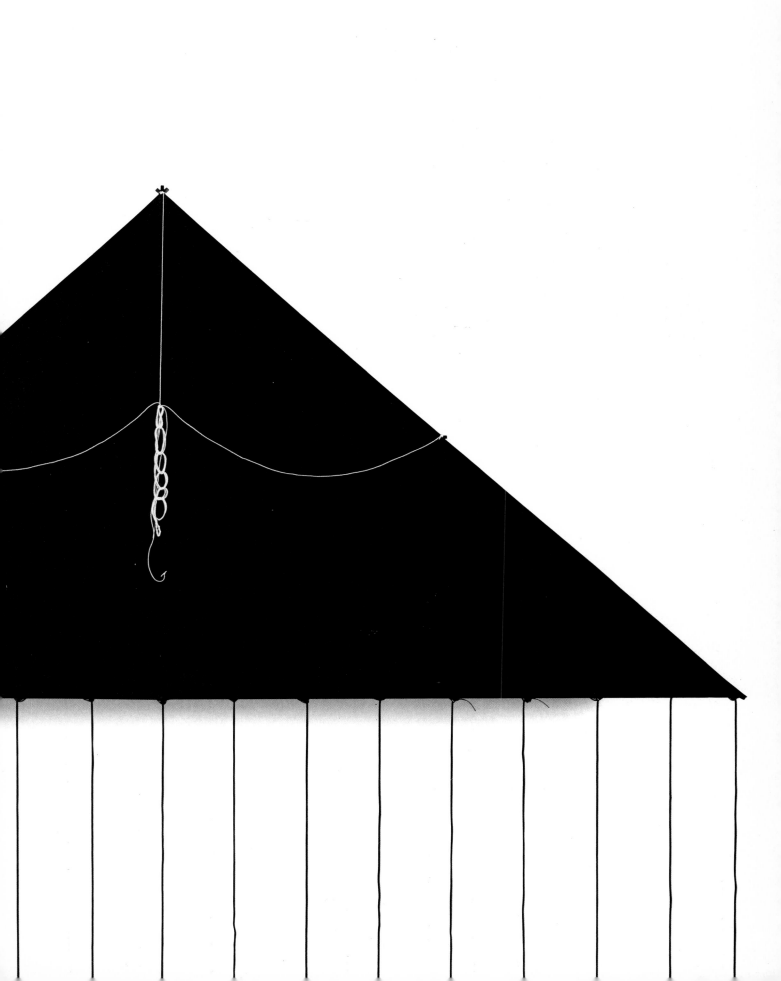

Tom Wesselmann

Born 1931 in Cincinnati,
lives in New York

Famous as a Pop Art force with his "Great American Nude", Wesselmann has given us numerous variations of his faceless Madison Avenue ideal. She lies on a bed, Matisse-like, with "sinful lips"; her breasts heave while she dangles a cigarette; or she is drying off in a bathtub. He has also created massive collages in which he integrated an actual mass-consumer item, such as a radio, a radiator or a shower curtain.

The artist uses trivial situations and gives them a pseudo-sexuality resulting in an ironic effect. In time, Wesselmann has reduced the earlier sexual clichés to cut-out montages of lips, breasts and fingertips holding a cigarette, the final shape of the work determined by the contours of the cut-outs.

His Project piece features his trademark blonde beauty replete with red lips, earrings and little else. Wesselmann specifically requested that the "shaped canvas", cut-out nature of his design be maintained when transformed into a kite. The problem was, since kites must be perfectly balanced, how to construct an airworthy one out of the blonde's true-to-life asymmetrical visage.

This challenge was admirably met by kite-master Hiroki Shimizu of Himeji, whose solution was to adjust the main bone slightly off-center, a form which may find its way into the Japanese repertory. The result flies so coquettishly that one day we may find numerous beautiful female faces alongside those of samurai warriors in the skies over Japan.

トム・ウェッセルマンはその大作グレート・アメリカン・ヌードによりポップ・アートの主導者の一人として有名になった。私たちは、美的・理想の広告のスタイルとして表われるあのほっそりした、目鼻の欠けた金髪の女性の顔にそのシリーズでたびたび出会うことになる。ベットに横たわる女性が平坦にマチス風に描かれていたり、"罪深い唇"や、つぼみのような乳首、吸いかけのタバコを持った手をみだらにさしのべている様子、あるいは浴槽で体をぬぐっているところなど、日常生活に見られる平凡な情景ばかりである。極端に拡大されたコラージュの中には、ラジオ、ヒーター、シャワーカーテンなどのような典型的な消費財がとり入れられている。ありふれた場面を芸術的に強調し、様式化することによって、冷淡な、偽の性が表現され、アイロニカルで美的な効果が生れている。後にウェッセルマンは性のシンボルとして扱われる型にはまった女性の体を"アウト・カット"へと切り詰め、唇や乳房、タバコを持った指先はキャンバスにコラージュされるようになったのである。ここで描かれるもののかたちは輪郭をとることによって画面に表現されることになる。

トム・ウェッセルマンはそのアート・カイトにも、やはりあの金髪の美女の顔を描いた。例によって目と鼻はないが、それがために官能的な赤い唇が強調されている。彼のアート・カイトもまた"アウト・カット"の様式に従って顔の輪郭どおりの形にして欲しい、ということであった。シェープド・カンヴァスの凧は魅力的なアイデアではあるが、よく見ればそれを実現するのは至難のわざである。だれの顔もそうであるように、この金髪の美女の顔も左右対称ではない。髪の分け目は中央にはなく、髪は右側が多く、カールした髪の長さは左右が同じではない。さらに首の部分はくり抜きにし、そこに竹骨が通っていてはいけない…など。凧が空中で安定飛行するためには面の左右対称がなによりの条件であるが、この金髪の美女はそう簡単に条件を満たさない。

私たちは、この難題を解く凧作りの名人、志水洋己をやっと姫路に見つけた。このブロンド・カイトはテスト飛行の際すでに愛嬌をたっぷりふりまいたが、これがいずれ日本の凧のレパートリーに加わり、武者絵の凧が占有している日本の空に、ウーマン・リブの一石を投じるということもあり得るだろうか。

Blonde Kite
Acrylic
Free form 280 × 200 cm
Kite-maker: H. Shimizu

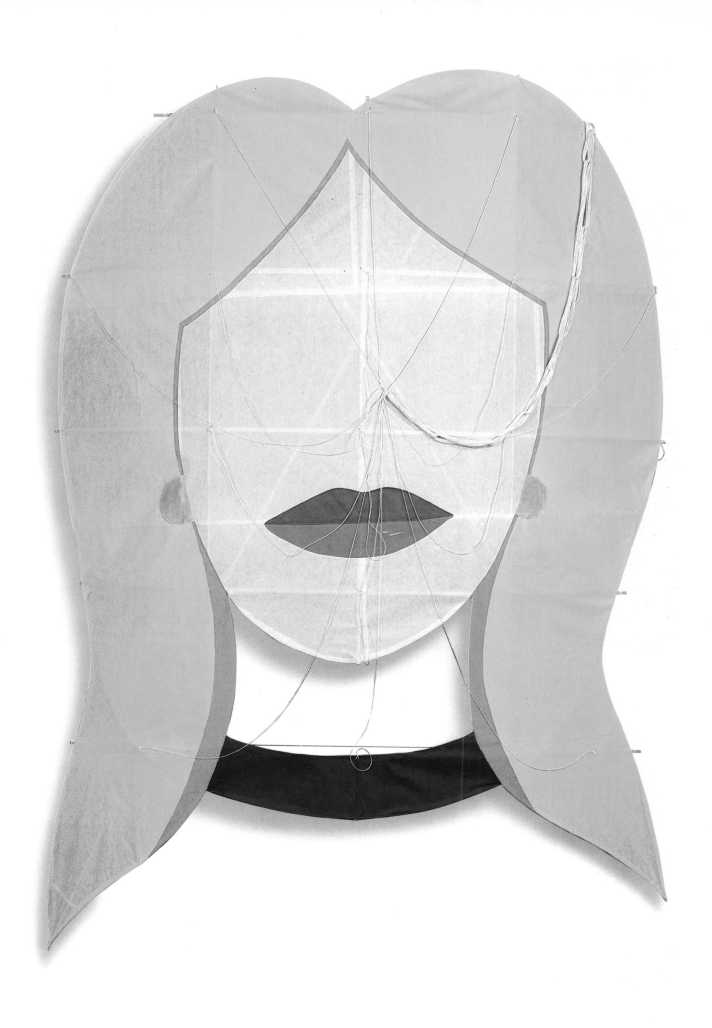

Blonde Kite in the sky over Himeji

ひと飛び先きに姫路の空に浮かぶ「ブロンド・カイト」

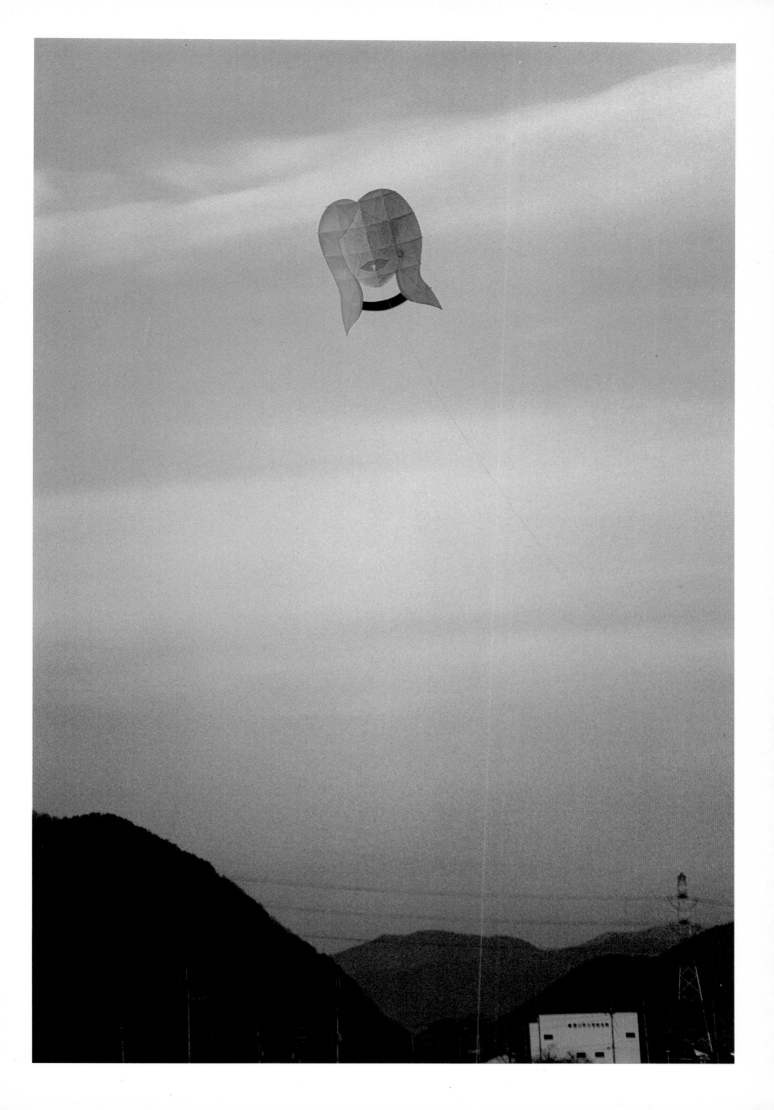

Mika Yoshizawa

Born 1959 in Tokyo,
lives in Tokyo

The youngest participant in the Project, Yoshizawa attracted attention in Kassel's Documenta 8 with her huge propeller. It was painted in the style of a technical drawing on semi-transparent paper and affixed directly to the wall. She uses a similar figure for her art kite, a motif redolent of movement, flight and speed – the last re-inforced by the fleeting sketchiness of the design, as if it were a lightning sketch done in the wake of a brainstorm idea.

The only kite to use a synthetic material, Yoshizawa's vinyl has a transparency that heightens the impression of functionality.

The propeller and technology serve the kite's flight – the technological era is here. Of course, everything is a game.

吉澤美香は今回のアート・カイトの企画に招待した最年少の芸術家である。私たちは彼女の「ドクメンタ8」の参加から彼女にも目を向けた。ドクメンタでは、彼女は、半透明の、コラージュした紙の上に一つの大きな製図様に描いた巨大なプロペラの絵を壁に直接貼りつけていた。そして、アート・カイトにもやはりこのプロペラを描いている。このモチーフは飛行、運動、速度を連想させる。スケッチ風の仕上げにより何かつかの間のはかなさ、あるいは一時的なものといった感じがする。この絵は製図として使える確証はもたないものの、アイディアが物質化され、構想が具現化する一瞬を捉えたものであろうか。

凧にビニールという人工の素材を使用した芸術家は外にいない。ビニールの透明感が技術的な機能性に対する印象をより強めている。プロペラと技術が彼女の凧の飛行を支えている。伝統の世界にも技術の時代が始ったのであろうか、もちろんすべてが遊びではあるが。

Untitled
Acrylic on vinyl
Kaku kite 242 × 184 cm
Kite-maker: H. Shimizu

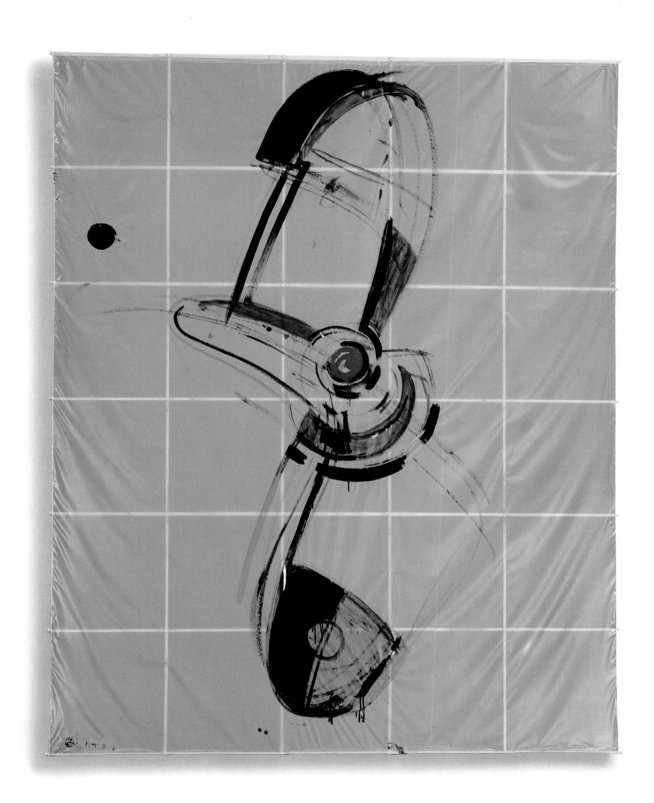

Satoru Shoji

Born 1939 in Kyoto,
lives in Nagoya

For the past 20 years Shoji has been placing objects in suspension, his installations attempting to make the forces of gravity visible to the eye. Countless points on a large piece of fabric, for example, are attached to the ceiling with long threads, the resulting crests and troughs illustrating the gravitational effect. There is a counterforce being applied from above, of course, and this produces a stable tension, an equilibrium of forces.

The same principle has been shown by another Shoji installation. Suspending long lengths of cloth diagonally across a space, he has tried to reveal the natural forces at work. Recently, additional tension has been created by raising the fabric into tent shapes by means of numerous thin rods. Again, the point is to demonstrate as graphically as possible the basic ineluctable laws of our physical world.

It is the cloth and rod concept that Shoji has used in his art kite, this time the fabric being opposed by the combined forces of the wind and the bridle line. In other words, the Project has allowed for an added factor of aerodynamics to be brought into play.

庄司達は、布を用いた作品を20年以上も前から創り続けている。空間インスタレーションを通じて、彼は地球の引力を具体化しようとする。彼がよく用いるのは、赤か白の大きな布であり、この布に無数の糸をつけ上から吊して、空間に水平に固定する。地球の重力は布の垂れ下っている部分にはっきりみてとれる。立体のフォルムを創り出すのはそれなのだ。上から吊られることによって反動が起きる。張力と反張力、抵抗と弛緩から均衡や安定感のある緊張が生まれる。

彼は、同じ原理を天井から部屋を横切るほどの広幅の大きな布を使って可視化させている。この場合、形成は全く自然の力にまかせている。

最近の彼の布によるインスタレーションでは、布をテントのように支える多数の細い棒を用い、新たなる緊張をもたらしている。多くのとがった円錐形に身をゆだねて、伸縮性に富んだ素材は、そこに作用する力の動きを明らかにしている。

この布と棒の原理を、彼は凧にも応用している。凧においては、風と凧糸の張力との二重の力を、布自体の張力と対抗させる。そこにはもちろん空気力学と美的感覚も顧慮されている。

Shoji Kite 88
Polyester cloth, bamboo, cord
Free form 220 × 195 cm

Thomas Lenk

Born 1933 in Berlin,
lives in Schloss Tierberg near Schwäbisch-Hall

In 1964 sculptor Lenk discovered a "layering principle" in which a staggering of sharp-contoured elements simulated movement. With this principle he sought to re-define the relation between surface and space.

This discovery occurred to the artist while playing with a highly prosaic object – beer coasters. Through them he recognized the possibilities latent in the art of arranging flat elements. Since then, dials and squares with rounded off corners have become the basic structural components of his sculptural works.

These standard parts are layered side by side in rows or shifted into diagonals, and are often marked by curves and counter-movements. Despite the flatness of the components, the observer is struck by a sense of three-dimensional space, the inner tension further heightened by an impression of fragility.

Lenk has varied this principle two-dimensionally in extensive graphic works, using fluorescent dyes – in particular yellow and pink – in many of them.

With his chain kite, the artist has successfully translated the principle of layering into a "sky sculpture". The work undergoes countless permutations in movement within spatial parameters determined by the materials and the fixed distance between layers.

彫刻家トーマス・レンクは1964年に、はっきりした輪郭をもつ要素により空間につくる「層形成」という原理を見い出す。その作品の中では配列が同時に運動の過程を示し、驚くほど新鮮に面と空間の織りなす緊張関係を証明している。

この発見はビアーコースターという極く平凡なものをもてあそんでいる時に起こっている。彼はそこに、面という構成要素のつくる層の並列の中にどんなにダイナミックな可能性が秘められているかを認めたのである。それ以来、円盤形のものや角に丸みをつけた正方形のものが立体作品の基本要素となっている。

このような基本になる素材を、前後や並列に並べたり、あるいは斜めにずらせたりして層をつくって並べ、往々にして急なカーブをつけたり反対方向にも向けたりして立体作品にしている。この素材は平面であるのに立体感があるような錯覚にとらわれる。これらの立体作品は静的であるのに不安定さを感じさせるため緊張感が更に加わっている。

大がかりなグラフィック作品の中で、トーマス・レンクはこの「層形成」の原理を二次元にまで拡げ変化させていった。螢光染料がよく用いられるが、黄色とピンクが彼の仕事の典型的な色となっている。

彼は「層形成」の原理を連凧というかたちで巧みに空間彫刻に置きかえている。そして、この連凧には、素材と層と層の間隔によってできる限られた空間内で、動きによって無数の可能性が実現される。

Fly Away
Luminous paint
Chain kite 170 × 170 × 1000 cm
Kite-makers: Y. Esashi, G. Yazawa (Tokyo)

Susumu Shingu

Born 1937 in Toyonaka,
lives in Osaka

Shingu's art is forever in motion – on land, in the water and in the air – driven by wind, rain and heat. Inspired by nature's own tricks, Shingu has created sculptures which play in the elements and which twirl about themselves in seemingly ecstatic, narcissistic states.

The beginnings of Shingu's kinetic art can be traced back to a stay in Italy when he decided to hang some paintings on the branches of a tree. Intrigued by the effect, he has since made the wind an important partner in his work.

Since 1967 Shingu has worked exclusively on kinetic sculpture – from glittery mini-ventilators to massive wind machines – using materials such as steel and polyester and employing state-of-the-art technology. With precision ball-bearings to turn with the wind and bright colors to add humorous charm, his works can be found in numerous Japanese public spaces. In 1987–88 a dozen of his largest wind sculptures, grouped together under the banner "Wind Circus", toured Europe and the United States.

For indoor environments, Shingu has developed a collection of "Breathing Sculptures" that make use of heat generated by lightbulbs (as well as air movements in the room) to set their parts in motion.

Needless to say, Shingu's art kite is designed to make full use of the wind. The twin discs can be flown by a single cord while inside the Sky Window a whimsical little star spins in a stubbornly unpredictable manner.

新宮晋の芸術は動く。地上でも、水面でも、空中でも。原動力となるのは、風、熱あるいは雨。自然からインスピレーションを得て作家が創り出す彫刻は、自然の諸要素によって戯れつつ、自己愛に浸りながら自分を中心に回転する。

新宮晋と動く彫刻との出合いは、長期に渡るイタリア留学中のことで、彼がある日外に持ち出して木の枝に吊るしてみた絵画に風が触れた時に溯るのかもしれない。

彼は1967年以来、専ら動く彫刻ばかり制作している。鉄やポリエステルなどの材料を用い最新の技術を駆使している。精密を極めたボールベアリングのおかげで、回転部分は微風にさえ反応する。輝く色の彩色により、彼の作品はユーモラスなニュアンスを帯びてくる。キラキラ光る小型送風機がグルグルと回転し、精巧なスカイ・グラフィティーが作られるかと思えば、ずっしりと重量のある風のマシーンが登場したりする。頑丈なポールやボリューム、そしてゆっくりとした動きは、港湾のクレーンとオイルポンプを思い起こさせる。彼の作品は、日本の多くの都市や多数の公的なコレクションに収められている。

1987年から1988年にかけて、新宮晋は野心に満ちた世界規模のプロジェクトを実現した。「ウインド・サーカス」というタイトルのもとに、12台の巨大な風の彫刻をヨーロッパとアメリカ合衆国を縦断する巡回展に送りだしたのだ。

新宮は、室内空間のためにアンサンブルになる作品「呼吸する彫刻」を展開させた。作品の内部にとりつけられた白熱燈の起す熱気流を利用したり、空調気流や室内の空気震動を受けて、回転部分が動く仕組みになっている。

彼の凧もやはり風で動く。二重になった和紙の円板は、ただ一本の糸目で空に揚がる。開かれた「天の小窓」の中で、気まぐれな星は風に乗ったり逆らったりしながら休むことなく、グルグル回転している。

Small Sky Window
Dye, bamboo, wire, Japanese paper
Free form 143 × 40 cm

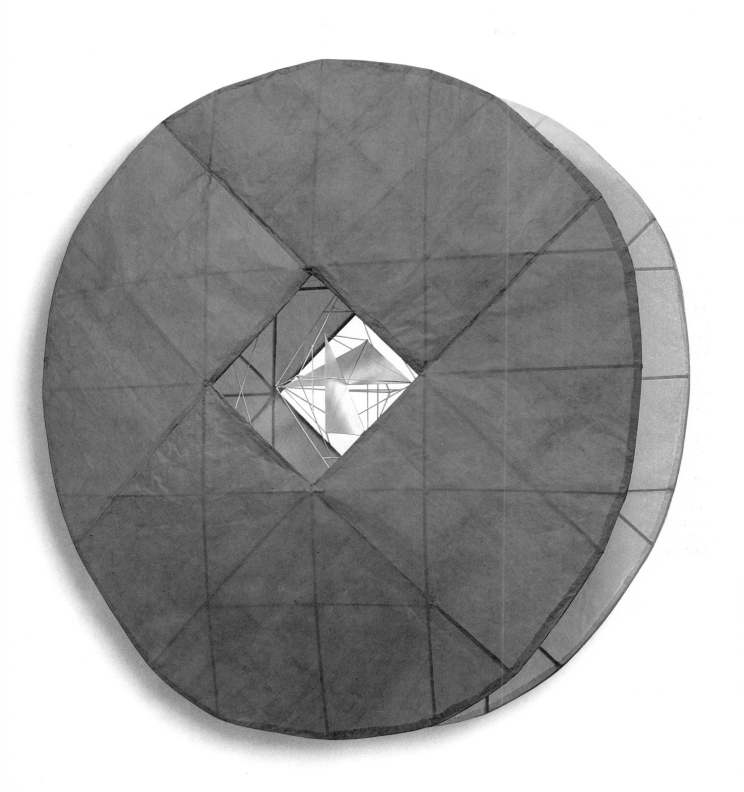

Yukio Imamura

Born 1935 in Ise,
lives in Paris

Imamura's abstracts could well be collectively termed "The Enigma of Space", though his own word for them is simply "Zeno", named after the Greek philosopher who questioned the limits of the world within space. Though he has achieved, in his large oils, color fields of near extra-terrestial brilliance (blues and reds dominate, often accentuated with gold), his paintings are nonetheless marked by an unshakable iciness. This stems from the transparency of his colors, as well as the work's lack of relationship to anything organic or of this world. We peer into his pictures and see spheres without limits, images of eons and galaxies, plus bleak moonscapes full of ominous craters.

The artist produces these otherworld effects with a special technique. After preparing the canvas with an undercoat, he loads on colors and then disperses them with an air compressor. The movements of the air jet over the canvas create the impression that the works were created by wind over sand or water, not by the artist's hand. Imamura's paintings give no clues as to interior, exterior or spatial orientation. The eye gets lost in an infinity which can mesmerize, as though one were travelling through galaxies at the speed of light.

As an exhibit the artist wanted the kite to inspire meditation but, once in the air, it should simply become a tiny point and be swallowed up in the infinite expanse of the cosmos.

今村幸生の抽象絵画にタイトルをつけるとすれば「謎の空間」とでも言えようか。画家本人はそれを「ゼノン」と呼び、古代ギリシャの哲学者エレアのゼノンと関連させたものとしている。エレア派のゼノンは運動と空間についてのパラドックスとアポリアを唱え（例えば、「アキレスも先に出発した亀に追いつけない。」）、宇宙における地球の境界に関する問題を解こうとした哲学者である。

今村幸生は大判の油彩による抽象画の中で、宇宙のような輝きの色空間を実現している。輝かしい鮮烈な色にもかかわらず（青と赤が主に使われ金色がアクセントになっているものが多い）、その絵画は氷のような冷やかさを感じさせるが、彼の色がガラスのような透明感を持っていること、有機体、生命のあるもの、世俗的なものとは無関連という様相はここに由来するのか。私たちははてしない宇宙を眺め、光年、永却、銀河などという宇宙の現象や、時にはでこぼこのクレーターの河口をもつ月面の風景までも彼の絵画の中に思い浮かべることができる。（今村の初期の作品を知る者は強迫観念につかれたような、シュールレアリスム的でエロティックな時期の追憶を見るかもしれない。）

今村幸生は彼独自のテクニックを駆使してこのような自然の効果を得ている。地塗りをしたカンヴァスにコンプレッサーで絵の具を吹きつけていく。圧縮した空気を塗られた絵の具に向って吹きつける方向を変えることでかたちをつくっていく。このかたちは人間の手で制作したという印象を与えない色調を生むのである。これは、風が砂の上層や、水面に当たった時に描いてつくる自然の芸術の生れ方と同じなのであろう。これに反して、今村の絵画においては、どこが表面なのか、あるいはどのような空間的繋がりがあるのかという手がかりを、全く与えてくれない。目は限りない深さに吸い込まれてしまい、観る者は催眠状態に陥りそうになる。もし、何光年かの速さで銀河の宇宙を疾走するとすればこの絵のような印象を得るにちがいない。

画家の意図によるとこのアート・カイトは観る者を瞑想の世界に導くということである。
「私の絵画のテーマは地上的・人間的視座からの空間観を離脱した、不可知な宇宙の果ての時空を切りとってくることにある。それは、正に人間的な空間である美術館や室内の壁の上の四角い絵画である時、そのような私のイデーやパンセが人々にある種の瞑想を与えるであろうが、凧となり、広大な空中に舞い上った時…… それは宇宙に吸い込まれてゆく、可愛いい点にすぎないだろう。」

Zenon Vol. 88011
Acrylic, gold mud
Wanwan kite 235 × 245 cm
Kite-maker: U. Fujinaka

ワンワン凧は裏面でそりを入れることによりもともとの楕円形がまんまる
の形になる。凧を揚げる時には更にしっぽがつけられる。

When the tension strings on the reverse side of the wanwan kite are tightened for flight, it curves and changes from an oval into a circular form. For flight a tail is required.

Toyoshige Watanabe

Born 1931 in Tokyo,
lives in Kawasaki

Like the classic wooden puzzle in which many different animal shapes fit togehter to form a completely new image, Watanabe translates flat drawings into three dimensions by first outlining shapes on wooden boards and then cutting them out. His forms are simple, often suggesting oak leaves or tongues of flame when standing upright, and clouds when raised horizontally on supports. The contours – moving in and out of conjunction – give the flat form a fluid impression, alternating between suggestions of cloud-like good-naturedness and rough aggressiveness. The works are further accentuated by regularly distributed points, holes or notches.

Viewed from the side, a rhythmic repetition is produced by the parallelism of the front and back contours, the edge between them (usually painted monochromatically) providing the play of light and shadow wholly absent from the main surfaces.

The festive red color and the fluttering streamers are both in keeping with kiting traditions – especially those of New Year's, the most important holiday of the year in East Asia.

Watanabe's kite form, though clearly derived from his earlier work, also bears a resemblance to the baramon, a type of kite native to Kyushu in Southern Japan. Because of their long experience in constructing circular bamboo frames, the kite artisans in Kyushu's Kumamoto Prefecture were given the task of building Skyleap Hop Hop.

板から切り抜かれた様々の動物の形をうめ込んで組み合わせ一枚の板にする動物パズルのおもちゃがある。それぞれの動物の形は三次元に拡がる型抜き細工とも言える。

渡辺豊重が彼の彫刻制作に見出した原則がまさにこれなのだ。彼は平面線画を分厚い木の板の上に置き、それを切り取り空間的な広がりへと移し変える。彼の使うフォルムは簡素であり、垂直に立てればカエデの葉や炎の形を、また細長い脚をつけて水平に立てれば宙に浮いた雲を思い起こさせる。あるときは並行して、またあるときは相反して流れるような輪郭線が平面のフォルムに静かな、あるいは流動的な表現をつくり出している。「モクモク」と雲のようにおだやかな、またワニの背のような攻撃的な「ギザギザ」の性格をもっていたりする。平面にほどこされた個々の規則的な点や穴や切れ込みが作品のアクセントになっている。

横から見れば、前と後ろの輪郭線の平行が躍動感のある繰り返しを演出している。厚みとなる細長い側面は、たいていモノクロームに塗られていて、平らな表面には当然表われることのない光と影の効果の見せ場となっている。

渡辺豊重は造形家として新しい形の凧の制作に挑んだ。彼の天翔ける凧はすでに存在するよく知られた凧の形から程遠くない。華やかな赤とひらひらと舞う色とりどりの帯は東洋における最大の祝祭、新年の凧揚げの伝統によく合っている。

日本列島の南端、九州にバラモン凧と呼ばれる凧の形があるが、それがかすかに渡辺の凧を思い起こさせる。熊本の凧師たちは少なくとも円形の竹の骨組みをつくることには慣れ、優れた技術をもっている。そこで熊本にこの凧の製作を依頼したところ、凧師たちはやはりそのすばらしい器用さと技量で「天翔けるモクモク」を立派に完成させたのである。

Skyleap Hop Hop
Acrylic 380 × 200 cm
Baramon kite
Kite-maker: Kite Association, Kumamoto

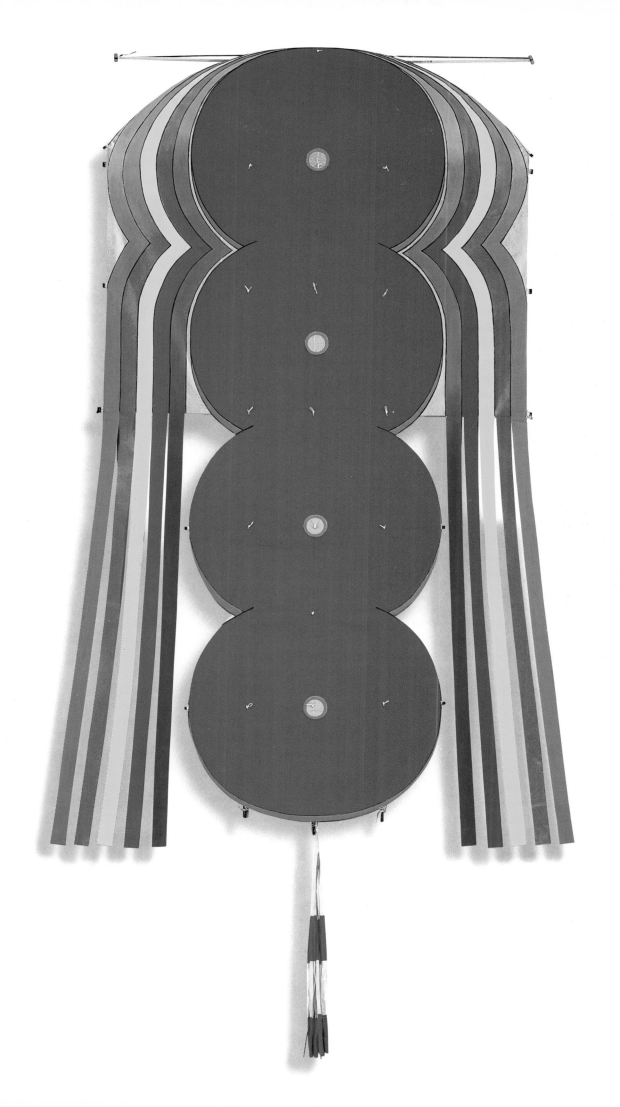

Kumamoto
熊本での試験飛行

GENERAL IDEA
Toronto and New York

Is it an ideology, a multi-national corporation, a brain trust or, perhaps, a military figure, that lies behind this enigmatic name? Three unconventional artists – A. A. Bronson, Felix Partz and Jorge Zontal – delight in playing with paradoxes and strive to make them an essential characteristic of their work.

With a sense of Performance and Conceptual Art, they have developed a unique style which is Dadaistic, provocative, frivolous and critical of society. Their pieces always play off well-known things, be they clichéd expressions (rendered nonsensical through words and pictures), fashion shows (ruthlessly satirical) or a photo-magazine (transparently titled "FILE-Megazine").

The functions of various objects or visual patterns are twisted inside out, giving an original look to the old and familiar. And they practice the art of camouflage to heighten the effect of visual intrigue, whether in performances, videos, photography, painting, sculpture or published works.

As the stage for a "Perceptual Cabaret" in 1969, the artists pretended to create a "Miss General Idea Pavilion, 1984", using its imaginary rooms for their "counter rituals". A "Miss General Idea", herself, was the central muse, appearing everywhere and yet mysterious.

In 1977 the decision was made to "demolish" this Pavilion, but afterwards it was quickly reconstructed, the mosaic-like pieces being re-assembled in mock archeological style. Whereas before the artists played with an imaginary future, now they managed to fool with a non-existent past. Unearthed, for instance, were fragments of elegant frescos done in Pompeian style. But alongside the wine glasses, half-moons and cornucopia were poodles! – a motif that has since become General Idea's trademark.

A 1985 exhibition in Ghent resulted in General Idea's discovery of the vast artistic possibilities inherent in heraldry, the shield as a bearer of personal corporate identity particularly suiting the group's theme of alienation. "The honeymoon is over" seems to be the message on Miss General Idea's art kite, five golden drops trickling down the shield like bitter tears.

ジェネラル・アイディア。この名前の背後に隠されているのは、イデオロギーか、多国籍企業か、ブレーントラスト、それとも軍国主義の理想像であろうか。三人の一徹な芸術家、A. A. ブロンソン、フェリックス・パーツ、ジョージ・ゾンタルはすでにジェネラル・アイディアという奇妙な雅号で矛盾をもて遊んでいる。そしてこれは彼らの芸術作品の本質的な要素でもある。コンセプト・アートとパフォーマンスの雰囲気の中で、ダダイズム的で挑発的、軽薄で批判的な彼ら独自の様式を展開させてきた。そこで彼らは必ず、例えばきまり文句（言葉と絵がナンセンス化している）、あるいはファッションショー（皮肉っている）、そしてまた写真集（あのグラビア雑誌をもじって「ファイル・マガジン」と題をつけている）など、広く知られたものを引き合いに出している。彼らはそのようなものの形も機能もするりっと変えてしまう。引き合いに出した言語的、視覚的モデルを内からねじ曲げるために、それらをうばい、我がものにしてしまう。彼らは視覚的な陰謀のためカムフラージュの細工をする。パフォーマンス、ヴィデオ、写真、絵画、彫刻そして出版物など、どんな方法ででも。

彼らは、知覚演芸ショーのための舞台として（1969年？）、空想上の「ミス・ジェネラル・アイディア・パビリオン 1984」を設置した。それ以来、この空中のお城の部屋部屋は彼らの反撃儀式のために使われている。中心的、虚構の像、そしてミューズとなるのは荒っぽくて怪しげな「ミス・ジェネラル・アイディア」である。1977年、彼らはこの（空想の）パビリオンを、再構築するため解体することに決める。ばかげた見せかけ考古学の上で、建物の瓦礫によるモザイク石を集め復元する。前に空想の未来を実現したように、今度は存在しない過去を再現したのである。ポンペイの遺跡スタイルで、エレガントなフレスコの端片らしきものを堀り出す。ワイングラスや半月、豊穣の象徴である宝の角と並んで繰り返し現れるモチーフがある。そしてそのモチーフはそれ以来このグループのトレード・マークになった、あのプードルである。

1985年、ゲントでの展覧会を契機に、彼らは新しい制作活動の材料となる紋章学に出会う。個人およびグループのシンボルを担う紋章盾は、とりわけ彼らの異化効果にふさわしいものである。「ミス・ジェネラル・アイディア・アート・カイト」は「ハネムーンの日々は過ぎ去った」とばかりに、悲哀を表わす黄金の涙が五粒こぼれている紋章凧である。

Far Cry
Acrylic, copper-leaf
Heraldic kite 155 × 125 cm
Kite-maker: H. Shimizu

Kumi Sugai

Born 1919 in Kobe,
lives in Paris

Trained at the Osaka Art Academy under a traditional Japanese painter, Sugai moved in 1952 to Paris where he started adapting Japanese calligraphy to oils. He painted bold, heavy symbols with strong brushstrokes, often duplicating the stroke order of real pictograms. At times he combined the character with the real object it represents; for example "Moon", "Black Cloud", "Circle", or "Samurai". Such paintings evoke a distant past and their titles further link them to ancient Japan.

Since 1960 Sugai's work has shifted to combinations of circles, triangles and squares, with titles – such as "Way of the Demon" and "Devil's Chain" – emphasizing the magic in these shapes. Most recently, he has added elements like a serpentine line and floral designs, images which can be interpreted as a wave-rippled sea or luxuriant forest.

Already in the 1960s Sugai's paintings took on the Hard Edge look, his signs becoming more geometric, the pigments clearer and more evenly applied. These pieces resemble traffic signs in their anonymous, functional aestheticism, and their titles strengthen the association with technology, cities and transportation: "National Route", "Parking-B", "12 Cylinders" and "Sky Signal".

Speed is a crucial element in these paintings, not in the sense of Action Painting, but – probably based on Sugai's love for Porsches – in their motifs, which seem to reflect the icy concentration needed at dizzying speeds, or the sensation of split-second glances at a rear-view mirror.

Sugai's art kite is dominated by his favorite red and blue, and its various components bring to mind the imperial Japanese rising sun flag, the wind, speed and the artist's initial. It is like a heraldic shield bearing Sugai's coat of arms into a tournament in the sky.

菅井汲は大阪美術学校で学び、日本画の師にもついた。その後、1952年にパリに移ったが、この頃の彼の絵画様式には、日本のカリグラフィックが一番よく絵画化されているといえる。力強い筆の運びにより重量感のある記号が描かれている。往々にして、漢字を書き順に従って書くように実際に描くことから始め、時には、「月」「黒い雲」「円」「侍」など、記号と自然にできる形象的なかたちを組み合わせたりしている。これらの絵は古風に写り、そしてそのタイトルは、日本の古い伝統とかかわりをもつものである。

1960年以降の円と三角形と四角形の組み合わせによる作品が菅井の仕事の中心的な意味を獲得するようになる。様々のヴァリエーションの中で○△□の基本的なかたちが繋ぎ合わされている。「鬼の散歩」や「鬼の鎖」などのタイトルが記号の神秘性を強調している。その後、絵画記号として蛇行する線や花、植物の要素が加えられ、それは時には波状をなす海であったり、時には森であったりする。

60年には、彼の作品は絵画の主題にハード・エッジの流れをとり入れた標識・シグナルのかたちへと移り変っていく。かたちは幾何学的になり、色は鮮明で均一に塗られている。このような普遍の、しかも機能的な美をもつ作品は交通信号を思い起こさせる。それらが技術的なもの、大都会、交通に関連するというところから、タイトルも「ナショナル・ルート」、「パーキング-B」、「12気筒」、「空の標識」とつけられている。このような作品の中で重要になるのはスピードである。しかし、アクションペインティングでいうスピードの意味とは異なる。それどころか、菅井汲の仕事には製図板を使用して制作される冷静な精巧さがある。彼の絵画の発想の根源になっているのがスピードなのだ。菅井は熱狂的なポルシェの愛好家である。猛スピードで疾走する（作品：時速280㎞）時の精神的な集中が作品に反映しているのであり、バックミラーの中に確認できる炸裂する瞬時の視覚的な印象が作品のモチーフになっているのであろうか。

菅井汲のアート・カイトは、彼の好きな青と赤が基調になっているが、菅井の記号としてまごうことのない凧を空に揚げようとしている。それは日本の朝日を表わす旗、風、スピード、そして作家のイニシャルSという構成からなっている。菅井汲の記号となる紋章の凧は菅井のサインそのもので、空中で戦いに挑む騎士の盾のようでもある。

Wind · Sun · SUGAI
Acrylic
Rokkaku kite 240 × 186 cm
Kite-makers: K. Tamura, S. Ogasawara

Salomé

Born 1954 in Karlsruhe
lives in Berlin and Los Angeles

Following training as a civil engineer, Salomé studied at the Berlin College of Art under Karl Horst Hödicke and, as one of the "Fierce Four" (with Helmut Middendorf, Rainer Fetting and Bernd Zimmer), founded an independent gallery that introduced Wild Painting to Germany in 1980.

Salomé's activities span a wide range that includes performances, films, radio plays and rock group appearances. Themes of his paintings are rooted in his conflict with society's mores and conventions. "Unlimited freedom, the freedom actually denied to me in life, I realize in the realm of painting. Therein, when painting I am myself. I can do what I please and I can let myself go completely."

The male body is an ever-recurring, sometimes erotic theme in Salomé's paintings, in his performances (Tightrope Walker, 1979) and in his rituals (Kung Fu, 1980). He has also experimented with numerous East Asian motifs, his two sumo art kites paying homage to the ritualistic tradition of the sumo ring, where a grotesque exaggeration of masculine strength is combined with ancient ceremonies to make a fascinating performance. The smaller of the two hexagonal kites shows a pair of grappling wrestlers, the Japanese characters in the upper right-hand corner indicating that it's the opening day of a wrestling contest. The wrestler on the right is on the verge of stepping off-line and losing the match.

In the larger kite, Sumo Flyer, Salomé has grouped together a central pair of wrestlers with scenes representing key sumo moves. There is something of a textbook quality to these images, and the whole is reminiscent of Hokusai's sketchbooks. The festive colors of a sumo tournament are also captured here, the compositional symmetry reflecting the ritualistic character of this strange martial art.

ザロメは地下建築のデザイナーとして見習いをした後、ベルリン芸術大学に進み、カール・ホルスト・ヘーディケの一番弟子となる。ライナー・フェッティング、ヘルムート・ミッデンドルフ、ベルント・ツィンマーらとともに、ベルリンのモーリッツ広場に自主画廊を開く。1980年、ベルリンのヴァルトゼー・ハウスで「荒れくるった」この四人によって開かれた展覧会が、人も知る「ドイツ新表現主義」の始まりなのである。ザロメの芸術家としての活動はパフォーマンス、映画、ラジオ劇、ロックグループへの参加など、広範囲にわたっている。

ザロメの絵画はそのほとんどが社会の道徳的慣習に対する精神的葛藤を主題にしている。「限りなき自由、現実の生活において私に許されない自由を、私は絵画の世界で実現するのだ。絵画の世界では、私は私自身のために在り、私のやりたいことが自由にできる。思う存分荒れくるうことも。」

彼の絵の中では、エロティックな場面やパフォーマンス（綱渡り、1979年）や古武道（カンフー、1980年）など、繰り返し男性の肉体が主題になっている。幾つかの東洋的なモチーフも取り上げられている。二つの大きな相撲の絵は、ほとんどグロテスクなまでに誇張された男性の肉体も古式ゆかしい儀式にしてしまい魅力的なパフォーマンスへと結びつけている相撲という典礼的な格闘競技の伝統に対して敬意を表わしたものである。小さい方の凧には六角形の土俵の中心に一組の対戦力士ががっちりと組み合った情景が描かれている。土俵の縁に書かれた漢字は相撲の第一日目を意味するのであろうか。右側の力士は、足が編んだ綱の土俵を割ってしまい、敗れたところである。大きい方の凧「飛行力士」には、真ん中の一組の力士の廻りに何種類かの取り組み方の場面が描かれている。これらの情景は北斎の写生帳にでも描かれていそうな力士絵を暗示している。ザロメにとっては、ドラマティックな肉体のぶつかりあいや相手を役げ倒す稲妻のように素早い身のこなし、土俵の外へ突き出す一撃は興味の対象ではない。この、むしろ静止する絵の中にしっかりと表現されているのは、教科書にでてくるような模範的な勝敗を分ける決まり手なのである。相撲という競技のもつ華やかさが、輝く赤の土俵と色あざやかに描かれた観覧席で強調されている。このシンメトリックな絵画構成は、規則の厳格な儀式的競技を映し出している。

Sumo Flyer
Acrylic 400 × 328 cm
Rokkaku kite
Kite-makers: K. Tamura, S. Ogasawara

Sumo
Acrylic 270 × 223 cm
Rokkaku kite
Kite-makers: K. Tamura, S. Ogasawara

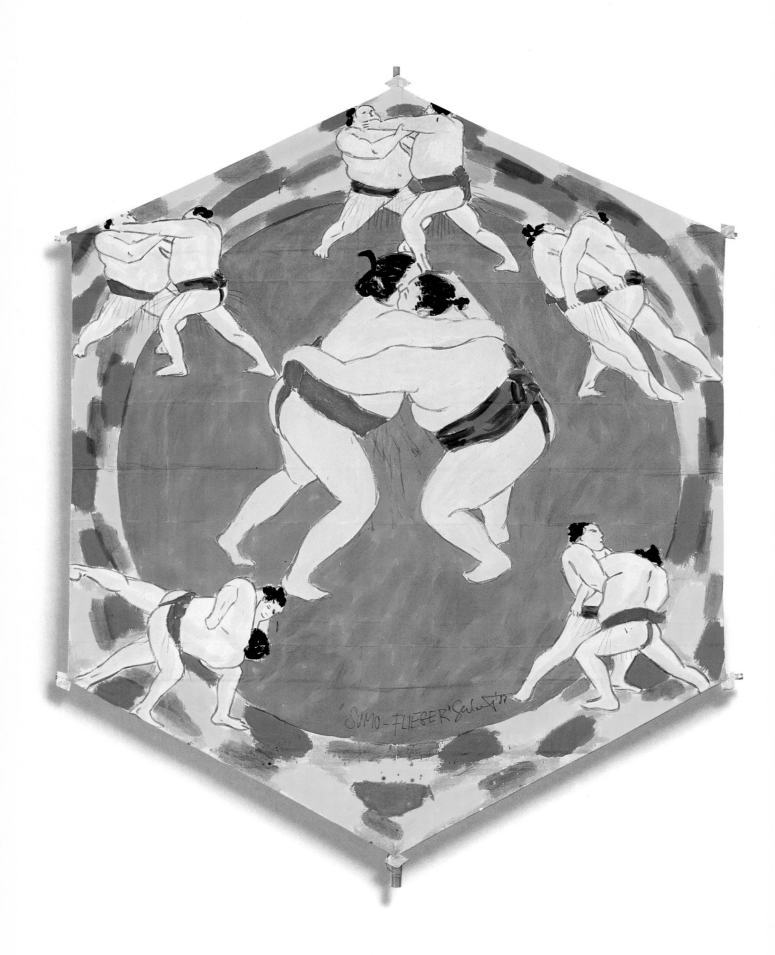

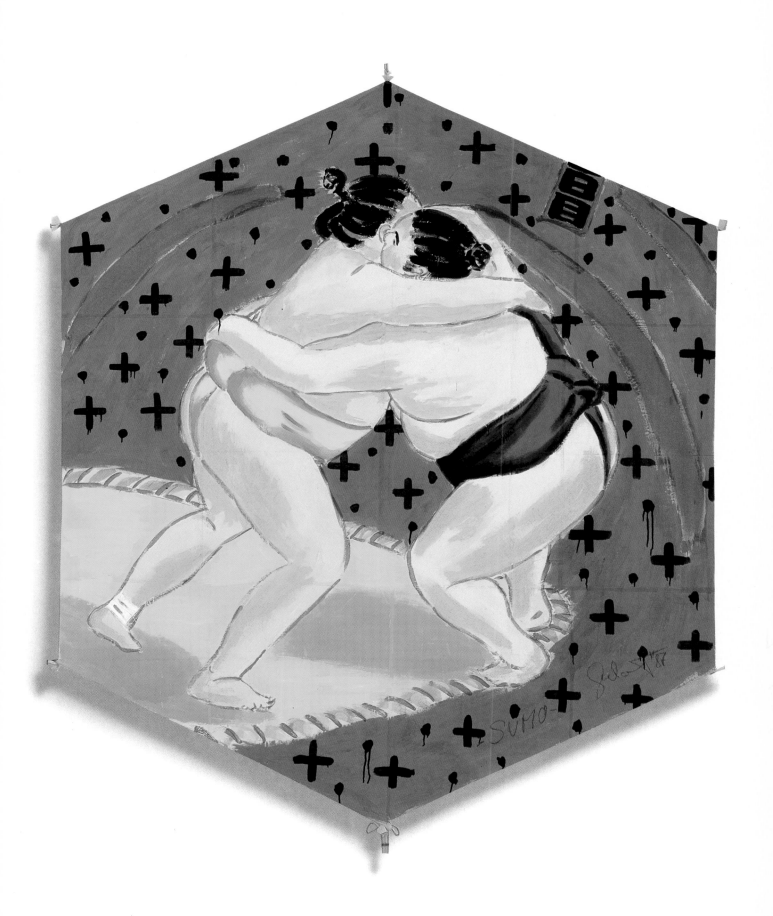

ARMAN

Born 1928 in Nice,
lives in New York

"Actually, it all began with Schwitters." says Arman, referring to the great Dadaist who stood for building a new culture from the fragments of the old. Kurt Schwitters is regarded as the inspiration for both Neo-dadaism in the USA and Nouveau Realisme in Paris. In the early 1960s, Arman (a name born out of a misprint for Armand Fernandez, his real name), began the job of smashing the world, destroying cultural fetishes as well as daily use items: bronze statues, period furniture, coffee grinders, etc.

Dismantling, cutting or burning the objects, he afterwards offered up the wreckage as art. Sometimes he welded identical items together in assemblages (oil cans, trumpets); other times he nailed them in a clump (tennis shoes, woollen socks); or they were packed together in boxes (door knobs, shaving brushes) or coated with plexiglass (color tubes). Always, the resulting accumulations were as useless and meaningless as they were provocative, displaying a powerful expressiveness derived from the tension between individuality and mass, destruction and creation.

Arman also became engaged in performance art and, in 1963, sawed up a violin and pasted the pieces onto a canvas. He thereby accomplished in three dimensions what Picasso and Braque had done around 1910 with their deformations, in both cases the idea being to destroy an original form and create something new from its debris.

Though Arman's compositions suggest fierce aggression and haphazard arrangement, it is clear that his destructive acts are carefully calculated. His art kite offers a kind of record of such planned vandalism. The multiple impressions left behind by violin parts hurled at the paper reflect the intensity of the creative/destructive process, the use of red suggesting blood.

「実際、すべてがシュヴィッタースで、始まっている」とアルマンは言う。（アルマンド・フェルナンデスの方が正しいのであるが、印刷ミスによる表記をそのまま使用している。）彼はここで文化の断片から新しきものを構築することが肝要だとするあの偉大なダダイストの言葉を問題にしているのだ。クルト・シュヴィッタースはアメリカにおけるネオ・ダダやパリのニュー・リアリズムの物質作家、オブジェ作家たちの素材物質芸術の生みの親とされている。

60年代の初期、アルマンは世界を打ち砕くことから始める。怒りをこめて、われわれの文化や伝統の偶像、また日常用いる道具類をめちゃめちゃに打ち砕いて、破壊の残がいを芸術として呈示する。コーヒーミル、ブロンズの彫刻、年代物の家具などがその対象である。これらはバラバラにされ、切りきざまれ、焼かれるかあるいはおびただしい数の同じオブジェを熔接アサンブラージュにし（ガソリンかん、トランペット）、釘で打ち重ね（テニスシューズ、木綿の靴下）、箱の中につめ込み（ドアの取っ手、ひげそりブラシ）、あるいはプレキシグラスに流し込んだりすることで「使用不可能」にしてしまっている。個々の特質と量のすごさによる緊張感から、また破壊と新たな創造から驚くほどの表現力をもった無意味で啞然とさせられるアキュミュレーション（集合）が生まれるのである。

1963年には、ヴァイオリンをノコギリで細く挽き、バラバラになった部分をカンヴァスに貼りつけたが、これは同時に象徴的な行為でもあったのだ。1910年頃、ピカソやブラックがヴァイオリンやギター、マンドリンを例にとって絵画的デフォルメを試みたのを具体的にオブジェを使ってくり返したということになる。破片から新たな（当時は立方体の）フォルムのコンセプトを展開させるためにフォルムの破壊を試みるのである。よく観察してみると、彼のアサンブラージュの場合同様、この破壊行為はきちんと計算されていることがわかる。構成が最終的には激しい攻撃性と偶然の配置という印象を与えてはいるものの、この破壊は入念に考えられたものである。アルマンは、アート・カイトにそのような破壊的行為の記録を書き残しているのだ。凧の面に繰り返し投げつけられたような楽器の痕跡は破壊のプロセスの激しさを物語っている。

Untitled
Acrylic 230 × 182 cm
Rokkaku kite
Kite-maker: T. Kashima

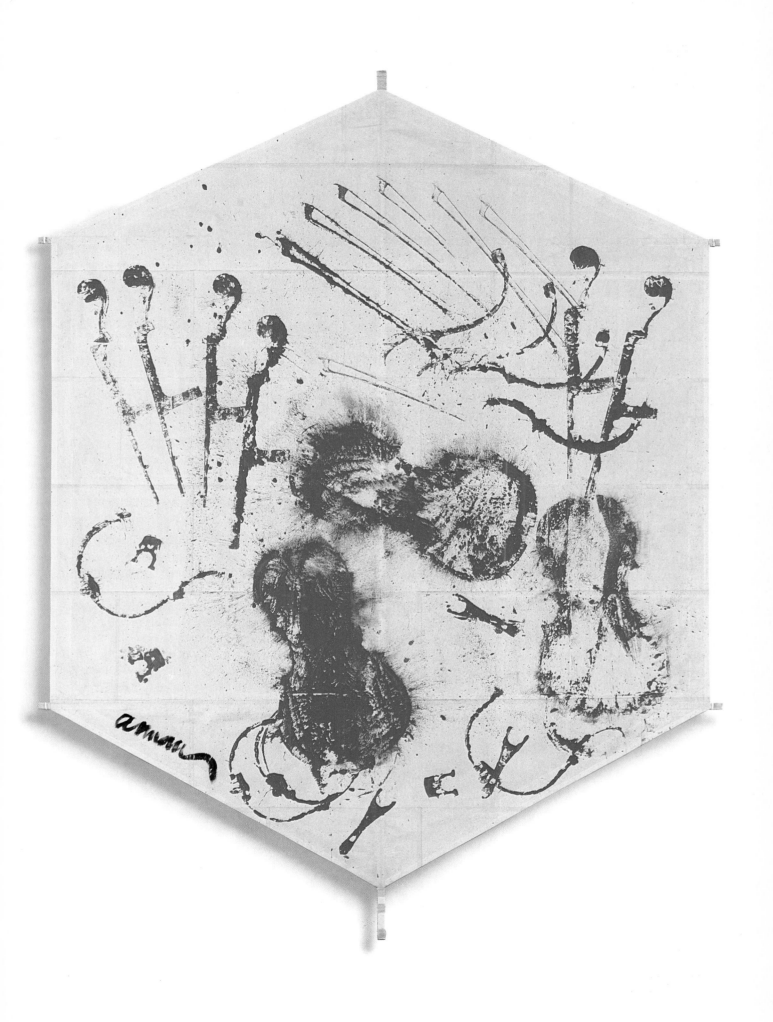

Mimmo Paladino

Born 1948 in Paduli, Italy,
lives in Benevent and Milan

Paladino is one of those prominent young Italian artists for whom the terms "arte cifra" and "transavanguardia" have been coined. For them, originality does not stem from stylistic innovation but from an eclecticism that combines elements ranging from mythology to Conceptual Art.

Cultural present and past are blended together in Paladino's creations, especially the mysterious, the inscrutable and the forgotten. "When I am engaged in a work, I endeavor to penetrate to its core."

Paladino chose the six-sided rokkaku style for his art kite. A human figure is spread-eagled over this geometrical form like Leonardo's man in the squared circle, the man seemingly enshrined in the hexagon along with animals and zodiacal signs. Touches of gold-leafing lend the work the aura of a devotional picture, and the donkey's ears, usually understood as a sign of abuse, here seem to indicate a divine being.

Unlike Leonardo, Paladino is not concerned with the choice between a square and a circle. With the hexagonal form he discovered a harmonious balance, animating it with lyrical imagery that leaves the door open to endless interpretations. "At all times and places things are borne in the air, and whoever has an appropriate antenna can sense and grasp them. Even though they sometimes seem to tell stories, my paintings offer no explanations and are sheer illusion. The concept is musical rather than literary."

ミムモ・パラディーノは「アルテ・シフラ」とか、「トランスアバンギャルディア」の名で呼ばれる有名な「若いイタリアの芸術家」を代表する一人である。彼らの独創性は、受け継がれたアヴァンギャルド概念という意味での様式の革新性から取り入れられているのではなく、古代の神話的な絵画からコンセプト・アートに至るまでの総合的美術史、文化史からの引用を相互に結びつけることによる折衷主義からきている。

広範囲にわたって独学により展開してきた彼の作品には、今日の現実と文化的な記憶の要素とが混在している。とりわけ彼が興味をもつのは神秘的なもの、究めがたいもの、忘れられているものである。「私が一つの仕事をする時、私はその領域の真髄に足を踏み入れたい。」

ミムモ・パラディーノはそのアート・カイトに六角凧の形を選んでいる。十字架にかけられた人のように、この幾何学的な六角形の中に人間がはりつけになっていて、区切られたみつばちの巣房の中に、動物や占星術でいう星座のシンボル、様々なものがはめ込まれているようである。金箔を使用することにより、作品は神秘的な神聖さを湛えている。過去には罵詈の対象として誤解されてきたロバの耳は、ここでは神聖なものの象徴として理解することができる。

この絵を観る者はその美術史の知識から、レオナルド・ダ・ヴィンチの美のプロポーションの理論についての1485年のあの有名な素描を思い起こすことであろう。レオナルド・ダ・ヴィンチは、人間の体型の理想的な規範を学問的に追求し、一つの絵の中に「円形における人体」と「正方形における人体」の融合を試みた。そして、人体学的にいう本来の人間の形が、教義上の均衡の規準に合致するものではないという結果に至った。同様に、円形と正方形を調和させることは容易なことではないのである。

パラディーノにとって、円形と正方形はどちらかをという選択の対象になるものではない。六角形にこそ、調和のとれた均衡の幻想を見いだしたのである。この叙情的な絵画言語は謎と暗号を同じぐらい含んでおり、限りなく多くの読み取り方ができる。「どんな時にも、いろいろなところに空中に浮遊するものがある。それを感じるアンテナを持つ者は、それを感じ、しっかりと捉える。時にはそう見えても、私の絵はなにも物語らないし、説明もない。ただ幻想のみだ。その概念は文学的というよりむしろ音楽的なものなのである。」

Untitled
Acrylic, gold-leaf 231 × 185 cm
Rokkaku kite
Kite-makers: K. Tamura, S. Ogasawara

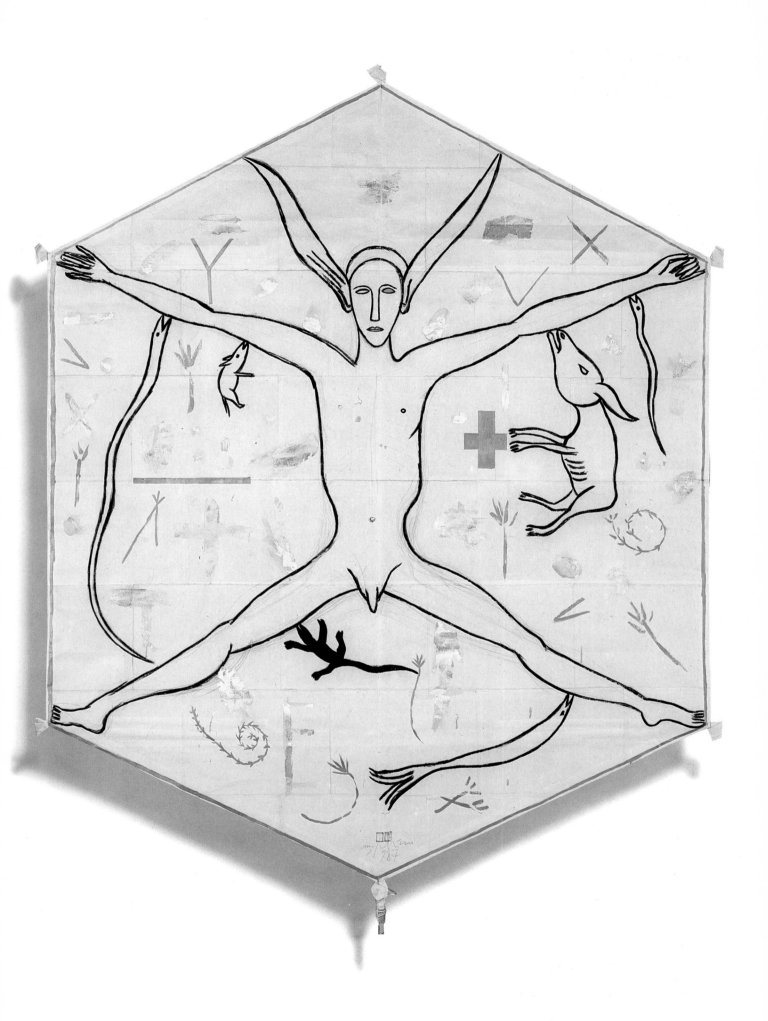

Robert Kushner

Born 1949 in Pasadena, California,
lives in New York

A mid-1960s trip to Iran, where he became fascinated with Persian art, architecture and the patterns of old carpets, led Kushner to the possibilities inherent in intentionally decorative art. More precisely, he started to explore ways to overcome the distinction between art and decoration, soon concluding that the appropriation of historical motifs was a highly valid means of artistic expression. As an artist, therefore, he sees himself as a prism: receiving, transforming and projecting diverse ideas and influences. What is unique about Kushner is that he does not try to obscure his original sources.

Kushner's first technique was to copy patterns from old fabric onto paper, concentrating exclusively on form. Content remained of secondary importance and there was no attempt at optical depth. The works were totally flat with frequent pattern repetitions – leaves, hanging plants and other floral configurations being especially common motifs. Later, he broadened his repertoire with borrowings from European fabric and wallpaper designs, as well as from books of Chinese illustrations.

In 1977 appeared his first works with figures done in the style of baroque ornamental painting. They showed three cherubs bearing a basket of fruit, joined by cupids, dancers, Egyptian musicians and operatic characters. Matisse's influence is recognizable in Kushner's efforts to integrate figures into a decorative scheme.

In 1982 Kushner began using models, initially painting on washi, the rich texture of which he incorporated into the composition. Over a base of patterned wallpaper he applied cut-out figures, sometimes leaving out body parts (like a head or a hand) which he then hand-painted in. Again, the effect was one of Matisse-like flatness, a complete absence of perspective. This style he varied frequently, occasionally substituting cloth as the background and choosing irregular forms akin to stage scenery or apparel.

ロバート・クシュナーにとって芸術とは、装飾でありその目標は装飾である。

70年代なかばのイラン旅行に触発され、ペルシャ芸術や建築、古い布地やじゅうたんの模様に魅了されて、クシュナーは装飾絵画の可能性を見つけ出した。それらを復活させると同時に、彼は芸術と装飾の分別を乗り越えようとする。歴史的な様式の活用は、彼にとって芸術の適正な表現方法であった。芸術家として彼は、自分自身をアイディアと感化を受け入れ変形させるプリズムとみている。画家としての彼の独創性は、モチーフをその出所が明らかにわかるように変形させるところにある。

ロバート・クシュナーは、歴史的な織物の模様を紙に写し取ることから始めた。この時期は絵の練習と同時に、彼独自の形式語彙を編み出す方法を展開させる時期でもあった。この時、彼がこだわったのはかたちである。内容は彼にとっては二義的なものであったし、その絵画の中に幻想主義的な深さを表現することはしなかった。彼の絵は全く平面的で、多くの場合模様が反復している。木の葉、つる植物、花模様の飾りなどが繰り返しテーマに取り上げられる。彼は又、ヨーロッパの伝統の布地や壁紙の模様を取り入れ、中国の絵画の本から模様の基礎を学び、かたちのレパートリーを拡げていった。
1977年、人物を描いた彼の最初の絵が誕生する。それはバロックの装飾絵画の様式の、果物カゴを持つ三人の少女の絵で、その後、キューピット、踊り子、エジプトの楽隊、オペラの登場人物などがあらわれる。人物像を一つの装飾的なわくの中に統合させるという彼の試みの中に、マチスの影響をみることが出来る。

1982年、モデルをおいて描くことを始める。まず用いたのは和紙で、紙の組織を絵画構成に取り入れていく。しかし、彼は絵の下に壁紙を使い写し取ることによって人物像全体を装飾された完全な平面に置きかえることになった。最終的には、体の部分は模様のある紙でコラージュし、顔や顔の半分、手など体の部分部分を墨の線のまま残した。彼は絵の下に布を使うこともよくあり、それは彼の作品に、舞台の背景画やパフォーマンスの時のマントなどの作品を思い出させるような様々な大きさや不規則なフォルムをもたらすことになった。

Two Angel Kite
Acrylic, gold-leaf
Rokkaku kite 150 × 122 cm
Kite-makers: K. Tamura, S. Ogasawara

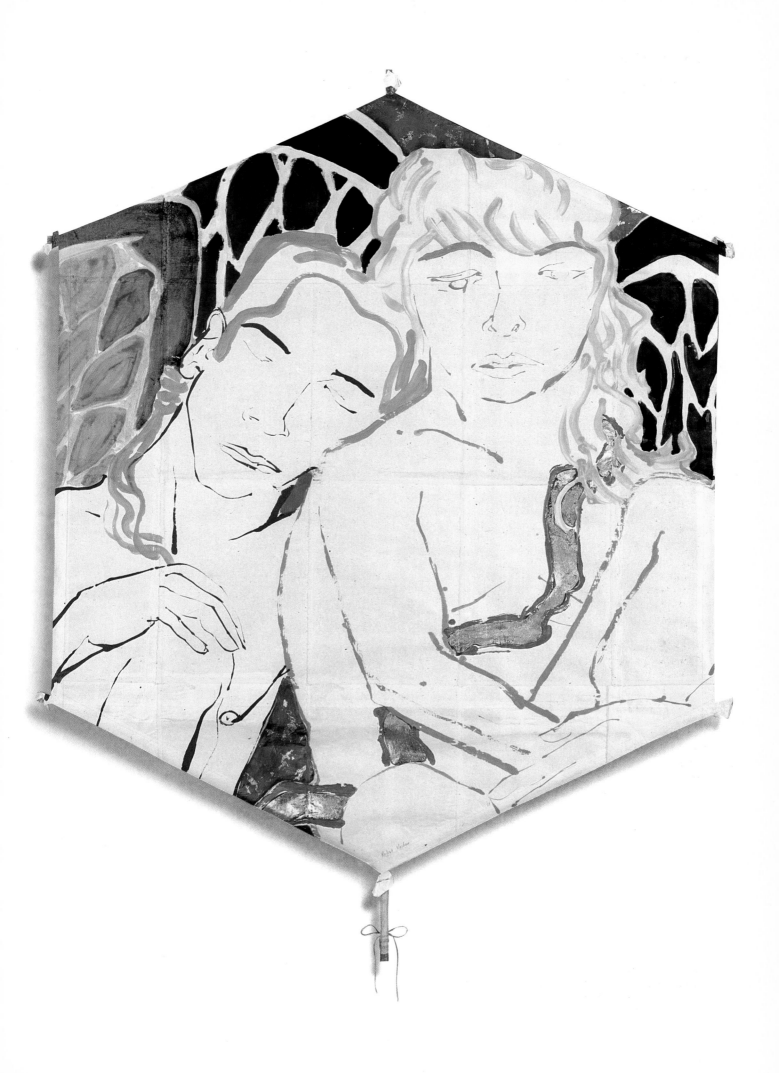

Barry Flanagan

Born 1941 in Prestatyn, North Wales,
lives in London

Trained at the St. Martin's School of Art in London, Flanagan worked in the beginning of his sculpture career with unconventional materials. His creative process has included shovelling sand, filling bags with styrofoam, covering a floor with rope and pouring gypsum into pieces of fabric sewn into conical shapes.

Only gradually has Flanagan turned to traditional materials such as marble and bronze, creating numerous animal figures that, although somewhat transformed by his singular humor, remain easily identifiable. Particularly well-known are his rabbits, cast in bronze and often embellished with gold plating, they seem to be able to hop over all obstacles with effortless élan.

Flanagan's series of kites consists of faces looking down from the sky with friendly, thoughtful and occasionally anxious expressions. All the kites convey a peaceful message since the brushstrokes used are those of the Japanese character for "peace".

バリー・フラナガンはロンドンのセント・マーチン美術学校に学ぶ。彫刻の既存の概念に全く反して、初期の頃から並はずれた素材を扱っている。シャベルで砂をすくったり、ポリスチロールを袋一杯に詰めたり、円錐状に縫い合せたものに石膏を詰めたり、ロープで床を覆ったりして作品にしている。

やがて、彫刻の造形としての伝統的な表現手段や大理石、ブロンズなどの素材へと戻っていく。数多くの動物彫刻が生まれているが、これらは一風変ったユーモアと、モチーフとなる本物の動物との繋がりがわかるように作られている。そして有名になったのがうさぎの彫刻である。青銅を溶かして作られ、時には金メッキがほどこされたこのうさぎは軽々とあらゆる障害を飛び越えていく。

バリー・フラナガンはユーモアたっぷりに私たちのアート・カイトの制作依頼に応じてくれた。様々の表情をした顔の一群、そこには優しい顔、もの思う顔、悲しそうに上から見下ろす顔がある。しかし、どの顔も平和のメッセージを伝えている。顔を作っている筆のタッチが同時に平和の「平」という字を形作っているのである。

Peace
Silk-screen
Rokkaku kite 60 × 120 cm
Kite-maker: T. Uno

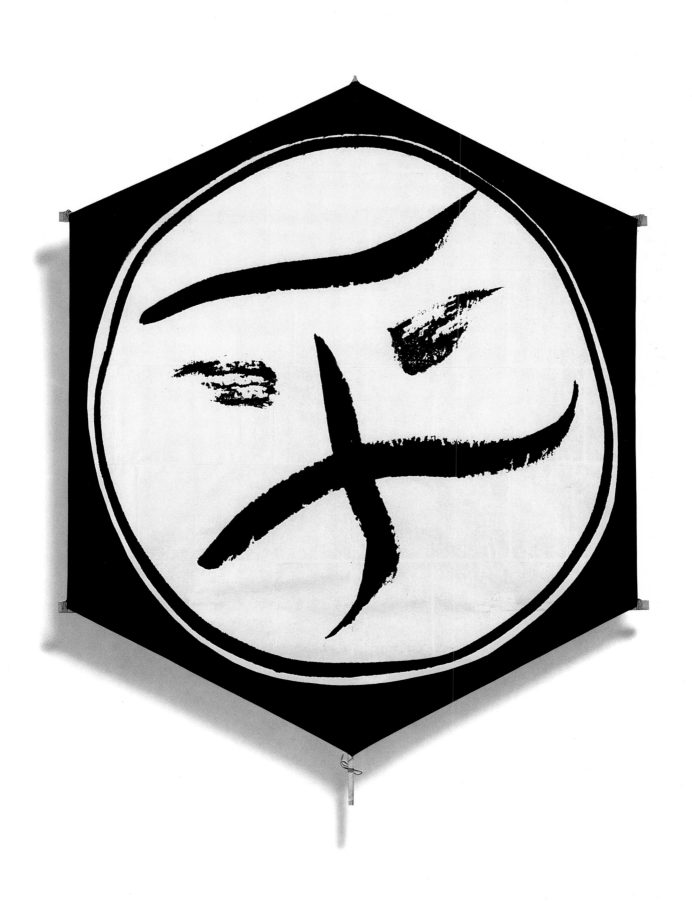

Miyagi Prefectural Art Museum
宮城県美術館　1988年6月

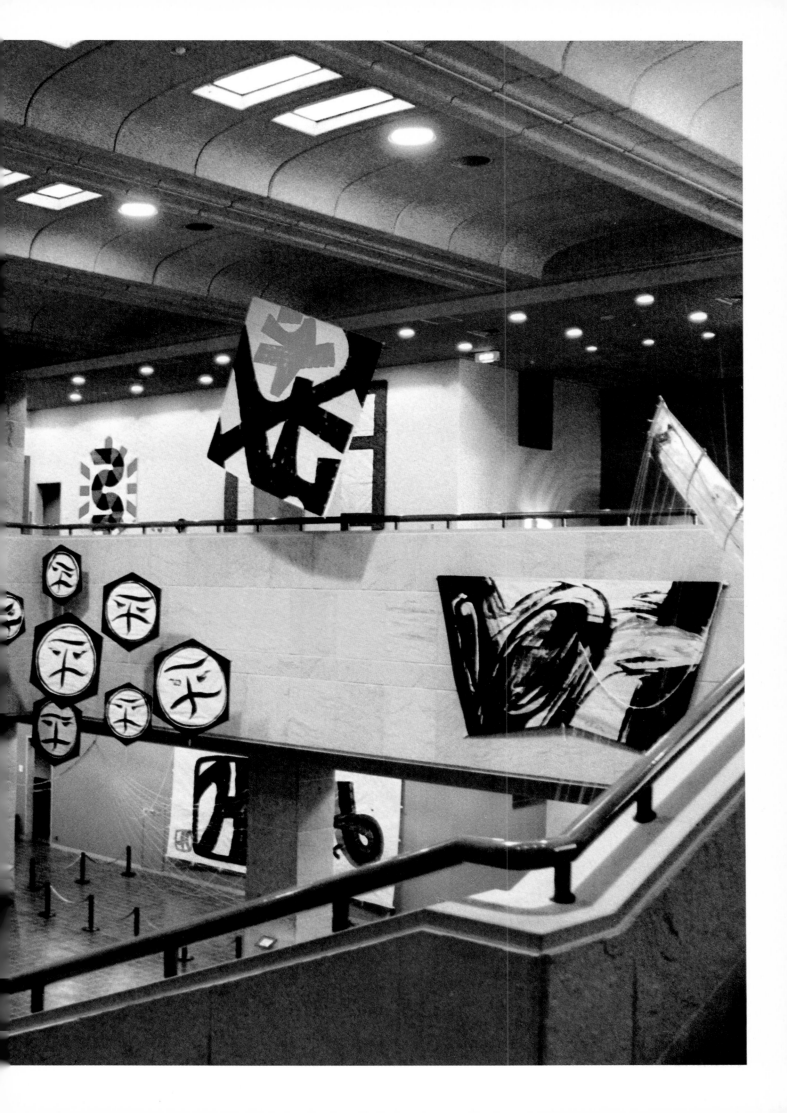

Ushio Shinohara

Born 1932 in Tokyo,
lives in New York

With both intensity and irony Shinohara has worked through a large sampling of modern art styles, from Informel through Action Painting to Neo-dadaism. In 1960 he formed a Neo-dada group – together with Arakawa and Akasegawa – that produced "anti-art". Later, he modelled his paintings on Edo period wood-block prints, and this, in turn, gave way to the influence of Pop Art. In his sculptures Neo-dada mixes with Pop Art and the Japanese world of ghosts to forge a terrible and grotesque world filled, for example, with apparitions of motorcyclists mounted on monstrous machines.

Shinohara chose for his kite the rokkaku, within which he placed a traditional Japanese thatched roof house. Typically, he also created a long-necked Hokusai-type monster emerging from the house, adding a ghastly tone to the whole scene. Beware one and all: it is the witching hour!

Shinohara's Ghost art kite is heavy in the physical sense, too. He used thick board material and the frame consists of beams. Thus, even with a gale wind, there is no danger of the 30-kilogram kite rising to haunt the sky.

篠原有司男は、激しさとあざけりとを込め、西洋美術の様式をアンフォルメルからアクション・ペインティングをこえて、ネオ・ダダに至るまで徹底して修練した。1960年彼は、荒川修作、赤瀬川原平らとともにネオ・ダダイズム・オルガナイザーズを結成し反芸術運動を起こした。

60年代には、彼の絵画は江戸時代の木版画を模範とするようになるが、その後の作品の中にはポップ・アートの影響が見られる。立体作品にはネオ・ダダ的な要素と、ポップ及び北斎漫画に見られるような日本のおばけの世界が混ざり合っている。彼は恨みを込めてグロテスクな世界をつくっている。例えば、あのカフカの甲冑をつけた虫の変身のように、ばかでかいモーターバイクに怪物のような人間がまたがる立体の作品もその一つである。

篠原はアート・カイトに神秘的な六角凧を選んだが、その立体作品の中にはかやぶきの屋根と竹の生垣をもった全く伝統的なスタイルの和風家屋がつくり出されている。しかし、この牧歌的な雰囲気はとりとめもなくくずれてしまう。突然ヘビのようなろくろ首とグロテスクで恐ろしい顔がそこからにゅうっと延びているのだ。まさしく丑三つ時、それとも有司男時か。

彼のこの作品は重量感のある手法で仕上げられている。凧の表皮にはごつい板をつかい、しかも裏には薄い板ではなく、梁のような木を渡してがっちりと重々しく組み立てられている。30キロもあるこの凧は嵐の強風でも揚がりそうにない。

Ghost
Mixed media (wood, corrugated cardboard, polyester tile, canvas, lacquer, dye)
Rokkaku kite 200 × 140 cm

Leon Polk Smith

Born 1906 in Chickasha, Oklahoma,
lives in New York

His first influence being Mondrian, Smith originally applied the principle of the interchangeability of surface and space to the curved line. For this, sketches of the seams of tennis, soccer and basketballs were especially helpful, the space between their lines being a source of fascination for him. He varied this idea in two-color works.

In the 1950s Smith ventured into Hard Edge painting, setting sharply contrasting fields of color against each other in abstract, geometrically-structured works. Since 1967 he has been combining round, oval, rectangular and square color plates in his so-called "constellations" in which, owing to their cut-out character, the color elements appear to extend beyond the picture frames and out into ambient space.

In pairing two different types of kite forms, Smith has here also created a constellation. Though somewhat unusual shapes for paintings, they are true to his strict geometrical style. He has further divided these five and six-sided surfaces into three and four-sided parts, so that his kites strike one as being cut-out sections of much larger fields of color. Like the crisp, clean design of flags, these kite are impressive even when viewed from a distance.

レオン・ポルク・スミスは元来、オランダのデ・ステイル派の画家ピエト・モンドリアンの絵画に傾倒し、芸術の方針をモンドリアンの絵画に求めた。モンドリアンの平面と空間の交換の可能性の原則を、曲線にも置き換えるという試みをした時、テニス、フットボール、バスケットのボールの縫い目をスケッチしたことが役立った。これらの線に囲まれた空間は、平面として彼を魅了した。この発見を、二つの色のコンビネーションの中で、様々に変化させたのである。

50年代、彼はハードエッジ絵画に到達し、反具象的で幾何学的に構成された絵画の中でコントラストの強い色面を対置させた。1967年以来スミスは、円形、楕円形、長方形、正方形の図形を組み合わせ、いわゆる「コンストレーション（色面の集合体）」を形作っている。切り抜かれたような特徴をもつ個々の色面は、まるで色彩が画面の縁を越えて空間へ拡がるような印象を与えるのである。

アート・カイトの作品にもスミスは二種類の異なった凧を組み合わせて色面の集合体を作り出している。ケロリも六角凧も珍しい絵画のかたちではあるが、厳格にして幾何学的であるので画家の形態言語に似ていると言えよう。これらの凧の五角形あるいは六角形の平面を更にいくつかの三角と四角の平面に分け、巧みに彩色をほどこしている。このようにして凧の絵は、より大きな色面の一断面という印象を与えている。信号のような、そして旗のような性格をもつこれらの凧は遠くにあっても人目を引きつける。

Kerori · Rokkaku · Kite
Acrylic
Kerori kite 191 × 364 cm
Rokkaku kite 129 × 99 cm
Kite-makers: T. Kashima, K. Tamura, S. Ogasawara

KERORI KITE 1987

Anton Stankowski

Born 1906 in Gelsenkirchen,
lives in Stuttgart

One of the pioneering graphic designers of this century, Stankowski is the dean of Constructivism in Germany. Simplify, objectify and humanize are the guiding principles of his work, and he has explored almost all areas of visual communication, from company logos to information systems.

Stankowski spent the 1950s and '60s investigating problems of symmetry, screens, diagonals, progressions and other matters of compositional concern, and he has developed several of his own systems of color harmony.

"Aesthetics is order. The observer must be able to recognize this before entering into a dialogue with a piece. To order means to omit nonessentials. In this way the impact of the material is heightened; what is essential cannot be spoken of without making a selection on the basis of order."

For his kite Stankowski chose the six-sided rokkaku (which he has transformed into a eight-angled cube) and applied his knowledge of color gradation to suggest the lightness of flight.

アントン・スタンコフスキーは今世紀最大のグラフィックデザインの草分けの一人で、ドイツにおける構成主義及び具象絵画の大家でもある。すでに30年代、リトグラフ・デザイナーとしての彼の「機能をもった活版印刷」は、国際的評価を得ている。芸術と応用芸術の相互関係が彼には当然のことであったが、このことはエッセンのフォルクヴァング学校に学んだという結果でもある。

発見、単純化、客観化、擬人化といったことが彼の仕事の推進力となっている。ヴィジュアル・コミュニケーションのほとんどの分野で活躍しているスタンコフスキーは、企業の商標、トレードマーク、インフォメーションやガイド標識、さらに公共空間のためのデザインなど広範囲にわたって影響を及ぼしてきた。

「美は秩序だ。観る者が作品と対話するのに役立つよう、原則は認識出来なければいけない。秩序とは不必要なものを取り除くということだ。そうすることによって大切な情報が強調される。秩序を介することなく選択するのでは、本質について述べることが出来ない。」

50年代には、シンメトリー、アシンメトリー、格子模様、進行の急変、階段調の進行といった課題に体系的に取り組み、これらをさまざまに正方形のかたちで解決している。60年代には新しい構成要素として、彼の絵画に斜めの線がとり入れられ、これが後にスタンコフスキー独自の作品構成の基礎となる。斜線の要素を取り入れた数多くのシリーズとなる作品の中で、彼は色の調和についての体系も展開させていく。

アントン・スタンコフスキーは、アート・カイトに六角凧を選んだ。その上に驚くほど巧みに八角形のサイコロを描いた。パステル画のような色調と繊細な色のぼかしによって、この空飛ぶオブジェの軽さが強調されている。

Space Kites
Acrylic 115 × 100 cm
Rokkaku kites
Kite-makers: K. Tamura, S. Ogasawara

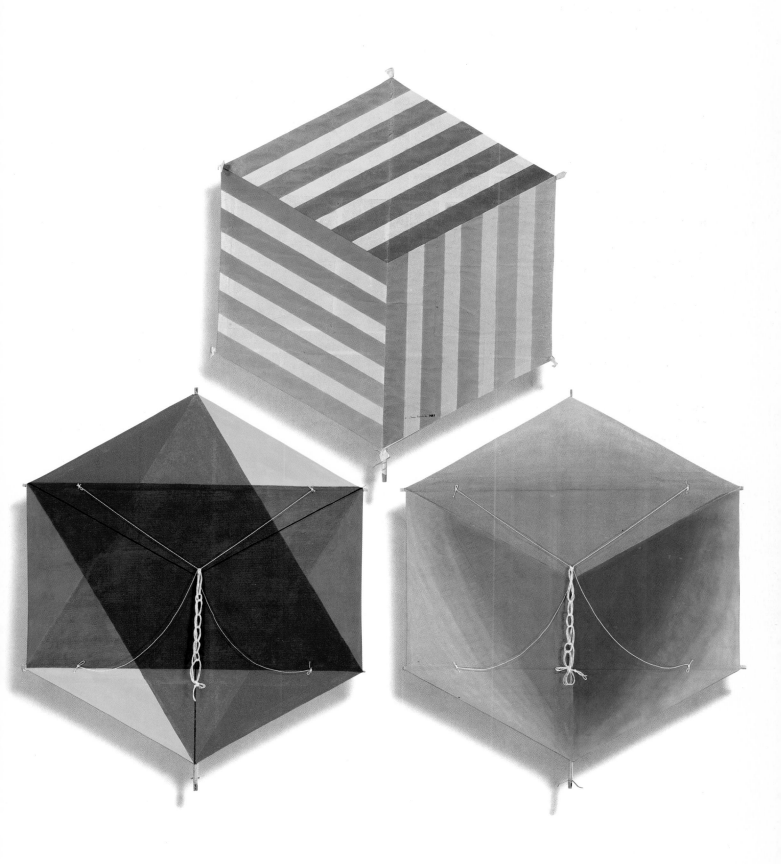

Victor Vasarely

Born 1908 in Pécs, Hungary,
lives in Paris

In 1928–29 Vasarely attended lectures at the "Hungarian Bauhaus" in Budapest, where no distinction was made between fine art and craft. Rather, the emphasis was on trying to combine art and technology, form and production. Vasarely's teacher, Moholy-Nagy, was particularly occupied with transparency and optical refraction.

In 1930 Vasarely took up residence in Paris and worked as a graphic designer, for ten years devoting himself to the building of a systematic repertory of graphic techniques. In his graphic works, the stripe and checkerboard predominate, the rows of "distorted" squares – which undulate at the surface and give rise to transparent cubes – being early signs of his emerging kinetic style. Initially considered a surrealist (and nick-named the "Prince of Trompe l'œil") he was later recognized as the founder of Op Art.

Over time Vasarely developed a complex lexicon of techniques based on superimposition of painted cellophane and projections. The effect by which colors apparently flow in and out, and positive forms change, to negative (and vice versa), produces a conflicting spatiality that seems caught between movement and inertia, true three-dimensionality and a rotating plane. The eye falls into visual traps that are also cognitive traps.

ヴィクトル・ヴァザレリーは芸術アカデミーで学んだあと、1928年から29年にかけてブダペストの ハンガリー・バウハウス の講座に参加した。そこでは応用芸術と芸術はなんら区別されることなく、むしろ芸術と技術、造形と製造を結びつけることに一層重きがおかれていた。またモホリ・ナギも教鞭をとり、透明と光屈折のテーマに取り組んでいた。

1930年、ヴァザレリーはパリに移り住み、グラフィックデザイナーとして働いた。10年間、無数の試みを行い、グラフィック的な手法で系統的なレパートリーを組み立てた。彼のグラフィック作品で先ず目につくのは、線と格子という二つのモチーフである。平面を波打ってならぶ "ゆがめられた正方形" や、透明な立方体がすでに、彼のキネティックの様式を予告している。彼は最初、シュルレアリスムの芸術家として、「だまし絵のプリンス」と名付けられ、後にはオプティカル・アートの創始者と呼ばれることになる。

その後、彼は彩色して重ねたセロファンに光を投影することによって、複雑な造形的手法をあみだした。一つの色が前に浮き出したり、他の色が後に沈んだり、あるいはポジとネガの形が交互に見えたりするその効果は、動と不動から、あるいは、立体性と回転から起る矛盾した空間感覚やイリュージョンを招くのである。目は視覚的な錯覚に陥るが、それは思考上の錯覚でもあるのだ。

Untitled
Poster colors
Rokkaku kite 205 × 180 cm
Kite-makers: K. Tamura, S. Ogasawara

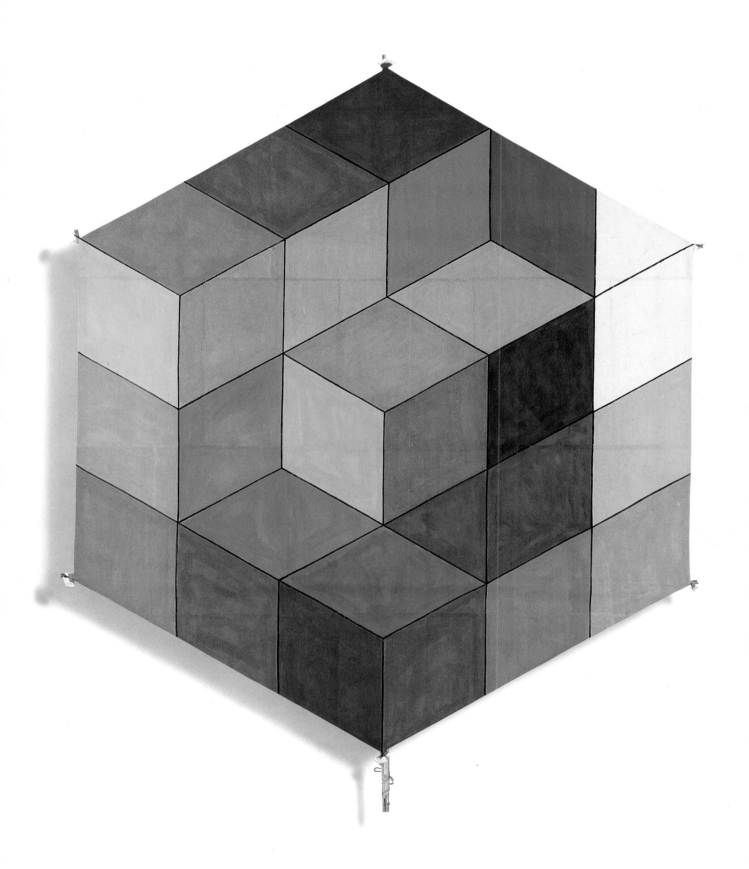

Vasarely derived this principle of an architectonic polychrome from an awareness of the atomic age, suggesting thereby a new definition of the artist's task: that of combining the activities of the technician and researcher with that of creator. He has consistently opposed the "myth of unique art pieces" as a possession and a symbol of privilege, and has, instead, tried to create a quality which is bound to the very conception of the work itself. Rather than the works suffering from their multiplication, their availability has actually enhanced their social impact, his magnificent prints and silkscreens being known all over the world.

Vasarely made two kites for the sky museum: the hexagonal rokkaku from Niigata Province and the tsugaru (the square kite with the black border) from northern Honshu. Since bamboo does not grow in northern Japan, the tsugaru kite frame is made from Japanese cypress. Both kites create optical and spatial illusions.

この多彩な構成原理は、ヴァザレリーが原子核時代を意識して引き出したものである。それはまた、技術者や研究者の活動と、創造を結びつけるという芸術家が担うべき新しい課題の定義でもある。

結果として彼は、所有物や特権のシンボルとなる「ただ一つの作品という神話」に反駁することになる。その代りとして、複製によって損失を受けるどころか、反対に、複製の技術によって社会に広く浸透させるような、しかも彼の芸術に対する基本理念に添った質のものを作り出そうとしている。すばらしい仕上りのシルクスクリーンや複製版画によって彼の作品は世界中に広がっている。

空の美術館のために、ヴァザレリーからは二つのアート・カイトが寄せられた。一つは新潟の六角凧で、他の一つは角凧になるもの。これは縁が黒いところから、黒い縁をもつ伝統の津軽凧になり、そのふる里青森の津軽で作られることになった。どちらも視覚的な錯覚と空間的なイリュージョンのあそびが取りいれられている。

Untitled
Poster colors
Tsugaru kite 240 × 200 cm
Kite-maker: G. Fukushi

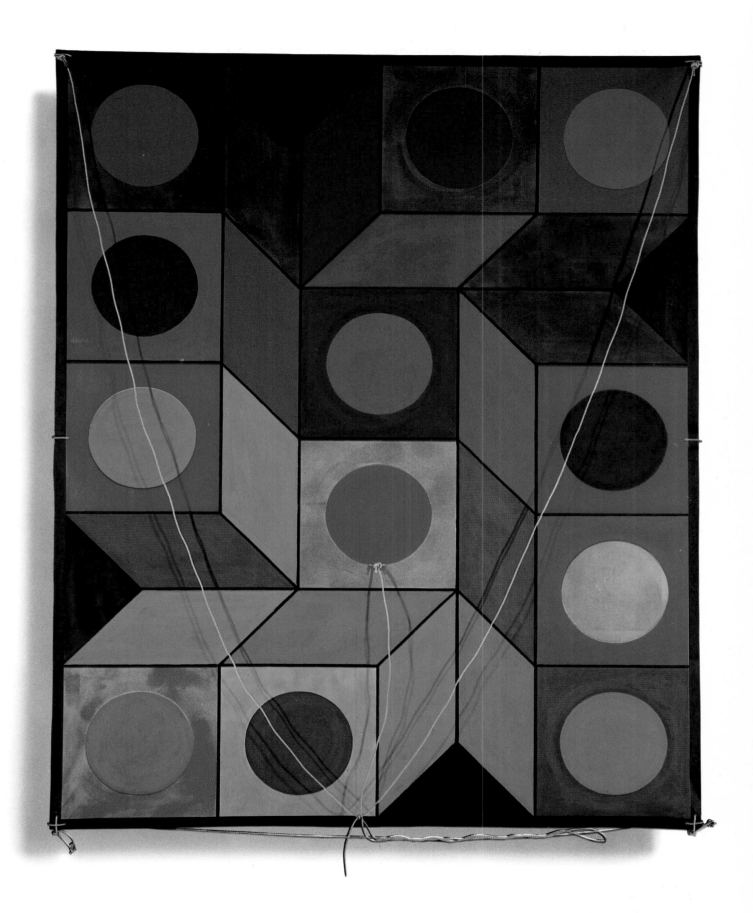

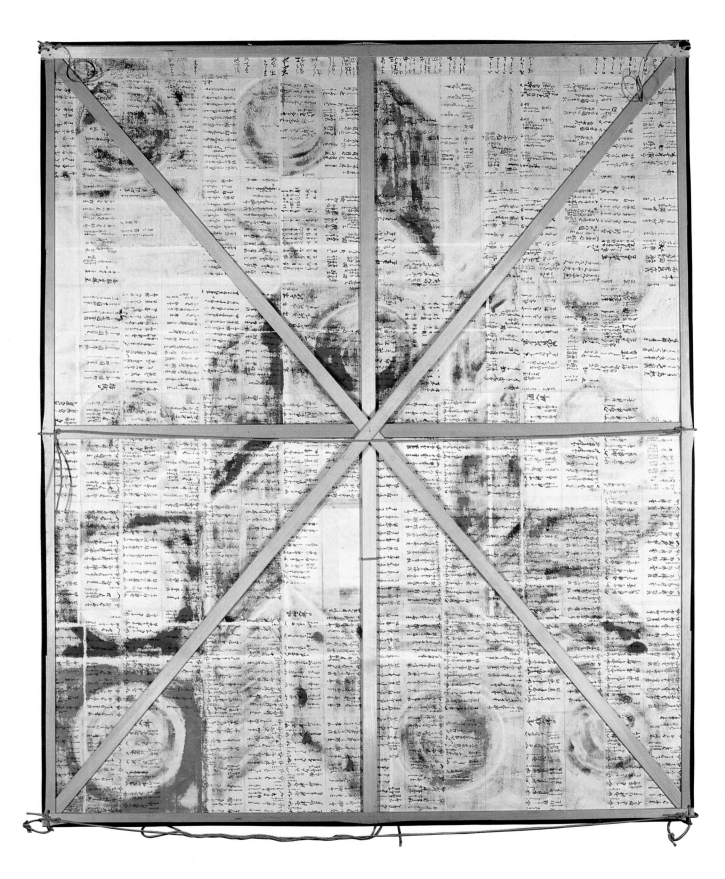

津軽凧の裏打ちにも古文書が使われる。凧の大きさによっては何枚か貼り重ねられ、その表面をはじくと大太鼓のように響き、これがうなりのすばらしい共鳴体になる。

For reinforcement the reverse side of the Tsugaru kite is pasted with paper. Old invoices, ledgers or certificates made of Japanese paper are used for this.

Atsuko Tanaka

Born 1932 in Osaka,
lives in Asuka

For a decade from the mid-1950s Tanaka was a member of the Gutai Group, the most important Japanese avant-gardists of the postwar era. Already in the '50s Gutai anticipated happenings, performance art and Flux-style events, famous examples including Saburo Murakami smashing through paper screens, Kazuo Shiraga's mud performance, Sadamasa Motonaga hanging plastic bags of colored water in the open air, and Akira Kanayama (Tanaka's husband) painting by means of remote-controlled vehicles. Tanaka, herself, created an original sound installation entitled "Work (Bell)" in which she placed electric bells over an entire exhibition area, all programmed to ring at different pre-determined intervals.

A subsequent Tanaka performance became the starting point for her painting. In 1956 the then 24 year-old artist put on a "dress of lights" consisting of countless electric bulbs and neon tubes, leaving only her face visible out of the confusion of wires and flickering lights. She subsequently applied this image to the canvas and painted linked polychromatic discs that overlapped and appeared entangled in innumerable colored lines.

Over the years Tanaka has continually re-worked this motif, arranging the elements in ever-new constellations, her art kite being one such adaptation, designed to fill the sky with a shimmering play of light.

田中敦子は1955年、戦後の日本にあって、重要な役割を果した前衛派のグループ「具体美術協会」のメンバーになり、1965年まで所属する。

このグループの芸術活動は非常に多彩で、50年代すでに、後にハプニングとかパフォーマンスとかフルクサスとして評価を受けるようになる表現形式を先取りする。村上三郎は、紙の衝立てを何枚も立てて、それをつき破り駆け抜け、白髪一雄は、そのパフォーマンスで泥にいどみ、元永定正は、戸外の自然の中に色つきの水の入ったプラスティック容器をぶらさげる。後に田中敦子と結婚した金山明は、絵具をたらしながら走るラジコン自動車によって絵を描く。そんな中で田中敦子はベルを使った独自の世界（作品　ベル）を発表する。彼女は、展覧会の会場内に広く、コードをつないだベルを配置し、時限装置をつかって、次々に鳴らしてみせる。

これに続くパフォーマンスが、彼女の絵画における出発点ということになろう。1956年、当時24才の女流芸術家は、色とりどりの数えきれないほどの電球とネオン管で出来た「光の服」を身につける。明滅する電球と配線コードの混沌の中からは顔だけが覗いていた。この電飾服のイメージが、彼女が後にカンヴァスの上に描いていく絵画作品へと展開していったのである。色彩豊かな円形が画面をおおい、その上や間を、多数の色とりどりの紐状のものが幾重にもはい回り、あるいは重なり合っている作品が生まれた。それ以来、飽きることなく、彼女はこのモチーフを使って多くのヴァリエーションをつくっている。絶えず新しい組み合わせを試み、この絵画要素に緊張感さえ与えている。同じ大きさの、同じ色の円形が整然と並ぶ初期の様式を経て、構成は段々表現が繊細になっていく。円形は、異なった大きさになり、同心円的に種々に彩色された輪の重なりになっていく。

この輝く光の遊びを、彼女は芸術凧にも応用した。

Untitled
Acrylic on canvas
Tsugaru kite 162 × 130 cm
Kite-maker: T. Kashima

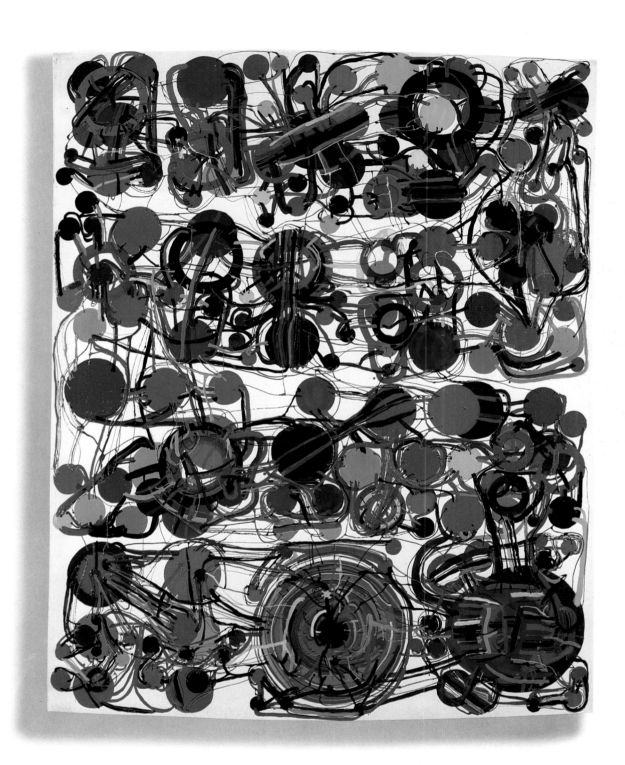

Horst Antes

Born 1936 in Heppenheim/Bergstrasse,
lives in Karlsruhe and Berlin

Antes' first works were rooted in the Informel with
Willem de Kooning as his model, but by the early 1960s
the intense color structures of his paintings had sharp-
ened to clear, precisely-contoured surfaces. At the
same time he developed his well-known "head-foot
men", profiles of shadow figures which he has varied in
countless works. Later, he discovered similar shapes in
the Kachina dolls of the Pueblo Indians, which he now
collects. Apart from paintings he also produces many
sculptures and graphic pieces.

For the Project Antes created a pair of kites. The large
Edo kite, "Berlin Window", was designed in his new
studio, where the view gives out over a row of working-
class houses with white-painted window cross-bars.
Their endless grid pattern caused Antes to reflect on
military cemeteries and the hidden semiotics of
crosses in building construction, and the bridge-like
nature of the kite's forms could be seen as an attempt
to build a link between the earth and the sky, or
between Berlin and Japan.

The second kite shows a solitary "head-foot man",
perhaps a retired sage, sitting in a sanctuary of infinite
space.

ホルスト・アンテスの芸術の出発点はアンフォルメルで、彼が傾倒した
のはデ・クーニングである。1960年頃、アンテスは強烈な色使いの絵画構
成を、正確に輪郭をとった、はっきりした色面をもつ絵画に凝縮させて
いく。この時期に肖像画を切り抜きにしたようなアンテスのあの「頭足
人間」が様々に展開されていく。後に彼は、北アメリカのプエブロイン
ディアンのカチーナ人形の中にこのモチーフを見つけ、それ以来この人
形を蒐集する。絵画のほかにグラフィックや彫刻などの作品も数多い。

ホルスト・アンテスは空の展覧会のために一対の凧を制作した。幾何学
的に構成された大江戸凧は有名な建築物の一部がそっくり抜け出たよう
でもある。「ベルリンの窓」というタイトルからもモチーフの由来が推測
できる。ホルスト・アンテスは少し前、ベルリンのモアビート街のア
トリエに越し、そこで制作されたのがこの凧なのである。アトリエの窓か
らは、白ペンキに塗られた十字形の窓桟が並んで見える。これは当時、労
働者の居住地区に見られた典型的な家の建て方である。アンテスにはこ
のような窓の数限りない格子模様が印象的であったのか、それは戦士た
ちの墓地をしのばせ、建築構造の中に隠された十字形の象徴的表現につ
いて考えさせることになった。空に浮ぶ窓になった彼の作品は、ベルリ
ンと日本、天と地を結ぶなど、アンテスのいくつかのアイデンティティ
ーになっている。

「ベルリンの窓」はもう一つの凧と統合して完全な作品になる。二つ目
の凧は、世俗から離れた老賢者の姿に極端に単純化され、無彩色の空間
に肖像画のように形どられた「頭足人間」である。

Kneeling Figure and Berlin Window
Acrylic 370 × 153 cm
Kaku kite
Kite maker: T. Kashima

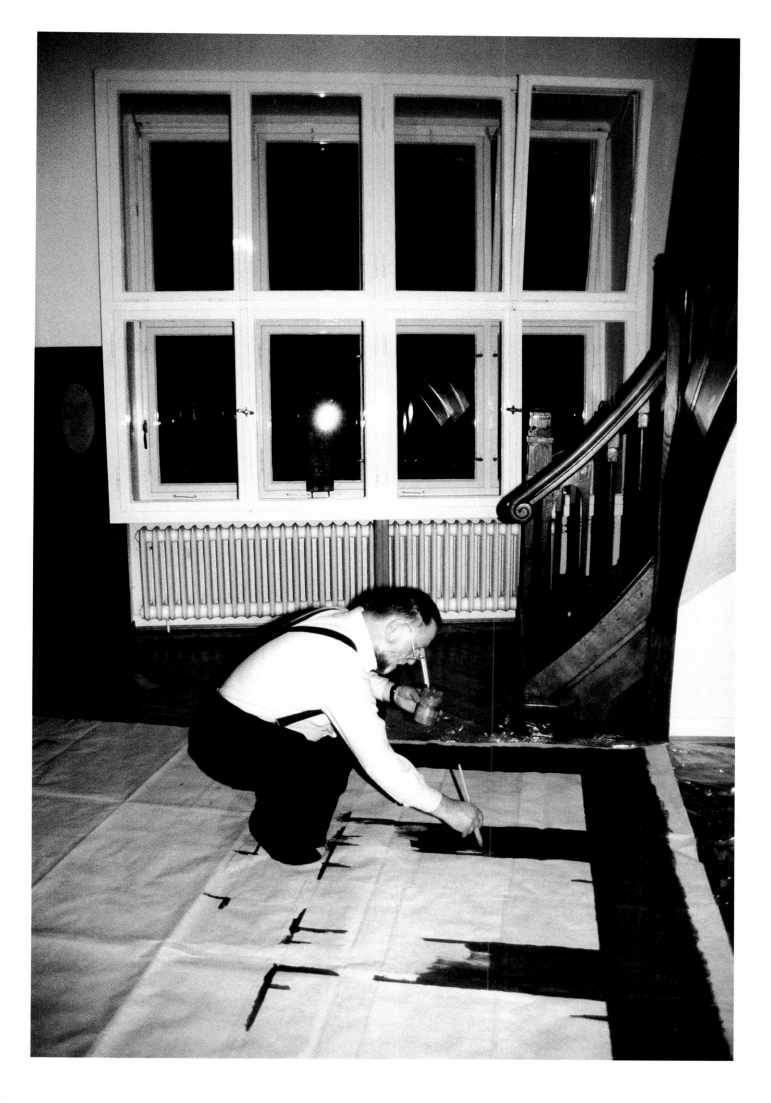

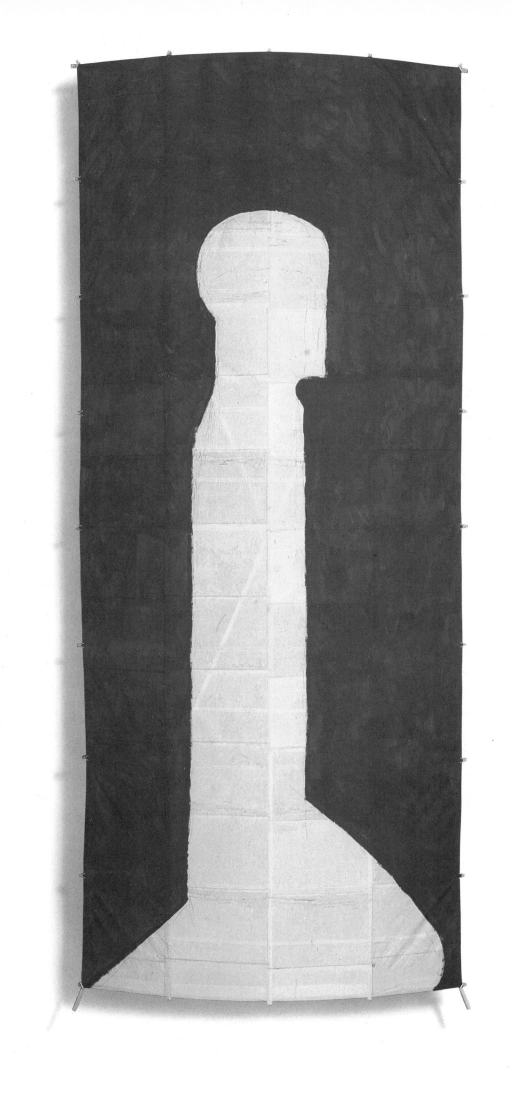

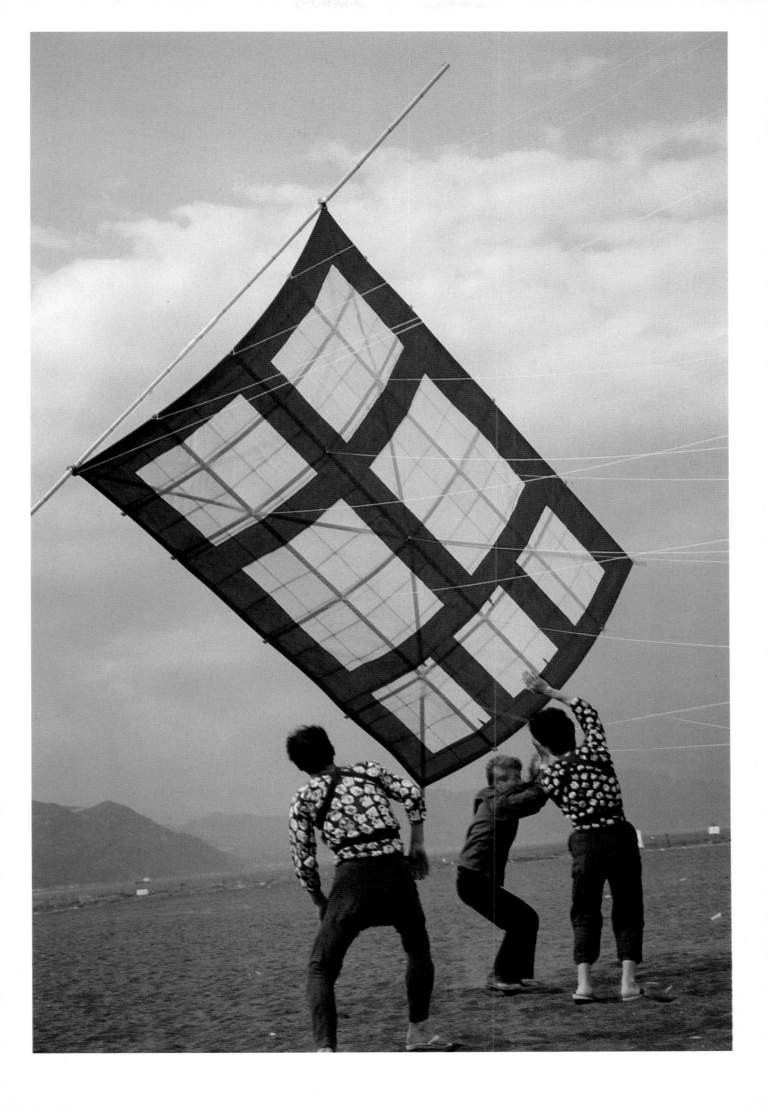

Toon Verhoef

Born 1946 in Voorburg, Holland,
lives in Edam

The most conspicuous features of Verhoef's works are their unusual shapes and sizes, the length sometimes three to four times the width, and the whole standing a narrow three meters high. Equally uncommon is the artist's design approach, the process beginning with tiny, matchbox-sized sketches. Verhoef transfers these sketches to the canvas indirectly with plastic templates which he shapes, paints and then imprints. After that, he applies additional pigment with a brush, or his fingers, before wiping it off and repeating the entire process. This is done over and over until he has attained the intensity of the original sketch.

Verhoef's predominant colors are black, blue, green, white and reddish brown – always realized in dry tones – while frequently recurring images are the arc and a form that resembles a smoking chimney.

Though Verhoef's art kite features his standard bizarre dimensions, there happens to exist a similarly-shaped kite on the isolated island of Hachijojima, a small point in the Pacific 400 kilometers due south of Tokyo!

トーン・フェアホーフの作品の特徴は、まず並はずれたカンヴァスの形と大きさである。高さが2～3m、横幅の3～4倍はある縦長のカンヴァスである。彼の仕事の進め方も一風変っている。まず、マッチ箱大の小さなスケッチを最初の下絵にする。これを基にして大きなカンヴァスに転描する。ここではまだ直接にではなく、彼が正確に作ったプラスチックの型紙に描きそれをカンヴァスに写すのである。そこで筆や指をつかって、他の色も塗られ、また、色が取除かれたりする。その大きなカンヴァスが、最初の小さなスケッチと同じ緊張感を得るまで繰り返される。

色は黒、青、緑、白、茶色が好んで用いられ、普通は「乾いた」色調が支配的である。折にふれフェアホーフが取り上げる好みの形態は、弓形や煙をはく煙突を連想させる形である。

トーン・フェアホーフは、予想通り凧にも独特の縦長の絵を描いている。この見慣れない形は、実は日本の伝統凧に存在する。東京から南方400㎞の太平洋上の孤島、八丈島の「為朝の長凧」がそれである。

The Troublesome Kite
Dye, acrylic 305 × 108 cm
Hachijojima kite
Kite-maker: N. Yoshizumi

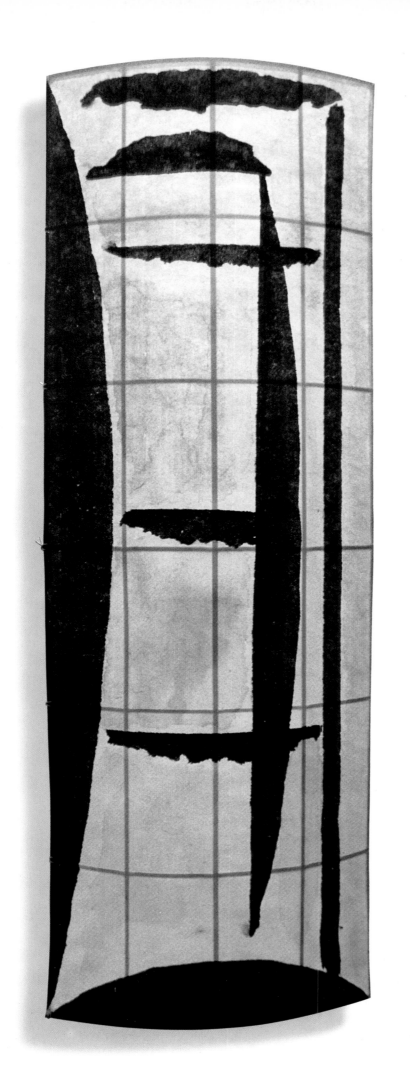

Imre Bak

Born 1939 in Budapest,
lives in Budapest

Regarded as the most prominent proponent of Radical Eclecticism in Hungary, Bak, inspired by his mentor and the Bauhaus movement, has developed a personal style which fuses rigid geometric structures with elements from traditional Hungarian folk art. The sharply contrasting color surfaces of his paintings bring his work within the periphery of Hard-Edge, Op and Minimal Art, and he has also combined photographs, drawings and texts into Conceptual pieces.

In his sculptures Bak brings into play a quality of dislocation. He removes objects from their original contexts and, through this isolation, accentuates their external structure. "An object moved to a new place acquires an entirely new meaning," an effect he has also proved by means of photographic collages.

Bak's art kite also synthesizes disparate styles. Out of simple shapes he has put together an ensemble which is enlivened by stark color contrasts and symbolic elements. A stringent geometrical standard and an ascetic ordering of parts contrast with an ambiguous spatialness and a dissonant sense of color and material.

Interwoven into this work are elements of Constructivism, Hungarian folk art, flags and Japanese folding screen art, the individual parts appearing like the diverse materials of a collage, each possessing its own specific and unique value.

Warm and soft parts meet with a cold, hard mass; compact elements alternate with flat, gaseous zones. The variance of temperature within the composition conveys an impression of material transformation, and only upon close inspection does one realize that this "collage" is a painted work.

イムル・バクはラディカルな折衷主義のすぐれたハンガリーの第一人者とみられている。彼は恩師を通じてバウハウスとかかわるようになり、厳格に組み合わせた幾何学構造にハンガリーの民族芸術をとり入れるというひとつの様式を生み出した。厳しい色彩対比の絵画は彼をハード・エッジ、オプティカル・アート、それにミニマル・アートへと近づけていく。後に彼は、写真、素描画、テキストなどを結びつけ概念的な一連の作品にしている。

立体作品においては位置の転換による効果をその仕事にとり入れている。彼はオブジェを本来あるべき関係から引き離し、隔離することによって外面的な構造をより認識させようとしたのである。「ある物体は、それを別の場所に移し変えることにより、全く新しい意味を得るのだ。」彼はこれと同じ効果をフォト・コラージュを用いて実現させている。

イムル・バクはこのような構造様式の原則をアート・カイトにも用いた。単純な数多くのフォルムから、強い色彩のコントラストと象徴的な要素を生かすことにより一つのアンサンブルをつくりあげている。厳しい幾何学的な規範と、ほとんど禁欲的ともいえる秩序とが多義的な空間と不協和音的な色彩と素材に対して、対比の妙味を見せている。構成主義の要素、ハンガリーの民族芸術、国旗の象徴性、日本の屏風絵の引用といったものが織り混ぜられている。アンサンブルの中の個々の単位はまるで様々の素材をコラージュしたかのようであるが、それぞれがまた独自の特異な存在価値を持っているのである。暖か味のある、また柔らかい部分が冷たく固い本体とぶつかり合う。そして集約的な空間要素が平面的で気体がかったような部分と入れ変わる。この構成の中の色のもつ温度の差によって、人為的に実験を試みているかの印象を与えている。より細かに観察してみると、この布地のコラージュが本当は描かれたものだと認められる。

Untitled
Japanese ink, ink, poster colors
Kaku kite 350 × 210 cm
Kite-makers: N. Yoshizumi, T. Okajima, I. Fujieda, O. Okawauchi

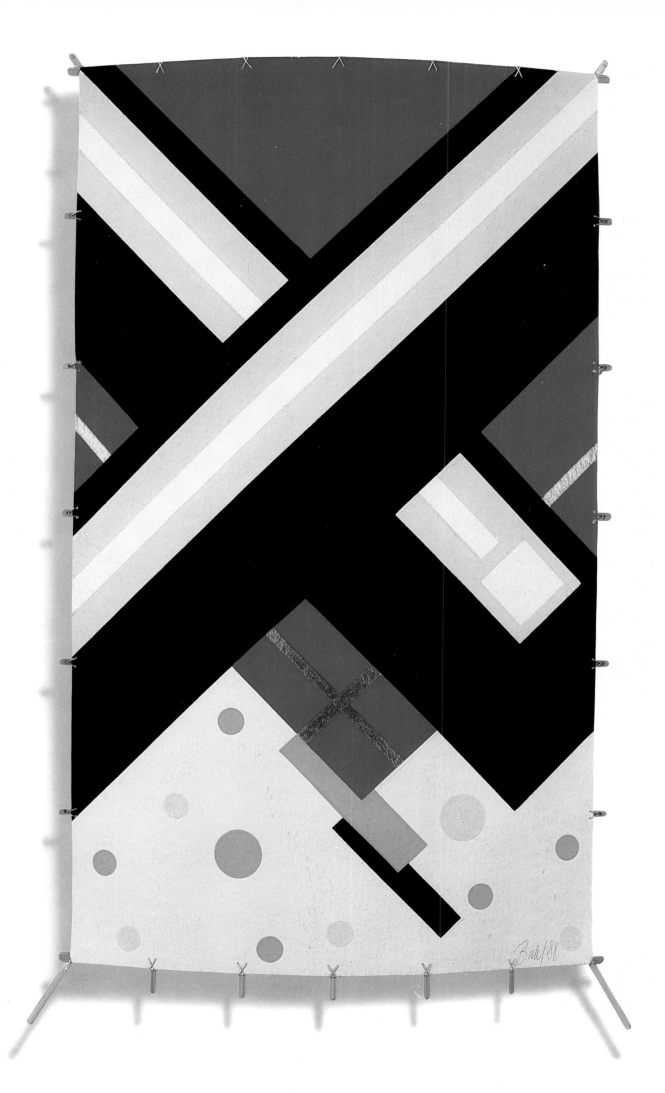

The kite-makers from Kyoto with the painting from
Budapest.

チームワークのいい凧師たちは京都から、凧の絵はブタベストから

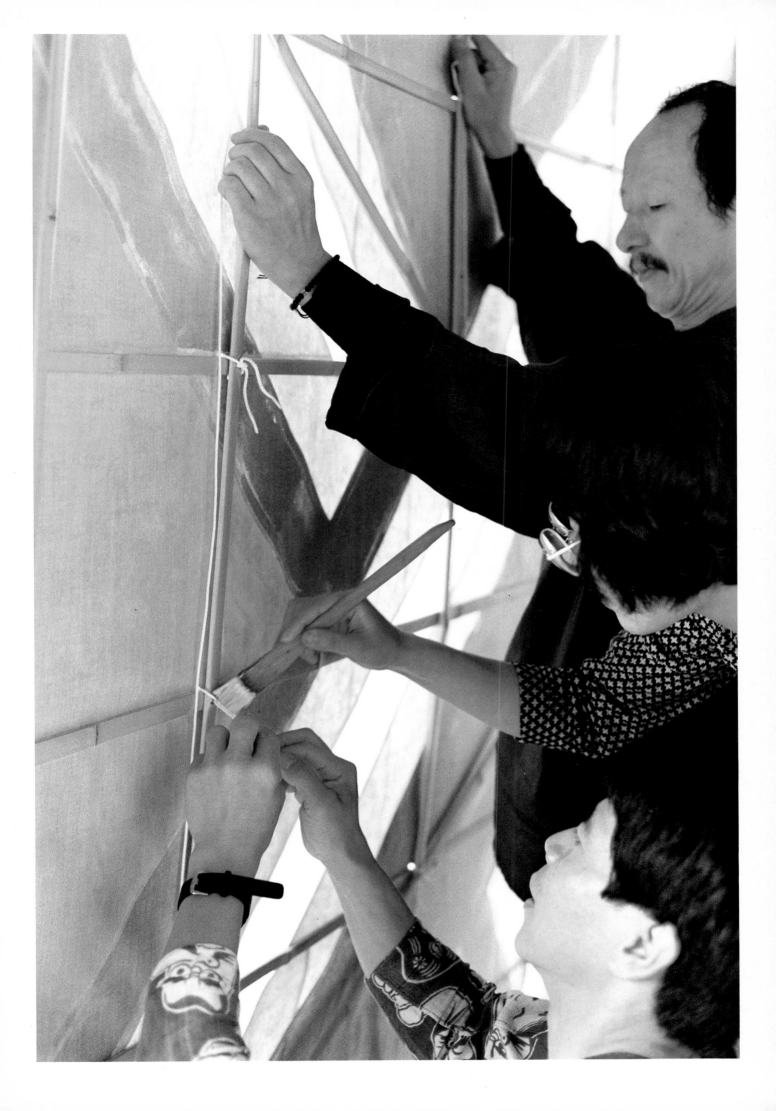

Tadanori Yokoo

Born 1936 in Nishiwaki, Hyogo,
lives in Tokyo

The enfant terrible of the Japanese art scene, Yokoo first became famous as a graphic artist. His prize-winning illustrations combined images from Japan's bygone days with collaged fragments of sex, crime and advertising. Similarly charged are his efforts as an actor, singer, performance artist and writer, areas where he has likewise aroused considerable notoriety.

Resembling film billboards in their size and style, Yokoo's paintings borrow from art and cultural history, mythology and trivia, Goya and Picabia – the whole swinging between apocalyptic invocation and consumer age votive painting. Themes of sex, violence, hell and martyrdom recur continually, nearly mirroring his creative process, which involves multiple stages of attacking, carving up and re-assembling the finished canvas.

The first level of Yokoo's kite has been rendered in black and white. It depicts samurai warrior scenes and points back to the rich tradition of painted Edo kites. Inserted into that theme is a large Jane Russell pin-up which, in turn, is interrupted by Rubens' depiction of Christ's descent from the Cross. The net effect is to reflect the tensions of cultural synthesis, tensions present in recent Japanese history and in every Japanese psyche.

日本の美術界において「異端児」であった横尾忠則は、まずグラフィックデザイナーとして有名になった。日本の、特に過去百年にわたる近代化の過程に現われた広告やセックスや犯罪をテーマにコラージュしたイラストやポスターは、数々の賞にかがやいている。

彼の絵画は、映画のポスターやフレスコのような天井画を思い起こさせる。形式や内容からみると、それは美術史や文化史からの引用、神話と通俗的なもの、ゴヤとピカビアが自由奔放に入り混じったものであり、構成においてはシュールレアリズム的で、様式は激情的である。彼の作品は、黙示録の呪文と消費時代の奉納画の間を行きつ戻りつしている。作品のテーマには、セックス、暴力、地獄や殉教がくり返しとりあげられている。
燃えるような筆使いによるこのような絵の激しい熱気の中には、何か不安を感じさせる自己破滅的なものが潜んでいる。

それだから横尾忠則が、近作の中でカンバスを激しく切り裂いているというのも不思議ではない。この解体のプロセスはまず、帆布を裂いた小片をカンバスに貼りつけることから始まった。布切れはおい茂るようにカンバスの表面を覆い、その上を絵筆が猛威をふるって走った。そのあと、彼はカンバスに近よって傷をつけ、切り裂き、それを編んで何層かの下絵としていったのである。

今回のアート・カイトに使われた紙もこのような方法で編まれていて、そこには意識の層のように互にオーバーラップし、しかも一部は溶け合っているいくつかの現実の層が描き出されている。

第一の層は、冷い白と黒のコントラストを基調にして、戦争の喧騒と地獄を表した古典的な武者絵の世界へと導く。ここで横尾は、数多い古典的な江戸凧の一部をほのめかしている。この層に重っているのが、長々と横たわったブロンドのピンナップガールで、ここにジェーン・ラッセルの面影を偲ぶことができる。そして第三の層には、キリストをモチーフにした一種の祭壇画が背後から浮びあがってきている。

日本がかつてその歴史の中で経験したような、文化の融合によって招来した内なる緊張感、個々の意識の中に受け継がれている内なる緊張感が、精神分裂症と紙一重の強烈さをもって具現され、そして暴き出されているのだろうか。

Descent and Ascent
Oil
Kaku kite 270 × 220cm
Kite-makers: N. Yoshizumi, T. Okajima, I. Fujieda,
O. Okawauchi

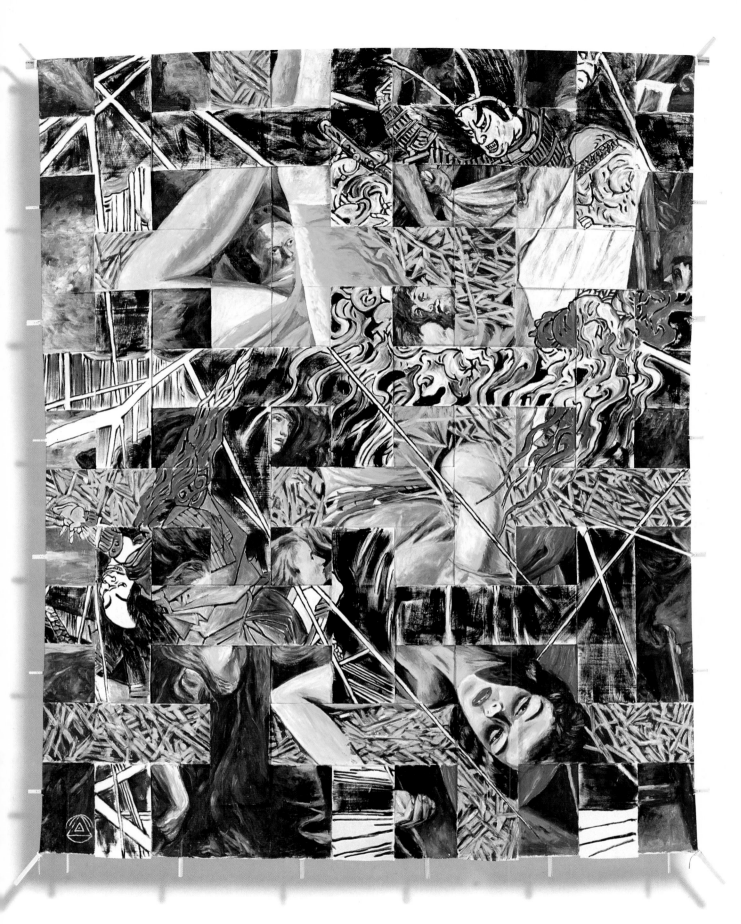

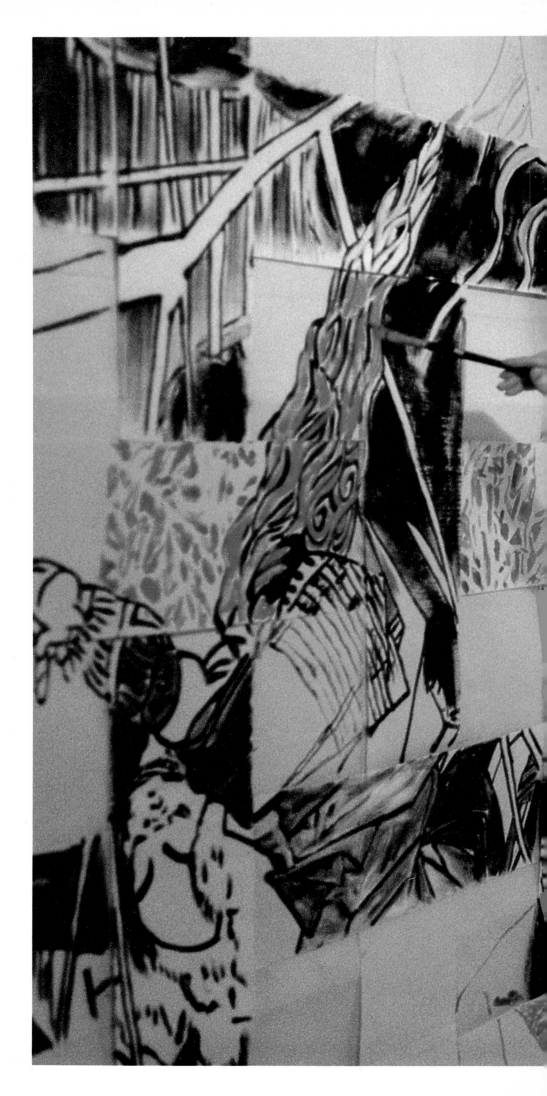

Tadanori Yokoo painting his kite
in his Tokyo studio

アトリエで芸術凧の制作をする横尾忠則

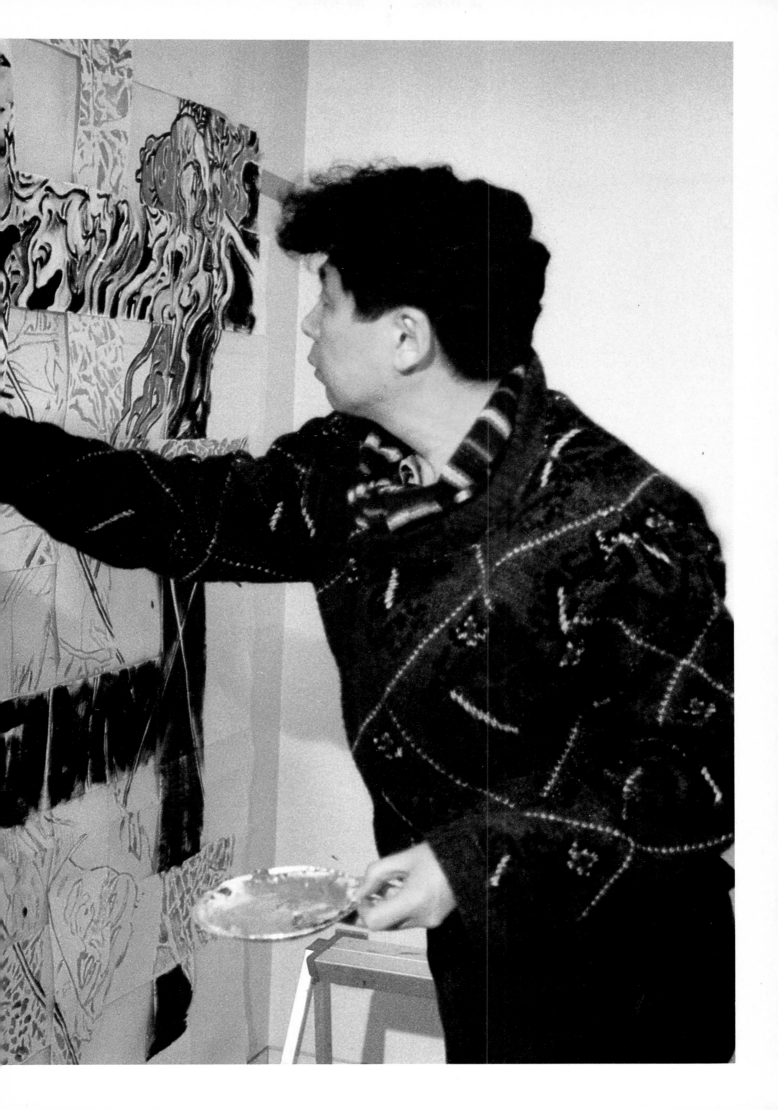

Elvira Bach

Born 1951 in Neuenhain, Taunus,
lives in Berlin

Bach began her career with still-life paintings of the small but necessary items of daily life – things which one must reach for when going out: spectacles, money, keys, lipstick – before the appearance in 1979 of her "Bathtub Series", a theme which, with its intimation of solitude, isolation and regeneration, she used to resolve her internal struggles about her roles as woman and painter.

In one of her bathtub pieces, Bach depicted a corpse-like woman being circled by a small shark. This woman was the first human figure ever included in her painted work and it evolved into one of her main female archetypes. In general, Bach's women are naked, self-assured, tall with square, broad shoulders and high-heeled shoes, their made-up faces a mixture of stereotype and Expressionistic exoticism. A shock of hair, often in the shape of a snake, winds down from the forehead and coils erotically about the body. "Women are not like snakes, they are snakes", she has said.

Bach's females, despite their sensual nudity, are never sex symbols. Their pose is self-assured, their gaze is rivetted relentlessly on the observer, and their quality of untempered directness is experienced by the viewer like a slap across the face. Whether it is as a proud individual, a rapturous lover or a triumphant mother, these women are always shrouded in a ritual-allegorical aura, a puzzling ambiguity charged with elements of carnal worldliness and archaic ecstasy.

Bach's art kite depicts a scene that is likewise linked to this mythology of the mysterious Feminine. Done in rich tones redolent of Chagall, an exotic female figure hovers in an expanse of boundless space with a writhing snake extending out from her forehead. Bach's female is a modern witch with her broom symbolizing the magic powers inherent in flying. A cosmic circle indicates secret forces between heaven and earth.

エルヴィラ・バッハは、人が外出する時に必要とするもの、眼鏡、お金、鍵、口紅といった日常の小物を集め、それをテーマにした静物画から始めた。

1979年には彼女の「浴槽の絵」が制作された。このモチーフとなった浴槽は孤独、孤立あるいは再生の場であり、この若い芸術家にとっては、芸術家としての成長のための、また女として、画家としての役割の中で自己と対峙するための保育器のようなものであった。「一度は自身に立戻ることだ。」一連の浴槽の絵の一つに、小さなサメのそばで女性が死体のように泳いでいる作品がある。これが彼女の絵に初めて登場した人物像である。体をねじって横たわるその姿は、次々と展開して彼女の作品の特徴となる絵画記号になった。絵の中の女性たちは殆んどが裸で、自意識が強く、大柄であり、肩がいかって大きく、かかとの高い靴を身につけている。その化粧した顔は表現主義的なエキゾチックさと紋切型が入り混ったものである。毛の束は、しばしば蛇の姿をし、額から下って絵と身体の囲りをエロティックにとぐろのようにとり巻いている。「女は蛇のようであるのではなく、蛇なのだ。」

この裸体は快楽を強調してはいるものの、女性の肉体は性の象徴にはならない。それは、自信ありげなポーズや、絶えず相手を見すえるような視線、「顔面に一撃」をくらうかのような印象を受けるところにあるのかも知れない。それが誇らしげな個であろうと、我を忘れて恋にふける者であろうと、あるいは勝利にひたる母親の姿であろうと、かならずこれらの女性は、自らの体から輝き出る何かしら荘重でアレゴリー的な力につつまれている。肉欲的な現世と太古の陶酔との狭間で暖昧模糊とした印象を与える。

今回のアートカイトの作品も、この神秘に満ちた女性の神話からの一説をはらんでいる。シャガール風に深々と底知れない空間にひとりのエロティックな女性が浮かんでいる。彼女の頭からはのたうつ蛇が生まれ出ている。エロチックな肉体は槍で突き抜かれているが、これは絵の中で暴力的な要素であるはずなのに、血糊に縁どられているにもかかわらず、なぜかアレゴリー風な印象を与えている。ちなみに、まん丸の渦巻も、どんどん大きくなっていって、この絵を速度を増して回転させてしまうかのように見えてくる。

Out of the Clouds
Acrylic
Kerori kite 180 × 337 cm
Kite-maker: T. Kashima

Chema Cobo

Born 1952 in Tarifa,
lives in Tarifa

Recognized as one of the outstanding younger Spanish artists, Cobo paints with an eclectic vision, an elegance and, above all, a playful zest for life. In 1981 he went to study in New York and Chicago, an experience that caused a radical transfiguration of his artistic idiom. His views of Spanish tradition deeply altered, he returned to his hometown of Tarifa on the southern tip of Spain, itself a confluence of currents both European and North African.

Since then his paintings have conjured up the archetypes of his culture: the mythic dualism of blood and night, flame and darkness. He powerfully projects the tension between creation and annihilation, invoking the spirits of Goya and El Greco, and he revels in the Spanish tradition of the artist as mystical seer and visionary.

With the artist's quest for light an ever-recurring theme of his work, Cobo has written:

"Painting is light between two darknesses, a tunnel in an ocean without shores from which spirit waves away the echoes of memory."

チェマ・コボは70年代後半以来、スペインを代表する若手芸術家の新進気鋭の一人である。彼の絵画は折衷主義に通じるエレガンスに富んでいる。1981年、彼はニューヨークとシカゴに留学する。その時の体験は彼の作品にラディカルな変容をもたらす。ここでスペイン伝統に対する彼の見方が深く変わり、ヨーロッパと北アフリカの双方、地中海と大西洋の潮流が混ざり合うスペイン南端の故郷タリファに戻ってくる。

それ以来彼は絵画の中にスペイン文化の元型、「血と夜」、「炎と闇」が織りなす二重性を呼び覚ます。創造と殲滅的な力の間に、彼の作品が描き出す緊張感を力強く表す。彼の絵画は、ゴヤとエル・グレコの幻影が呼び出されていると同時に、神秘的な予見者及び幻視者としてのスペイン画家の伝統に深く根ざしている。芸術家が追求する光が主要なテーマである。

「絵画は二つの闇間にある光、岸辺のない大洋におけるトンネルであり、そこから精神が記憶の谺を波で洗い流すのである。」

The Power of No-Disappointment
Acrylic 360 × 230 cm
Edo Kite
Kite-maker: T. Kashima

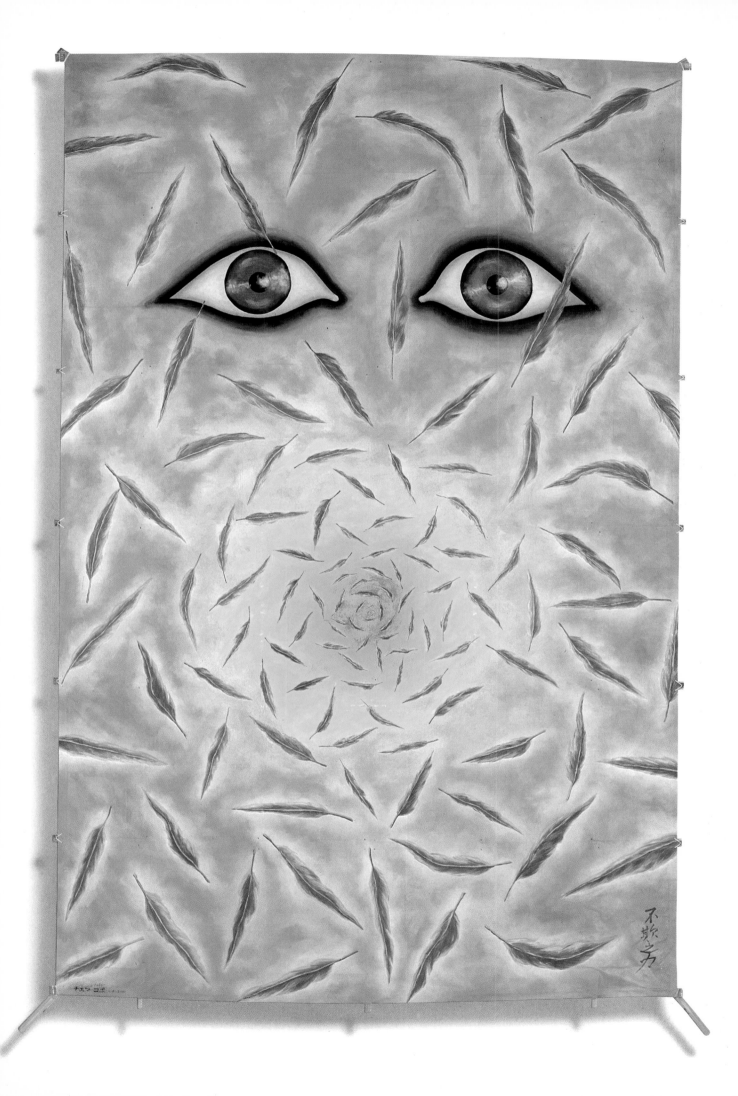

Birds can ~~not~~ fly without roots
Be seen to see
Man is ~~and~~ an endless dynamo,
a running spiral of streams
a water-mill in the Ocean,
between a pair of shoes and a hat
Hat is a feather collector
shoes are map-makers
Birds do not ~~to~~ know geography
Man look-up to the sky
to grow-up, out of the stones
Look to be reflected on the eyes of the Sky
Reflection to be located
far away from heaven and
from hell. point cero
crossroad
 no time
 no space
IN between the journey of the
bird, a trip to heal.
MAN-MAKER, THE POWER OF
NO-DISAPOINTMENT.

 Ximena Cobo
 87

Shiga, December 1987
今、「不欺之力」がつけられる

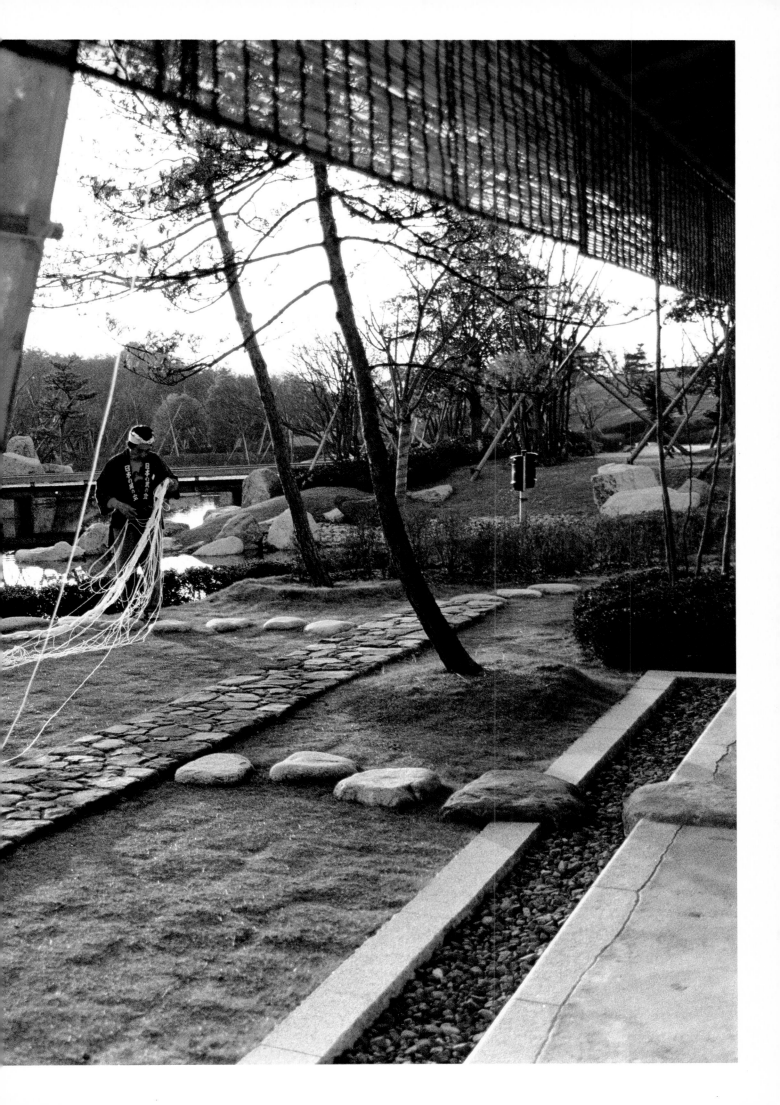

Gerhard Hoehme

Born 1920 in Greppin/Dessau,
lived in Neuss/Düsseldorf, †1989

For the recently deceased German master of the Infor-mel, color was like energy in its rhythmic flow and growth, composition and structure. Constrained by boxed-in painting surfaces, Hoehme's art strives to break out into open space, one expression of this being the strings which project out of the paintings like feelers.

Naturally enough, Hoehme chose for his art kite the Edo, a style with its own numerous strings that pro-duce a unique aesthetic effect by themselves. The part of the Daedalus strings closest to the frame he has painted in light colors, but everything gradually dark-ens as if the pigment flowed down away from the kite.

As for the kite surface itself, brilliant colors and the use of latex give the kite a glass-like transparency. This "sky window" is an incomparable sight as it rises up, catches the sun and shines between the clouds. Like a stained-glass window, Hoehme has explained, his kite comes alive only when light passes through it and the colors are thrown into sparkling motion.

Hoehme long sought to make "open", not static, works of art. ("Paintings are not on canvasses, but inside people.") Now, with his art kite, an apparition that changes at every moment depending on the wind and sunlight, a new dimension has been added to his creative ideal.

ドイツのアンフォルメルの巨匠ゲルハルト・ヘーメの場合には、色彩がその規則性、流れと拡がり、物質性や構成において作品のエネルギーとなって支配している。ヘーメにとって、絵画を四角いかたちの中に納めてしまうことは拘束である。彼の憧れるものはもっと拡がりのある空間の形成である。ヘーメの絵画ではしばしば絵から紐が突き出ているが、それは想像上の絵画空間を現実の空間へ導いていく「触手」ともいえるものである。

こんな芸術様式の作家が凧の糸を作品の構成にとり入れない法があろうか。ゲールハルト・ヘーメはそのアート・カイトにすでに数多くの糸目が独特の美をつくり出している江戸凧を選び、その糸に色をつけている。絵からとび出している糸は、凧の近くは色が薄く、その集結点、地上に近づくにしたがって濃くなっている。

輝くような色と乳性アクリルの使用によって凧の絵はガラスのような透明感がでている。この大きな天の窓が雲間に舞い上り喜色満面となる。何とすばらしい情景か。凧は、光が通過してきらめく色と戯れる時、はじめて生を得る。そんな凧の絵が大寺院のステンドグラスに似ているとヘーメは理解した。ヘーメは静止した絵ではなく「透きとおった絵」、意識的な視覚の体験をさせる絵を創造しようとしたのである。「絵画はカンヴァス上のものではなく人間の内にあるのだ。」空間の風と光の角度により一瞬一瞬変化するこの凧の絵によって、彼の芸術理論にもう一つの新しい解釈をつけ加えているのであろうか。

Daedalus
Acrylic, latex
Edo kite 400 × 230 cm
Kite-maker: T. Kashima

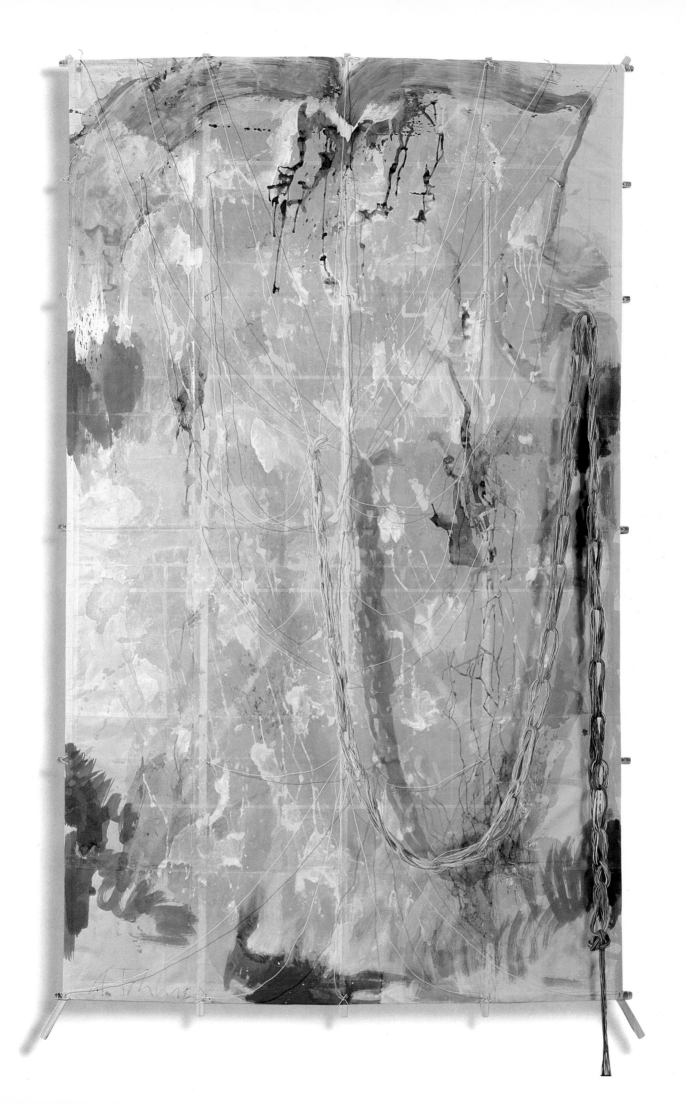

A word about the kite's title: In Greek mythology, Daedalus was the master craftsman who built the labyrinth to contain the Minotaur, and then helped Theseus to escape from it and flee from King Minos. Furious, Minos imprisoned Daedalus and his son, Icarus, but they escaped with wings (some say kites!) made by Daedalus. He is considered the founder of crafts and sculpture.

名エダイダロスはギリシャ神話によるとアッティカの英雄でクレタ島に怪物ミノタウロスを閉じ込めておく迷宮ラビリントスを築いた。ダイダロスはアリアドネに糸の玉を与え、それによってテゼウスは迷宮からぬけ出すことができた。ダイダロスはタレタ王ミノスの命令で息子のイカロスとともにこの迷宮に閉じ込められることになる。ダイダロスは翼を作り、舞いあがってシシリア島へ脱出しようとする。イカロスは親の戒めを守らず太陽に近づきすぎ、翼をとりつけるのに使われた蠟が解け翼がはずれて落ちる。ダイダロスはギリシャの工芸と大彫刻の創始者とされている。

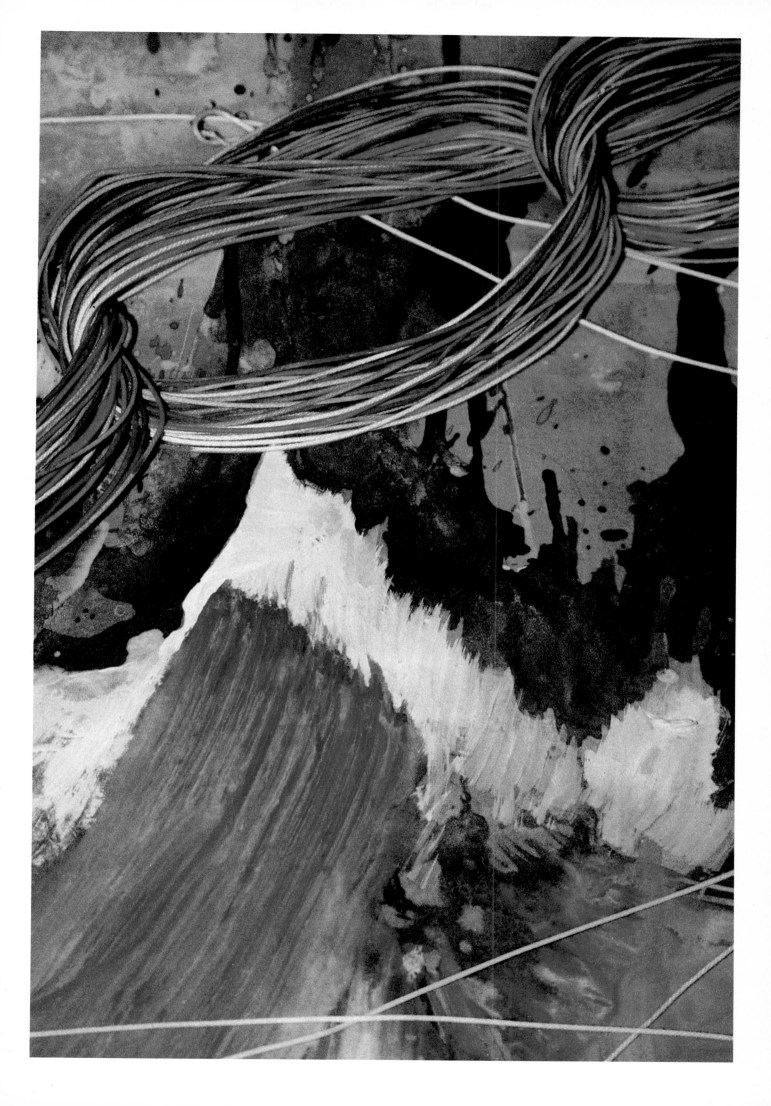

Horst Janssen

Born 1929 in Hamburg,
lives in Hamburg

Janssen's kite is remarkable in several regards, not the least being its size which, at 5.9 × 2.4 meters is by far the largest in the Project. For an artist whose regular media are woodblocks, etchings and drawings rarely exceeding half a meter, the grandness of his kite was truly unexpected. The logical question is "Why"? What could have moved him to produce something so gigantic?

The kite's second peculiarity is that it is the only one constructed with a collapsible frame. Because of the painting's horizontal format, no kite-maker believed it could ever fly, (though a vertical of the same dimensions would simply be an oversized Edo kite, a shape long known for its airworthiness!). Only kitemaster Masayuki Yamaguchi of Itami City accepted the challenge of Janssen's monster, and he succeeded brilliantly.

Thirdly, no other artwork had such an adventurous passage on its way to being made into a kite in Japan, having at turns been discarded, sold, rescued, skinned and lined: The piece was painted by Janssen in the winter of 1987, at which time he covered it with his initials linked by a blood-red umbilical cord to the letter "a" (for Annettchen) and an ominous "5". Apparently he was not satisfied, however – perhaps because the ink had softened the washi and made it stick to the backing paper – and he left it in a corner of his studio.

Some time later, the notoriously eccentric painter rediscovered the piece and "sold it for nothing to the next costumer". Friends recalled though, that it had been intended for the skies over Japan, and hurriedly retrieved it. Finally, safely in Osaka, it had to be separated from its backing and then lined by the kite-master with cotton cloth to give it the strength to withstand the wind.

Besides being a witty offering from the Hamburg recluse, it happens to make a magnificent kite.

ホルスト・ヤンセンの凧には注目する点がいろいろある。まず、コレクションの中で最大の凧となったこと。幅5.9m、高さ2.4mの堂々とした凧である。普通は木版画やエッチング、素描を好み、大きさもほとんど50㎝を越えることのないこの画家にしては、きわめて異例のことである。何が彼をそのような巨大な寸法へと駆り立てたのであろうか？

第二の特徴は、その大きさにも関係するが、これは出品作品の中で唯一、複雑な組み立て式の凧に仕立てざるを得なかったということである。というのは、風が運んでくれるなら話は別だが、そうでもしなければ運送が不可能だからである。組み立てることそのものは凧師にとっては、問題ない。（展覧会の飾り付けにはやはり問題になるが）本当に頭を悩ましたのは、横長の形である。横に広がった凧を、しかも飛ぶように製作することは、ほとんど誰にも出来るとは思われていなかった。（縦長の江戸凧形式のものなら、たやすいことであるが。）しかし伊丹の山口政行は、この難行こそ凧師の腕の見せどころとこの製作に挑み、そして見事に完成させた。

さて、ヤンセン凧の第三の特徴は「龍の表皮」の成立過程にある。凧は、描かれ、捨ておかれ、売られ、救われ、皮をはがされて、そして裏打ちされた。
1987年の冬、ホルスト・ヤンセンが署名をして、その絵は「描かれ終った」。黒い大きな落款は、画家のイニシャルをあらわしている。その左手にもう一度、赤く小さく浮び上っているのは、裏からも読めるように逆に描かれた落款である。さらに絵が描かれた当時、ヤンセンと、血のように赤いへその緒で結ばれていたアネットヒェンの〝a〟と不吉な〝5〟。

「捨ておかれ」たのは、画家がおそらくこの絵の出来ばえに全く満足だというわけではなかったからか、そしてイギリス製のインクが下に染み込んでしまい、和紙の下敷になっていた包装紙にしっかりとはりついてしまったからかもしれない。作品はとにかく、まずはそのままに放置されてしまっていた。
しばらくして画家が再びこの絵を見たとき、カッと頭にきて、さっさと「一つのリンゴと一つの卵」分の値段で、この絵を彼の隣人に「売りとばして」しまった。
「救った」のは、この絵が凧となって日本の空に舞い上るように定められたものであることを知っていたヤンセンの誠実な友人達で、彼らが急いで大阪に送ってくれたのである。
大阪に着いてこの絵は、のろわれた包装紙から自由になるためにまず「皮をはがされた。」
薄くなった「龍の表皮」を共の和紙で繕い、続いて極薄の綿布をやせ細った凧に補強のため「裏打ち」をしたのは、京都の凧師大河内修であった。こうしてこの凧は、強度の風にも耐えうるよう力を蓄えたのである。

それにしても、ハンブルクの天才的奇人にふさわしいティル・オイレンシュピーゲルの何という悪戯と壮大な凧であることか。

Untitled
Ink
Buka kite 240 × 590 cm
Kite-maker: M. Yamaguchi

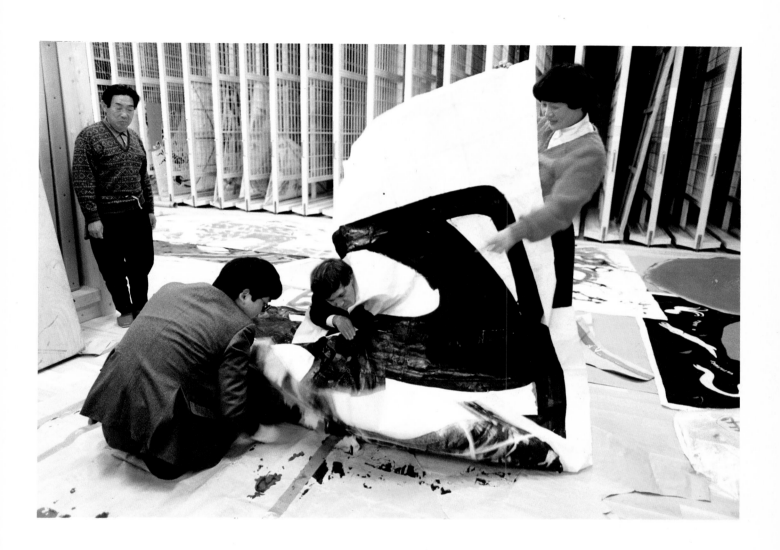

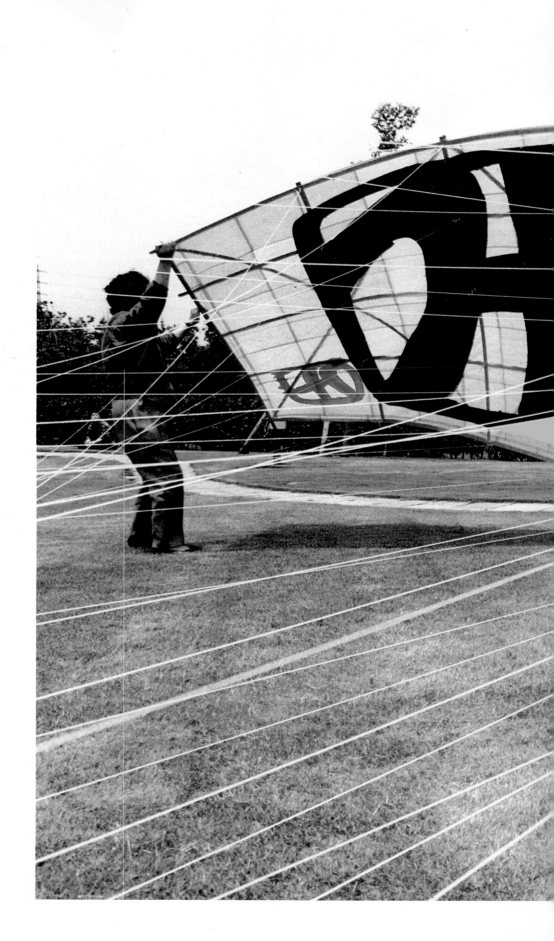

H J 5 a at take-off

揚げ渡し式

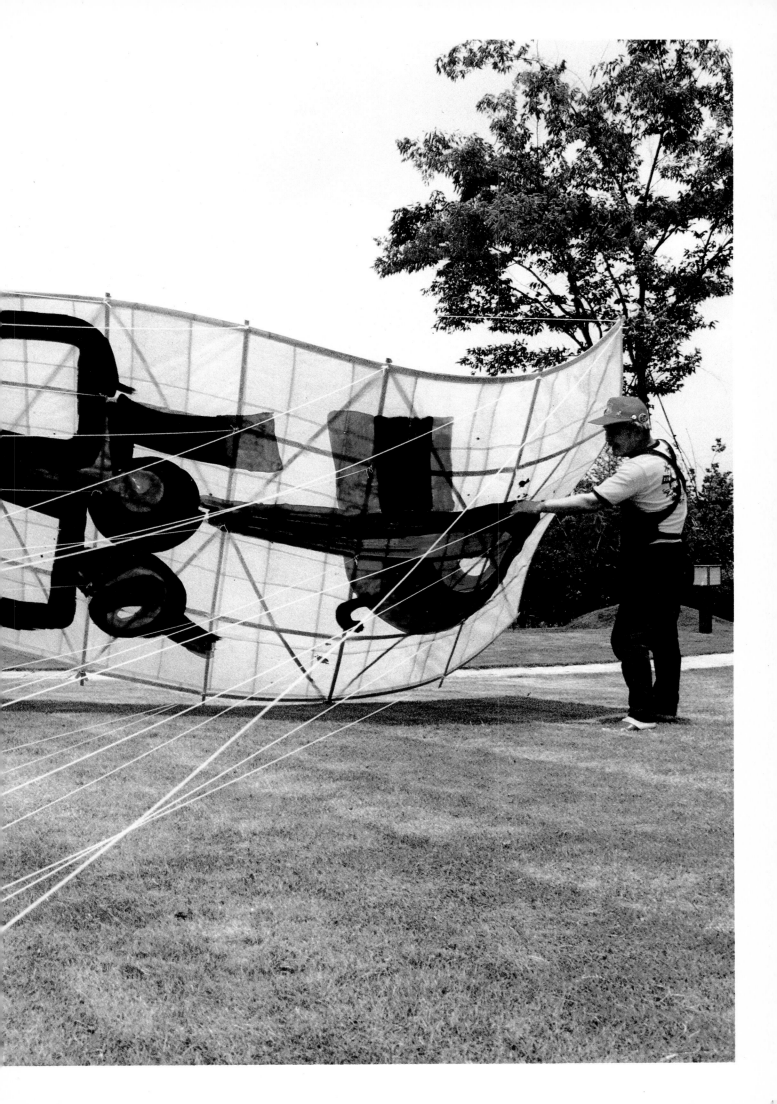

Karl Otto Götz

Born 1914 in Aachen,
lives in Wolfenacker, Westerwald

"The Edo kite is finished. The first try ended in total failure but you did provide two sheets of washi. Regarding technique: after a short trial with fluid wax, I gave that up. I then tried my usual casein pigments on the washi, working them in with a trowel, positive and negative – that is to say, peeling off the reds, yellows and blacks, just as I have been doing since 1952."

"What a mistake that was! The paper instantly absorbed the casein through my layer of paste, and did not give it back! No matter how much I scraped with the trowel, I couldn't change it. As a result, I made a mess of the whole first sheet of washi."

"With the second sheet, I proceeded differently. I made a large drawing, and where the color couldn't be scraped, I left it as it was."

"First I drew red, and then black. It is a typical Götz ring motif, a schema which I first developed back in 1956/57, and have used now and again since then. I hope that those familiar with my work will appreciate it."

「江戸凧の方はでき上りました。しかし、一回目の試作は全く失敗に終りましたが、あなた方はここに二枚の紙を置いていってくれましたから。技工上のことについて。始めは液体ワックスを少しは使いましたがすぐやめました。第一作目では私はいつものカゼインを使う方法で試み、絵の具をのせた直後に広巾のヘラで処理しようと思っていました。——ポジ・ネガ——つまり赤、黄、黒の絵の具をヘラでけずりながら描いていこうとしたのですが。1952年以来ずっとやっている方法です。それがとんでもない見当ちがい。和紙がこの厚い糊の層を通して絵の具を吸収しつくしてしまったのです。そして吸収してしまった絵の具を返してくれようとはしませんでした。何度ヘラでけずろうとなんの変化も起らないのです。こんなわけで大きな和紙を一枚だめにしてしまいました。

二回目の時には別の方法をとりました。エスキースのようにまず大きく下絵を描き、ネガの部分、即ち剝しとれない部分はそのままにしておきました。まず赤、そして黒という順序で描いていったのです。これはいつものゲッツのモチーフ「リング」で1956／57年に生み出し、その後時折使っているものです。私の仕事を知っている他の人が、これもいいといってくれるといいのですが。」

K. O. ゲッツ

Untitled
Casein
Edo kite 370 × 230 cm
Kite-maker: T. Kashima

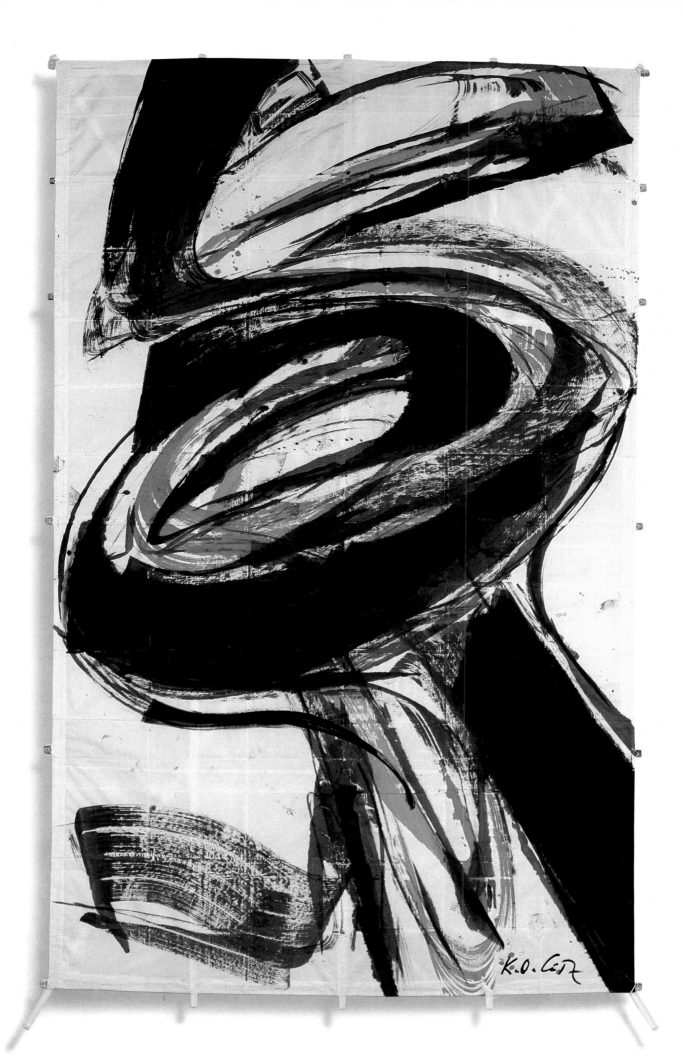

Antoni Tàpies

Born 1923 in Barcelona,
lives in Barcelona

After studying law, Tàpies began to teach himself painting in 1946. Influenced by Klee, Miró, Dubuffet and the Dadaists, he experimented with collages composed of the waste materials of everyday life. His paintings, too, are striking with respect to their novel use of materials.

For example, he adds marble dust, sand, earth and glue to his pigments. With a trowel he spreads this mortar-like mass thickly over the canvas, and then scratches in cryptic signs and hieroglyphics. With this type of painting he has transferred the tangible features of sculpture to the canvas, uniting motif and technique in his mystifying "walls".

"The meaning of a work of art is based upon the observer's participation. Whoever lacks the inner pictures, the imagination and the sensibility which one needs in order to associate ideas in one's own mind, will see nothing at all."

In contrast to his heavy, static paintings, the drawing-like art kite is characterized by vigorous lines that highlight the fleeting and the (apparently) accidental. The blots of red seem to taken on some special meaning and the signs and ciphers lead one to think of an encoded message.

"I am sending you a great cry from the other side of the globe, saying, 'Here is a Catalonian in love with the culture of your country, who thinks of you and sees the great beauty of the festival in the sky that will aid those in distress.'"

アントニ・タピエスは、最初法律を学び、1946年になって独学で絵画を始める。クレー、ミロ、デュビュッフェやダダイストたちに影響を受けて、日常生活から生じる廃棄物によるコラージュを実験的に制作する。絵画でも、素材の取り扱いの斬新さにおいて際立っている。例えば、絵の具に大理石の粉抹、砂、土、糊を混ぜ合わせ、モルタル状にしてその塊をへらで厚く塗っていく。次に、そこに魔的な符号や象形文字を掻き込んでいく。このような物質絵画で、彼は彫刻の触覚的な特質を絵画に持ち込んだ。この閉ざされた壁面にモチーフとテクニックが溶け合ったのである。

「一つの作品の意味は、観る者がどれ程協力的にかかってくる。個人個人の心の中で様々な観念を結びつけていくために必要な内的イメージもなく、空想もなく、感受性もなく生きている人には何も見ることができないであろう。」

重厚で静的な物質絵画とは対象的に、大きな線描の作品は、軽妙さや一見の偶然がテーマになり、エネルギッシュな線に支配される。タピエスには絵の具のしみでさえ、大きな暗示的意味を持つ。図柄、記号、文字的要素は、暗号化されたメッセージを思わせる。

明るい黄土色の和紙に、勢いのあるタッチで、幅広い赤の帯を描いて、彼は「カタルーニャからのメッセージ」を日本に送ろうとした。愛のことばを添えて。
「地球の反対側から皆様に大きな叫び声で、こうお伝えしたいのです。ここに、あなた方の国の文化を愛し、あなた方のことを思い、そして困っている人々を救済するというこの空のフェスティバルの美しい心を理解する一人のカタルーニャ人がいますと。」

Message from Catalonia
Acrylic 198 × 362 cm
Kerori kite
Kite-maker: T. Kashima

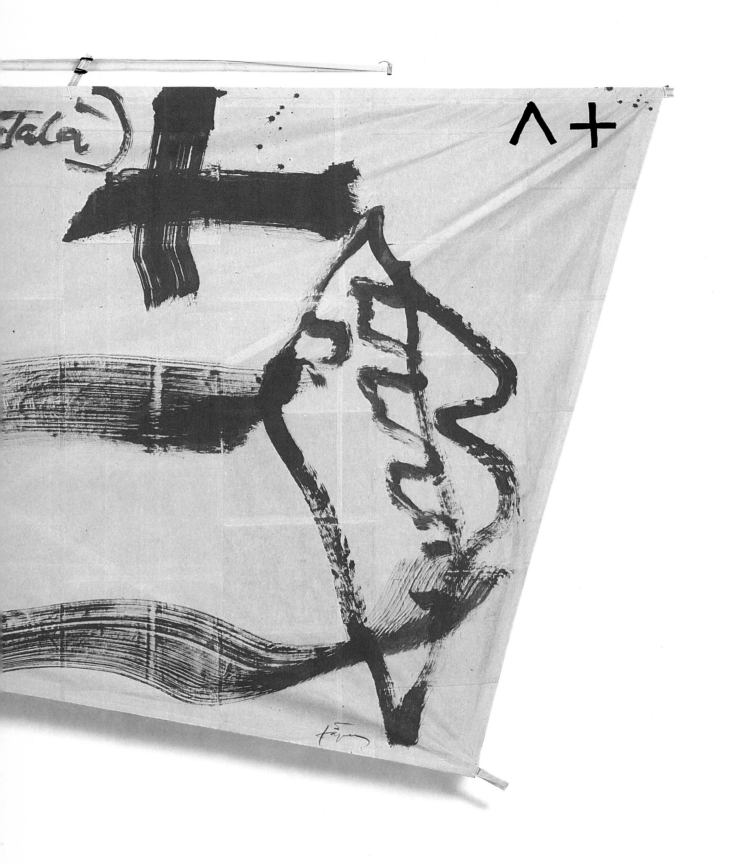

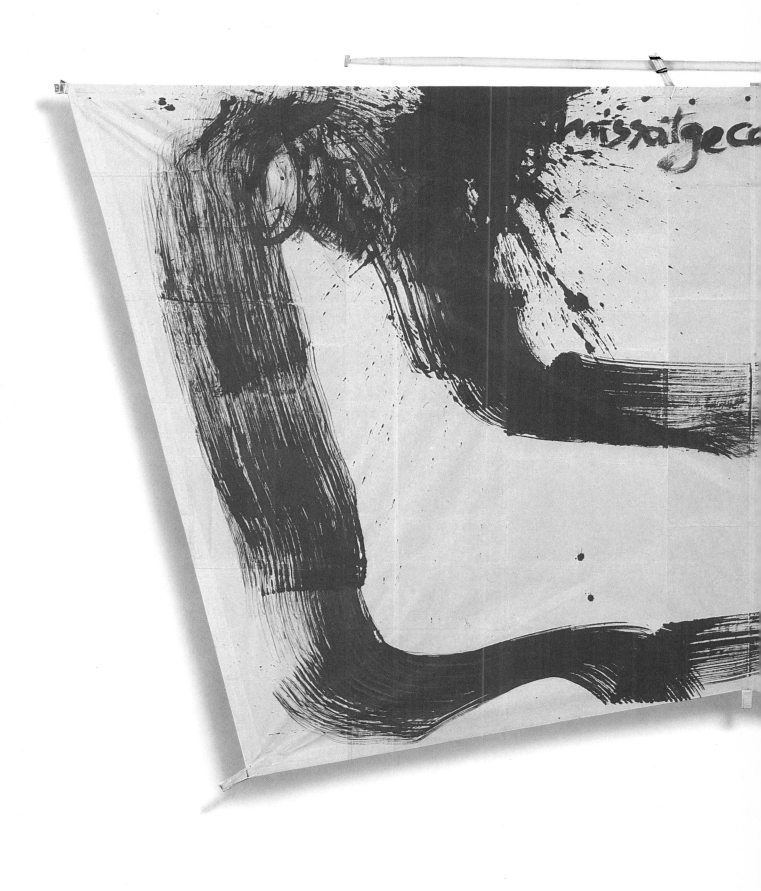

Karel Appel

Born 1921 in Amsterdam,
lives in Amsterdam

Initially drawn to German Expressionism, Appel, in his search for pure painting, turned to experimental art and became a founder of COBRA. He started with plaster and wood sculptures as well as simple, cheerful, somewhat burlesque styles of painting that abounded in light and lively colors. Basic forms were arranged as though by children.

In this connection he was inspired by folk art, primitive art and the naive-grotesque art brut of the early Jean Dubuffet. Also interwoven into his work are Nordic images, such as clowns and trolls, their eerie quality lightened by more ironic elements. His painting always returns to figurativism.

The distinctiveness of Appel's paintings lies in their expression of color – in the amount of color applied in frenetic, dynamic, convulsive rhythms – as he somehow transforms the creative impetus into a spontaneous current of artistic improvisation. His orgies of color have been christened "Dionysian Expressionism", and he has added that his "tube of pigment is like a rocket that describes its own space."

In his art kite, Appel varied his usual style and applied pigment more delicately, perhaps so as not to weigh down its flight or detract from the transparency of the washi. The choice of an Edo kite suits Appel's taste for the monumental, and he has covered the huge surface with a single figure, a red knight astride his steed. Conceivably Don Quixote, Hartmann von Aue, or St. George engaged in battle with the dragon, his knight is certainly a worthy herald for art in the sky.

カレル・アベルは先ず、ドイツ表現主義にひかれるが、純粋絵画を求めて関心は実験芸術へと何けられ、そして後に美術家のグループ「コブラ」の最も重要な代表者となる。彼は石膏や木の彫刻作品を手がけた。その絵画は子供がテーマにするような明るくて元気な色とかたちをベースにしたもので、単純でおもしろく、いくらかふざけたものであった。彼にインスピレーションを与えたのは、民族芸術であり、ジャン・デュビュッフェの初期の頃のナイーヴでグロテスクなアール・ブリュット（生の芸術）である。作品の中には北欧世界の道化や妖怪が登場する。しかしこの不気味さも、快活な皮肉っぽい落ちによって解き消される。彼は常に形象に立ちかえろうとした。

アベルの絵画が他の芸術家のものと異なるところは、色による表現方法や絵の具の量において、荒れ狂わんばかりのリズムをつくりながら、ダイナミックに彩色することである。さながら痙攣を起こしたように。バイタリティにあふれる創造意欲の激しさを、彼はそのまま絵画的即興の流れにまかせて作品に変えていくのである。彼の色のオルギエ、色の宴は「酒神ディオニソスの表現主義」と命名されている。「私のチューブ入りの絵の具はまるで自分の空間を描くロケットのようだ。」

カレル・アベルのアート・カイトは彼の作品にしてはむしろ上品すぎるぐらいである。恐らく飛ばす時の軽さと、光の透過性を考え、色使いを少くしたのであろう。堂々とした大きなものを好むアベルのことゆえ、凧には当然、大江戸凧を選んでいる。巨大な画面に君臨している唯一の形象、それは馬にまたがった赤い騎士である。ハルトマン・フォン・アウエかドン・キホーテか。あるいは滑稽に、龍と闘う聖ゲオルクを表わしているのか。空の競演にアベルが送り出した騎士はまぎれもなく彼の芸術を伝える使者である。そしてこの騎士は、アベルの若々しい精神と心の喜びを生き生きと表現しているのだ。

So Near And Yet So Far
Mixed technique
Edo kite 367 × 233 cm
Kite-maker: T. Kashima

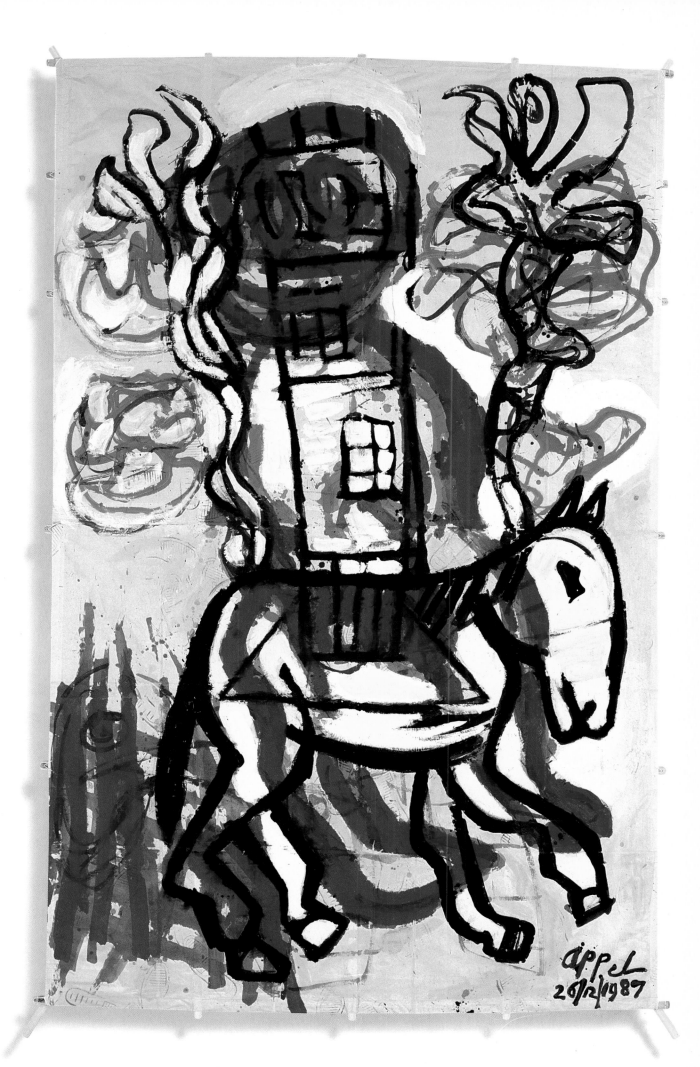

Robert Rauschenberg

Born 1925 in Port Arthur, Texas,
lives in Captiva, Florida

At the outset of his career Rauschenberg was deeply influenced by Abstract Expressionism, but he symbolically proclaimed the end of that phase by erasing a pencilled drawing of de Kooning's and declaring the result a piece of art.

Calling for the re-integration of art into the everyday his own work became filled with fragments of the mundane world. The 1950s, for example, found him photostating life-sized silhouettes on blueprint paper, while his drawings were collages of extracts from newspapers and magazines.

Selecting from a horde of second-hand goods, comic books and photographs – and employing Dadaistic devices to drag art out of the studio – Rauschenberg melds the principles of collage, bricollage, découpage and assemblage with abstract painting. Moreover, he adds modern printing processes such as silk-screen, offset and photo-lithography, thereby obscuring the difference between originals and reproductions.

In the '60s Rauschenberg's "combine paintings", on which he directly affixed found objects, (mainly worn-out everyday items), finally severed the last distinction between painting and object. "There is no reason not to look upon the world as a gigantic picture," he has declared.

Rauschenberg disregards ideas of hierarchy and harmony, his works finding arrangement according to the principle of equal, value-free ordering. They unfold like a kaleidoscope – without a compositional center but revealing multiple focal points – all the while creating intriguing contrasts between autonomous color fields and structural parts.

Asked why he had painted chairs for his heavenly work, he wittily replied, "Well, there is no furniture up there, no place to sit!"

ロバート・ラウシェンバーグは抽象表現主義を出発点としている。しかし、1953年、あるセンセーショナルな行為で象徴的にその終焉を告げた。彼はデ・クーニングの鉛筆によるドローイングを抹消し、それを芸術作品と宣言した。彼は芸術を実生活と再び結び付けることを追求し、事実、彼の芸術作品に現実の世界の一部を結合させることで目的を達した。50年代に、実物大の人の影をシルエットとして大きな青写真用印画紙に焼き付けるという実験を行った。彼のドローイングには新聞や雑誌の写真を引用画として使い、ある摩擦による技法でコラージュにしている。彼は、廃棄物、コミック雑誌や写真などを集め、芸術をアトリエから日常の世界へともち出すためにダダイズムの表現手段をつかっているのである。コラージュ、ブリコラージュ、デコパージュ、アッサンブラージュを表現豊かに抽象絵画と結びつけている。それだけではなくシルクスクリーン、オフセット、写真平版などの近代的な印刷術を駆使しているが、そこにはオリジナルと複製の違いがなくなっている。60年代にラウンシェンバーグは、実生活からくる日常物や廃棄物など、レディー・メードのオブジェを画面に直接持ち込むというコンバイン・ペインティングにより、絵画と物質芸術の境界線を打ち破った。「この世界を一つの大きな画面として見てはいけないという理由はどこにもない。」

彼の造形作品の数々は、多くの異質な素材ばかりが組み合わされて、予測できない壮観な芸術になっている。ラウシェンバーグは絵画から、構成の際にある一点に中心を置く序列や、ハーモニーを排除している。彼の絵画の世界は典型的な舞台上の作品であり、平等及び価値の等級性からはなれた原則に従ってまとめ上げられている。独立して、同価値をもつ彩色部分と絵画の構成部分との間にいくつかの焦点も緊張感に満ちたコントラストも置くことのない平等の表現をもつ万華鏡である。

Sky House II
Acrylic, silk collage
Kaku kite 372 × 248 cm
Kite-maker: T. Kashima

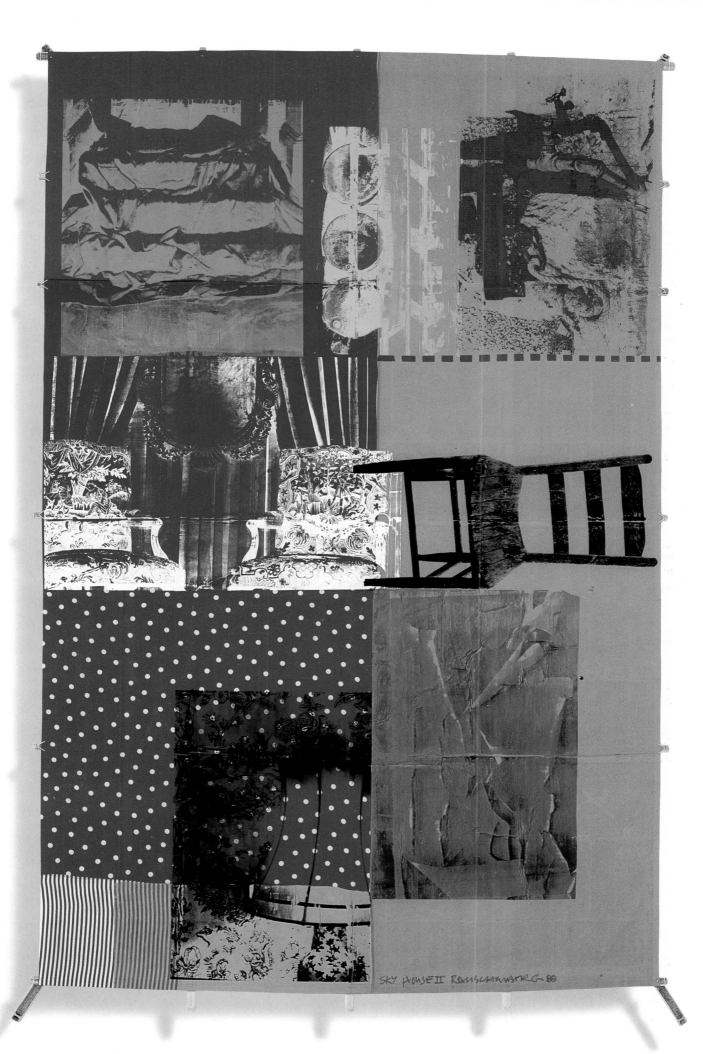

Robert Rauschenberg working on Sky House II
「スカイ・ハウスⅡ」を制作するロバート・ラウシェンバーグ

Sky House I

「アート・カイト」になったばかりの「スカイ・ハウスⅠ」

Daniel Buren

Born 1938 in Boulogne-Billancourt,
lives in Paris

The distinctive feature of Buren's work is its reduction of art down to a single basic structure, stripes, nothing but stripes. Mainly executed in glaring red, but sometimes also done in yellow, blue and black, Buren's stripes are always arranged vertically in 8.7-centimeter widths to cover museum walls, window panes, advertising pillars and buildings.

He has sailed boats with striped sails on Lake Geneva and Lake Wannsee (outside Berlin) and he has tailored striped silk vests for the guards at a Dutch museum. More like performances than true paintings, such works are evanescent and leave no record beyond a souvenir snapshot.

For Buren, art is a "visual tool to direct the observer's attention to something else". In the manner of Japanese garden-viewing windows, he has also set up striped boards with various shaped openings against natural backdrops, such "windows" bringing the framed landscape into heightened relief.

By far his largest and most controversial work, though, was the 1985 installation in the courtyard of the Palais Royal, where he planted 256 black and white striped marble columns.

"Contrary to all appearances", says Buren, "my work is not an ensemble of stripes. They are only an instrument to show what lies between them".

フランス人のダニエル・ブーレンの芸術の基点は、絵画の基本構造を極限に達するまで減少させることである。その結果がストライプ。ストライプ以外になにもない。色は黄色、青、黒などであるが、多くの場合、目の覚めるような赤。ストライプは幅が正確に8.7センチに決められた垂直の色の帯である。ストライプの模様が美術館の壁、建物の一部、窓ガラスや広柱などを覆う。

ジュネーヴ湖やベルリンのヴァンゼーではストライプを描いた帆のヨットを走らせ、またアイントホーフェンのファン・アベ美術館の警備員には赤と白のストライプのシルクのチョッキを着せている。彼の仕事は絵画ではなく、パフォーマンスである。作品は死すべき運命にあり、あとには〝記念写真〟だけが残る。

ダニエル・ブーレンにとって芸術とは、なにかを象徴するのではなく、「観る者の注意力を喚起するための視覚に働きかける道具」である。日本では牛窓で、自然を背景に丸、三角、四角の形をくり抜いたストライプのボードを据えつけている。この「窓」を使って、景色の断片を額に入れ、意識の覚醒を試みたのである。

1985年には、彼はいままででで最も大規模な、しかも最も議論の的になったインスタレーションをフランス文化省の依頼によりパレ・ロワイヤルの庭園で行った。白と黒のストライプの大理石の柱256本をその場に埋め込んだのである。

ダニエル・ブーレンはアート・カイトにも定評のあるストライプをデザインし、日本の空に飛ばすため、まぎれもない彼の作品である赤と白の垂れ幕を制作したのである。「私の作品は、外見に反して、ストライプのアンサンブルではない。その間になにがあるかを認識させるための道具である。」

Untitled
Acrylic 208 × 208 cm
Hamamatsu kite
Kite-maker: Sumitaya

Kite festival in Hamamatsu
浜松凧揚げ祭

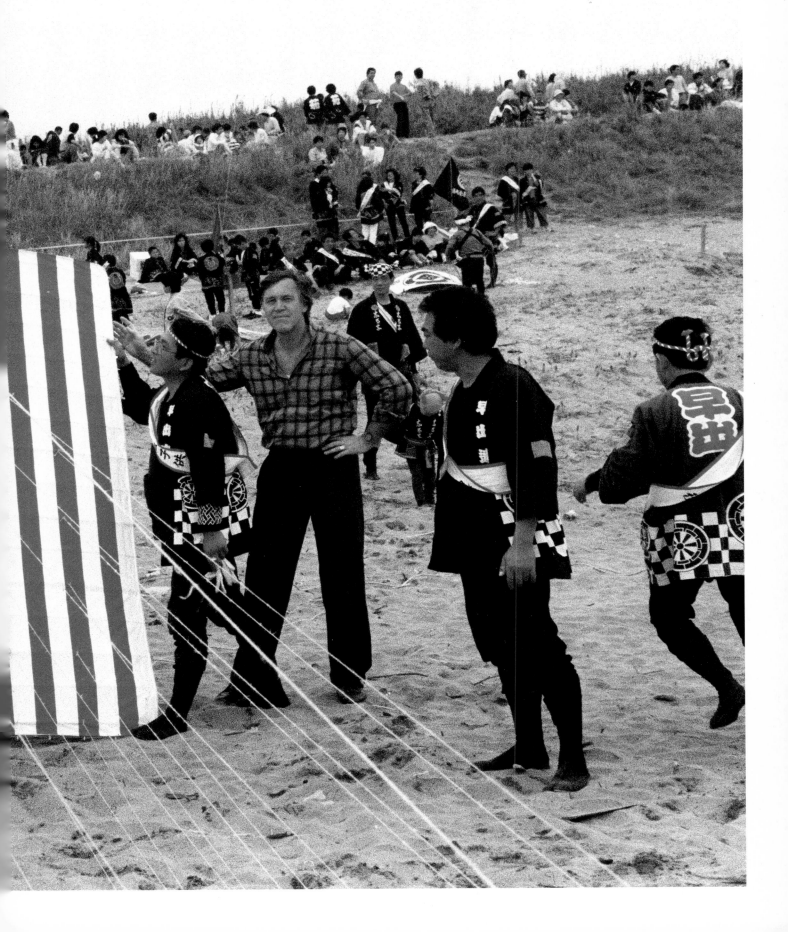

Kenny Scharf

Born 1958 in Los Angeles,
lives in New York

Scharf's art comes from the underground, its forerunner being the exotic Graffiti Art of the New York subway. Although initially viewed as vandalism, subway art became recognized as a colorful, ethnic art full of power and life, and it gradually worked its way up to the surface and into galleries and museums.

Those graffiti artists who were academically trained soon embellished the raw, subcultural anarchism, of course, adding to the effervescent markings images from comic books and the advertising world. European Wild Painting was also reflected in this colorful Pop-Surrealism.

The forms, coloring and disorder prevalent in Scharf's work are suggestive of paintings in fairground booths. Grotesque creatures with glaring eyes and grinning mouths appear often, Mickey Mouse as seen through a distorting mirror, or homunculi from outer space? With his gaudy and morbid array of images, Scharf seems to be depicting all the fear, obsession and neurosis that lie behind the glittery veneer of the disco lifestyle. As the Hieronymus Bosch of the plastic age, he lures us with florid paintings into the oppressive confines of his hall of mirrors.

Fanfare! Starring . . . The Star. A crimson face shines from the center of colorful concentric rings. The cyclopean eye goggles gaily and the mouth display rows of sparkling teeth. Is our star an actor, entertainer, or hero of the political stage? Could despair be concealed behind such effusive optimism?

ケニー・シャーフの芸術は、地下から出発している。ニューヨークの地下街の壁のグラフィティーが、彼の芸術の前身と言える。当初は破壊行為と見られていたが、しだいにこの地下鉄芸術は表に出て、画廊や美術館の中にまで表現の場を得ていった。この強烈な色のアナキー芸術にいち早く飛びついたのは、エスニックなサブカルチャー一族たちであった。これに対して、アカデミックな教育を受けた知性派のグラフィティー作家たちは、派手な略図記号を、コミックや、シュールレアリスム的、ダダイスム的な引用文と同じように企業宣伝用の言語と結びつけている。ヨーロッパに生まれたワイルド・ペインティングですら、この派手なポップ・シュールレアリスムの前には降参した。

ケニー・シャーフの絵画を支配しているフォルム、色彩、そして野生的な混乱が思い出させるものは、年末市で見る売店の絵の色使いである。いつも登場するグロテスクな生き物はぎょろ目をし、口はニヤニヤ笑っている。ゆがんだ鏡に映るミッキーマウスなのか、はたまた宇宙からやってきたホムンクルスなのか。ケバケバしく、しかし病的な群衆を通して、ケニー・シャーフはギラギラしたベールをかぶったディスコの世界に潜む不安、妄想、ノイローゼを映し出そうとしている。プラスチック時代のヒエロニムス・ボッシュのように、派手な絵画で我々を狭苦しい鏡部屋へ引きこもうというのだ。

ファンファーレ／　スター登場。円の中にいくつかの円が描かれたその中央には、真っ赤な風船フェイスが光を放っている。サイクロンの眼はうれしそうに目を据えてこちらを向き、口からは輝かんばかりの歯をむき出している。役者かエンターテイナーか、いや政界の大スターなのか。これほど満ちあふれた楽観主義の背後には絶望が隠されていはしまいか。

Starring . . . The Star
Dye
Maru kite 200 cm
Kite-maker: K. Sogabe

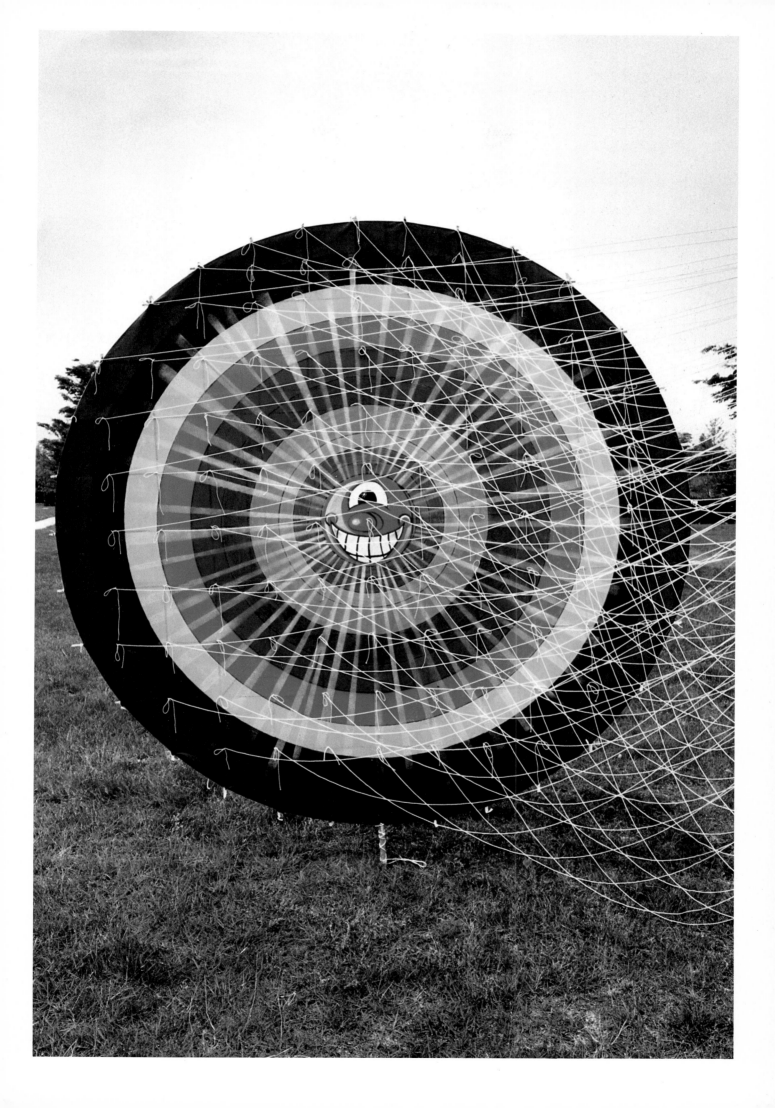

Jean Tinguely

Born 1925 in Fribourg (Switzerland),
lives in Neyruz

With wheels, fire, water and mechanical devices as his basic working materials, this Swiss alchemist makes moving objects, mobile sculptures and strange fountains that demonstrate over and over the hollowness of both our obsessive consumer society and our technological perfectionism.

Already as a young child, Tinguely constructed small waterwheels of wire which, when set in motion by the current, made a hammer drum a tattoo on empty cans and bottles.

With his contraptions he celebrates movement as a sign of life and his experiments with moving objects have extended our traditional conception of the nature of art.

Instead of costly materials, Tinguely works with industrial waste. From ugly scrap metal and trash, for example, he has created strangely beautiful "métamécaniques". Chaos and order, anarchy and law, enter into a surrealistic symbiosis in his sculptures.

The basic idea of Tinguely's art narrows down to seriousness at play being the real approach to freedom. We are reminded somehow of all the possibilities in life that we have already lost. "The dream is everything, technology is nothing".

Tinguely did not submit a finished design for a kite because "The Japanese are much better at it". Instead, he sent a message that he wanted encoded into a kite, rebus-style, a speciality of the Yokaichi kite-makers. The message is a greeting to his friends in the Gutai Group (the Japanese artists whose world-wide happenings have done so much to enlarge our notions as to what is art) and consists of "love", "money", a Chinese character and a fish, spelling out "Ai-satsu Gutai" – "Homage to Gutai".

水、車輪、火、機械、これはこのスイスの錬金術師の使う基本的な素材である。ジャン・ティンゲリーは動くオブジェやモビールの造形作品、グロテスクな噴水彫刻などの作品群によって、現代社会における技術の完璧主義とその消費態度の無意味さを示唆している。すでに子供の頃、森の中に小さな水車をつくり、水の流れで歯車が作動し、その動きに合わせて、ハンマーが空缶や空ビンを打ち鳴らすように組み立てていた。芸術家となってからは、機械や車輪を使って生の証ともなる動きの連続性を造形化している。芸術と生を結びつけるために、このような可動装置の実験によって、彼は従来の芸術概念を拡張することになった。ティンゲリーは、もっともらしい高価な芸術用の素材を放棄し、現代の文明の廃棄物を利用して、くず鉄や廃物をあの奇妙に動く機械に変容させているのである。汚らしい物体が取り合わされて美が生まれている。混沌と整頓、無秩序と規律がその動く立体造形の中に超現実的に共存している。媒体となる素材が本来の目的に束縛されず、真剣にその遊戯性を表現できることがティンゲリーの芸術に対する基本的な考えである。ティンゲリーは我々が喪失してしまった生のさまざまな可能性を暗示してくれている。「夢はすべてにつながる。技術は問題にならない。」

もちろん自ら凧を制作することは彼のもくろみではない。「凧は日本人の方がずっと上手だ。」しかし彼は凧の中に、日本の具体グループの友人たちに送るメッセージを織り込むことを望んだ。まだ世界のあちらこちらでハプニングやフルクサスのイヴェントが展開するずっと以前に、数多くのアクションで当時の芸術概念の枠組みを打ち壊したのは、ほかならぬあの「具体」の芸術家たちだったからだ。このメッセージを謎解きの形で巧妙に伝えてくれるのが、昔から判じ絵や判じ文で知られる八日市の凧である。「具」の文字に添えて、鯛と愛とお札を絵で表わし「具体へのオマージュ」を鮮かにつくりあげている。

Greetings to Gutai
Japanese ink
Yokaichi kite 200 × 180 cm
(Not shown)

Niki de Saint Phalle

Born 1930 in Neuilly,
lives in Tuscany

Raised in New York City, Niki de Saint Phalle attained international acclaim in the early 1960s with her "shotgun paintings", Conceptual happenings at which she fired bullets at gypsum plates filled with pouches of pigment. These events were hailed as ironic salvos of non-objective art, dramatic, aggressive acts representing the artist's liberation from stifling social trammels.

Since then she has staged numerous events with Jean Tinguely: an "Anti-Corrida" in Figueras, Spain, where she exploded a dummy bull by remote control (in honor of Dali); the gargantuan walk-through female HON (She) in Stockholm (1966); and the "Earthly Paradise" in Montreal (1967), not to mention the Stravinsky fountain in Paris. More recently, she has been working on a "tarot garden" in Tuscany, the summation of her life's work, in which she is creating enormous habitable sculptures inspired by the 22 cards of the tarot deck.

"Most of Niki's monuments have a timeless quality to them, reminiscent of dreams and ancient civilisations. There are evil dragons, hidden treasures, witches and man-eating mothers, but also in abundance are birds of paradise and kind mothers. In other words, her universe encompasses flights into heaven as well as descents into hell". (Niki on Niki).

Among the many creatures in her kaleidoscope of myths, mysteries and reveries, the most famous is Nana, the fat-bottomed blonde. De Saint Phalle's art kite, suggestive of naive folk art or amusement park advertising, features Nana in a flight of passion with a bird of paradise, calling to mind Indian erotic sculpture, Nazca, Mythos and Pop and other cultural archetypes, both mythic and whimsical.

パリに生まれ、ニューヨークで育ったニキ・ド・サン-ファルは、60年代の始め、射撃絵画で国際的に注目されるようになった。いろいろの絵の具の袋を付け、白い石膏をかぶせてレリーフ状にした標的板に、銃弾を撃ちこむと袋が破れて絵の具が石膏板の表面に流れ出すというものであった。このような「射撃による絵画」でニキ・ド・サン-ファルはアンフォルメル絵画を皮肉ると同時に、攻撃的な行為を通して、息のつまるような社会の束縛から自分自身を解放したかったのであった。

その後数年間、ジャン・ティンゲリーと共に、数多くのセンセーショナルなハプニングを試みた。たとえば、フィグエラスの闘牛場ではサルヴァドル・ダリに敬意を表して、機械じかけの闘牛を遠隔操作で爆発させた「反闘牛」を実現した。1966年には、ストックホルム近代美術館で動く壮大な女性像「ホーン（彼女）」が、1967年にはモントリオール万博フランス館で、「幻想楽園」が公開された。パリのストラヴィンスキー広場の噴水彫刻もやはり、ティンゲリーとの共同制作である。1979年以来、彼女はライフ・ワークとして、トスカーナに、タロットの22枚のカードを、その中のいくつかは居住可能な巨大な建築物に置き換えるという、「夢の宮殿」を制作中である。

「ニキの造形作品のほとんどは、時代の流れにとらわれないが、古代の文化と夢を想起させるものである。彼女の作品も生活そのものも、メルヒェンのようであり、邪悪な竜、隠された宝物、人食の鬼婆や魔女が登場する冒険に満ち満ちたものである。そこにはもちろん、極楽鳥ややさしい母親の姿、天国へ昇れる予感も地獄への落下もみてとれるのだ。」（ニキを語るニキ）

絵や思想、神話、夢想や秘儀の色どり豊かな万華鏡の中にはニキ・ド・サン-ファルの名を世界に広めた一つの像がある。それは「ナナ」、ぴちぴちして明るく、豊かな表情をたたえた一女性像である。そのふっくらとした形と単純で多彩な色どりが、皮肉にも民衆芸術や年末市の美しさを思い起こさせる。

極楽鳥にしっかりと守られ、抱擁しあうナナは、凧となって空中に舞い上り、すばらしい忘我の飛翔を体験することであろう。そして、インドのエロティックな彫刻とナスカ、神話とポップ・アート、模範的な英知と陽気なあざけりが融け合い、みんな一体となってしまうであろう。

The Amorous Bird
Dye
Free Form 260 × 285 cm
Kite-maker: M. Yamaguchi

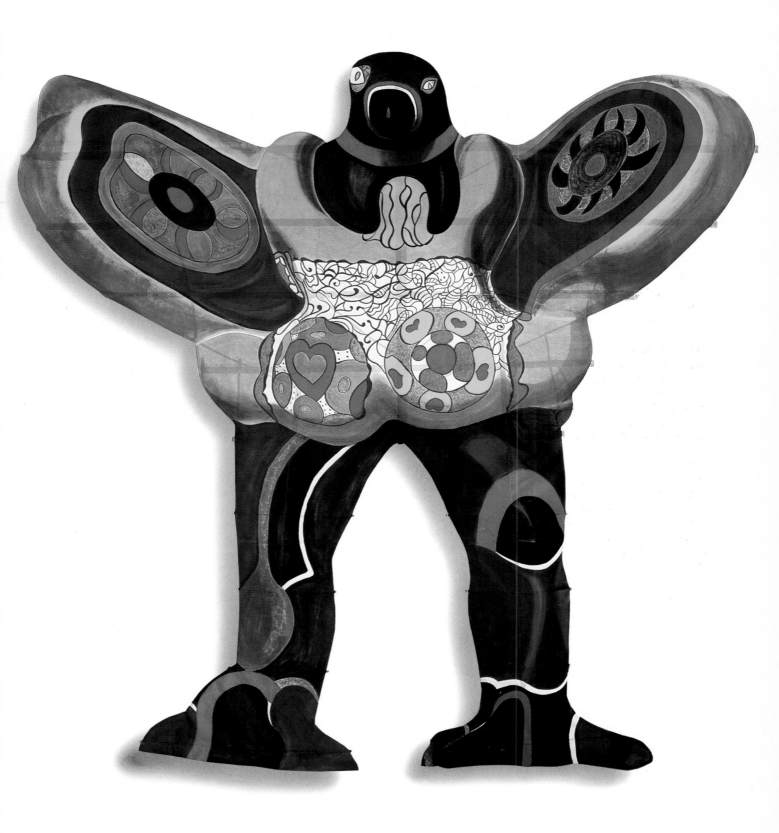

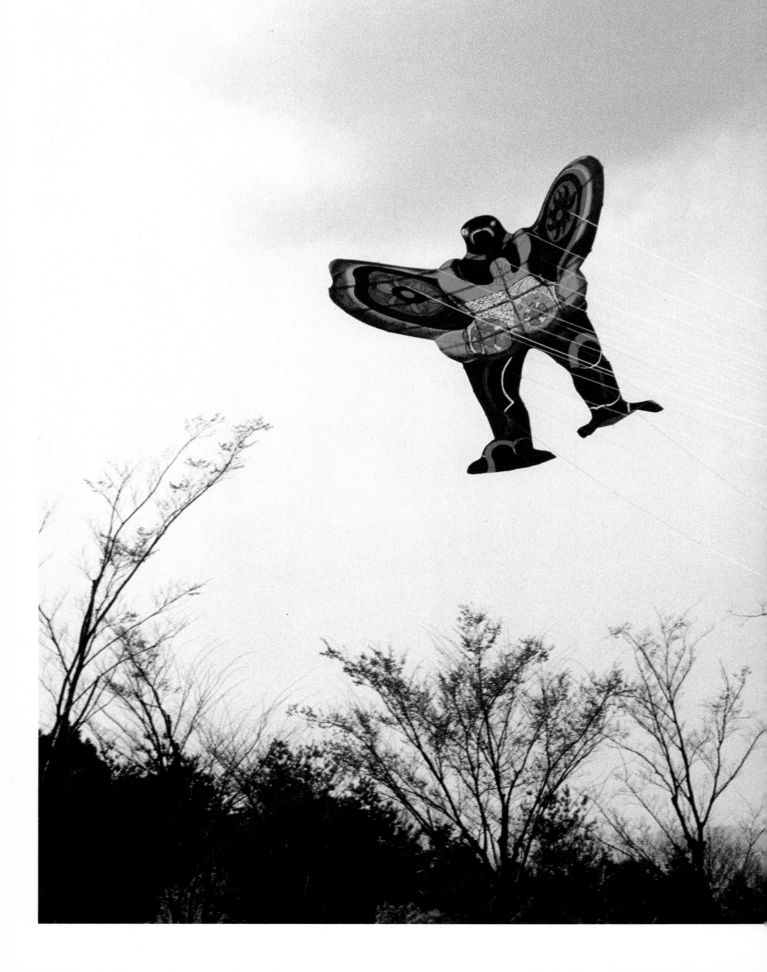

Erik Bulatow

Born 1933 in Sverdlovsk,
lives in Moscow

"Strictly speaking, pictures are the only reality that I trust. The world that surrounds us with its activity is too uncertain to really trust. Everything is in flux, shimmering and changing before our eyes. Only a picture remains the same."

In the style of Photo-Realism Bulatow reproduces newspaper photos, postcards and other pictures with technical perfection, principally choosing scenes from daily life in the Soviet Union. – Muscovites hurrying to work under an absurdly huge poster of Lenin, for example.

Over such paintings he often places imposing messages such as "LONG LIVE THE SOVIET COMMUNIST PARTY" (in red against a brilliant, blue sky) or words like "DANGEROUS" (poised above an idyllic, totally unthreatening picnic scene). The interaction between message and setting, plus the physical tension between the raised lettering and the painting's spatial depth, make such works somewhat garish and invasive – almost like an ad poster or political placard. On the other hand, these pieces also are ironic and puzzling. The quiet, idyllic quality of some scenes, for instance, can be seen as a reference to the "Little Utopia" vision of the late Breshnev era when society was stagnant and the people near political suffocation.

Bulatow intends such paintings to be less denunciations than social chronicles. "I believe that the artist's job consists of just naming. Everything else – censuring, passing judgment – is not one's task." Nonetheless, some of Bulatow's mild satire was sharp enough to get him banished to the underground for years. "I was embarrassed about my work and could not get rid of the complex of doing something almost illegal."

One of the artist's favorite motifs is views of the sky – a gazing into endless blue depths. For his kite he has written "sky" in perspective, justifying the theme with: "We don't really perceive nature – we only see a sunset because it has been shown to us before."

The artist's motto: "I live – I see."

「厳密に言えば、絵は私の信頼できる唯一の、真実を語るものである。我々をその活力で取りまく世界は不確実であり、とても本気で信用するわけにはいかない。この世のすべてのものは流れの中にあって、ちらちらと動き、我々の目の前で変転していく。ただ絵のみが変らないものである。

エリック・ブラトフはフォトリアリストの様式で完璧なまでの技術を駆使して新聞から写真や絵ハガキや絵を再生していく。大抵はソビエトの日常生活から取り出したシーンである。例えば、とてつもなく大きなレーニンのポスターの下に描かれた、仕事に急ぐモスクワの人々など。このような絵の表面にはしばしば、赤い格子さながらの、どっしりした角材のような文字で、日の照り輝く青空の絵の上に「ソビエト共産党万歳」とか、さも平和的な自然の中で憩う牧歌的なピクニックシーンの絵の上に「危い」と描かれていたりする。現実的な絵と文字との相互作用、空間的な奥行きと刷り込まれた文字とが織りなす緊張感が、これらの絵に宣伝ポスターや政治的なポスターでよく知られているような何かけばけばしいもの、扇動的なものを与えている一方で、どこか皮肉めいた不可解なものを与えている。描き出されている静けさと牧歌的情景とはブレジネフ時代の末期、すなわち、体制が楽しくも単調な日常の「小ユートピア的な理想社会論」に甘んじていた行き詰まりの時代に於ける、古典的なものと考えられる。しかしブラトフは、彼の絵が政治情勢の中傷ととられることを望んではいない。むしろ注意深い記録と理解されることを願っている。「芸術家の仕事とは、まさに写し挙げることに終始すると思う。他のことはすべて、例えば評点をつけるとか、判決を下すとかは、芸術家の任務ではない。」もっともこのような控え目な諷刺にもかかわらず、この芸術家は何年も隠れた活動を強いられることになった。「私は自分が行ったことを恥ずかしく思わなければならなかった。何か非合理なことでもしているようなコンプレックスをずっと捨てることができなかった。」

ブラトフが好んで用いて、しかもたびたび様々に変化して表われるモチーフは、空、すなわち無限に続く青い深みに向けられた視線である。空の一部を凧として空へ揚げてしまうということは、一見思いもかけぬことに映るかもしれないが、芸術家の世界経験からはしごく当然のことなのである。すなわち、「世界そのものを認識することはできない。私は人間が自然現象さえも直接には知覚できないということに確信を持っている。日没についていえば、それがすでに描き表現されているので我々は見ることになるのである。

芸術家のモットー、「生きること、それは即ち見ること。」

Sky
Acrylic
Kaku kite 203 × 203 cm
Kite-makers: N. Yoshizumi, O. Okawauchi

Sam Francis

Born 1923 in San Mateo, California,
lives in Santa Monica

An injury to his spine while training for the U.S. Army Air Corps in 1943 ended both Samuel Lewis Francis' career as a pilot and his medical studies. He was consequently bed-ridden for many months and it was as a hospital patient that he first discovered his talent as a painter. By 1947 his unmistakable style was already evident: abstract, all-over-paintings that emphasized verticality, paintings with luminous surfaces awash in a variety of colours, especially red, yellow, orange and an ever-recurring radiant blue (or "Sam's blue" as it has been called by certain poet friends).

In 1950 Sam Francis moved to Paris which remained for a decade his second home. At first the painter received greater recognition in Europe than in America. He travelled in 1957 to Japan to carry out his first commissioned work: an eight meter wide mural for the Sogetsu Ikebana School. He also created large murals for the Basel Art Gallery, the Berlin National Gallery, the Lousiana Museum, many American banks, the San Francisco Airport and the San Francisco Museum of Modern Art.

Besides these large-scale paintings, aquatint and lithographic works have also been appearing since 1959. With his so-called metal series beginning in 1971, he forewent his luminous colours completely for the first time and experimented with accenting brown, grey and black with metallic silver ink. His kite is related to this new series which represents an unusually rigid style for the artist. It should rotate in the sky like an "apocalyptic wheel of fortune". That Sam Francis did not choose one of his airy sky-paintings for his art-kite may be because they already give the impression of weightlessness and need not undergo further transformation. For, according to the artist's own words, the desire to be lighter than air is an integral driving force behind his work:

"There is no conflict in my painting. The conflict is my life. I feel trapped by gravity. I would like to fly, to soar, to float like a cloud, but I am tied down to a place. No matter where I am . . . it's always the same. Painting is a way out."

サムエル・ルイズ・フランシスはパイロットであり、かけだしの医学者であったが、1943年の戦闘機事故をきっかけにそのキャリヤを断念した。脊推の怪我のため何カ月間か病院での療養生活を強いられることになる。この時彼は自分の画家としての才能を発見して、すでに1947年彼独自のスタイルが生れる。それは抽象的なオールオーバーペインティングで、その多くは画面に縦のアクセントになるものが描かれ、明るさの満ちた絵は淡い輝くような色の面をもつ。特に赤、黄、オレンジ色が使われ、友人の詩人に「サムの青」と歌われたあの輝く青がくりかえし出てくる。

サム・フランスは1950年パリに行き、そこで10年過す。パリは彼の第二の故郷になり、彼の画家としての活動は故国でよりヨーロッパでずっとよく認められることになる。1957年彼は世界一周の旅をし日本を訪れ、いけ花の草月流のために始めて依頼された仕事をし、8mもの長さの壁画を制作する。大型の壁画はバーゼルのクンストハレやベルリンのナショナルギャラリー、ルイジアナ美術館、アメリカのいくつかの銀行、サンフランシスコ空港やサンフランシスコ近代美術館等のためにも制作している。

サム・フランシスは大型の色あざやかな作品ばかりではなく、1959年以来石版画やアクアチントの作品もつくっている。1971年以後のいわゆる「メタル・シリーズ」では、彼のあの輝くような色は全く見られなくなった。茶色とグレーと黒が基調になった絵にメタリックな銀でアクセントがつけられる。彼のアート・カイトはこの色彩で描かれた、サム・フランシスの作品としてはいつもと違った厳しいシリーズに変容している。空ではむしろ黙示録的な幸運の車輪として回転するのであろうか。

サム・フランシスが芸術凧にあの軽やかな色彩の空の絵を選ばなかったのは、彼の絵がすでに重力を解かれた飛揚を表現するものであり、転換の必要がないからであろう。空気よりも軽くというあこがれは、芸術の創造の原動力になるものであると画家自身が証明しているからである。

「私の絵に葛藤はない。葛藤は私の生活だ。私は重力のわなにかかっている。私は飛びたい。空中を泳いで雲のように浮きたい。しかし私はある場所に縛りつけられている。どこにいようと……それはいつも同じだ。絵は逃れる道だ。」

Sam Francis Art Kite
Aquatint
Printed by Jacob Samuel at the Lithoshop, Santa Monica
Edo kite 79 × 55 cm
Kite-maker: T. Nagashima

Igor Kopystianski

Born 1954 in Lvov (Lemberg),
lives in Lvov and Moscow

"If a painting is taken out of a frame and rolled up, it is still a picture. However, its perceived role may drastically change as well as its function. Standing upright by itself it can bear weight, etc."

Since 1985 Kopystianski has used paintings as construction and finishing materials in installations termed "Interiors". The concept arose accidentally, the result of having years of creative output on hand and no opportunity to exhibit it. With his atelier gradually reduced to the status of a storeroom, the artist was obliged to heap his pictures together and treat his art as sheer physical mass. "If paintings are not allowed to enter the intellectual stream, they become like any other ordinary object."

Kopystianski's installations call into question our deepest assumption about fine art. When he reproduces the works of old masters, for example, and displays them bundled like newspapers, or used as furniture covering, viewers responses are strong and visceral. Some bemoan the reminder of the perishability of all art, while others find refreshing the abolition of the protective border that usually stands between art and life.

Kopystianski's art kite diptych is a logical development for him, again demonstrating – with a touch of cruelty – the ephemeralness of art. Two lovely landscape paintings have been joined like Siamese twins, creating a form not unlike a ginkgo leaf, or perhaps a butterfly. As always, the viewer's feelings are left divided between regret over the "wasteful" combining of two fine pieces, and appreciation of the new creation. The thought that the wind could easily destroy the work intensifies the observer's emotion.

「絵が額からとりはずされ、巻かれても、それが絵であることにかわりはない。しかしその絵は物体として全く新しい性質を得ることになる。即ち、支えなしに垂直に立つものであったり、ある程度の重量が支えられるものになるなど……。」1985年以来、イゴール・コプュイスティアンスキーは、コンストラクションとかインテリヤとか呼ばれる彼のインスタレーションの構成要素としてカンヴァスに描かれた油絵を使用している。このアイディアは、長年にわたってただ描き続け、展覧会をする可能性に恵まれなかった一画家としての、個人的な状況から生れた。彼のアトリエは山のように絵を積み上げるための倉庫に変ってしまい、芸術は単なる物体になってしまった。「芸術的で、かつ精神的なプロセスに関与することを禁じられた絵は、物としての世界により近づく。」

イゴール・コプュイスティアンススキーは、古典の作品を模写し、これを傷つけ、反古のように積み重ねたり、あるいは家具の覆いやテーブルクロスに格下げしたり、ひどい状態に修復し、これらを絵画インスタレーションに使用しているが、このような扱い方を通してくり返し我々の芸術理解に疑問を投げかけている。傷つけられた絵を鑑賞することによって、芸術の傷つきやすさを認識するという隠されている危惧が呼びさまされる。作品に対する距離が取りのぞかれる故に、多くの人にとっては、これらの「死ぬ運命にある」絵の方が、美術館の壁に用心深く掛けられたオリジナルより、より魅力的にうつるのである。

いちまつの無慈悲な芸術の有限性を証明するこの遊びの精神は、二枚の絵による祭壇画状の彼の凧ディプティックにも引き継がれている。二枚の美しい風景画は、半ば銀杏の葉のように、半ば蝶々のように互いに寄り添って、一つの翼のある物体となっている。観る者の感情は、二枚の絵が機械的に結合されてしまった哀れみと、結合することによって思いがけない魅力をもたらした新しい作品の誕生の喜びの間を揺れ動く。その上、風がこの芸術を数秒のうちに破壊するかもしれないという想像は有限性をもつ出来事のみに特有の集中度の高い観察を要求する。

"Diptych"
Oil on canvas
Free form 235 × 350 cm
Kite-makers: N. Yoshizumi, T. Okajima, O. Okawauchi

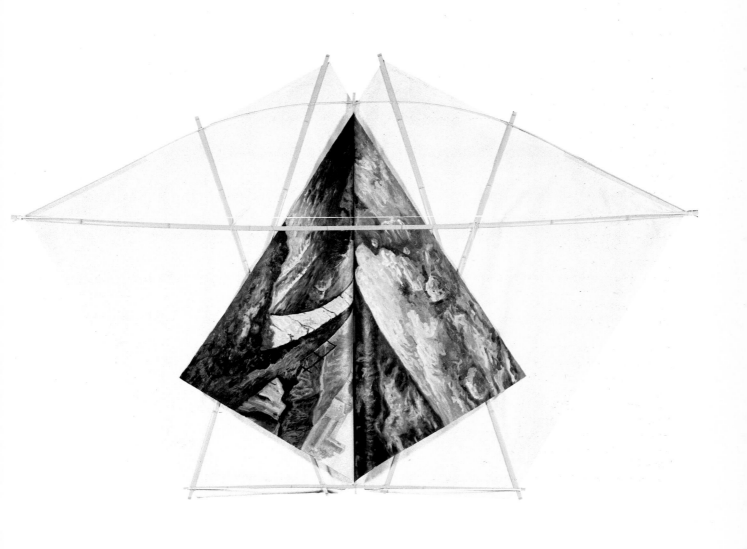

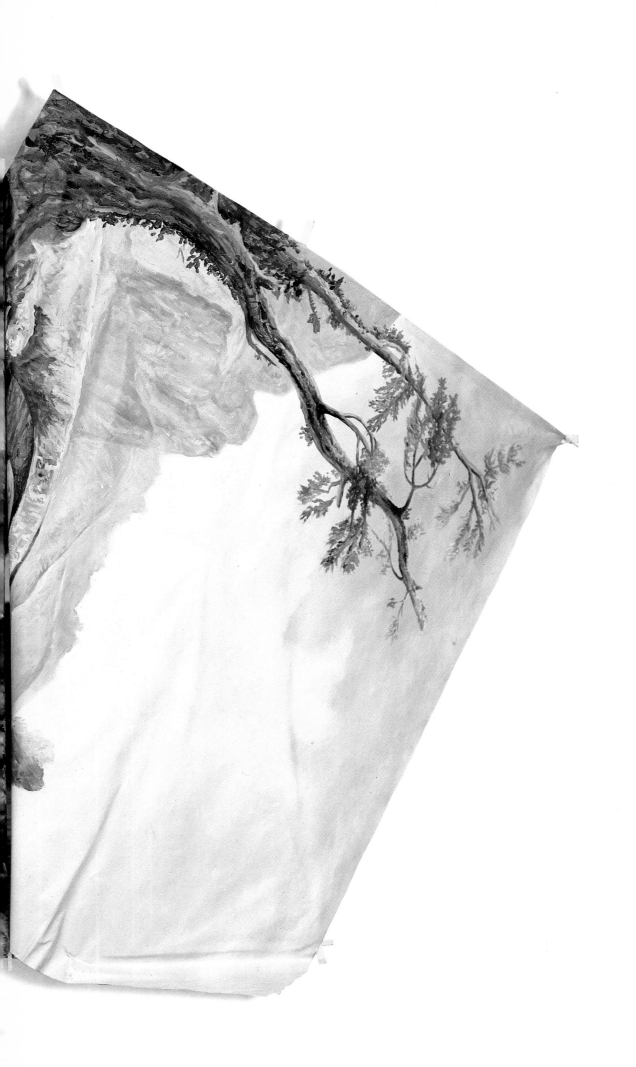

Grischa Bruskin

Born 1945 in Moscow,
lives in Moscow and New York

Grischa Bruskin grew up in the "Schtetln", the Jewish settlement area of Moscow in tsarist Russia and became an artist despite his father's opposition. His works have been denied official recognition, his exhibitions closed by government order and he himself sternly rebuked. To this day he does not understand the reasons for his mistreatment.

Since 1983 he has been working on two main themes: "Alef Bet" (Hebrew for alphabet), standing for the world of Judaism, and "Lexica" representing the world of socialism. When asked how two such totally different works can co-exist, he answers plainly: "I work just as I live". He deploys historical types or figures on these plates as in a street-ballad show.

The background of the paintings is covered with mostly unintelligible scrawl. The "writing" in this context is to be understood as a sign of a fundamental world knowledge. The figures are outfitted with a wide range of accessories as though for a small world theatre. Their meaning, however, remains mysterious. This play with social and ideological emblems may treat existing orders with irony, but it likewise represents an attempt to create a lexigraphical picture system of the universe, one that will be set in motion by a mysterious mechanism with clockwork precision.

Owing to the success of Moscow's first ever auction of modern Soviet art organized by Sotheby's in 1988, Grischa Bruskin became famous overnight. An invitation led him forthwith to New York, where he has remained to continue his work.

Bruskin's kite consists of two sheets, each with a pair of figures painted on it. The upper part has a six-winged angel and a robed and capped Jew with magic eyes; below is a cabbalistic figure with three triangles and a demonic bird/man. The background is covered with Hebraic writing but the meaning remains obscure. The work is entitled: "Message."

In Sagamihara (Kanagawa Prefecture near Tokyo) one can find a kite form made by glueing individual sheets of paper onto filigree bamboo frameworks. These kites carry a message – perhaps asking for a good harvest or the blessing of children, or patriotic slogans in wartime and even comments on current events. It was therefore appropriate to fly Bruskin's "Message" as a Sagamihara-kite.

グリシャ・ブルースキンは、帝政専制政治体制下にあったロシアのユダヤ人入植地域シュテットルン出身の両親をもち、モスクワで育った。父の反対を押し切って芸術家になった。彼の作品は長い間正式に認められることはなく、展覧会は一度ならずも中止され、芸術家は叱責を受けた。どんな理由からなのか、彼自身にも今なお不明である。

1983年以来、ブルースキンは二つの大シリーズ、「アレフ・ベット（ヘブライ語のアルファベット）」と「百科全集」に取り組んでいる。一方はユダヤ教の世界を、他方は社会主義の世界を表わしている。このように異った二つの世界がどうして共存できるのかと問われると、「私の生き様と同じように私は仕事をしているのだ。」と答える。ブルースキンはカンヴァスの上にモリタートの写真のように歴史上の人物たちや様々な人種をずらりと行列させる。絵の背景は、大抵読みにくい文字で埋めつくされている。テキストはここでは、世界についての基本的知識の印として理解される。小さなお芝居ででもあるかのように、人物たちはありとあらゆる附属品を身につけている。しかし、これらの意味は不可解なままである。社会的・イデオロギー的エンブレムを使っての遊びも、現行の諸体制を皮肉るものであると同時に、宇宙を百科全書的な絵画の体系として表わそうとするここみであり、ある秘密に満ちたメカニズムによって、時計の歯車装置のような正確さで動かされる人間たちの歴史的な歩みを表わそうとするこころみでもある。

1988年に競売の会社、サザビースによってモスクワで初めて催されたソビエトの現代美術を扱うオークションで、グリシャ・ブルースキンの名前は電撃的に世界中に知れ渡ることになった。その後すぐに招待を受けてニューヨークに渡り、それ以来ここで仕事をしている。

ブルースキンはそのアート・カイトに二枚の絵を描いた。それぞれの絵には一対の人間像が描かれている。六枚の翼をもつ天使と法服を着てずきんをかぶり二つのマジックアイをもつユダヤ人が一組で、他の一組は三つの三角形をもつカバラ風の人間と同じく魔神の鳥人間である。再にこの四つの絵の背後には一面にヘブライ語が書かれているが、その意味は特にはっきりしていない。作品のタイトルは「メッセージ」

神奈川県の相模原には一枚づつの絵を繊細に組み立てられた竹骨に貼っていくという凧がある。相模原凧のモチーフになるのはメッセージで、豊作祈念、戦争時の母国の国威、その時代の出来事などが題字になって凧の絵柄になる。それゆえブルースキンの芸術凧「メッセージ」が相模原凧になって揚げられるのは当然のことである。

Message
Acrylic 183 × 98 cm
Sagamihara kite
Kite-makers: N. Yoshizumi, O. Okawauchi

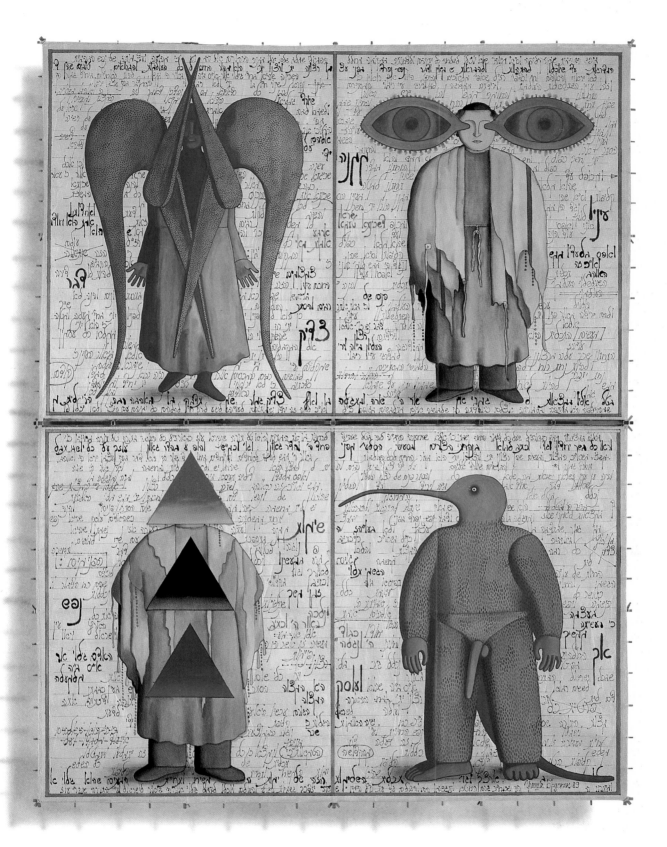

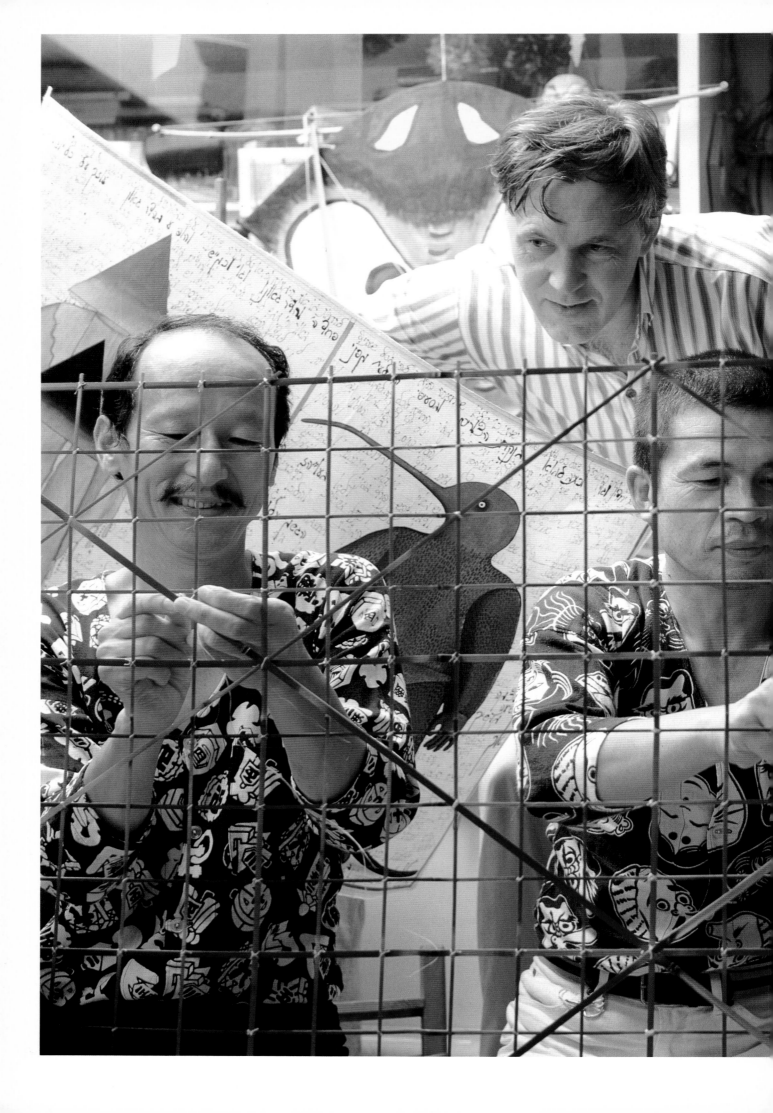

Georgij Litischevskij

Born 1956 in Dnepropetrovsk, The Ukraine,
lives in Moscow

Litischevskij is a historian by profession. He works at the History of Science Research Institute of the Academy of Science in Moscow. Among his academic works, he has translated Pliny's "Naturalis Historia" into Russian.

He began to paint at sixteen and his first exhibition took place in 1980 under the auspices of the Malaya Gruzinskaya (Union of Graphic Artists). He is especially interested in caricatures and comics done in the "Lubok" style (colourful paintings) like those that were earlier sold on the street corner. His paintings are combined in a cryptic way with captions which he writes himself. Some are reminiscent of proverbs, others of surrealistic prose. He paints mainly on large pieces of material with liquid dyes that lend his paintings the luminous transparency of batik.

Two kites were completed for the project. On one of them, a stark-naked witch on a broom soars through a winter's night. The caption reads: "Baba Yaga doesn't fear the cold. In the wintertime she flies naked on her broom." The other kite is like a rebus assembled together with letters and pictures. On the left hand side the Salvation Tower of the Kremlin is recognizable with its large clock: its hands hang sadly downward like a walrus mustache. On the right appear the symbols of medicine: snake, chalice, syringe and the Red Cross.

The crafty commentary reads: "The Tower lets its mustache hang down. Don't cry: time heals all."

ゲオルギ・リティチェフスキーは歴史学者としてモスクワの科学アカデミーの科学歴史のための研究所に従事しており、大プリニウスの「自然誌」をロシア語に訳した。

リティチェフスキーが絵を描き始めたのは16才の時で、最初の展覧会は1980年マラヤ・グルチンスカヤでのグラフィックデザイナー協会のものであった。彼の興味の対象は、特に諷刺漫画や、昔、路上で売られた「ルボック」という色刷りのコミック画のようなものである。そこに隠されているのは、彼が創作する文と絵が組み合せられるおもしろさである。そのような作品のあるものは格言の知恵を思い出させ、またあるものはシュールレアリストのプローザを想像させる。普通、彼は大きな布に染料で絵を描くがそれらの絵はろうけつ染めのように光の透過の効果をもつ。

リティチェフスキーは天のために二枚の絵を描いた。その一枚は真っ裸の魔女が箒に乗り冬の夜を飛んでいる絵であり、彼は「ババヤガは寒さを恐れることはない。冬になると彼女は裸でも箒に乗って飛んでいってしまう。」と文字で見る者に教えている。もう一つのアート・カイトは判じ物のように文字と絵が描かれている。左側にはクレムリンの救済の時計台が見られ、そこには口髭のように下にさがったメランコリックな針がある。右側にはアエスクラピウスの蛇、注射器、赤十字が点在している。そしてその狡猾な説明は「時計台には口髭がさがっている。泣かなくてもいいよ。時がすべてを解決してくれる」と。

Time Heals All
Acrylic on material
Kaku kite 138 × 128
Kite-makers: N. Yoshizumi, T. Okajima, I. Fujieda,
O. Okawauchi

Precision work
P. Eubel and Ikuko Matsumoto with
kite-makers: N. Yoshizumi and O. Okawauchi

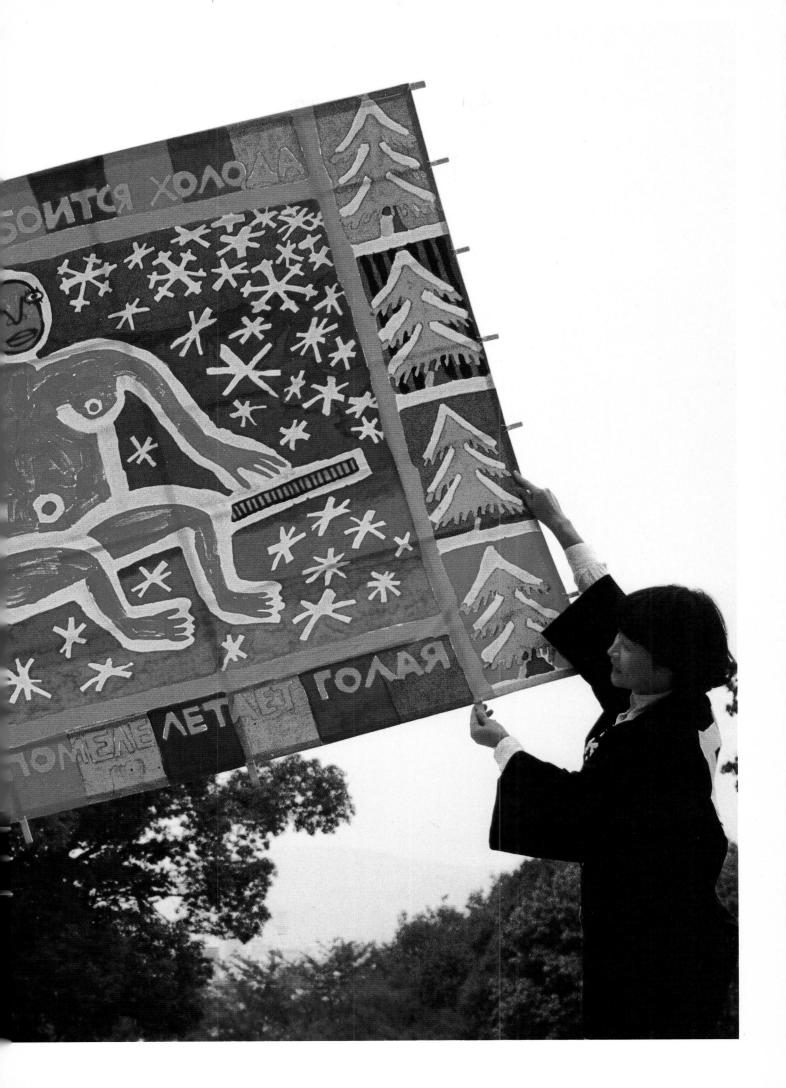

Toshimitsu Imai

Born 1928 in Kyoto,
lives in Kyoto

Modern art history is marked by many artists whose works underwent deep stylistic changes in the course of their careers: for instance, from figurative to abstract painting (or vice versa), from Informel to geometrical painting, or from Abstract Expressionism to hard edge. Toshimitsu Imai is arguably the most radical among them. He has switched between extreme positions not only in painting but also in cultural tradition. In 1955 he was the first Japanese artist who painted in Paris in the Informel style. It was he who brought Michel Tapié, the French apologist for the Informel, to Japan in 1957. Tapié's encounter with the Japanese avant-garde triggered off the "Informel Storm" in Japan. In the sixties and seventies Imai gained recognition in Europe as well as in Japan for his dramatic style, marked by dynamic expressiveness, controlled anarchy of gesture and eruptive streams of colour.

In 1983 Imai surprised the art world with another of his characteristically radical changes of style. His "Ka-Cho-Fu-Getsu" (flower, bird, wind, moon) series incorporates elements of classical Japanese gold-background painting. On folding screens and large murals, on kimonos and in exotic Installations, he has presented many dramatic works for his "Return to Japan". The extracts of Japanese painting which he has reproduced with templates have come to be known as "Imaigrams". Ironically, the beginning of New Painting effected this reflection on the roots of Japanese culture. Confronted with art developments in the West he asked himself anew the questions concerning originality and identity. As before he draws his creative energy from cultural tension, from a productive culture shock. He sees himself as a "wanderer between the worlds". For Imai there exists, however, a definite continuity between his informal work and his new style: the painting structures have always been determined by a Japanese-style distribution of space, and the principle of all-over-painting, his choice of colours and motives (the moon, for example) have persisted since his early work.

The French art critic Pierre Restany has called him the "architect of the air" who "paints on the wings of the wind and discovers the East through the West".

近代の美術史が特定の何人かの芸術家の作風の変化について語る時、具象画から描象画へ（又はその反対）、アンフォルメルから幾何学芸術へ、あるいは描象表現主義からハードエッジへと記載するのが普通であろう。今井俊満の場合、このような芸術家の中では最も極端な例である。彼は絵画の世界においてだけではなく、伝統文化の上においても極度に位置を転換してしまったのである。1955年、パリでアンフォルメルの仕事をした最初の日本人であり、彼こそ1957年にフランスの護教家ミッシェル・タピエを日本に連れてきたその人であった。このようにして生れたタピエと日本のアヴァンギャルドとの出会いが日本の「アンフォルメル旋風」をまき起すことになったのである。60年代と70年代に、今井俊満はヨーロッパでも日本でもその「劇的な画風」によって、ダイナミックな表現力、統制のある無秩序な行動、噴出するような色の流れなどと折り紙をつけられることになった。

1983年、今井俊満は極端な画風の転換により美術界を驚かせる。花鳥風月のシリーズにより、金地の上に展開する古典の日本画のような画風に遡ることになる。屏風に描き、大壁画に描き、着物に描き、華々しいインスタレーションをすることによって、今井は自己の「日本への帰還」を演出している。型紙を使って再生される彼の日本画の引用はイマイグラムと呼ばれている。おもしろいことにニューペインティングの始まりが、日本文化の根幹に回顧をもたらしたのである。西洋における芸術の展開に対して、独創性とは何か、アイデンティティーとは何かと、今井は改めて自分に問いただした。そしてまた、彼の創造力も異文化の中で体験する緊張感から生れ、創作のきっかけとなるある種のカルチャーショックから起っているのである。彼は自分自身を「異る世界を行き交う旅の芸術家」としている。しかしながら、彼自身の中では当時のアンフォルメルと新しい画風には何らかの連続性がある。すでに当時、絵画の構成の中に日本的な空間の配分があり、あるいはオールオーバーペインティングの基本となる描き方や色の選択がなされており、「月」など、いくつかの限られたモチーフの扱いからもそのことは明らかである。

フランスの美術評論家ピエール・レスタニーは今井を「風の翼にのって絵を描き、西洋を通して東洋を発見する『空気の建築家』である」と呼んでいる。

Full Moon
Acrylic, gold-leaf, silk
Oogi kite 207 × 400 cm
Kite-maker: T. Kashima

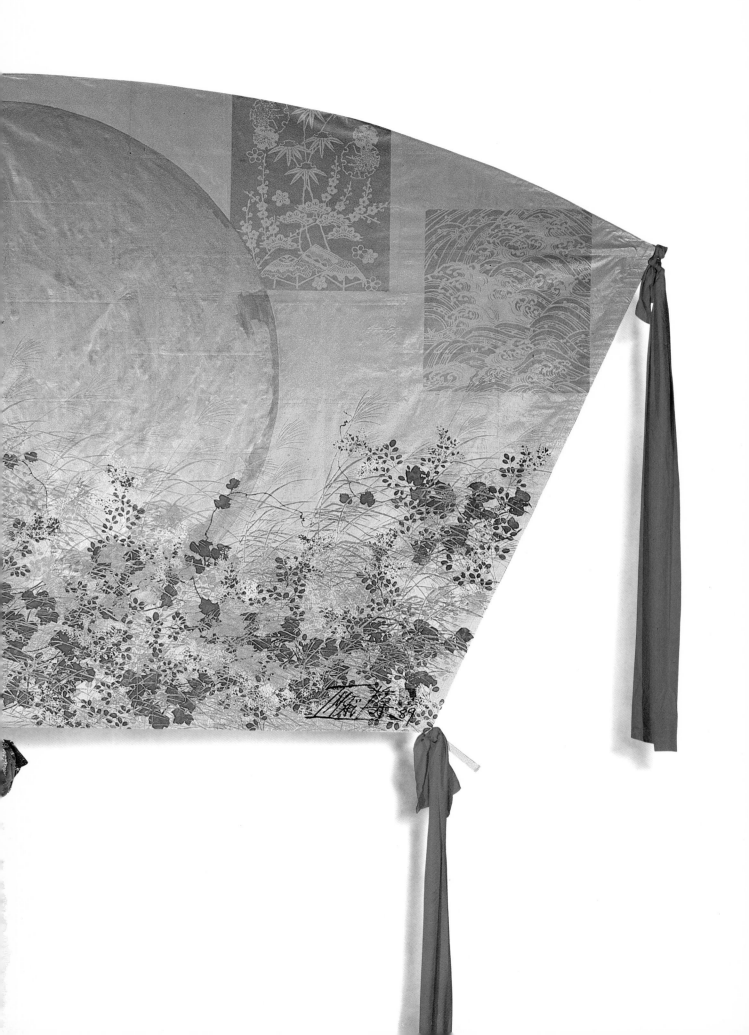

José de Guimarães

Born 1939 in Guimarães,
lives in Lisbon

José de Guimarães began painting at seventeen. His training as a civil engineer has influenced his art, particularly his plastic works, lending it a constructive aspect. His sculptures consist of upright flat elements attached to a framework of aluminium pipes, which often create the overall effect of a mannequin on display.

From 1967–74 Guimarães worked as an engineer in Angola, which was then Portugal's "territoire d'outre mer". In the myths, masks and amulets of Black Africa he discovered many symbols that he has incorporated into his work in ever-varying ways. His stunning use of "magic mirrors", for instance, stems from his fascination with a genre of African sculpture. Figures from Portuguese history yielded numerous of his distinctive motifs, three of which have appeared time and again in his paintings, silk screens and sculptures. The first, Don Sebastião, was a sixteenth century Portuguese king who set off with his kingdom's elite warriors to engage in a North African war from which no one ever returned. The Portuguese, whose adoration for their charismatic sovereign kept growing stronger, would not believe in his death and continued to wait hopefully for his return. The second figure in Ines de Castro, a Portuguese queen of Spanish aristocratic descent, who was murdered by a courtier during the king's absence. Finally, there is Luis de Camões, the poet who composed the Portuguese national epic poem, the Lusiadas.

ジョゼ・デ・ギマライシュが絵を描き始めたのは17才の時であった。建築技師になるための勉学が、造形作品の構想を練る時点で役立ち作品に影響を及ぼしている。作品は平版ないくつかのエレメントとそれを差し込んでつなぐアルミニウム管によって構成されていて、それは人形の四肢のように作品全体の骨組の役割りもする。

1967年から74年の間、当時ポルトガルの海外領土であったアンゴラに建築技師として行っていた。そこで彼はブラックアフリカの神話、面や魔よけのお守りなどに接して、今日もなお様々に変化して登場する図形記号のヒントを得ていたのである。特に魔力を秘めた鏡の使用はアフリカの彫刻に遡ぼる。絵画のモチーフの別の源はポルトガルの歴史であり、歴史上の三人の人物を絵画、シルクスクリーン、造形などによく扱っている。その一人は16世紀のポルトガル王ドン・セバスティオである。王は24才の時、王国の精鋭兵士たちと北アフリカの戦場に赴いたが、その地からは誰も戻る者がなかった。彼の死を信じず、帰還を願ったポルトガル国民にとって彼はカリスマ的存在となった。第二の人物はスペイン貴族出身のポルトガル女王で、王の不在の間に宮内官に殺害されたイネス・デ・カストロである。そして最後の人物はポルトガルの英雄叙事詩ルシィアエダスの詩人ルイス・デ・カモイシュである。

1989年3月ジョゼ・デ・ギマライシュは来日して姫路郊外の圓教寺にこもり絵を描き京都の凧師とともに芸術凧を制作した。その凧は4.5mもの大きさのセバスティオの姿となった。かぶとの代りに頭に大きい蛇（ギマライシュにとっては善のシンボル）をのせ、胴体には緑の蛇（悪のシンボル）を巻きつけている。

The Warrior
Acrylic, metal dust, pieces of glass
Free form 435 × 260 cm
Kite-makers: N. Yoshizumi, T. Okajima, I. Fujieda,
O. Okawauchi, K. Ono

Baba Yaga doesn't feel the cold. In the
wintertime she flies naked on her
broom.
Buka kite 147 × 225 cm
Kite-makers: N. Yoshizumi, T. Okajima,
O. Okawauchi

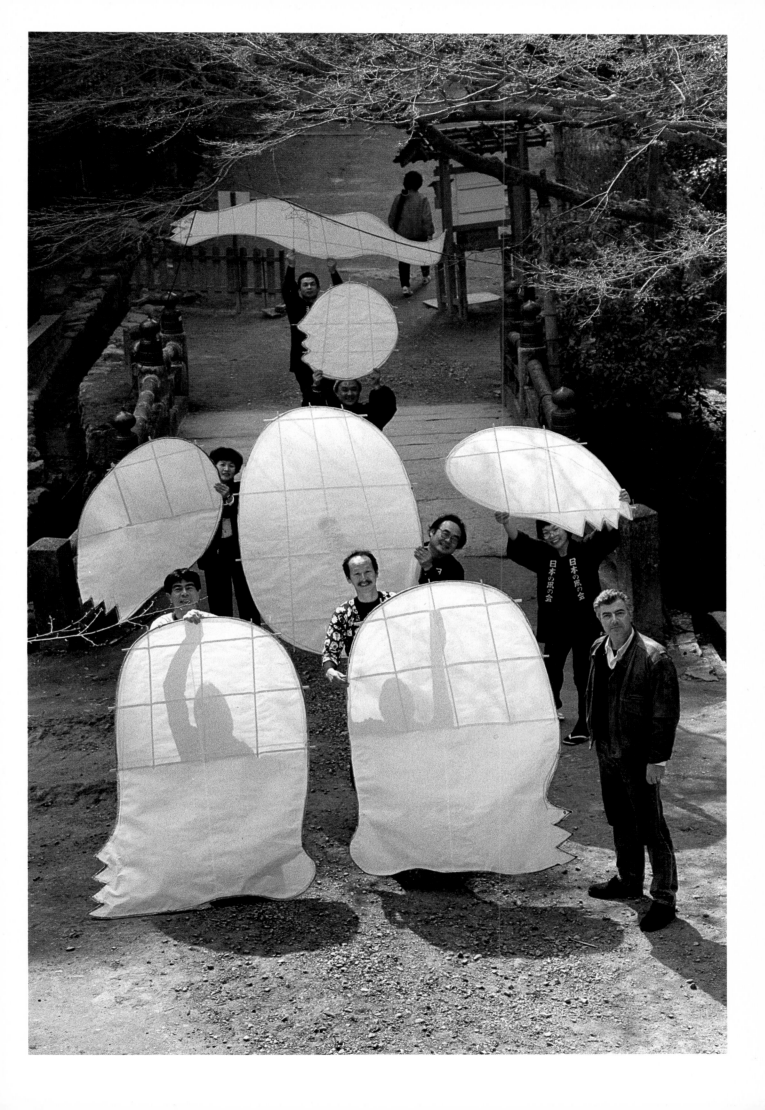

In March of 1989 José Guimarães came to Japan in order to paint and build his kite together with Kyoto kite-makers at the mountain temple of Enkyoji near Himeji. It became a four and a half metre high figure of Don Sebastião, carrying for a crest a large blue snake (for Guimarães a symbol of the good), while a green snake (evil) coils itself around his body.

The kite exemplifies how Guimarães' work is pervaded with the signs and elements of his private mythology. We encounter the symbols of a fantastic, colourful and burlesque world, full of mythical creatures, exotic plants, zoomorphic automobiles and grotesque marionettes.

To clarify his "alphabet of symbols" he has published a "form primer". But despite its explanations, his creations still retain something magical and mysterious. And in all their colourfulness, they somehow strike one as disturbingly archaic. They have been called "archeology of the future" because of their similarities with paleontology and archeology (to which he has actually been long devoted).

In form, his works defy conventional categorization. Although printed on paper (which the artist himself produces), they are painted differently on both sides (the one side emphasizing the internal structure), raised vertically and mounted on pedestals like sculptures. Guimarães has created a floating effect by raising many of these "pseudo-sculptures" on thin pipes over pedestals.

His kite goes one step further by taking off from the ground and floating in the wind. From the glittering plates of his armor, Don Sebastião sends down a storm of flashes towards the earth.

ここに見られるように、ギマライシュの作品には彼自身の神話の符号とエレメントが貫かれている。こうして我々がお目にかかるのは、幻想的な、ほとんどの場合色の華やかな道化じみた世界の図形記号、全くの想像上の生物、異国風の植物、動物化された自動車やグロテスクなマリオネットなどの図形記号である。

この芸術家はこれらのモチーフの「アルファベット」を彼独自のかたちによって絵解きをしているが、明白な解説にもかかわらずその創造物には何か秘密めいた魔力が感じられる。あざやかな色使いの中にも、人をどこか不安がらせるアルカイックな要素が漂っている。いくつかの断片からまとまった造形物を形成していくという彼のやり方から、彼の造形は未来の考古学と呼ばれ、実際彼も夢中になったことのある古生物学や考古学との類似性が指摘されている。彼の空間造形は外形上はこれまでのどのカテゴリーにも属していない。これらの絵は作家自身がつくる紙に描かれているが、二つの面には異なる色が用いられ、その一面は構造が強調され、彫刻のように台座の上に据え置かれる。ギマライシュはこのような「偽の彫像」の多くを、細い管を使用して作品が浮いているかのように台座にとりつけている。彼の凧はこれらをさらに発展させたもので、大地から解放され、風のマリオネットとして遊びのうちに重力を超越している。武具に一面キラキラ輝く鏡をまとうセバスティオは我々の頭上に光の嵐をまき散らすのであろうか。

Ilja Kabakow

Born 1933 in Dnepropetrovsk, the Ukraine,
lives in Moscow

Starting with colored pencil drawings in an Abstract Expressionist style, Kabakow has turned to absurd drawings and bitingly humorous pictures done in a hopelessly banal manner, portraying scenes of everyday life in parodies of Socialist Realist painting.

A viewer expecting "art" is even more alienated from some of these works by the inclusion of superimposed texts, like magazine advertisements. Finally, Kabakow is known to stick little paper flowers on the canvas, arranged in colored rows. In his pictures and, more recently, in his multi-media installations, he actualizes the distinctions between image and reality, language and meaning.

Kabakow (who presently lives and works in West Berlin) responded to the request for a kite by dismissing the material but addressing the spiritual dimension of the Project.

"Flying! Now that is one of the most exciting themes for an installation. And, of course, not only outwardly but you can fly inside yourself, too – which is exactly the choice my "hero" has made. In his imagination he has flown away, probably never to return.

A description of my installation Flown Away: a canvas measuring 5 × 3.5 meters is lying on the floor. A sky with clouds is painted on it from the perspective of a man lying on his back and looking up to the zenith. The sky is painted in oils, naturalistically, with the edges of the canvas simply lying flat on the floor like a carpet.

Next to the canvas stands an old chair on which there must be all the old clothes of the person who has flown away, arranged very tidily.

The impression the installation must convey is that this person has dived into the sky (which is on the floor), as if into a pool, and that he has disappeared into it. The large blue sky, spread out beneath the viewers strolling about, should create a mood that is ridiculous, absurd and nostalgic. I don't know if this fits into the concept of an exhibition where everything is made for the air and supposed to be flying, but perhaps it will be useful for contrast! I remember once, as a schoolboy, everybody went out to play soccer, except for one pupil. His leg hurt and he was left behind in the classroom though he would have loved to play . . . to fly!" (Berlin, May 1989)

FLOWN AWAY
Installation
Acrylic on canvas (500 × 350 cm), chair, clothing
Sketch: pencil, heavy lead pencil, ball-point pen on paper
(29 × 42 cm)
shown: the right half

イリヤ・カバコフは描象表現主義の画風を色鉛筆のスケッチで始め、ばかげたスケッチを経てむしろ野卑な、一見こっけい主義風の絵画に達した。日常生活の描写においては、色あせた感じの油絵で質の悪い印象に見えるように社会主義リアリズムを諷刺している。これらはしばしば、宣伝板のように書き加えられた文句をつけて、色とりどりの紙製の花をコラージュし変化させている。彼の絵画や、近年多くなってきている絵画とオブジェのインスタレーションでは、主張と現実、精神と行動、言葉と要旨の間の矛盾を視覚化しようと試みている。

現在、西ベルリンで作家活動をしているカバコフはアート・カイト展への参加依頼に対して、企画の趣旨からはかけ離れた、しかし存在感をもつテーマのインスタレーションをつくりたいと次のように提案してきた。飛ぶこと、これこそインスタレーションの制作には興奮するテーマである。外では勿論のこと、自分自身の中でも飛ぶことができるからである。私、ヒーローはこのうちの二つ目を選んだ。彼は空想の中で飛び立ち、もはや戻ることを知らない。

インスタレーション「飛び立ってしまった」の内容は次の通りである。床に5×3.5mのカンヴァスが置いてあり、その上には雲の浮かぶ空が描かれている。人が地上に横たわって空を見上げているが、その頭上には天が広がる。空は全く自然の通り油彩で描かれ、カンヴァスの端はそのまま床に置いておく。この絵のわきには一脚の古い椅子があり、その上に絵から飛びたった人の脱いだ洋服が整理して掛けてある。（背もたれにはジャケットが、座席にはシャツ、ズボン、スポーツシャツ、トレパン、靴下など。椅子の下には短靴があり、これらはすべて古く質素なもの。）このインスタレーションからは次のような印象を受けるものであって欲しい。

この人物は、水槽のような床に置かれたこの天の中に吸い込まれるようにもぐり消えて行った。この大型の空は、人々が行き交う会場の真中に設置され、おかしく、ばかげて悲しく、何か郷愁のある印象を与えるものであることを望む。私の作品が、すべて飛ぶもの、空中のためのものを扱うアート・カイト展のコンセプトに適応するかどうかは疑問であるが、ある種のコントラストとしてはおもしろいかもしれない。私には子供の時の思い出が一つある。私のクラスの子供たちはサッカーをするために皆元気よく外へ出て行ってしまった。脚の痛い子供一人だけが閉め切った教室にとり残され動けない。本当は彼もサッカーがしたいのに、飛びたいのに……。（1989年5月ベルリンにて）

PLAN

3,5m

5m

Vernissage in the Sky

空　の　展　覧　会

The Art Kites have only flown once in Japan. This "Vernissage in the Sky" took place on the 1st and 2nd of April, 1989, in front of picturesque Himeji Castle. Many of the participating artists were present, as well as kite-makers from all over Japan.

The music which Iannis Xenakis composed for the Project was heard there for the first time. The composition is based on the sound of the unari – humming strings attached to some kites – and is called "Voyage absolu des unaris vers l'Andromède" (Voyage of the unari towards Andromeda).

芸術凧のコレクションは一度だけそろって空に揚げられた。この「空の展覧会」は1989年4月1日と2日、今を盛りの桜に彩られた白鷺城を舞台に繰り広げられた。

世界各国からこの企画に参加した芸術家がこの姫路を訪れ、日本の各地からも多くの凧師たちがここに集ってきた。イアニス・クセナキスがこの企画のためにうなりを使って作曲したコンピューターによる凧の音楽が世界初演として披露された。そしてそのタイトルは「アンドロメダへのうなりの断固たる旅立ち」。

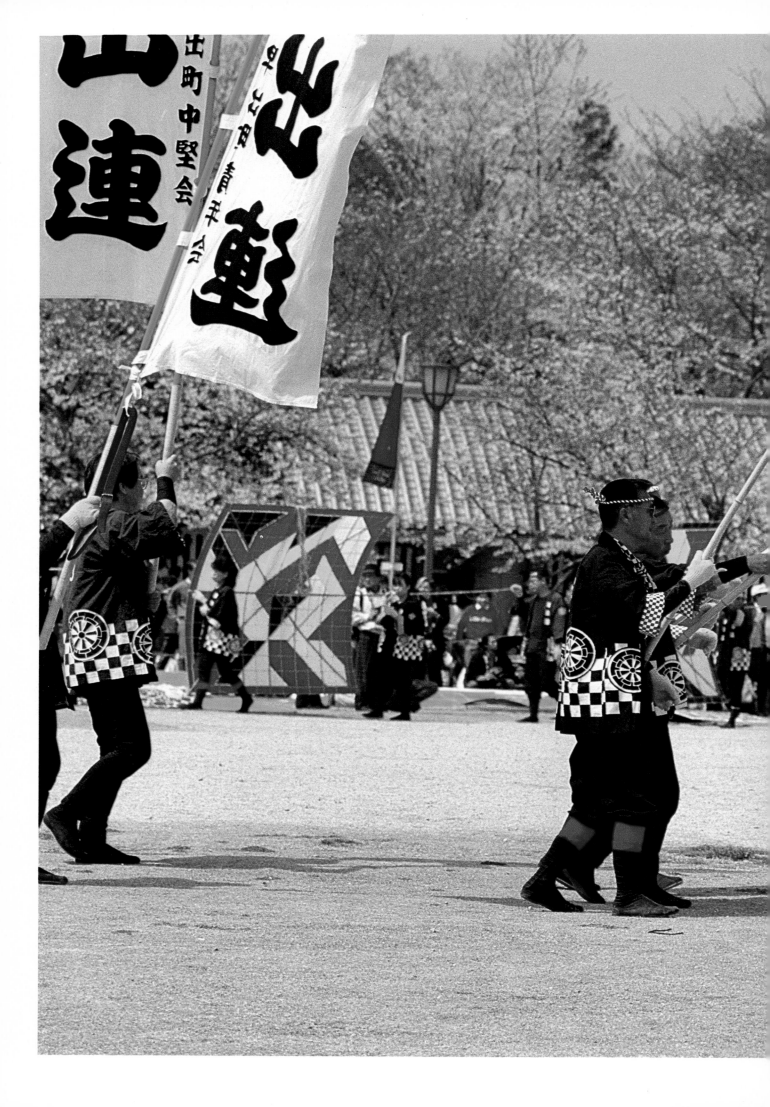

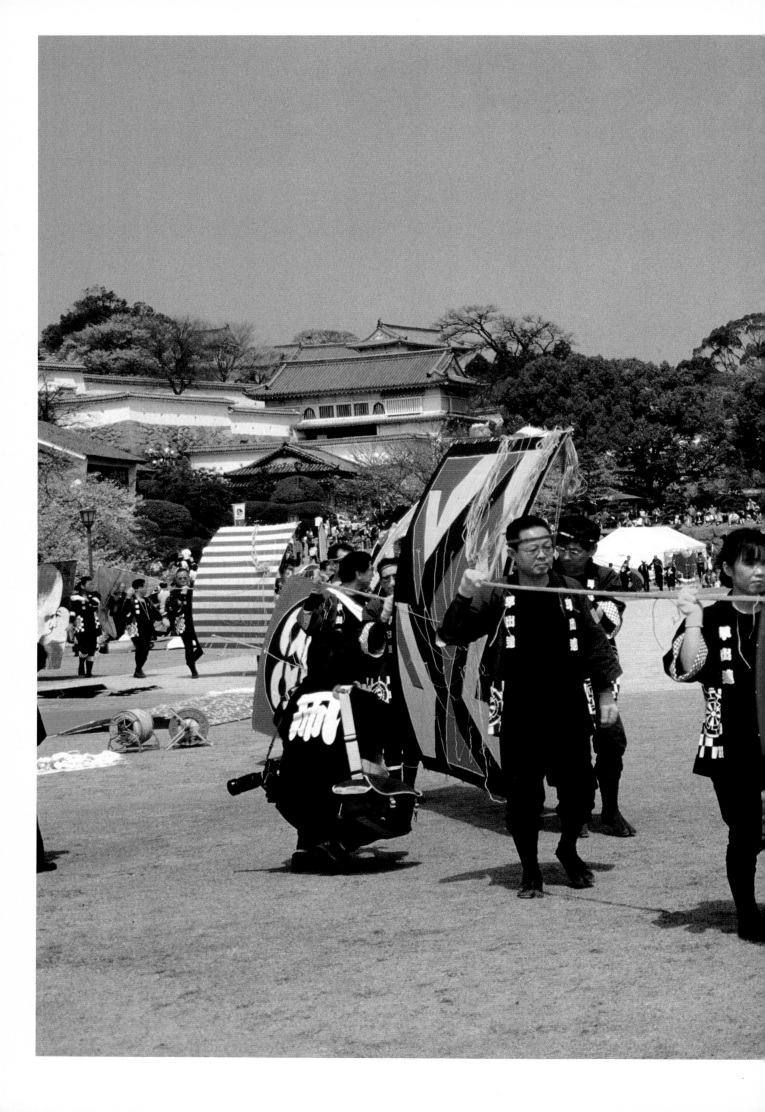

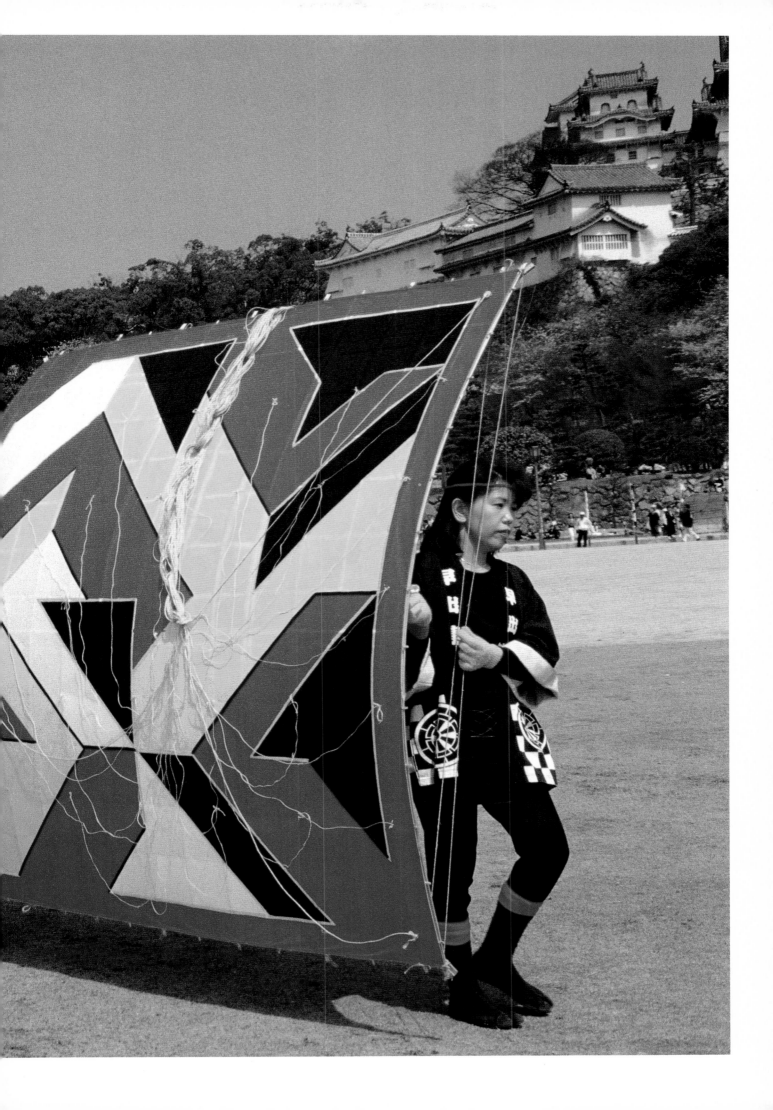

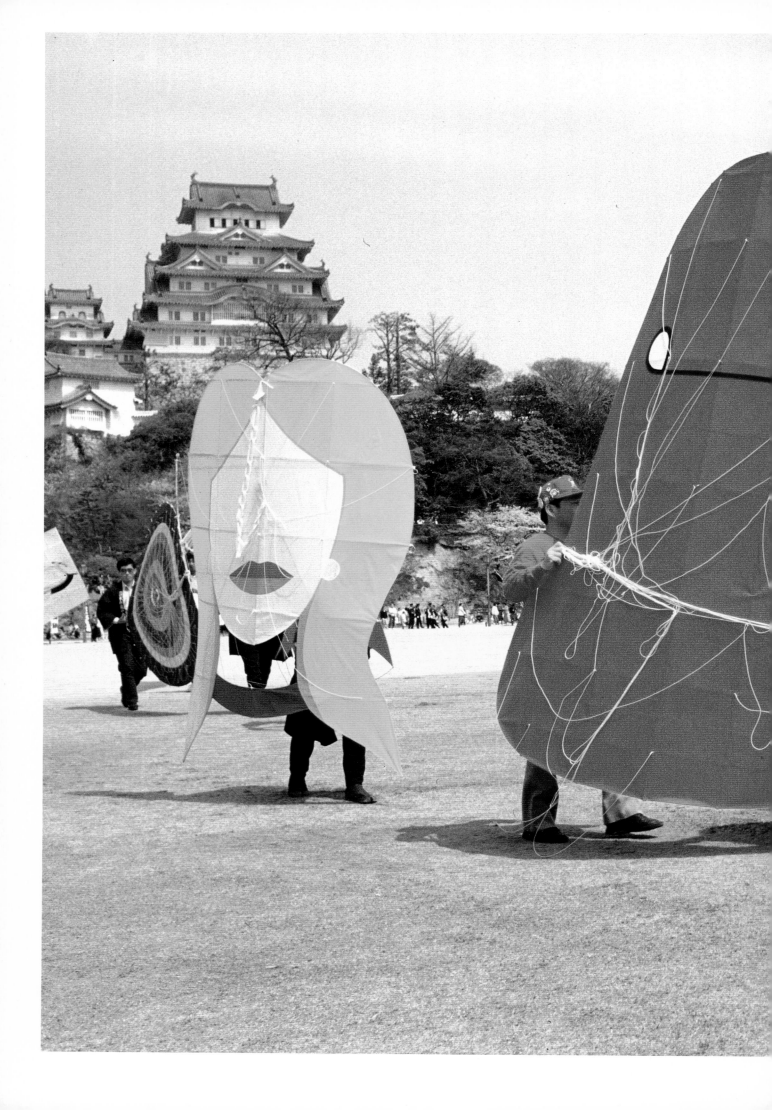

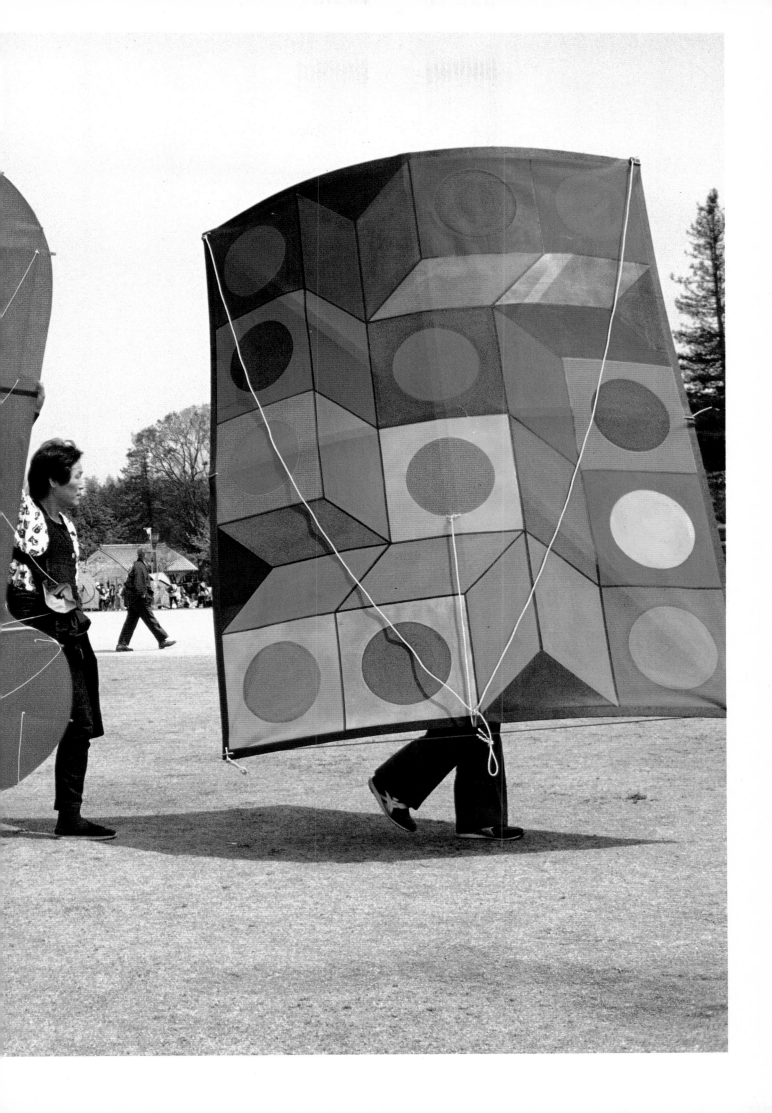

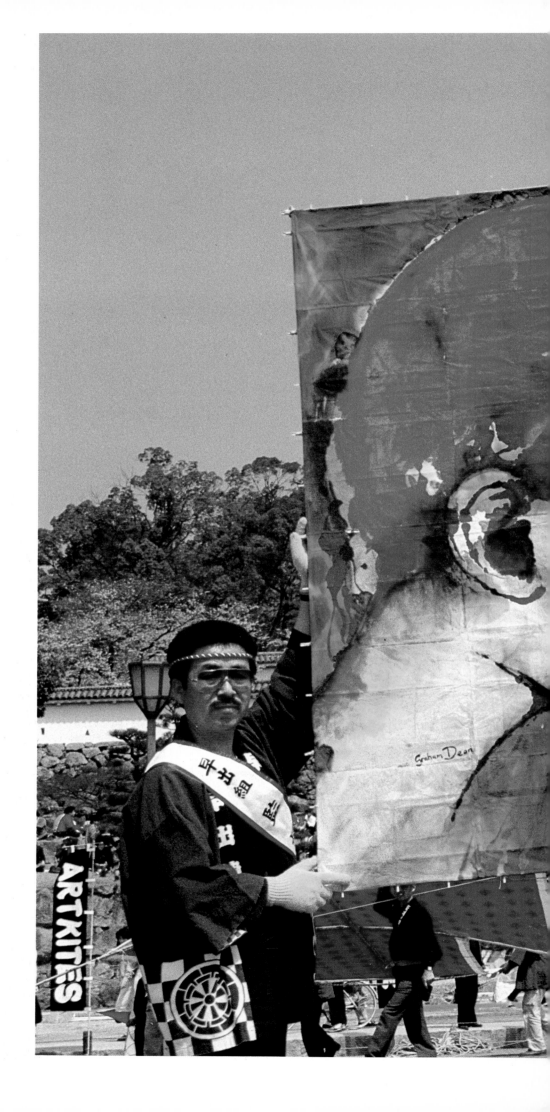

Graham Dean: The Kiss

グレアム・ディーン「キス」

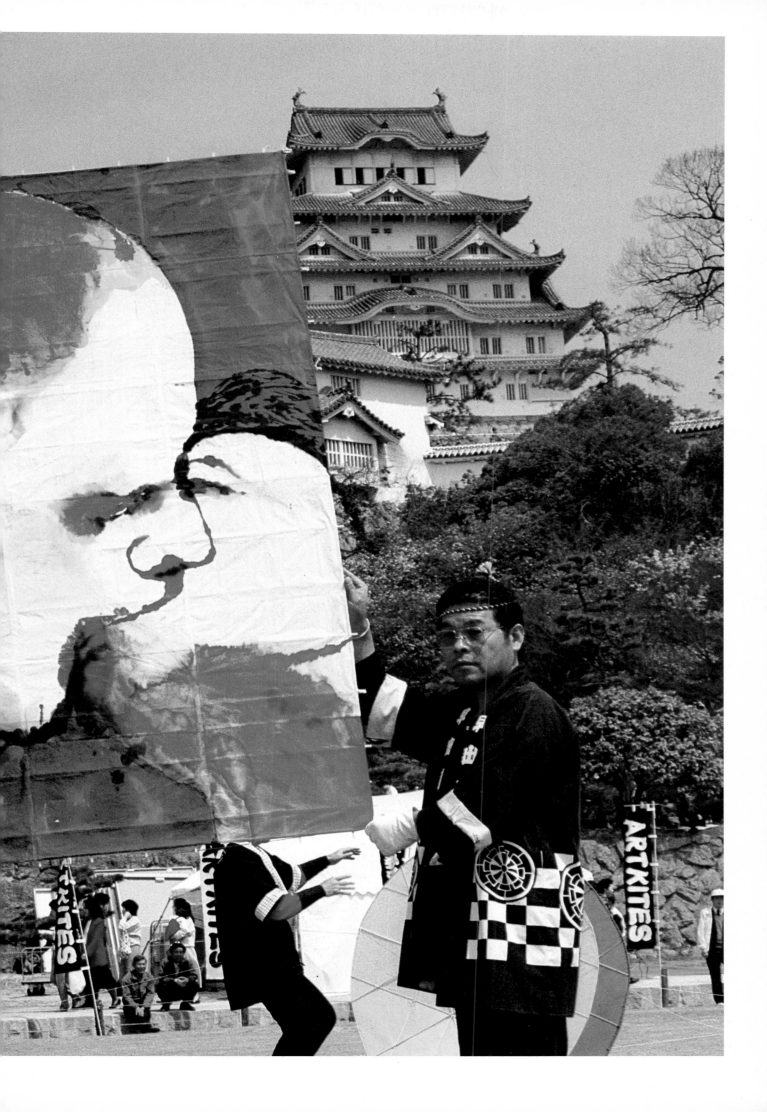

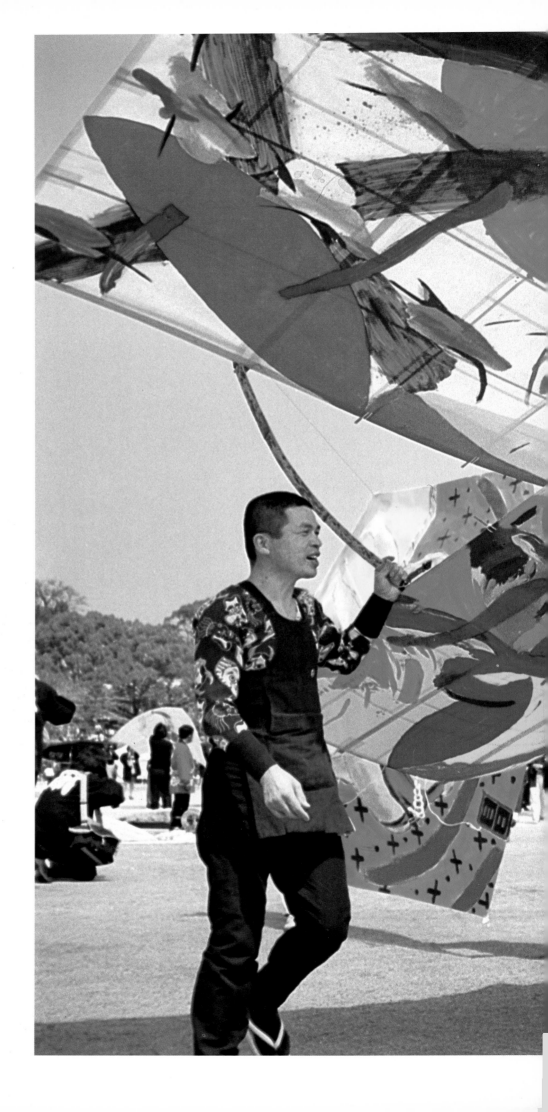

Tami Fujie: 4 m Span

藤江民「組立てれば巾４ｍ」

David Nash: Flying Tree

ディヴィット・ナッシュ「飛ぶ樹」

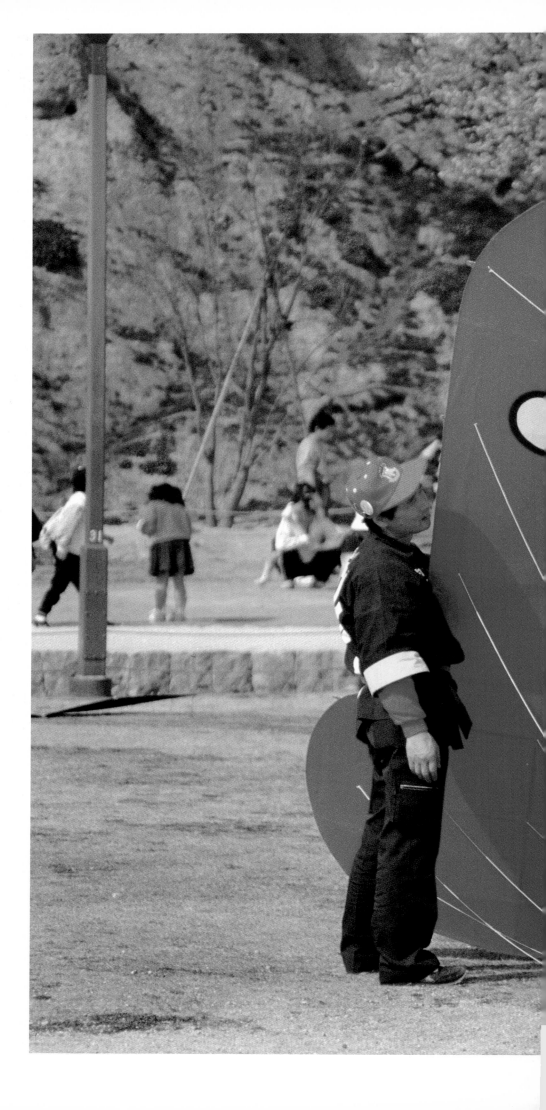

Sadamasa Motonaga:
Form in Red

元永定正「あかいいろだけ」

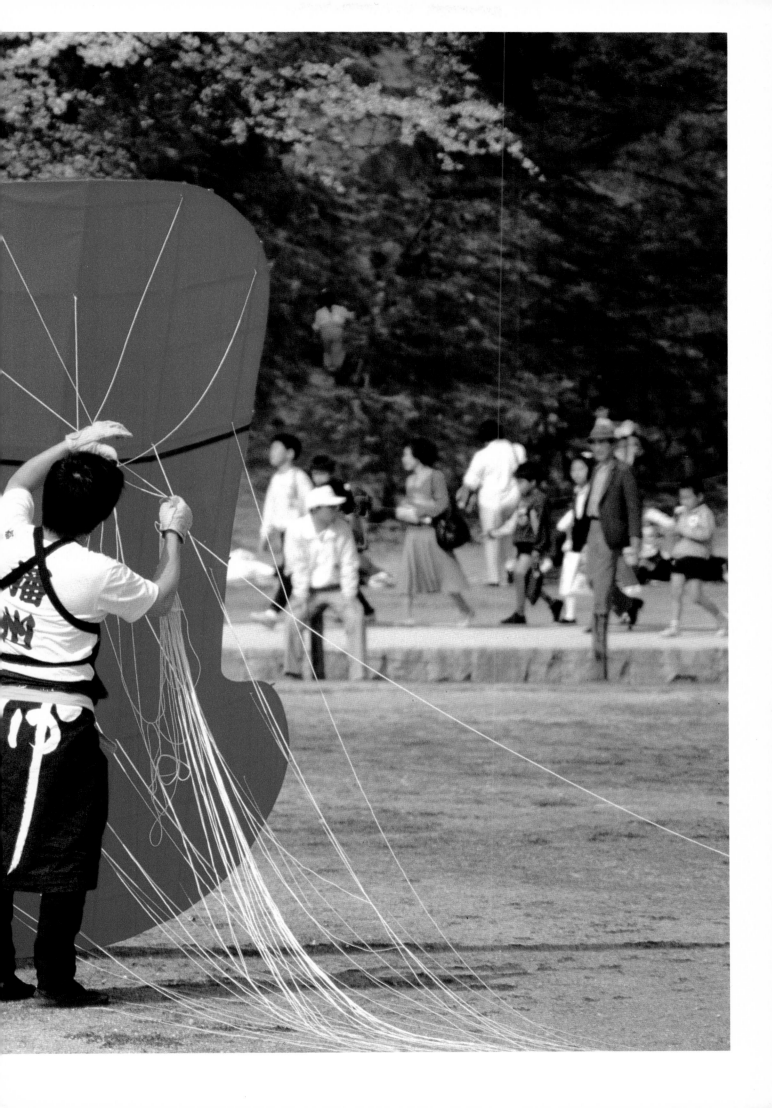

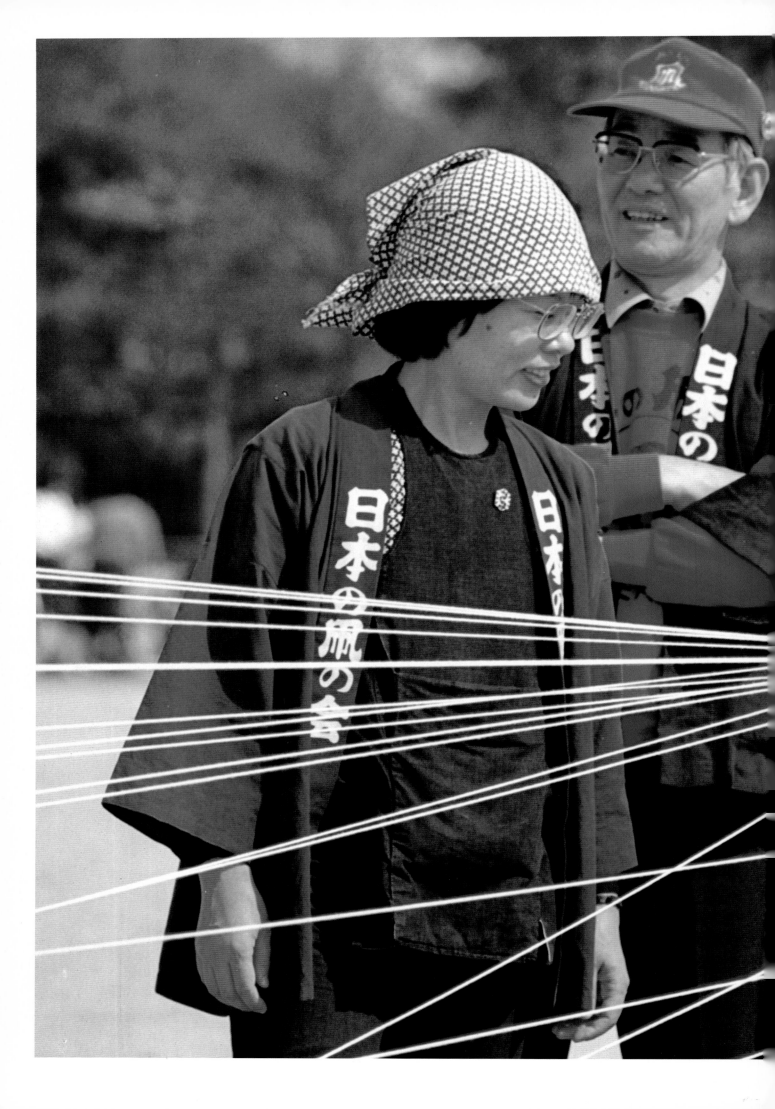

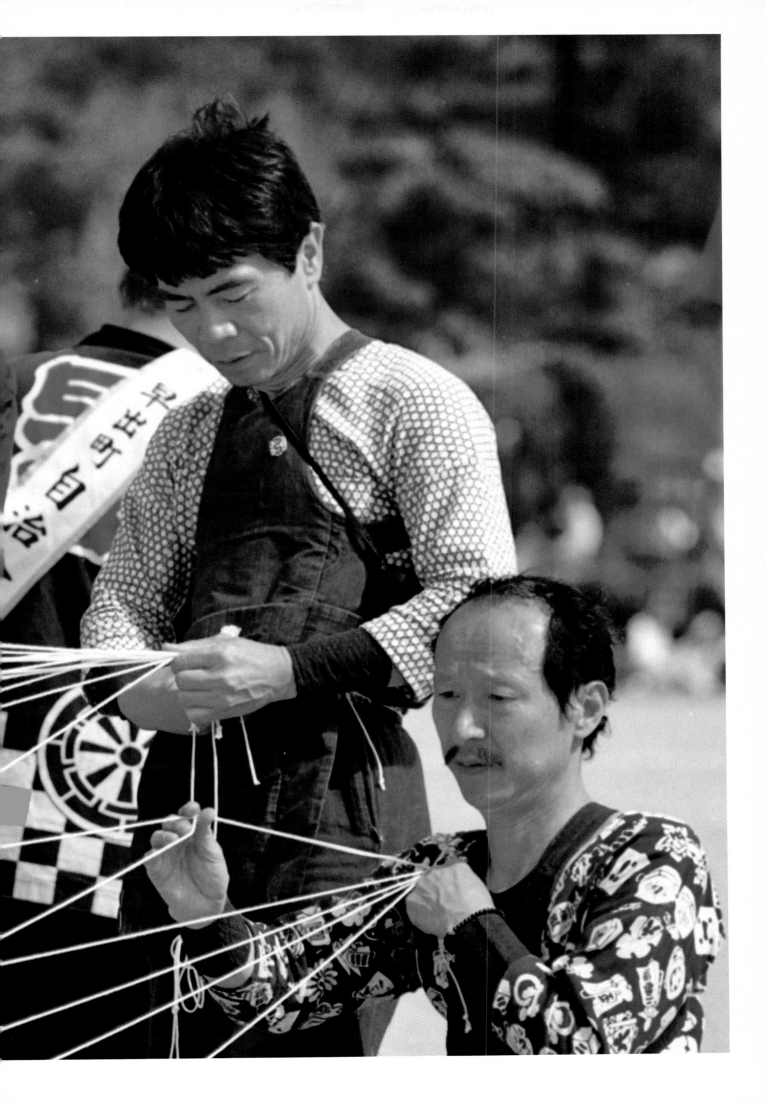

Kenny Scharf: The Star
ケニー・シャーフ「スター登場」

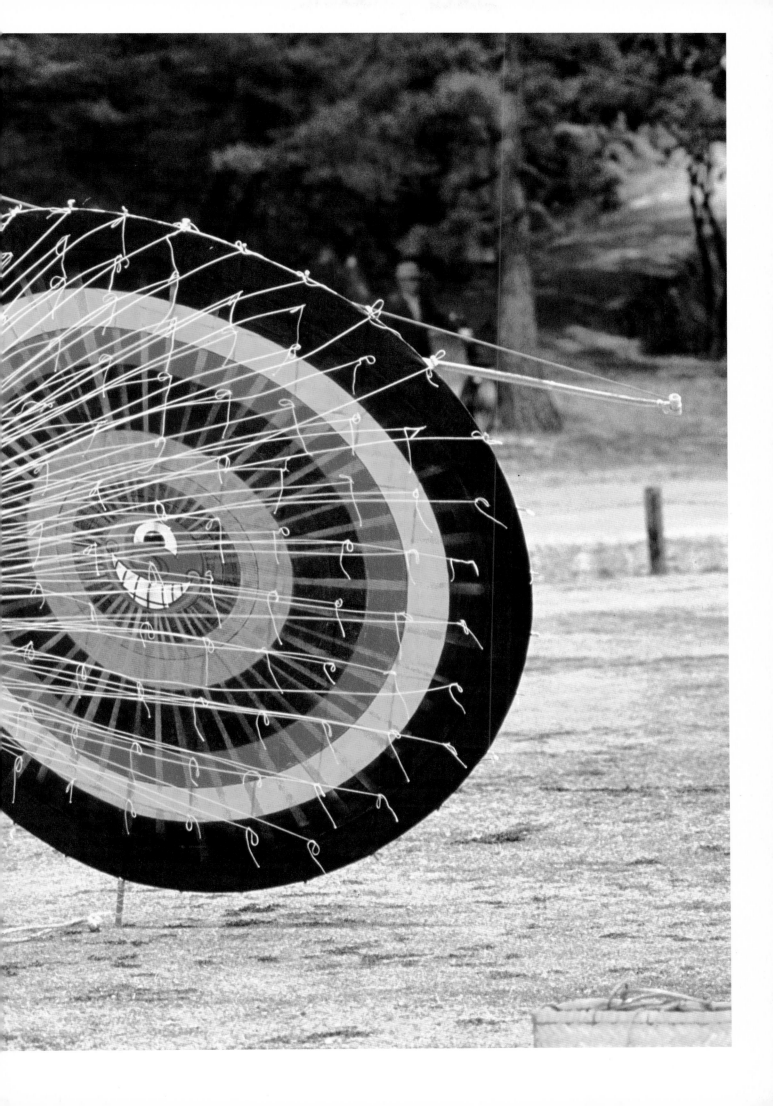

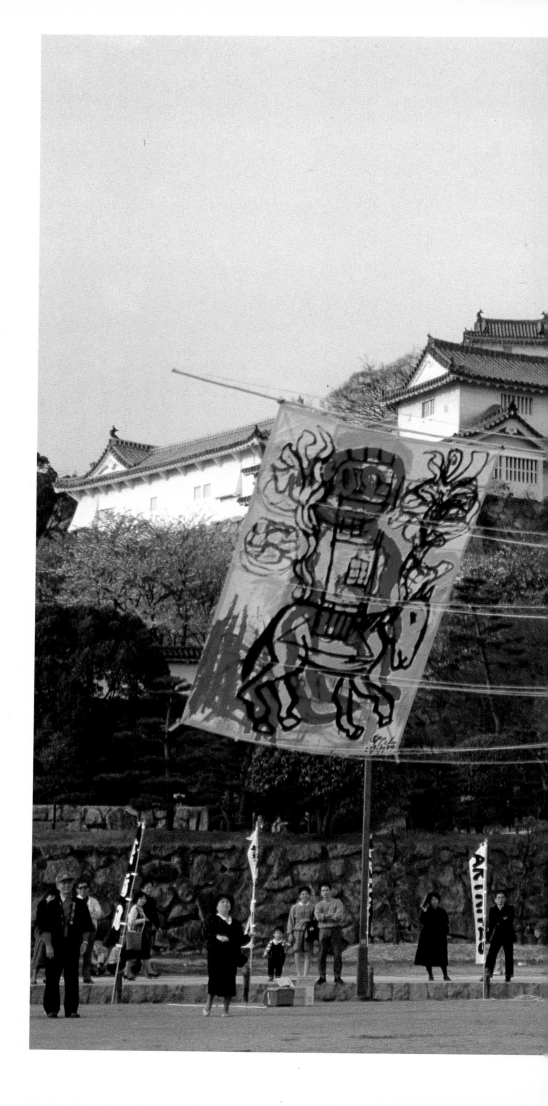

Karel Appel: So far . . .

カレル・アペル「遠くへ…」

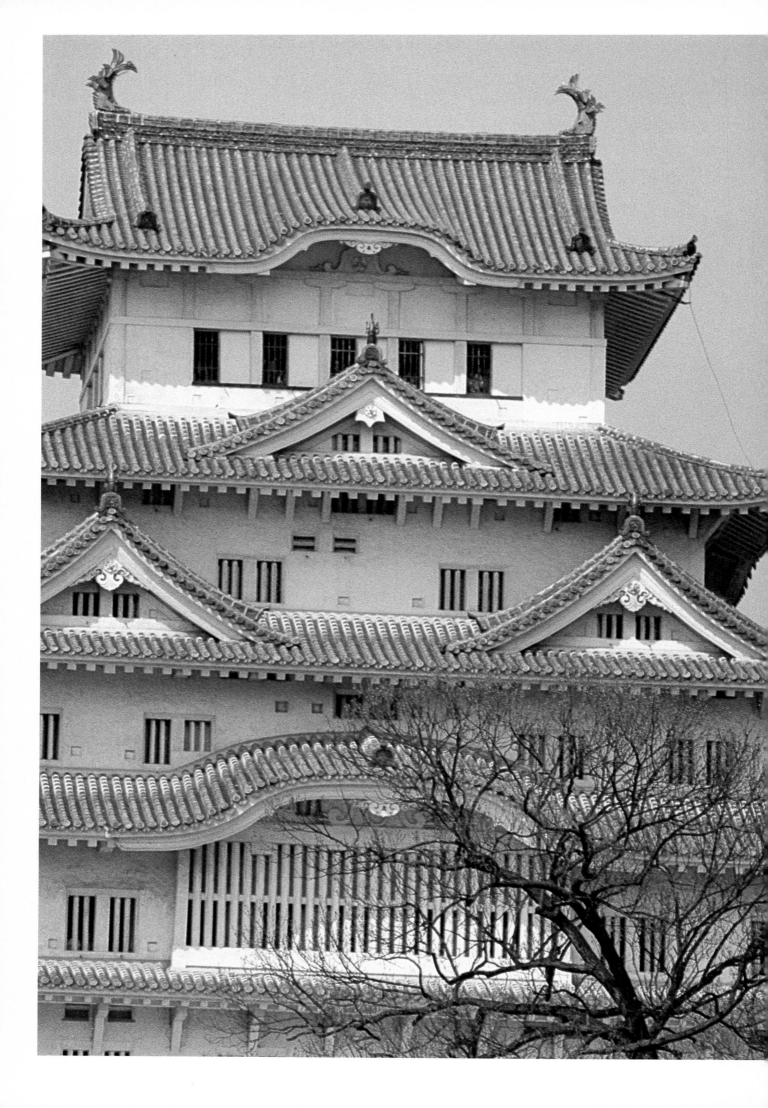

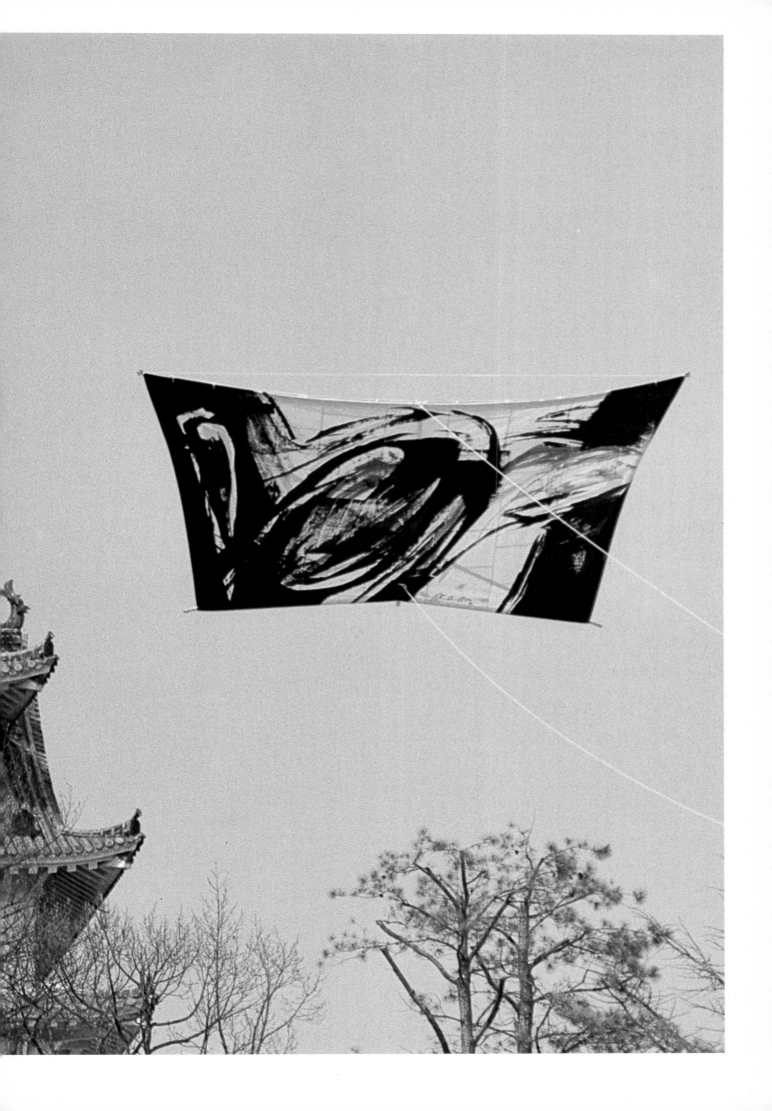

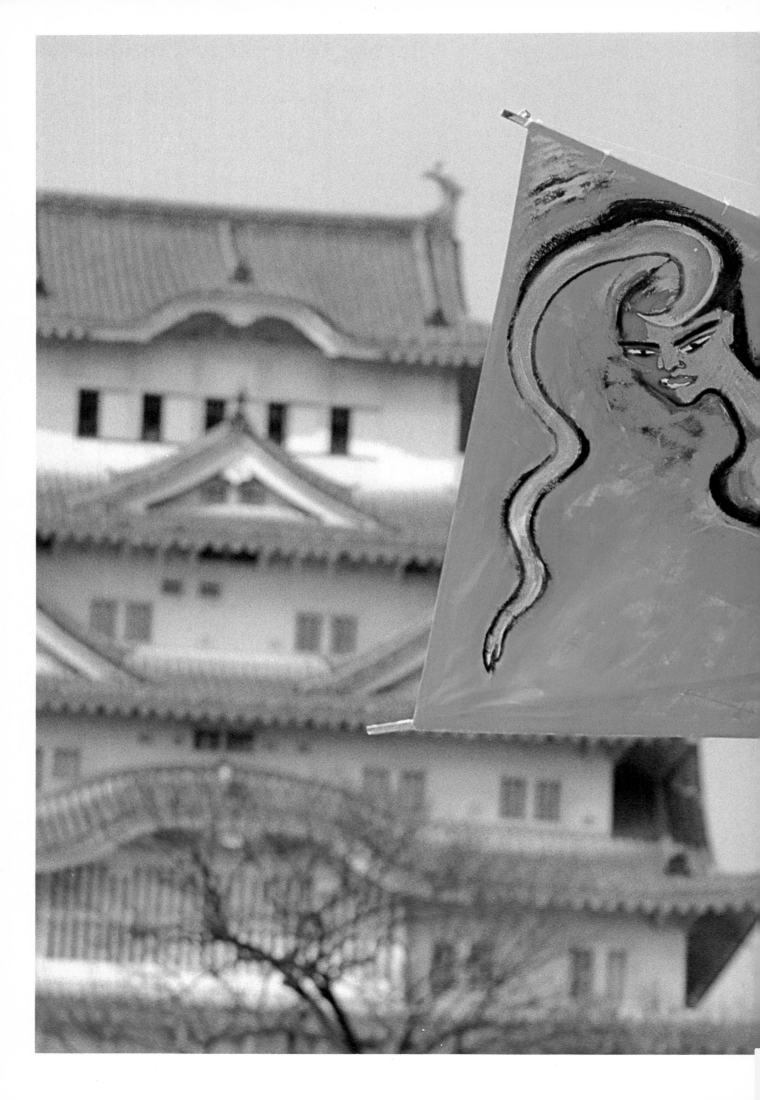

An elated Robert Rauschenberg watching his "Sky House II"
うっとりと天空に夢中になる。ロバート・ラウレエンバーグとその「スカイ　ハウス II」

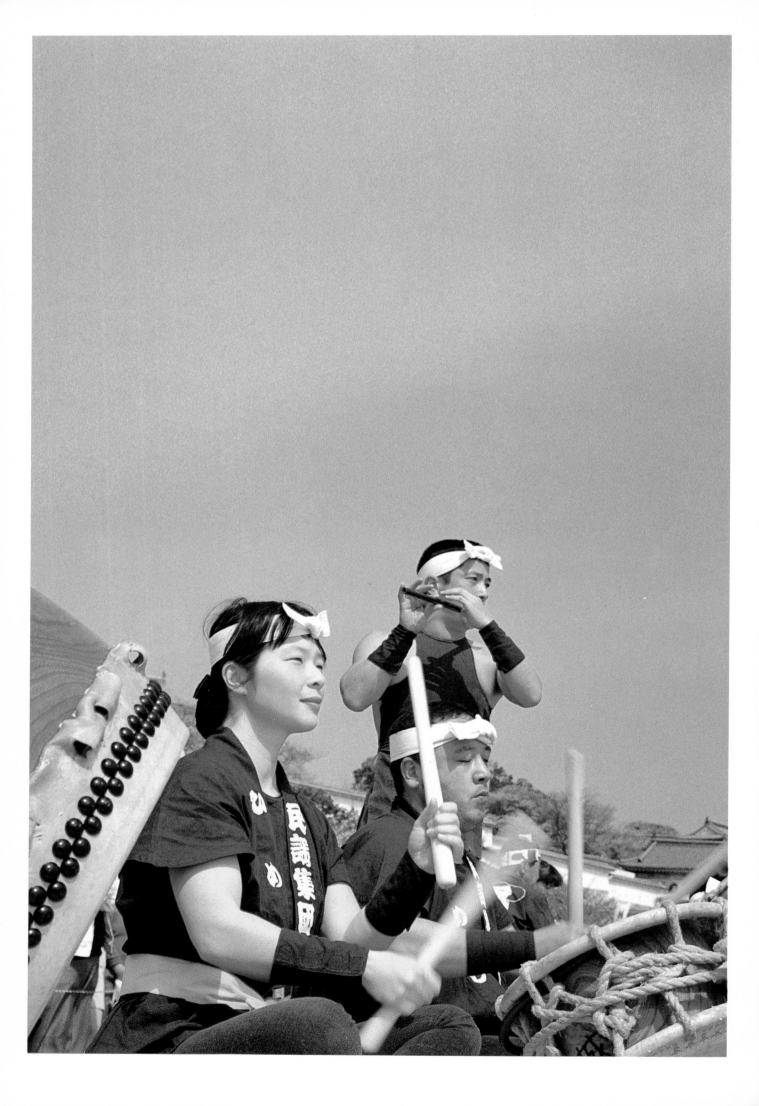

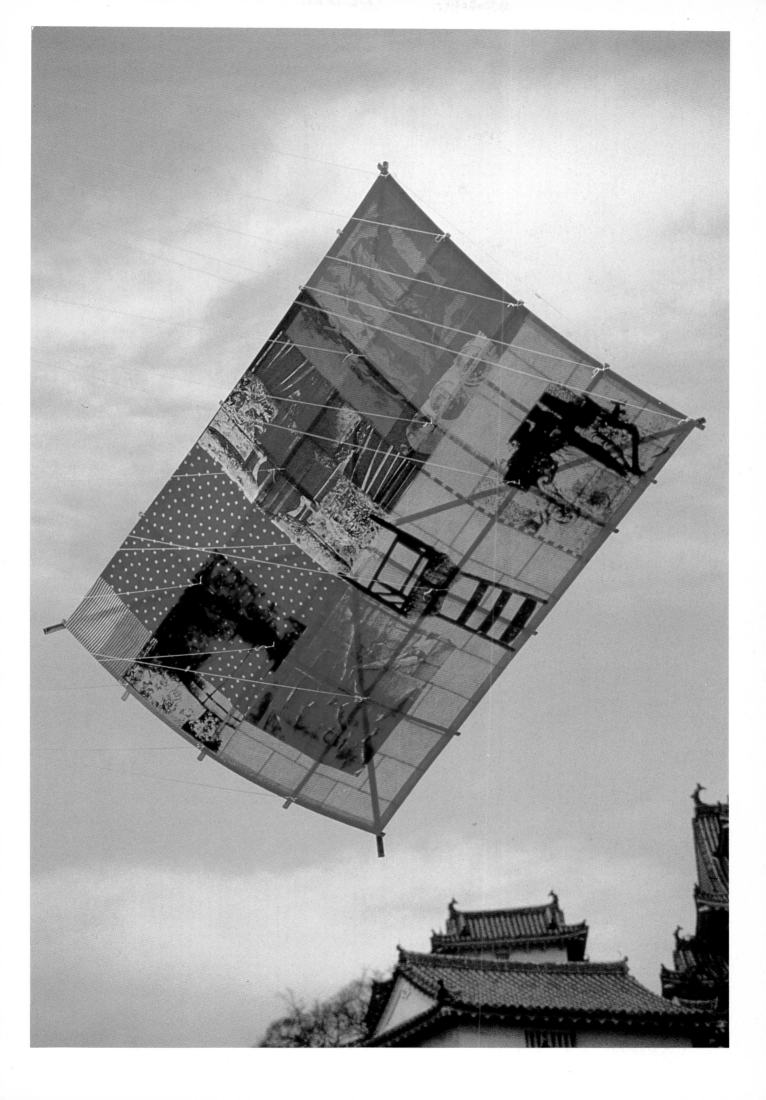

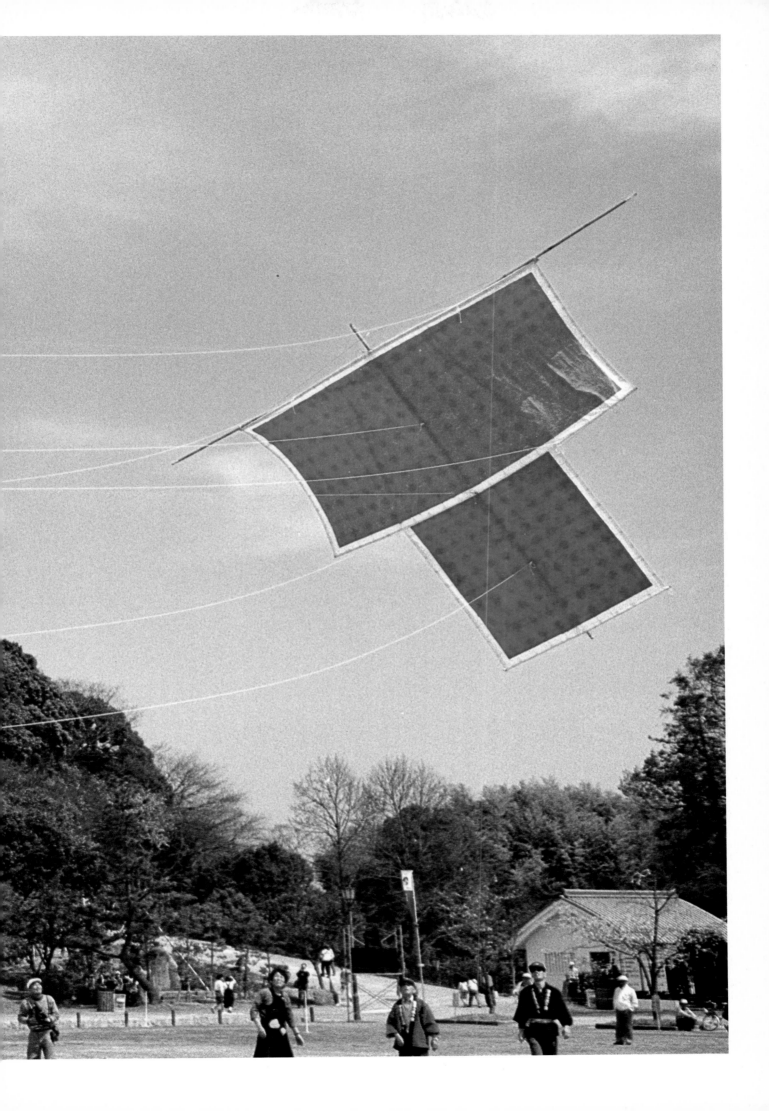

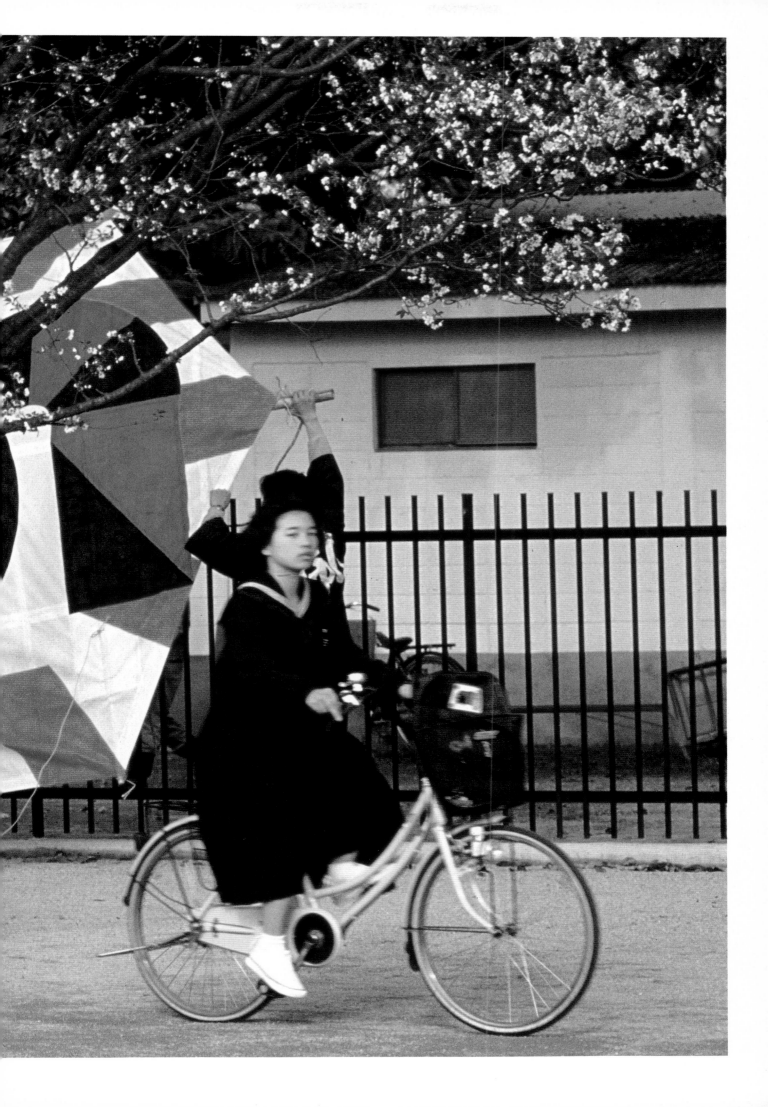

Saved from the tree: Kumi Sugai
木の陰から救われる菅井汲の凧

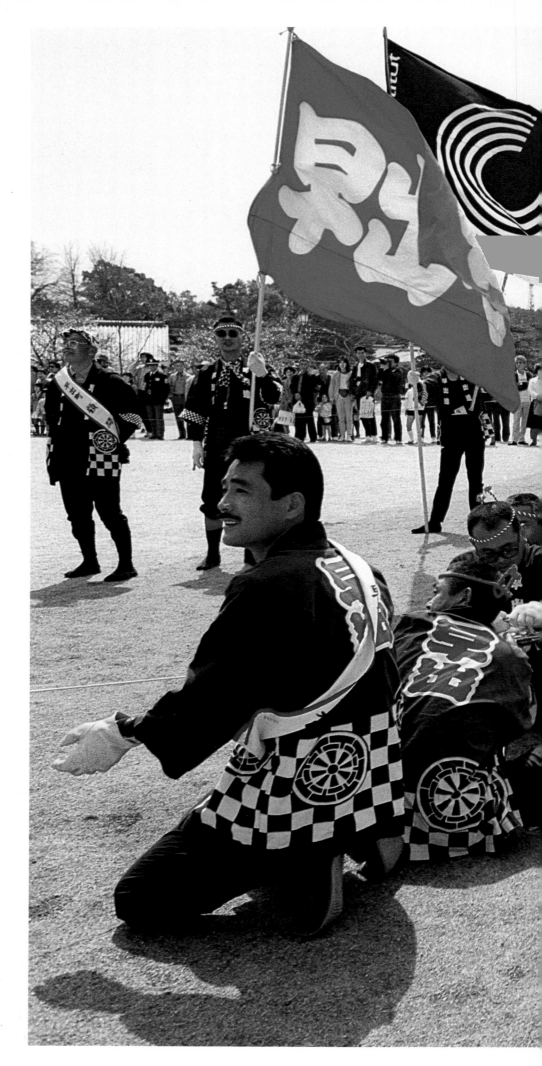

Team of kite flyers from
Hamamatsu using one of their
special techniques.
浜松のザイル隊と精妙なその技

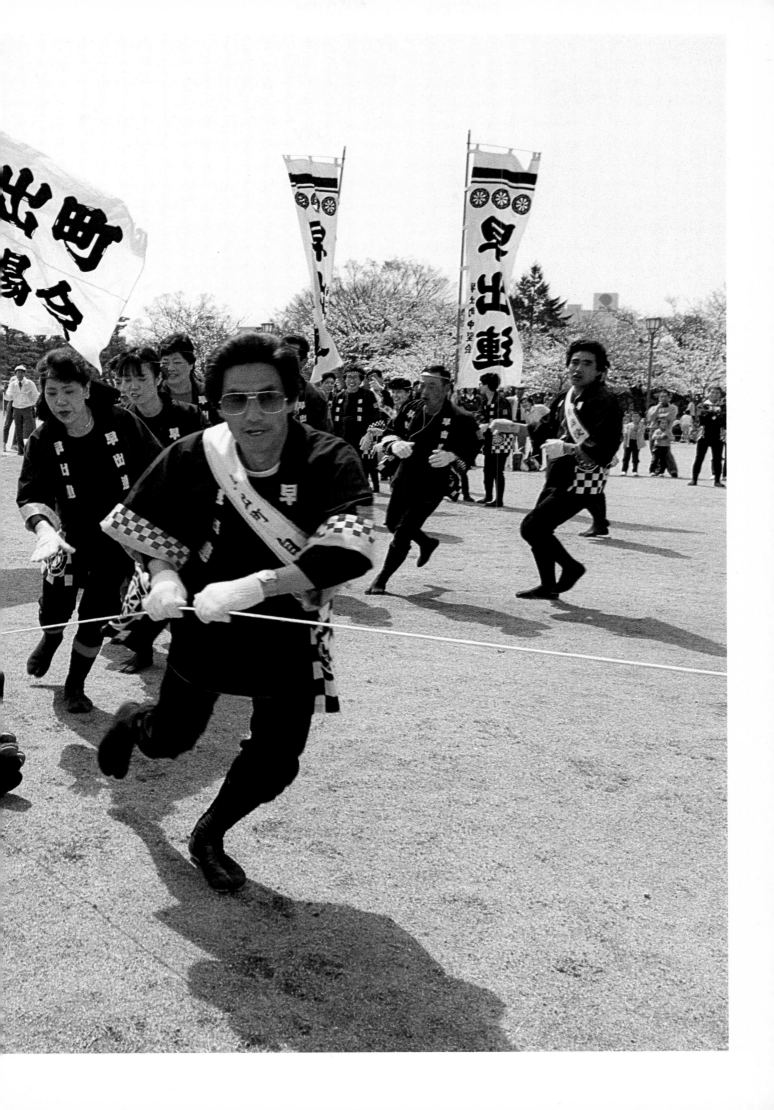

At the foot of Himeji hill, in front of the castle, the kites are lifted from their travel containers and the long strings are unravelled and brought to the same length – the slightest knot would destroy the delicate balance needed for flying. Finally, accompanied by drums, trumpets and whistles the picturesque procession of kite-flyers from Hamamatsu enters the festival ground.
They march in like ancient samurai tournament fighters, following their banners. They are dressed in black under blue jackets bearing the red crest of their area on the back. Running lightly around the ground they encourage each other with muffled cries and beat yellow gloved hands in the air. Finally, grouping around the banner-bearer, they cry: "Wasshoi, wasshoi – to the kite battle!"
(Dr. Peter Sager, ZEIT Magazin)

姫路城のそびえる山のふもと三の丸広場で、芸術凧は輸送用の箱から取り出される。からまった凧糸は長さが整えられ、揚げ糸につながれる。たとえ一ヵ所でも結びたがえがあるものなら空での曲芸飛行の微妙なバランスは狂ってしまう。ついに、絵のように美しい行列が、太鼓を打ちならし、ラッパや呼び子を吹きながら広場に入場してくる。浜松の凧揚げ師たちだ。縦隊はその先頭に旗手をたてて戦国時代の武士のように押し寄せてくる。黒のももひきに紺の法被、その背には町印の「早出」が赤く大きく染め抜かれている。早出連は地下足袋を地にすらせ小きざみに走って広場を一周する。くぐもった声でワッショイの連呼、そして黄色の軍手につつまれたこぶしをはずみをつけて力強く天につき出す。最後にはラグビーのチームのように旗出を真ん中にしてそのまわりに輪をつくる。ワッショイ、ワッショイ、凧揚げのために。

(Dr. P. ザーガー)

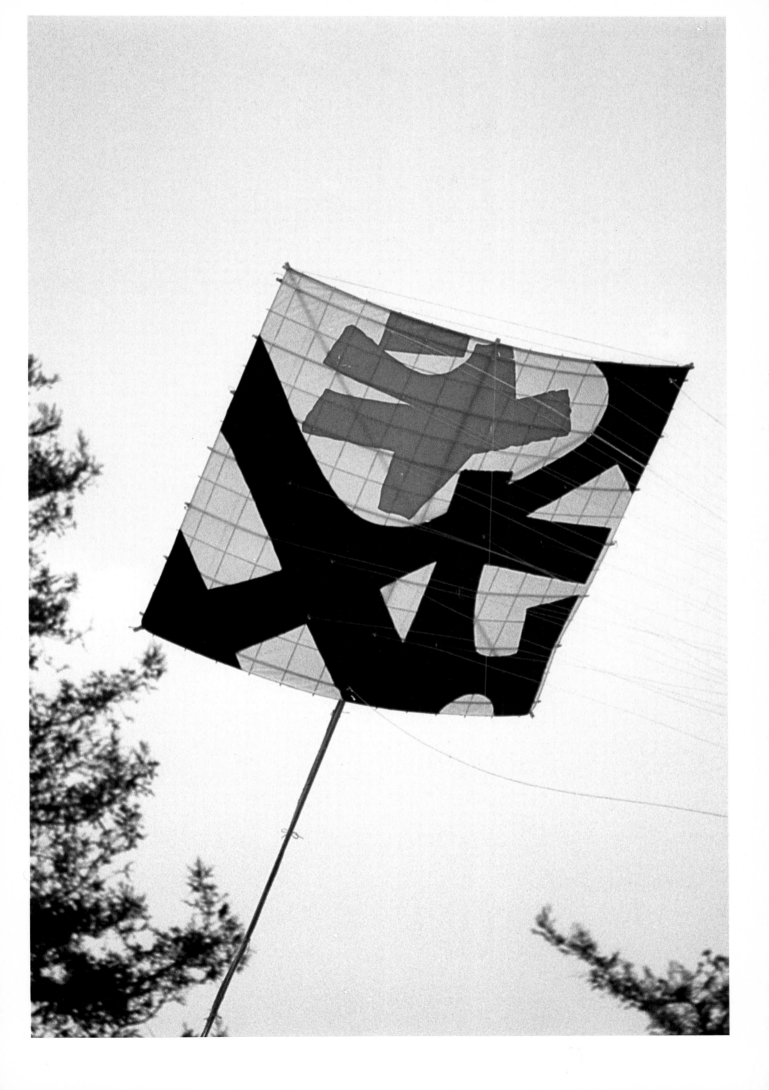

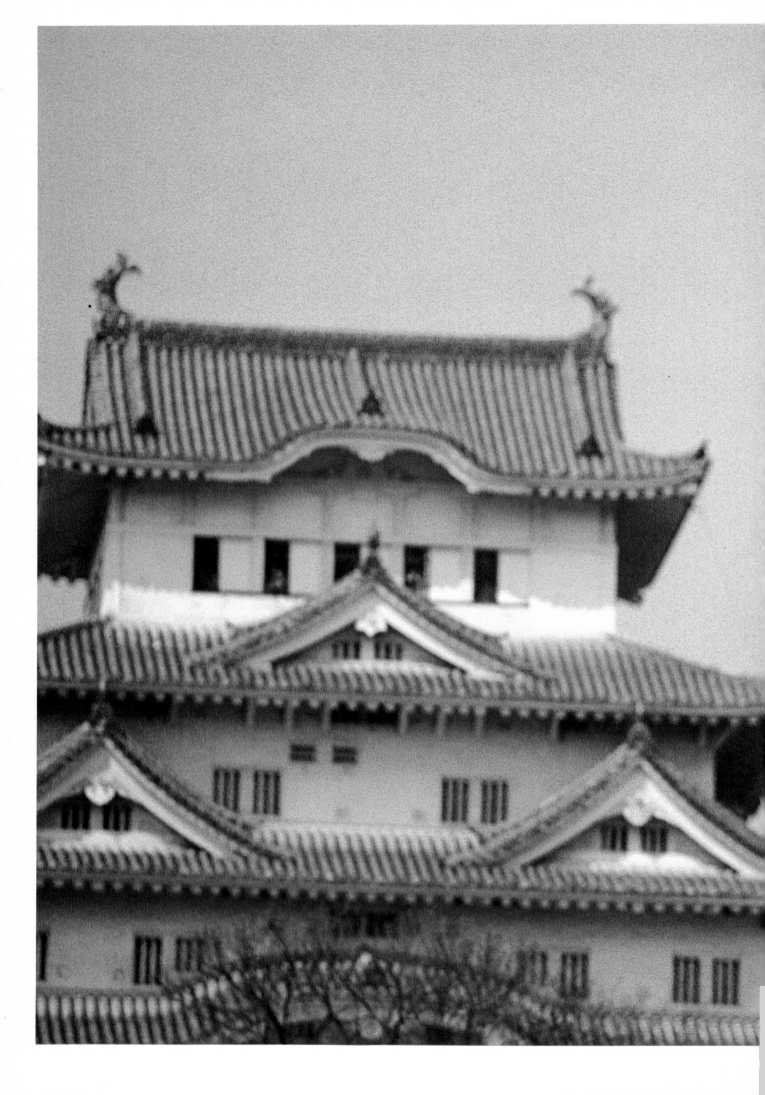

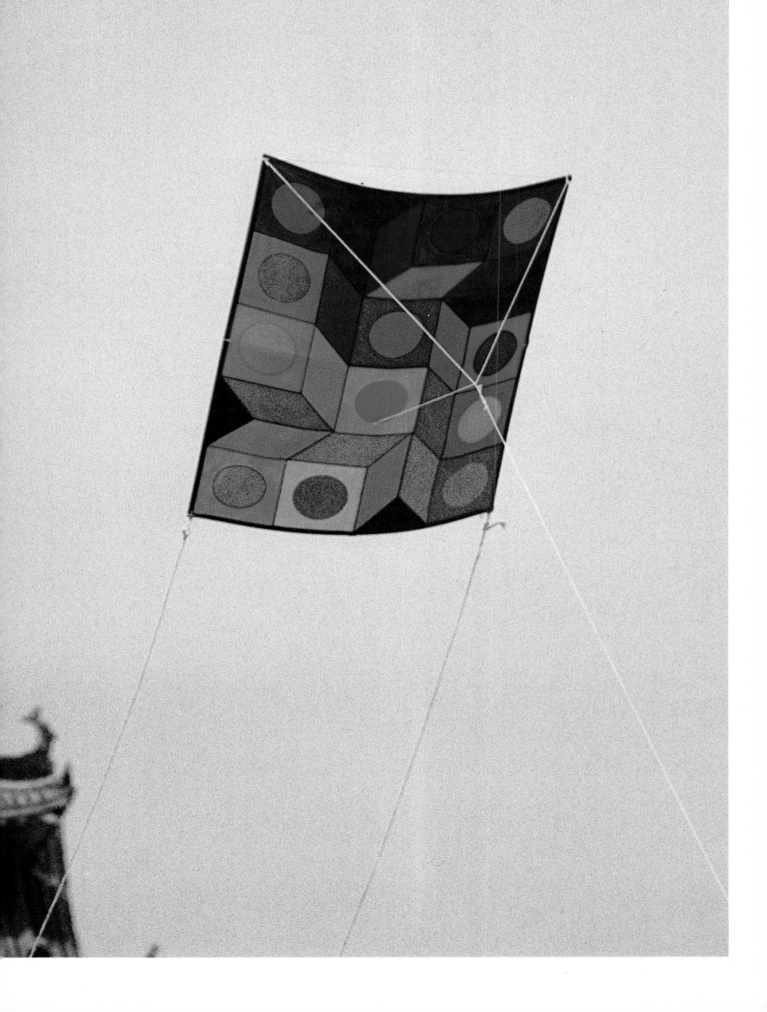

The Amorous Bird
Niki de Saint Phalle

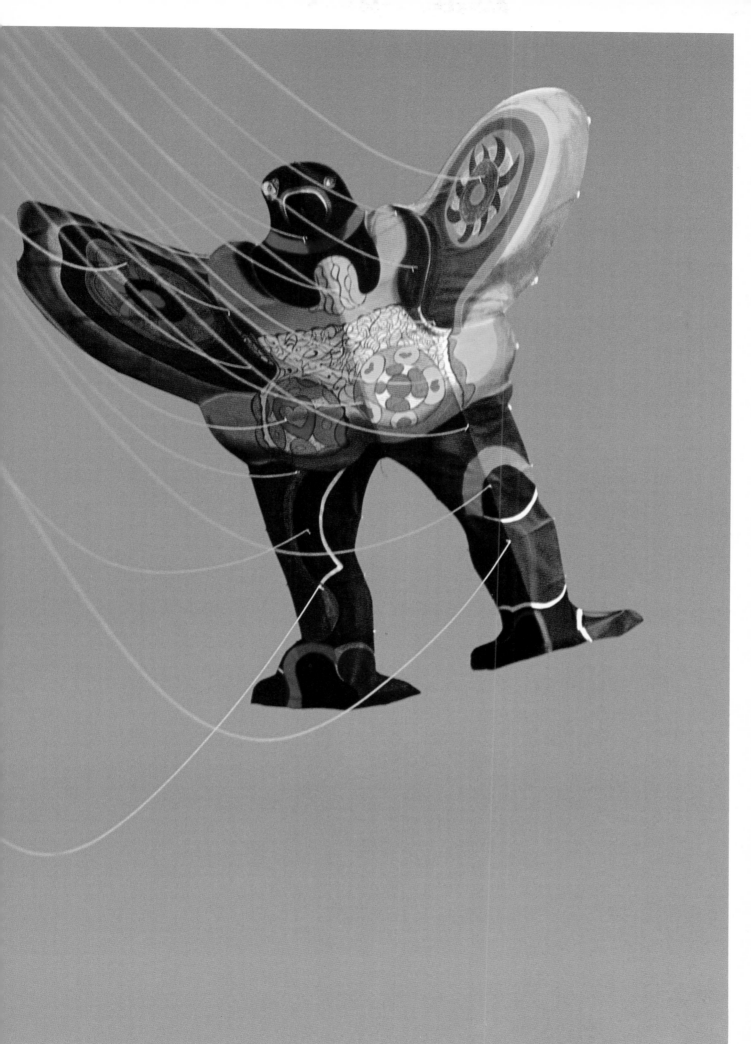

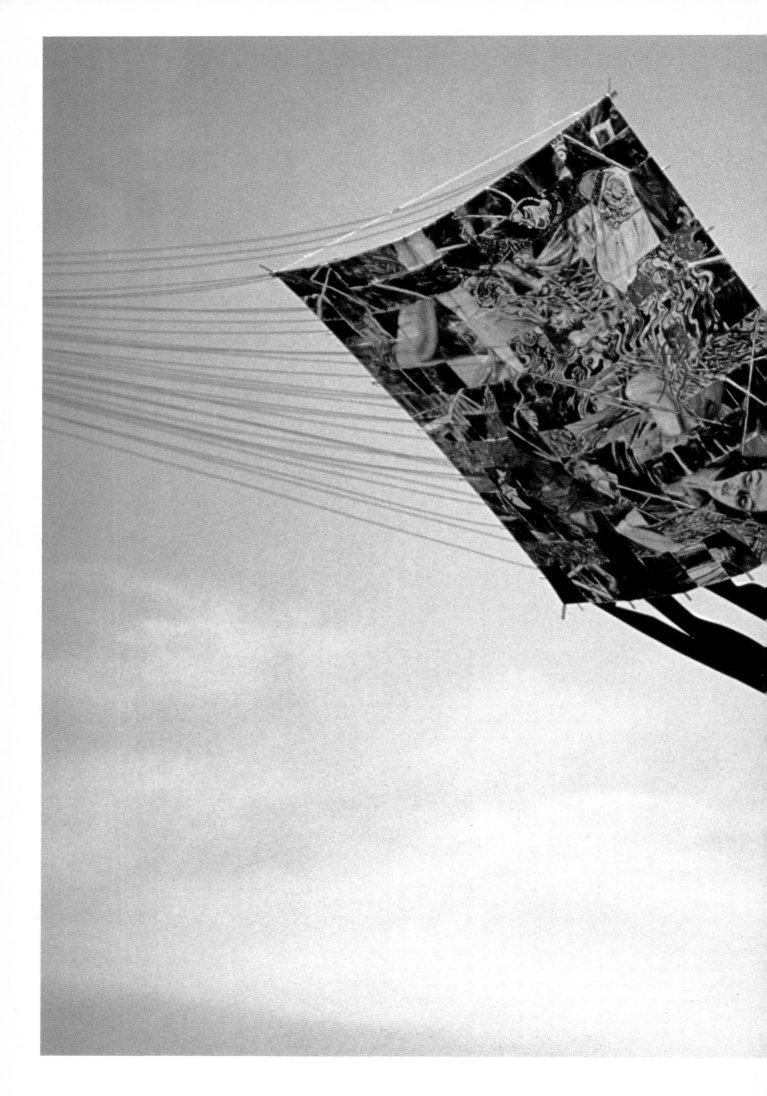

Retrospect

ふりかえる

The Artists

芸 術 家

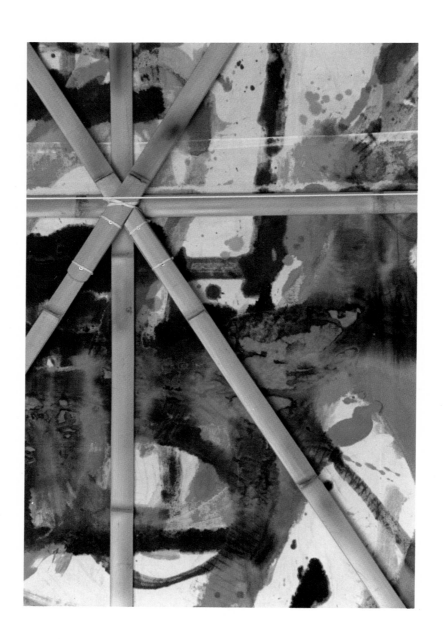

The Kite-makers
凧　師

Kite-map "Every wind has its kite."
凧 の 分 布 図

Hirosaki

Niigata

Tokyo

Chiba

Himeji

Yokaichi

Nagoya

Osaka

Hamamatsu

Naruto

Hachijojima

Kochi

Kumamoto

Okinawa

Region	Kite-maker	Kite form
Hirosaki	Gihei Fukushi	Tsugaru kite
Niigata	Kazuo Tamura	Rokkaku kite
	Shoei Ogasawara	
	Shoji Kobayashi	
Chiba	Hiroshi Kawasaki	Sode kite
	Teizo Okamoto	
	Shigeru Inaba	
Tokyo	Tatsuro Kashima	Edo kite, Kerori kite, Rokkaku kite
	Tetsuya Kishida	Edo kite
	Takeo Nagashima	Edo kite
	Yuzo Esashi	Chain kite
	Goro Yazawa	
	Tohenboku-an	Miniature kite
Hamamatsu	Masahiro Osumi (Sumita-ya)	Hamamatsu kite
Nagoya	Masaaki Sato	Cicada kite
Yokaichi (Shiga)	Kite Association Yokaichi	Yokaichi kite
Kyoto	Kite Association Kyoto	Kaku kite, Hakkaku kite
	Nobuhiko Yoshizumi	Sagamihara kite
	Tsuyoshi Okajima	Kinshoji kite, Free form
	Osamu Okawauchi	Miniature kite
	Izumi Fujieda	
	Kisho Ono	
	Takashi Uno	Edo kite, Rokkaku kite, Buka kite
Osaka	Mitsuo Okatake	Free form
	Kazumi Sagawa	
	Kaoru Kimura	Kinen-Dako
	Takuo Ichihara	
Itami (Hyogo)	Masayuki Yamaguchi	Large kite, Free form
Kobe (Hyogo)	Yasue Hamamoto	Buka kite
Fukusaki (Hyogo)	Hiroki Shimizu	Free form, Heraldic kite, Buka kite, Kaku kite
Naruto (Shikoku)	Umeo Fujinaka	Wanwan kite
Zentsuji (Shikoku)	Keiji Sogabe	Maru kite
Tosa (Shikoku)	Kite Association Tosa	Tosa kite
	Kiyoshi Nagasaki	
	Izumi Adachi	
	Ryosetsu Shimamura	
Kumamoto (Kyushu)	Kite Association Kumamoto	Baramon kite
	Takehisa Taniguchi	
	Tadashi Nagaoka	
	Koki Nojiri	
	Tadakazu Funasaki	

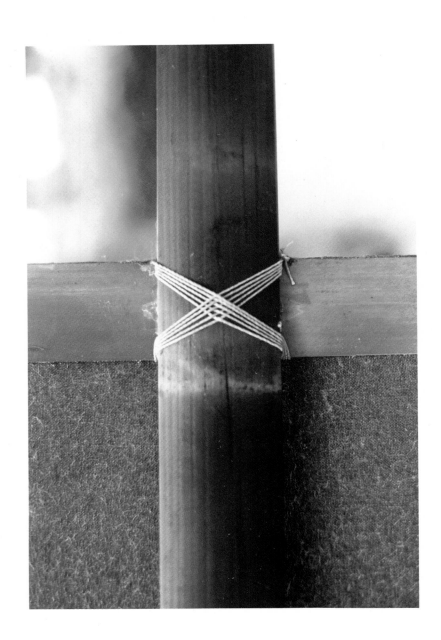

Photographic Acknowledgements

Shigeru Jufuku (Shiga) Art Kite, and p. 11, 16, 155, 269, 289, 349,
357, 359, 371, 373, 383, 387
Kazuko Aono (Tokyo), p. 393
Lene Eubel-Plag (Ashiya), p. 62
Paul Eubel (Ashiya), p. 9, 15, 23, 37, 59, 71, 109, 152, 189, 197, 209,
231, 242, 263, 287, 290, 305, 307, 316, 337,
339, 361, 363, 398, 402
Sakae Fukuoka (Nagoya), p. 321, 324, 325, 331, 336, 341
Tadakazu Funasaki (Kumamoto), p. 224
Gazzari (Venice), p. 46
G. Graubner (Berlin), p. 99
Ikuko Matsumoto (Takarazuka), p. 81, 89, 261, 272, 282, 308, 351,
369, 376, 389
Niedersächsische Staats- und Universitätsbibliothek Göttingen,
p. 7
Hiromichi Oikawa (Sendai), p. 31, 73, 255, 256, 259
John Peet (Captiva, Florida), p. 303
Dirk Reinartz (Hamburg), p. 9
Friedrich Rosenstiel (Cologne), p. 2, 77, 91, 161
Helmut Steinhauser (Kyoto), p. 319, 327, 329, 353, 367, 381, 391
Joji Takezaki (Kobe), p. 405
Lutz Walther (Tokyo), p. 375, 385
Georg A. Weth (Emmendingen), p. 21
Shuhei Yamamoto (Osaka), p. 355, 379
Hiroshi Yoshida (Hiroshima), p. 333
Yomiuri Shimbun Osaka, p. 45, 311
Karyn Young (Ashiya), p. 347, 377

写真撮影

寿福　滋（滋賀）作品撮影及び11，16，155，269，289，349，357，359，371，373，
383，387頁
青野和子（東京）393頁
レーネ・オイベル・プラーク（芦屋）62頁
パウル・オイベル（芦屋）9，15，23，37，59，71，109，152，189，197，209，
231，242，263，287，290，305，307，316，337，339，361，363，398，402頁
福岡栄（名古屋）321，324，325，331，336，341頁
船崎直一（熊本）224頁
ガッツァリ（ベニス）46頁
G.グラウブナー（ベルリン）99頁
松本郁子（宝塚）81，89，261，272，282，308，351，369，376，389頁
ニーダーザクセン州立大学附属図書館ゲッチンゲン7頁
汲川廣道（仙台）31，73，255，256，259頁
ジョン・ピート（フロリダ）303頁
ディルク・ライナルツ（ハンブルグ）9頁
フリードリッヒ・ローゼンシュティール（ケルン）2，77，91，161頁
ヘルムート・シュタインハウザー（京都）319，327，329，353，367，381，391頁
竹崎譲二（神戸）405頁
ルッツ・ヴァルター（東京）375，385頁
ゲオルク・A・ヴェート（エメンディンゲン）21頁
山本修平（大阪）355，379頁
吉田寛志（広島）333頁
読売新聞社大阪　45，311頁
カリン・ヤング（芦屋）347，365，377頁

World tour calender

Japan

Miyagi Prefectural Art Museum, Sendai
11.6.–10.7.1988

Mie Prefectural Art Museum, Tsu
30.7.–3.9.1988

Prefectural Museum of Modern Art, Shiga
22.10.–11.12.1988

City Art Museum, Himeji
3.3.–28.3.1989

"Vernissage in the Sky", Himeji
1./2.4.1989

Hara Museum Arc, Gunma
15.4.–4.6.1989

Prefectural Art Museum, Shizuoka
23.7.–27.8.1989

City Art Museum, Nagoya
5.9.–1.10.1989

Museum of Contemporary Art, Hiroshima
10.10.–12.11.1989

Europe

Haus der Kunst, Munich
15.12.1989–18.2.1990

L'Art prend l'air, Paris
21./22.4.1990

Grande Halle de la Villette, Paris
24.4.–1.7.1990

Kunstsammlung Nordrheinwestfalen, Düsseldorf
13.7.–2.9.1990

Centralni Dom, Moscow
20.9.–21.10.1990

Deichtorhalle, Hamburg
3.11.–16.12.1990

Modern Art Center, Gulbenkian, Lisbon
4.1.–3.2.1991

Musée des Beaux-Arts, Brussels
15.2.–21.4.1991

Nationalgalerie, Berlin
28.6.–11.8.1991

Charlottenborg, Copenhagen
24.8.–29.9.1991

Promotrice delle Belle Arti, Turin
19.10.–15.12.1991

Salas de Exposiciones del Arenal, EXPO '92, Sevilla
5.1.–9.2.1992

The Exhibition will tour North America 1992

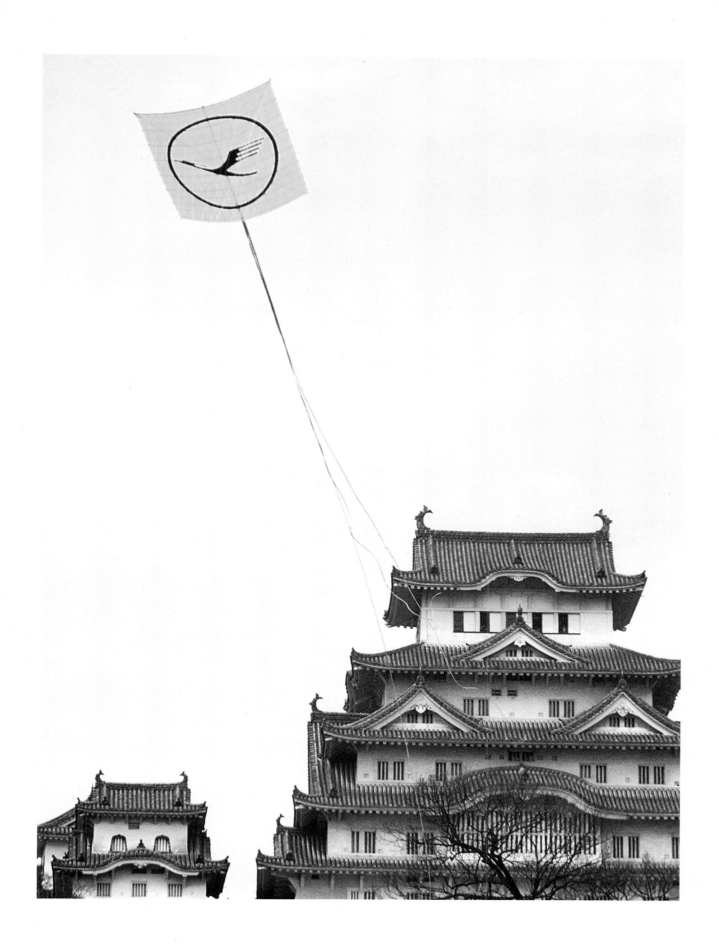

The world tour of the Art Kites is sponsored by Lufthansa
「芸術凧」の世界巡回展はルフトハンザの協力により実現する。

Pictures for the Sky. Art Kites

Graphic presentation	Paul Eubel, Ikuko Matsumoto
Texts	Paul Eubel
Translations	
Japanese	Ikuko Matsumoto, Mieko Fujiwara,
	Hiroko Sato, Mamoru Takahashi,
	Makiko Nakai, Veronika Knittel
English	Peter Ujlaki
	with the collaboration of
	Sebastian Gault and Theresa Edelmann
Secretariat	Veronika Knittel, Angela Sargian
Collaboration	Lene Eubel-Plag
Photography	Shigeru Jufuku (Shiga)
Production	Nihon Shashin Insatsu K.K., Kyoto NCP K.K. Osaka
Printers	Dr. C. Wolf & Sohn, Munich
Copyright	Goethe-Institut Osaka, 1991

芸術凧　空舞う絵画

構成　編集	パウル・オイベル，松本郁子
テキスト	パウル・オイベル
翻　訳	松本郁子　藤原三枝子　佐藤博子
	高橋　憲　中井麻記子　ヴェロニカ・クニッテル
タイプ	ミリアム・カルテンブルンナー　ヴェロニカ・クニッテル
協　力	レーネ・オイベル・プラーク
撮　影	寿福　滋
制　作	日本写真印刷株式会社　NCP株式会社
印　刷	Dr.C.Wolf & Sohn，ミュンヘン
	©大阪ドイツ文化センター1988

Otto Herbert Hajek

Born 1927 in Kaltenbach, Czechoslovakia,
lives in Stuttgart

In the 1950s Hajek created a series of mostly bronze, Informel sculptures called "Space knots", that included the surrounding space as part of each work. This evolved in the '60s into pieces that the observer could actually walk through – color tracks stretching out to adjoining areas that were integrated into the whole. Hajek's interest in public spaces, and the language of geometry he has developed for their improvement, can be found in his relief painting.

Taking a leaf from Goethe's color theory (itself based on the symbolism of antiquity) Hajek has made his dominant colors red, blue, yellow and gold. For Goethe yellow was closest to light, "something cheerful and noble". Red, on the other hand, "lends an impression of dignity and gravity, as well as graciousness and refinement"; while blue is almost inexpressible, "the color of energy, itself". In Hajek's eyes, gold represents the Absolute, blue the Transcendental and red – Love.

The "correct" arrangement of Hajek's kite triptych finds the color scheme growing lighter as the eye moves from left to right, a move toward the Absolute, with gold dominating. Large areas of unpainted washi let the sunlight pass, giving the kite a luminous quality. The Absolute is emphasized if the kites are regarded as heavenly bodies rather than paintings.

彫刻家のオットー・ヘルベルト・ハイエクは、1950年代に、彼が空間の繋ぎ目と名付けた彫刻を発展させていった。その大部分はブロンズの作品で、形の上ではアンフォルメルから出発して、空間を彫刻に取り入れながら形成していったのである。

60年代には彩色をほどこすようになり、ハイエクの彫刻は取り巻く空間を取り入れるようになってきた。観る者が近づき、四方から鑑賞できる通行可能な彫刻が生まれた。色の路線、色の道が作品の表面に延び、環境によく融合するようになった。ハイエクは都市空間の形成にも徹底して力をいれるようになった。

都市空間構想のための幾何学的言語は、ハイエクが60年代中頃から展開させているレリーフの作品にも生かされている。一定のリズムをもった垂直や水平の線、斜め線の組合わせによって、彼の立体画は、何か独特な意味を表現しているように見える。教会の祭壇画や参詣の回廊も制作している。

ハイエクの作品に彩色されるのは、主に赤、青、黄色（時には金色）に限られている。ハイエクはこの彩色選定でゲーテの色彩論を継いでいる。ゲーテはこの三色を古来の象徴的意味から定義づけ、「黄色は光に最も近い色である」として、その中に「何か快活さと気高さ」を見、赤は「厳粛さと尊厳、そして慈愛と優雅さ」を伝えているとしている。ゲーテにとって青はおよそ筆舌に尽くし難い効力をもつ「ある種のエネルギー」を表わす色なのである。同様に、ハイエクにとって金色は絶対者の色であり、赤は愛、青は超感性的意味をもつ色である。

「トリプティックの凧」はその彩色が段々と明るくなっていくように並べられるのが作家の意図である。三つ目の凧は、黄色が基調になっている。その大きな和紙の無地の面が太陽の光を捉えて、絵を内から輝き出させている。絶対的なものに向かう三つの凧のこの盛り上がりは、これらの凧が絵画としてではなくて、透明な天体の一部として鑑賞されるとき、とりわけはっきりしてくる。

Triptychon
Acrylic 205 × 205 cm
Hamamatsu kite
Kite-maker: Sumitaya

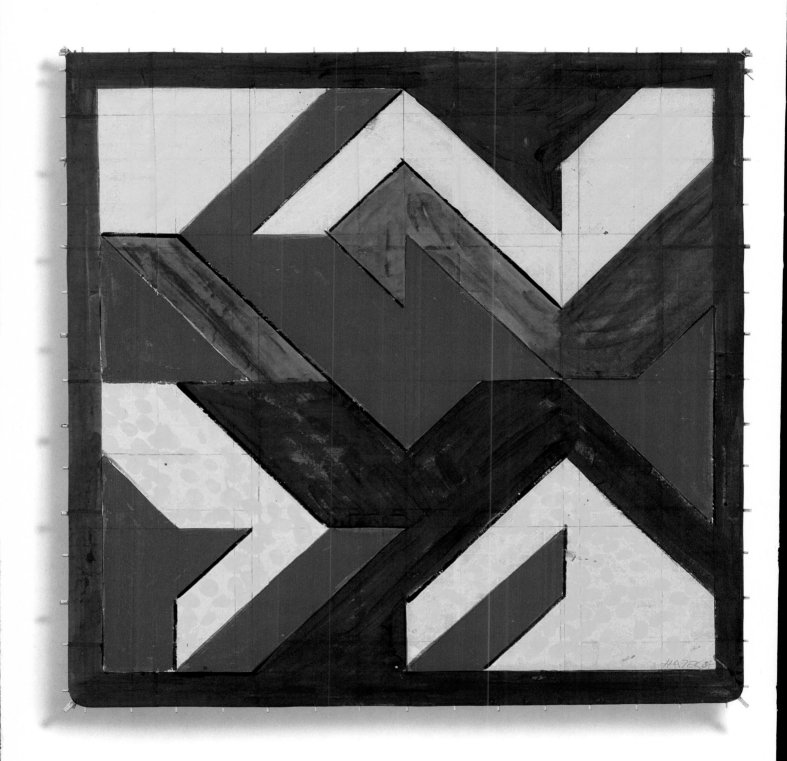

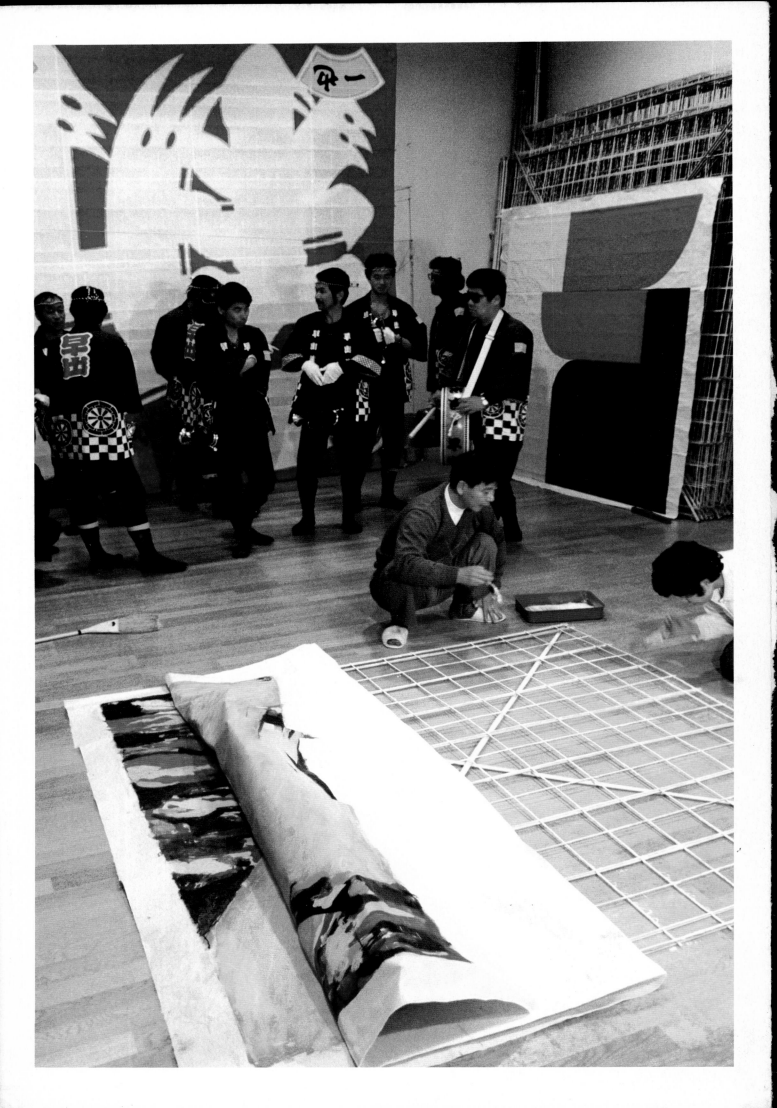

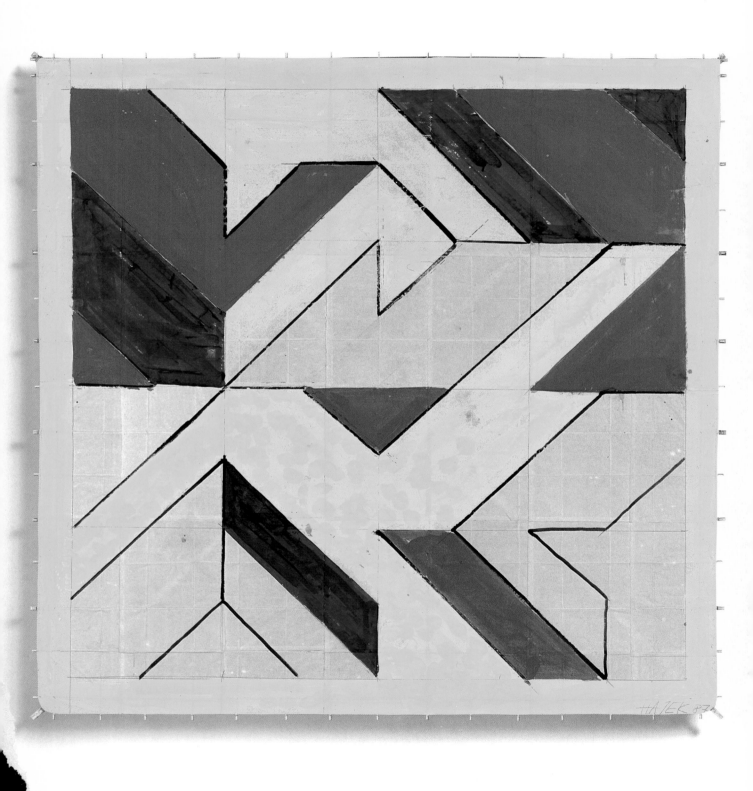

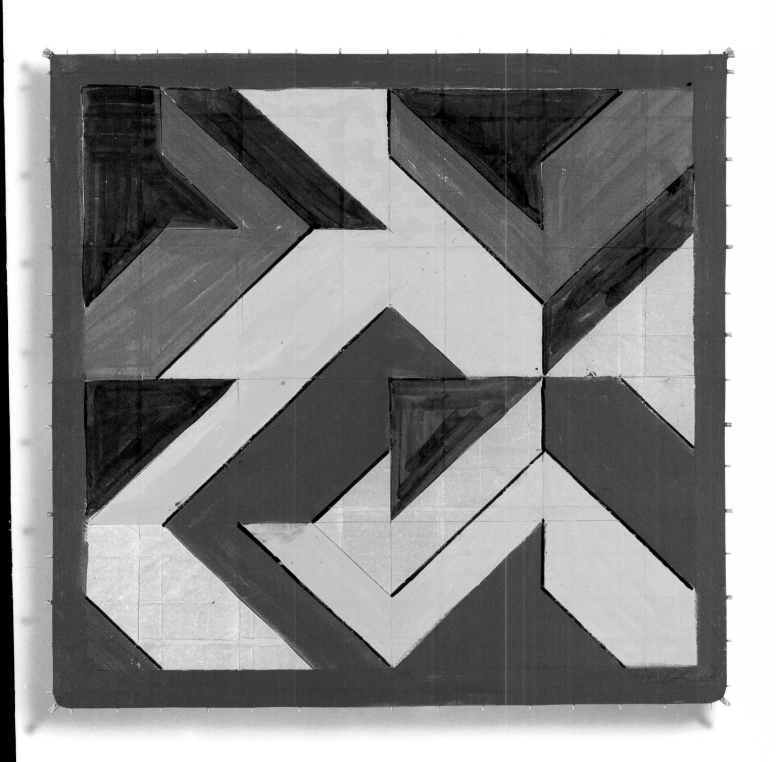

Georg Karl Pfahler

Born 1926 in Emetzheim, Bavaria,
lives in Fellbach near Stuttgart

Pfahler's work has moved steadily since the 1950s to ever simpler, more precisely defined forms, and in the process he has deepened his conception of the relation between color and space. Space here is not that of classical perspective, nor the space of Cubists or Concretists. Instead, Pfahler has endeavored to have his paintings unfold outward and envelop the viewer's space!

"For me the challenge posed by space is to have it dynamically projecting forward at the observer. I strive for dynamic construction, dynamic paintings. The surface bursts and the colors spill into space."

He has also extensively explored three-dimensional forms, putting together a color wall construction in 1970 that people could walk through, an experiment that led to numerous architectural projects.

For one of his kites Pfahler has adapted the motif of his "Fra Firenze" series with the color plane breaking away from the painting and passing beyond the borders. There is a tense interaction between surface, form and space in the piece, but the artist's main concern is the intrinsic value of color: "Color creates surface, creates form, creates space. Color is expansive."

初期のタシスム的画風を経たあと、ゲオルク・カール・プファーラーは1950年代末からブロックを構築したような作風に変わった。フォルムを極度に単純化し、明確に限定していくことによって、自分の絵画理念を色彩と空間がおりなす現象へと凝縮していっている。彼が意味する空間とは、古典的な遠近法による幻覚的空間でもなく、キュービズムの空間やオプティカル・アート的な構成や平面構成による具象画的な空間でもない。彼が求めるのは、絵画がそれ自身を越え出て観る者の中へ発展していき、空間の中へ展開していくように見えることなのである。

「私にとって空間とは、前方へ、観る者の方へと近づいていく動的な空間である。動的な構造、動的な絵画であり、平面は立体的に押し上げられ、色彩が空間にみなぎりあふれるのだ。」

彼は平板に描いたその色彩文字もこれに徹して三次元の立体造形へと変化させた。1970年のベニス・ビエンナーレ展においては彩色した仕切り壁を使って、中が歩ける色彩空間のオブジェをつくった。それ以来、彼は数多くの建築プロジェクトにおいて色彩空間に関する自分のイメージを実現している。

プファーラーは、今回のアート・カイトに彼のフラ・フイレンツェ・シリーズのモチーフを応用している。そのフォルムは全視野からその一部を切り取ったように見える。色彩平面はその画面構成から縁を越えて無限に拡がっていくことができる。画面中央にプファーラーはひとつの動的な、空間と時間の連続体を演出している。ぴったりと隣接する色彩平面の二次元的な並列が不動のものに見えるのは、最初の一瞬だけである。それらの色彩平面を互いに関連づけて見てみると、並列であった空間の印象は、幻覚的に前後に重なりあっているかのように変る。ひとつの色彩平面がこのように様々に変貌するというこの空間の謎は、時間的な相互関係が作用しているとしか説明ができない。平面、フォルム、そして空間という要素のかかわりが、彼のつくるコンポジションの内部で静と動の謎に満ちた方向緊張を生みだす動きを導いているのである。

しかし、プファーラーにとってまず大切なのは、幻覚的空間表現の効果ではなく、空間を決定する色彩そのものの真価なのである。「色彩は平面をつくり、フォルムをつくり、空間をつくる。色彩は広がる力をもつものである。」

Fra Firenze 86/88
Acrylic 208 × 208
Hamamatsu kite
Kite-maker: Sumitaya

Double-Tex 63–88
Acrylic 208 × 208
Hamamatsu kite
Kite-maker: Sumitaya